# TREASURES
## ON NEW MEXICO TRAILS

# TREASURES
## ON NEW MEXICO TRAILS

*Discover New Deal*
*Art and Architecture*

*Compiled and Edited*
*by*
*Kathryn A. Flynn*

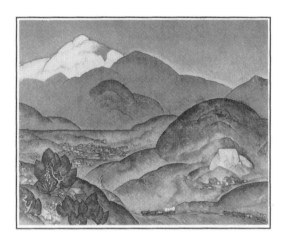

SUNSTONE
PRESS

SANTA FE
New Mexico

CONTRIBUTORS:

Andrew Connors
Sandra D'Emilio
Sally Hyer
Lynne Sebastian
Louise Turner

*This publication has been funded in part by a grant from the National Trust for Historic Preservation and by New Mexico Cultural Properties Publication Revolving Fund.*

First Edition
Printed in the United States of America

10 9 8 7 6 5 4 3 2 1

---

Library of Congress Cataloging in Publication Data:
Treasures on New Mexico trails: discovery of New Deal art and architecture / compiled, edited by Kathryn A. Flynn: contributors, Andrew Connors . . . (et al.)
     P. cm.
    Includes bibliographical references and index.
    ISBN: 0-86534-236-9
    1.Art, American—New Mexico—Guidebooks. 2.Art, Modern—20th century—New Mexico—Guidebooks. 3.Architecture, American—New Mexico—Guidebooks. 4.Architecture, Modern—20th century—New Mexico—Guidebooks. 5.Federal Art Project. 6. New Deal,1933-1939. I. Flynn, Kathryn A.
N6530.N6T74   1995                      94-36562
709' .789' 09043—dc20                   CIP

---

Published by SUNSTONE PRESS
      Post Office Box 2321
      Santa Fe, NM 87504-2321 / USA
      (505) 988-4418 / *orders only* (800) 243-5644
      FAX (505) 988-1025

# DEDICATION

## *To Helmuth J. Naumer . . .*

Mr. Naumer did not live to see this book published. He died on July 25, 1994, and New Mexico lost one of its own finest treasures. Therefore this book is dedicated to him in appreciation for his love of New Mexico, his dedication to the art created by its artists over the years (including his father), and his love of and concern for the land. May we all attempt to achieve what he did in living and dying.

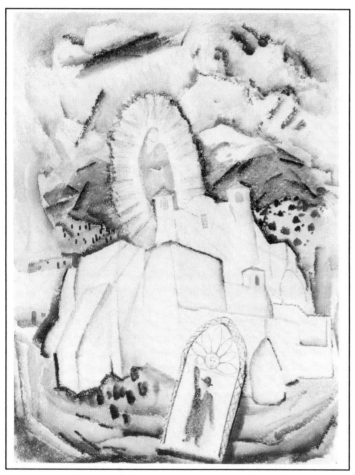

Victor Higgins did his modern version of the "Ranchos Church" of
Ranchos de Taos c.1933. This 29" x 21 $^1/_2$" watercolor is part of the
University of New Mexico Art Museum collection and photo was
provided by them.

# CONTENTS

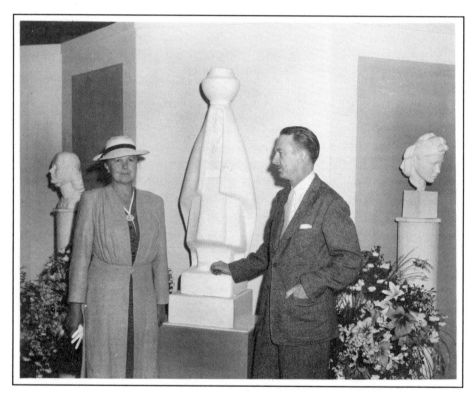

State Director of WPA Art Program, Russell Vernon Hunter, and Eugenie Shonnard, Santa Fe sculptress, at WPA sponsored art exhibition with some of her work. Photo from New Mexico State Records and Archives photo collection.

STEPHANIE GONZALES
SECRETARY OF STATE

STATE OF NEW MEXICO
SANTA FE

## OFFICE OF THE SECRETARY OF STATE

Dear Fellow New Mexicans and Friends of New Mexico,

In 1992 my office collaborated with several other state agencies to produce *Treasures on New Mexico Trails,* a small guide to the buildings and murals throughout New Mexico that were created under the auspices of President Roosevelt's New Deal programs. At that time, I noted that these programs helped artists of the 1930s fulfill their practical and aesthetic needs, and I emphasized the cultural and historical legacy that these works provide today. Now, I am delighted to note that this legacy has attracted so much interest from public agencies and private citizens in New Mexico that a book-length treatment is warranted. Thus, I am extremely pleased to offer some introductory remarks to the present volume, which highlights New Mexico's role in what one author calls the "national expression and national excitement" of New Deal art.

As Secretary of State, I find the New Deal art particularly invigorating because it illustrates the good that government can do. The same program that provided the construction of much needed roads and dams also produced truly democratic works of art: murals both representative and representational; and buildings functional as well as beautiful. Although the mural was a new medium for many of the artists involved, they approached their work with such enthusiasm and gratitude that they produced murals that not only met expectations but also set artistic standards. Likewise, many of the buildings helped define construction codes still applicable today.

In these ways, the New Deal integrated art and life more effectively than any other program before or since. It also demonstrated that fine art is not the exclusive property of wealthy patrons and expensive galleries but a sort of birthright of people everywhere, an ingredient of daily life passed from one generation to another.

Consider, for example, the courthouse in McKinley County, a registered historic place. In 1940 a county resident could enter the building to conduct some mundane business and watch, as a bonus, the history of New Mexico unfold before his or her very eyes as Lloyd Moylan completed his enormous mural spanning prehistoric and modern times. Although we New Mexicans of the 1990s cannot watch the artist, we can still enjoy his art; and with only a little imagination we can feel the thrill of artistic creation. We can also imagine, as another example, the appreciation of miners and cowhands in Grant County in the 1930s as Theodore Van Soelen transformed his hands-on experience with mining and ranching into faithful and lasting images. Impressive first as processes then as products, such magnificent murals and the buildings that house them connect the past, present, and future of New Mexico in what Willa Cather called the long chain of human endeavor.

It is important, I think, to acknowledge and preserve works that remind us of our heritage and that reaffirm the humanity common to us all. On a wall in the Quay County Courthouse in Tucumcari is a mural called "Coronado," which expresses in images and in words the universal yearning for immortality that motivates so much fine art and architecture. The inscription reads, "I, Francisco Vasquez de Coronado, have passed this way and left my mark." This book is a guide to hundreds of these marks--murals, buildings, roads, and dams--to be used and enjoyed as we go about making marks of our own.

Sincerely,

*Stephanie Gonzales*

Stephanie Gonzales
Secretary of State

Welcome,

"New Mexico, the State of the Arts" is a statement that some might think presumptive, but for those of us who live here the statement is true and natural. Art has always been the soul and spirit of New Mexico from the earliest pictographs to the flourishing art market today. Art in New Mexico is not just located in Taos or Santa Fé but throughout the state as this fine volume demonstrates. The WPA era, though late in New Mexico's art development, was a catalyst that helped the world recognize American Art. As the son of a participating WPA artist, it is exciting to see the revival of interest in this truly creative period and thus recognition for many of the hard working artists who captured for the future a world that is almost gone. Their understanding and insights have much to teach us all. Take the time to visit and browse among some of these works. It is a trip you will never forget!

*Helmuth J. Naumer, Past Director*
*Office of Cultural Affairs*
*State of New Mexico*

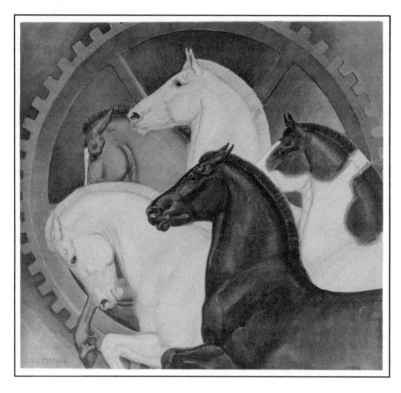

Horses and other animals have been the focal pieces for most of Ila McAfee's paintings. This oil painting (28" x 30") called "Horsepower" was most likely sent to the New Town schools in Las Vegas. Its current location is an unsolved mystery.

# FOREWORD

"TREASURES ON NEW MEXICO TRAILS" will give the reader an insight to some of the ways we as Americans and New Mexicans dealt successfully with the economic problem that faced the country between 1929-43. In 1930 the state's population was 423,317 and by 1935 over one half of New Mexico's citizens were enrolled in one of the various New Deal programs. The fourteen counties in the northeastern and east central areas of the state had the highest concentration; with between 24.3% to 72.8% of their inhabitants involved. The main result of that concentration was an overwhelming level of productivity by, and for, the people of that time, for us today and most likely, for generations to come. This book has been developed to lead you on a guided tour around the Land of Enchantment, to see and appreciate the fruits of those labors, done by the earlier members of many New Mexican households today.

For some it can be a chance to refresh the memories of that period when the federal government developed needed projects to employ its citizens, using their skills and talents to support themselves and their families while maintaining their pride. For younger folks, this book may provide a view of a part of this state's history by revealing the visual records that remain. For all, it should open our eyes to the quality and quantity of the varied accomplishments of that depression era. Today we are still using many of the public buildings (schools, post offices, courthouses etc.), roads, rock walls, campgrounds, dams, and furniture; and in many of those public places there is outstanding fine art. Some of this art goes unnoticed or is taken for granted while at other sites, it is cherished and protected. Hopefully, the latter reaction will spread throughout the state as a result of revealing the treasures in this material.

Finding and organizing the information together for this tourguide opportunity grew out of the compilation of the New Mexico *Blue Book* which is published every two years by the Office of the Secretary of State. Included in the 1991-1992 and 1993-1994 issues of this well received, but not well-known publication, were photographs of some of the fine art that was identified around the state in our public buildings when compiling these two documents.

Once again bringing this little known art into focus created much enthusiasm and interest. That response then created the catalyst for developing and coordinating a series of local art exhibits around the state in May 1992 in conjunction with National Historic Preservation Week and National Tourism Week. When we first began to think of the possibility of putting together a statewide tour of these treasures, we were unaware of these two national recognition weeks. Upon hearing of those planned events and how our goal of

making our citizens more aware of these historical treasures dovetailed with the goals of the two national entities' goals, the whole idea seemed to be validated. We met with state and local representatives of both groups and soon thirteen communities were busy developing ways to show off their New Deal Treasures during those first two weeks of May.

The Governor's Gallery in the State Capitol held the first exhibit and honored as many of the artists or their family members as could be found. Alamogordo, Albuquerque, Clayton, Clovis, Ft. Sumner, Gallup, Las Cruces, Melrose, Raton, Santa Fé, Silver City, Taos, and Truth or Consequences developed a variety of activities to feature their treasures from the past. "Discover Tourism Treasures" was the national theme for the tourism week, and discovering New Mexico's New Deal treasures became a reality.

Our statewide New Deal treasures included the historic buildings, their architecture and the art within. Researching which historical public buildings were created as the result of New Deal federally funded programs became the responsibility of the New Mexico Historic Preservation Division of the Office of Cultural Affairs. In some cases these structures have been placed on the National Register of Historic Places and/or the State Register of Cultural Properties. The Office of the Secretary of State worked with these agencies to coordinate the efforts around the state of local and state agencies and private citizens to identify and compile the history on the fine arts and crafts that were created for those public buildings or were placed in other public buildings around the state.

This proved to be a challenge because there were no centralized official records in the state, only pieces of information in various places. Locating the people with memories of the creations of the New Deal projects in New Mexico was like solving a mystery, that sometimes took the detective out of state to unravel the wonderful stories related to the art and artists sometimes long forgotten. Unfortunately we sometimes ran into major hurdles since a number of those artisans had died. Likewise, major clues were missing because the state project records were not retained as per directive from the federal government. The search goes on and, speaking as the "lead detective", I can say that it has been, and still is, a most enjoyable treasure hunt which, most likely, will not end anytime soon.

The main goals for this statewide project were:

- to celebrate the accomplishments of the New Deal project in New Mexico;

- to give our citizens of today an appreciation of those accomplishments, and

- to instill a sense of hope in overcoming our own economic challenges.

By doing this we were able to refresh the memories of some of our citizens and and give them the opportunities to rediscover what had been accomplished early in their lifetimes. The younger generations discovered, for the first time and firsthand, how our country pulled together in an earlier economically depressed era and created some very lasting treasures here in New Mexico. This approach to problem solving is still a viable philosophy and/or alternative to be considered today. A strong appreciation for these past accomplishments gave all a much needed good feeling about our society and that treasure of renewed hope for the future.

The findings of this "treasure hunt" include numerous buildings around the state--some look the same, others have been remodeled or have been enlarged while a few are no longer in use. Forty-eight communities have been identified to date with New Deal buildings that include or do not include New Deal art. We expect to find more as time passes and more as people become aware, interested, and report their personal knowledge. Sixty five murals, 657 paintings or other media, ten pieces of sculpture, ten pieces of pottery, forty-three wood carvings and numerous pieces of furniture and craft items have been discovered around the state. This book will guide you to them. No doubt there is more to be found. Quite a large number of the artworks can also be found in various public collections in Washington and some singular pieces in other locations around the country.

The numbers of workmen employed to build these public buildings and other construction projects, even in our forests, were great. According to Roberts and Roberts in *A History of New Mexico*, they were enrolled in at least two major work programs, the Civilian Conservation Corps (CCC) and National Youth Administration (NYA). There were some 56,000 young men working out of the 42 CCC camps in New Mexico, and this included a few artists charged with visually recording the activities of the projects. The NYA people were younger, ranging in age from 16-24. Interestingly, many of the men in both of these programs were some of the first to go into the military with the outbreak of World War II, substituting one form of service for our country for another.

As far as the number of artisans involved in the programs, we identified 162 people who worked on these art projects in New Mexico. Of that group thirty-seven were females, thirty were Native American and a large number of Hispanics were involved in the craft work. There are most likely others who have not surfaced due to limited records in New Mexico. Thirteen were still alive in 1994 and most of them are still creating artworks in some form. That group includes well known artists like Allan Houser, Bill Lumpkins, Pablita Velarde, Ila Mc Afee, Gene Kloss and Oliver LaGrone. In interviewing these people or reading about the lives of those now deceased, we feel that they all had some memorable experiences during that difficult time. Most were quite appreciative

of the programs that gave them the opportunity to use their talents to literally survive. Some projects paid on an hourly basis while at least one paid a flat monthly salary. Their creations of art were then sold to the various public sponsors (schools, courthouses, post offices, etc.) for as low as $1.00 or as much as $10.00. Today those works are considered collector's items and their values have increased significantly.

Each of the various federal New Deal governmental projects had different focuses. Some similarities and overlapping existed when one program's funding phased out and another started up. Each of these are identified in the text of the book. For the overall purpose of this book we have generally used the term "New Deal" as the generic name for all the programs or projects (see list in Appendices) since after sixty years, they have somewhat blended together. In the art funded programs there has been no attempt here to differentiate between the "amateur" and "professional" artist. Rather our focus has been to have the reader and viewer appreciate the outstanding creations that came out of that desperate time. It is also an attempt to expose the public to the way in which our government met the challenge in a manner that was both expressive and functional and whose products were built to last--and have.

To counter the limited available information we found in program records, we invited four authorities to include a small portion of their knowledge on the subject of New Deal art programs as it effected our various cultural groups in New Mexico. (See Chapters 3, 4, and 5). Hopefully this information will whet your appetite for learning more. We expect that actually seeing some of these fine creations will also cause you to want to see more and this book's format will lead you to them.

Some of the mysteries of locating the art were not solved. A chapter of this book addresses "Unsolved Mysteries of Art" and identifies artwork created by New Deal artisans that were believed to have been distributed around the state. Fifty plus years have changed the locations of some of those creations but our attempts to find them have been unsuccessful. We hope that by identifying them in this book, they will surface as readers don their own detective hats in the search.

We also hope each reader will appreciate that this book has been put together with great interest and in good faith; however, due to incomplete New Deal files here in the state, lost data and in some cases, no response to our inquiries, the information herein may be incomplete. Due to these conditions, we sincerely desire that each reader will respect that this has been an earnest attempt at compiling as much information as accurately as possible. We would greatly appreciate receiving any information related to this project that anyone might have--be they additions or corrections. We encourage readers to report any findings to Sunstone Press in Santa Fe.

Why was the New Deal "a good deal?" In summary, we conclude that in New Mexico:

• it was social purpose in action;

• it provided the chance for our people to survive and produce with pride;

• it recorded and presented the essence of New Mexico -- geographically, culturally, artistically, architecturally, agriculturally, even environmentally;

• it was the beginning of showing off the unique New Mexico style, in particular it assisted the Hispanic artists in marketing their unique goods for the first time; and

• it exposed the masses of our citizenry to actual fine art rather than just seeing it as reproductions in books or on calendars.

Today that "deal" is still sharing its legacy. It provides us an example of how to solve economic problems while giving our citizens hope and dignity. These are the two basic reasons why it is still a significant event that occurred in our country. When you examine the fine buildings and view the beautiful art, you will know that each is a good reason why it is was a good deal--old or new. Likewise it is important that in our appreciation of these treasures, we make sure we preserve and protect them from those who are not aware of their significance and value and for those young people who want to know more about the past.

There is hardly anyone who does not like to find a treasure and/or a good deal. The ones identified in this book are waiting for your discovery. There will be others. We hope you will look around and experience the public buildings and their contents in your community and do the same in other communities as you explore this, your Land of Enchantment and its New Deal treasures. In reality, it was and is a good deal for every state--so the treasure hunt can widen. What will you find? Happy hunting!

<div style="text-align: right">

Kathryn A. Flynn
N.M.'s New Deal "Lead" Detective

</div>

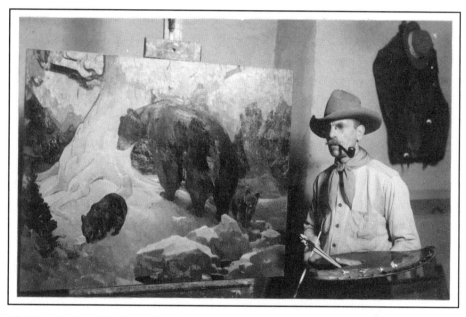

"Fall in the Foothills" caught the eye of President Franklin Roosevelt and Herbert Dunton's painting hung in the President's Office. It now is part of the National Archives of American Art in Washington, DC.

Chapter 1

# FIND THE TREASURES IN THESE TOWNS

## ALAMOGORDO

*"Painting a mural challenges a painter like composing a symphony does a composer. A landscape painting, by comparison, would be like the composer's simple tone poem."* —*Peter Hurd*, The National Observer. *February 8, 1971, p.10.*

I.  *WPA ART IN WPA BUILDINGS*

LINCOLN NATIONAL FOREST SERVICE BUILDING
(U.S. FEDERAL BUILDING)
1101 New York Ave.
Alamogordo, NM 88310
 (505) 437-6030

This building, which was built in 1938 as a post office in the New Deal project, PWA (Public Works Administration), is the home of a beautiful Peter Hurd mural which is on the front exterior of the building.

In Alamogordo, under the Art-in-Architecture program titled, "Sun and Rain," Peter Hurd painted one of New Mexico's most beautiful frescos in 1942, around the entrance to the building. The central part of the fresco is flanked by two smaller frescos, "Sorghum" and "Yucca." The *Alamogordo News* in 1941 described the central section:

The scene on the left of the main entrance portrays the sunshine and the green things that it brings from the earth, a beautiful scene of trees and flowers with Peter Hurd's own home at Picacho in the foreground, and the San Andreas Mountains and White Sands in the background. The life-size woman in the picture is Miss Edna Imhoff, teacher in schools at Rebenton

and the child picking flowers is Della Joiner, daughter of the postmaster at Hondo. At the right of the entrance is an old Mexican shepherd praying for rain. This shepherd is Dorothel Montoya, well-known to the big sheep outfits in the Hondo Valley, and back of him is the state flower with Sierra Blanca in the far background.

Below the shepherd with one hand raised to the sky in thanks of rain is inscribed, "Ven lluvia ven a acariciat la tierra serdiento" ("Come blessed rain, come caress the thirsty land"). Below Miss Imhoff, who has paused while hoeing in the garden to watch her daughter play, is inscribed, "Come sunlight after rain to bring green life out of the earth."[1]

Hurd chose to work in fresco due to the influence of the Mexican muralist, Diego Rivera, whom Hurd had previously met.[2]

(1) "Peter Hurd Completes Beautiful Murals at Alamo Post Office," *Alamogordo Daily News*, Vol. 45, No. 16, April 16, 1943. p. l.

(2) Frank Paine, *New Mexico Magazine*, January, 1977, pp. 36-48.

II. **WPA ART IN OTHER BUILDINGS** - None

III. **WPA BUILDINGS**

A. WHITE SANDS NATIONAL MONUMENT
White Sands National Monument Historic District (#1491)
State Register 9-9-88 National Register 6-23-88

The Historic District at White Sands National Monument (WSNM) consists of eight Pueblo Revival buildings constructed in the late 1930s by Civil Works Administration workers as a Recreation Demonstration and Emergency Conservation Work project. It is understood to have been done at the cost of $31,000. The centerpiece of the district is the Monument Administration and Museum Building, constructed in 1936-37. This two-story building with patios and portals was beautifully finished inside with exposed viga and latilla ceilings, a corner fireplace, tinwork fixtures, and Colonial style furnishings created by CCC workers and Girl Scouts. The district was also landscaped with native plants at the time of construction. The WSNM Historic District was found eligible to be included the National Register for

its architecture and its association with the history of the National Park Service (NPS), particularly the NPS emphasis on use of local materials and rustic styles in construction of park buildings.

B. WOMEN'S CLUB

IV. *MYSTERY PAINTINGS:* See Kloss & Nordfeldt in Chapter 2.

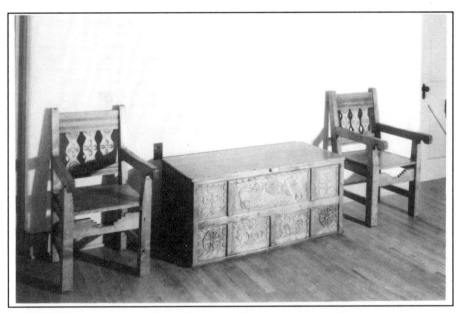

The carved chest and chairs were of the style discussed in this chapter. This beautiful furniture was placed in various public buildings around the state. These were in the Girls Scout Office in Roswell. This kind of work was designed and constructed in the New Deal programs and the vocational school programs. They were so well constructed and now treasured that they are still in use today in many sites around the state. The Roswell Art Center and the National Park Service in Santa Fe have some fine pieces. Photo from NM State Records and Archives.

# ALBUQUERQUE

*"The Thirties was our golden age, the only humane era in our history, the one brief period when we permitted ourselves to be good."* —Edward Laning, WPA muralist.

## I. *WPA ART IN WPA BUILDINGS*

### A. ANTHROPOLOGY ANNEX

The Anthropology Building was formerly the Old Student Union Building built by WPA funds. The Annex portion houses three Joseph Imhof murals depicting pueblo dancers.

### B. ZIMMERMAN LIBRARY

A beautiful example of John Gaw Meem's design of Santa Fé style architecture came into being with this federally funded project. Some of the furnishings of this building are also from that era as well as the mosaic murals.

## II. *WPA ART IN OTHER BUILDINGS*

### A. DOWNTOWN AREA

1. U. S. FEDERAL BUILDING/DISTRICT COURTHOUSE
   421 Gold SW
   (505) 766-8834 (Office of GSA Buildings Manager)
   SR #700 State Register 10-20-78 National Register 11-22-80

Completed in 1930, the Federal Building is a striking combination of Mediterranean style and decorative Indian design motifs. The lower portion of the six-story building is pale matte-glazed terra cotta above a stone foundation; the upper stories are of glazed brick in varying shades of tan. The top story is set off by a row of white tile and arched windows. The red tile roof is hipped and flat-topped. The exterior embellishments include patterned tile courses with motifs from Indian decorative arts. The interior also features Indian motifs and a WPA-supported mural of the Pueblo Revolt by Loren

Mozley. In 1936, under the Artist-in-Residence Program, Loren Mozley (1905-1989) painted a mural titled, "The Rebellion of 1680," designed to fit above and around the elevators of this building in the main lobby. The brightly painted mural is filled with highly stylized figures engaged in the dramatic revolt of the Pueblo Indians against the Spanish rulers of New Mexico.

A second mural is located on the sixth floor just outside the courtroom and is titled "Justice Tempered with Mercy - Uphold the Right, Prevent the Wrong." It is believed that this mural was created for the U. S. Post Office and Federal Courthouse in Roswell and placed there in November 1937. A transfer may have occurred when that building was demolished. It was created by Emil Bisttram (1895-1976) whose work on another mural won first prize and was placed in the Justice Department in Washington, D.C. Bisttram supervised the creation of murals in other parts of the state.

2. U.S. FEDERAL BUILDING
   517 Gold SW 8th Floor
   Army Corps of Engineers Office
   (505) 766-2738

A large painting by Odon Hullenkremer titled "Conchas Dam," a 6'x 4' oil, on the 8th floor, is representative of the scenes that came about during the creation of Conchas Dam in the eastern part of the state. There is a sister painting at the Administration Building of the dam.

3. OLD ALBUQUERQUE POST OFFICE
   123 Fourth Street SW

There may be two paintings in this building but their exact location has yet to be identified. This may be a WPA building.

E. Martin Hennings          "At Arroyo Hondo"
Carl Redin                  "New Mexico Fall"

4. ALBUQUERQUE LIBRARY
   501 Copper Avenue NW

An oil painting by Fremont Ellis titled "Old House at Chimayo," 22" x 30", still hangs in the library after being placed in this public facility many years ago.

### 5.  OLD BERNALILLO COURTHOUSE

A mural was done in the original courthouse by Esquipula Romero de Romero, Brooks Willis, and Stuart Walker depicting historical scenes of Albuquerque. When the building was destroyed, the mural went into private ownership.

### 6.  ALBUQUERQUE MUSEUM
### 2000 Mountain Road NW (Old Town Area)
### (505) 243-7255-Curator

This outstanding museum and gallery has become the repository for the WPA artwork that was originally placed in the U.S. Veterans Hospital and also the collection of Albuquerque High School. A painting by Carl Redin was also transferred there some years ago from the Albuquerque Public Library.

| | |
|---|---|
| Bisttram, Emil | "Juanita" oil 33"x44" |
| Bisttram, Emil | "Old Hunter" oil 27"x36" |
| Fleck, Joseph | "Don Quixote" oil 32"x45" |
| McAfee, Ila | "Antelope" oil 36"x42" |
| Redin, Carl | "Enchanted Mesa" oil |

### B.  UNIVERSITY AREA

### 1.  CARRIE TINGLEY HOSPITAL
### 1127 University NE
### (505) 272-5200 or 1-800-472-3235

A large collection of WPA artwork was placed in the hospital when it was originally built in Hot Springs (now Truth or Consequences). The paintings were transferred with the hospital when it came to Albuquerque in 1981.

As was always the case in T or C, upon entering the hospital reception area one viewed a near lifesize plaster sculpture of a mother and child. This was created by Oliver La Grone, the first black student in art to graduate from the University of New Mexico. He now resides in North Carolina and is still doing beautiful sculpture pieces. The statue was a creation of his memory of his mother nursing him back to health as a young sick child growing up in Albuquerque. This piece, called "Mercy" was finally bronzed in 1993 and "completed" after 60 years. In the cafeteria of the hospital one can enjoy the two large (72" x 120") murals by Gisella Loeffler (1903-1977). Created for the children at the hospital, they reflect the artist's childhood in the Austro-Hungarian empire, with strong influences of the folk art found there. Painted in a highly decorative combination of oil and gold paint, the murals portray Indian and Hispanic dances and customs and children's fairy-tale characters, all depicted in her imaginative style. Her daughter, Undine, remembers watching her mother paint them in their living room in Taos as she was recuperating from a childhood disease.

Upstairs in the administrative area of the hospital are located the other paintings provided by WPA artists. They include:

| | |
|---|---|
| Ellis, Fremont | "Winter Scene" oil, <br> "April Landscape" Trees/horses, oil, |
| Hullenkremer, Odon | "Boy in Helmut" (Isleta Village), oil, <br> "Convicts-Mining Scene" oil, <br> "Kids on Teeter-Totter" oil, |
| Jones, D. Paul | "Hernandez Church" oil |
| McAfee, Ila | "Bison" (damaged) oil |
| Parsons, Sheldon | "Autumn House with Gold Trees" oil <br> "Golden Trees with Flowers" oil <br> "Purple and Gold Iris" oil <br> "Lavender Iris" oil |
| Trevors, Franz | "Autumn Fields" oil |

2. UNIVERSITY ART MUSEUM

There is quite a large collection of New Deal artwork in this museum. Some of the works in the collection include six oils by Willard Nash (1898-1943) done in 1934 which were intended to be hung opposite six Raymond Jonson murals in the University library. Untitled and the same size as Jonson's, Nash's paintings portrayed the physical side of modern youth. Among the subjects are: a man shot-putting, women swimmers, women's tennis and basketball, men's track and tennis, men's football and boxing, and students walking to class. Nash, like Jonson, was a modernist, but Nash's more moderate experiments with form were inspired by Cezanne and Picasso.

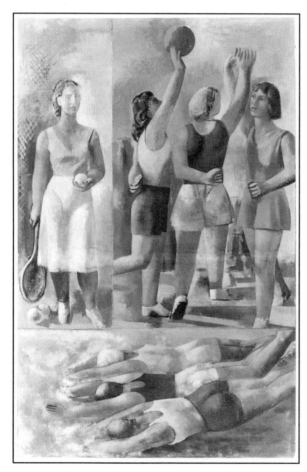

Willard Nash
85" x 55 1/4"
oil panel

Commenting on Nash's murals, Jonson, in 1936, wrote to Dr. J. F. Zimmerman, the president of the University of New Mexico:

*I want to say that I think Nash's panels worked out very well and it seems to me that they function as intended by him. Many may not like them-that does not matter. I believe artists will like them, for they contain much in regard to plastic work, and contain, for him who can and will see, a considerable amount of interest.*

The other New Deal artworks in this museum include:

Abelman, Ida*                "Janitor's Kids"

Abramoritz, Albert*          "Santa Monica"

Adams, Kenneth               "Church at San Antonio" oil 1934

Anderson, Carlos*            "Thirty Miles Upstate"

Arnold, A. Grant*            "Serenity"

Barton, Harold               "Abstraction" oil 1939
                             "Dead Tree" oil 1939
                             "Dead Tree" oil 1938
                             "South Second" oil 1939

Borne, Mortimer*             "Manhattan from Brooklyn"

Breslow, Louis*              "Puppet Show in Park"

Botts, Hugh*                 "Skyline"

Campbell, Blendon*           "New Hampshire Auction"

Chaney, Ruth*                "Subway Excavation"

Chapman, Manville            "Mountain Village"

Davis, Hubert*              "Holiday"

Dorman, John               "House on Canyon Road"

Dwight, Mabel*             "Christmas in Paris"

Easton, Cora               "Hollyhocks and House" oil 1939

Eldred, Thomas*            "Keeler Lane"

Fruhauf, Aline*            "Hotel at South Jersey"

Good, Minetta*             "November"

Grossman, Elias*           "The Church on Henry Street"

Hicks, William*            "Farm Buildings, Long Island"

Higgins, Victor            "Ranchos Church" watercolor 1934

Imhof, Joseph              "The Storm" litho

Jonson, Raymond            "Variation on Rhythm-D"
                           "New Mexican Village"
                           "Ranchito New Mexico"
                           "Twilight Scene"
                           "Snow Scene"

Kloss, Gene                "Twilight Scene" oil 1934
                           "Remote Village"
                           "Sanctuary - Chimayo"
                           "Winter Mass"
                           "Penitente, Good Friday"
                           "Acoma"

Kouner, Saul*              "Wind"

Kruse, Alexander*          "Jennie"

Limbach, Russell*          "Brown's Woods"

Lowell, Nat*               "Fulton Market"

Mongel, Max*               "Cargo Boat"

Morang, Dorothy            "Still Life Fruit on Green Bowl"
                           "Fiesta on Acequia Madre"
                           "Acrobat at Fiesta"
                           "Sunlit Walls"
                           "Landscape - Mountains From Tesuque"
                           "Sunset Glow"
                           "Aspen on the Sangre de Christo"
                           "Two Wine Bottles"

Morris, James              "Breakfast Tray" oil 1939
                           "Mountain Village" oil 1939
                           "Spring Morning, Santa Fé"

Moylan, Lloyd              "Navajo Runners"
                           "Two Men" litho
                           "Acrobat"

Murphy, Minnie Lois*       "Hurdy Gurdy"

Nash, Willard              "A Tree Study" oil
                           Untitled (football-boxing)
                           Untitled (men's tennis and track)
                           Untitled (shotput)
                           Untitled (woman swimmer)
                           Untitled (woman's tennis and basketball)

Naumer, Helmuth            "Oak Tree in Winter" oil 1940
                           "Mexican Houses" oil 1940
                           "Two Pines"

Nooney, Ann*               "April"

| | |
|---|---|
| Parish, Betty* | "Village" |
| Pillin, Polia | Five Domestic Science Panels |
| Sanger, William* | "A Bit of Albany" |
| Skolfield, Raymond* | "Caravan Theater" |
| Steffen, Bernard* | "Mine Village" |
| Supfer, Blanche* | "Morning on the Plaza" "Chichicastenango" |
| Wahl, Theodore* | "Colorado Ranch" |
| Weissbuch, Oscar* | "Cape Cod Coast" |
| Ufer, Walter | "Blaze and Buckskin" 1934 |

*These paintings were done by New Deal artists from other states and their work was obtained by the University possibly as a result of the traveling exhibits that occurred.

3.   JONSON GALLERY

This gallery is housed in the former home of Raymond Jonson (1891-1982) and has many of his works from the New Deal era. One might be aware that the 1934 series of six abstract oils called "Cycle of Science" include his abstract work depicting "Mathematics," "Biology," "Astronomy," "Engineering," "Physics," and "Chemistry." These pieces were scheduled to be placed in the Zimmerman Library opposite the six panels created by Willard Nash. He also created another group titled "Study for Art."

Of this series, Jonson wrote in his Technical Notes:
*These studies represent my concept of the spiritual side of modern youth, with the idea that contemporary knowledge offers an emotional and spiritual approach. When the panels are finished, I hope to have created not only an ideal wall decoration but works possessing a spiritual quality ...I think of them as symphonic compositions consistent with my medium and honest to the highest ideal I stand for.*

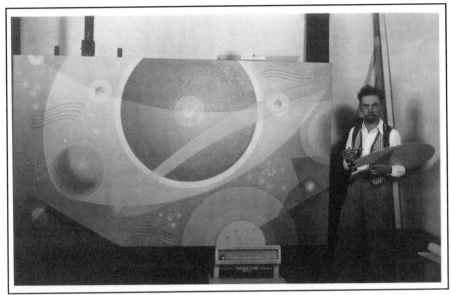

Raymond Jonson , "Cycle of Science: Astronomy" 1934   oil mural 60" x 105"

## C.  AIRBASE AREA

### 1.   KIRTLAND AIR FORCE BASE

The old Officer's Club, which originally was the Sandia Girls School,  had both art and furniture created specifically for it but most of it has since been lost. Six of the pieces of art by Lloyd Moylan still hang in the cocktail lounge of the East Officers Club. They are a series of different Indian dances. Originally there were at least seven paintings and maybe more but the missing paintings may have disappeared during a fire.

### 2.   VETERANS HOSPITAL

Building No. 1 which currently houses the Psychology Dept. was one of the buildings constructed during the WPA activities and has unusual carved animal heads on the vigas, and handmade furniture is located throughout.

### III. *WPA BUILDINGS*

Some of these buildings were designed by John Gaw Meem and were the landmarks for creating the Santa Fé style architecture for which he was famous.

1. OLD ALBUQUERQUE MUNICIPAL AIRPORT BUILDING
   2920 Yale Blvd SE
   SR #482 State Register 12-20-76 National Register 5-5-89

The 1939 Old Albuquerque Municipal Airport Building is a flat-roofed, two-story Pueblo Revival style structure that was designed by City Architect Ernst H. Blumenthal and built of adobe brick and other local materials by WPA workers. Adobe bricks were made on site and covered the reinforced concrete frame. Vigas and other wood elements were cut in the Jemez Mountains and milled or hand carved on site. The flagstones for the floors were cut and brought from the nearby Sandia Mountains. The interior is also Pueblo Revival with viga and herringbone-pattern latilla ceilings and walls of roughened stucco above tongue-and-groove wainscoting. The lobby was decorated with tinwork chandeliers, Indian rugs, and hand-carved wooden screens. At some point there were large paintings created by Pop Chalee which now hang in the current Albuquerque airport, but she reported she was commissioned to paint those by Howard Hughes.

2. ANTHROPOLOGY BUILDING (formerly the Old Student Union Building) Refer to II.B4 above.

3. BANDELIER WEST, MARIN HALL, NAVY ROTC, WOMEN'S DORMITORY, GOLF COURSE and HEATING PLANT.

4. SCHOLES HALL University of New Mexico
   SR #388 State Register 6-20-75 National Register 9-22-88

Built in 1936 as the Administration and Laboratory Building of the University of New Mexico, Scholes Hall was designed by John Gaw Meem and funded by the PWA. The H-shaped building with two-story wings and a three-story central section is Spanish-Pueblo Revival style and features two towers designed to be reminiscent of those of the Mission of Acoma. Built of brick and covered with stucco, Scholes Hall has seen many uses and much interior remodeling over the years, but the exterior is still very much as it was when the New Deal funded construction was completed.

5.   ZIMMERMAN LIBRARY - A beautiful example of John Gaw Meem's design of Santa Fé Style architecture came into being with this federally funded project. Some of the furnishings of this building are also from that era.

6.   MONTE VISTA FIRE STATION (currently a restaurant)
       3201 Central Ave. NE
       SR #849 State Register 12-18-81 National Register 3-19-87

The Monte Vista Fire Station, designed by City Architect, E.H. Blumenthal, was built with WPA funds and completed in 1936. As with all WPA projects, this hollow block and stucco building was constructed with local materials, using local labor. The exposed wooden lintels, projecting viga ends, ladders on the upper floors, and undulating parapets give the station its Pueblo Revival effect.

7.   ALBUQUERQUE LITTLE THEATER - This building was started by the veterans and initially may have housed the Albuquerque Veterans Recreation Quarters and the WPA offices.  As it later evolved into a local theatre, it was furnished with furniture created by the National Youth Administration (NYA) as well as Colcha embroidered cushions, pillows, and stage-curtains, tinwork fixtures and a beautiful fresco titled "Los Moros" which Dorothy Stewart created in 1936. A mural was also located in the ladies lounge. Unfortunately little of these beautiful gems remain today as the result of a remodeling activity.

8.   TINGLEY FIELD STADIUM

9.   RIO GRANDE ZOO ENLARGEMENT

10. NM STATE FAIRGROUNDS BUILDINGS-Wilfred Stedman designed the grandstand, paddock, track and clubhouses as part of this New Deal project.

11. REMODELING OF ARMORY

12. OLD ALBUQUERQUE HIGH SCHOOL
       # 464 State Register 6-20-77 National Register 11-17-78
       (Huning Highland Historic District)

Three of the Gothic Revival buildings in the Old Albuquerque High School complex were designed by Louis Hesselden and built using labor supplied by the WPA -- the administration building, gymnasium, and library.

### 13. OTHER ALBUQUERQUE PUBLIC SCHOOL BUILDINGS

A number of other APS buildings were built, remodeled, or had additions built as the result of this source of funding. Likewise adjacent school playgrounds, ball fields, etc. were also created. The schools include Armijo, Coronado, Duranes, Five Points School, La Mesa, Lincoln, Los Candelarias, Pajarito, San Jose, Santa Barbara, and Stronghurst. For specific information on each of these refer to the Albuquerque Museum Monograph written by Charles Biebel. See New Deal Program References section.

### 14. CIVILIAN CONSERVATION CORPS (CCC) CAMPGROUND

In the Cibola National Forest on Highway 526 is the site of an old CCC camp which housed most of the men that worked in that forest. Today it is the desire of the New Mexico CCC Alumni group to rebuild this site as a memorial park.

### 15. HEIGHTS COMMUNITY CENTER
823 Buena Vista NE

A WPA built project of the late 1930's, this community center located near the Albuquerque Technical Vocational Institute has provided the citizens of this village, now city, with many happy hours. It is still serving the populace as a community center.

IV. *MYSTERY ARTWORK* : See Chapter 2.

# AMISTAD

I. *WPA ART IN WPA BUILDINGS*: None

II. *WPA ART IN OTHER BUILDINGS*: None

III. *WPA BUILDINGS*

Amistad School building built in 1937 by New Deal programs.

**IV.** *MYSTERY ART:* None

# ARTESIA

**I.** *WPA ART IN WPA BUILDINGS*: None

**II.** *WPA ART IN OTHER BUILDINGS*: None

**III.** *WPA BUILDINGS*

   1.   ARTESIA MUNICIPAL HOSPITAL

Originally called Artesia Memorial Hospital when built in 1939 by WPA/PWA funds, it is still in use today. Additions were made in the early 1940's and the most recent renovations and additions finalized in the mid 1960's.

   2.   Old CITY HALL was also built in 1939 but is now being used as a real estate office and looks much as it did then.

   3.   The CCC was responsible for road construction, erosion control, telephone line  construction, fence and stock tank construction as well as the structures at Sitting Bull Falls.

**IV.** *MYSTERY ART*: None

# AZTEC

**I.** *WPA ART IN WPA BUILDINGS*: None

**II.** *WPA ART IN OTHER BUILDINGS*: None

**III.** *WPA BUILDINGS*

   CITY HALL was built in 1936 and is now the Aztec Museum.

**IV.** *MYSTERY ART*: None

## BANDELIER NATIONAL MONUMENT #56
HCR 1 Box 1, Suite 15
Los Alamos, NM 87544
(505) 672-3861

*"In spite of Depression gloom, there was a new and positive sense of the artist's place in American society and a more confident attitude toward American art...I have never heard an artist who lived through those years complain about the WPA art projects. It still remains for many a `golden age'."* — Milton W. Brown, "New Deal Art Projects - Boondoggle or Bargain?", *Art News*, April, 1982, p.87.

### I. *WPA ART IN WPA BUILDINGS*

Between 1936 and 1940 Bandelier National Monument participated as part of the WPA by employing a number of New Mexico artisans to create special artworks for their New Deal created buildings. These buildings are now on the State and National Registers of Historic Places.

Pablita Velarde, Helmuth Naumer, and E. J. Austin were commissioned by the National Park Service to do large murals, easel paintings, drawings, and Velarde's sister, Legoria Tafoya, was chosen to create a pottery making set for the newly built museum exhibits.

Paintings by Pablita Velarde are in watercolor on paper and glass. These works express her basic integrity and faithful portrayal of her people and the Indian culture. The entire collection includes 72 paintings by Velarde.

Helmuth Naumer's 14 pastels express the timeless Pueblo Indian landscape and Frijoles Canyon. In addition, Legoria Tafoya's work is two-fold with her Santa Clara pottery-making series and black and white photographs of her pottery-making techniques. E. J. Austin's works are primarily drawings of prehistoric site location maps and human facial structures.

### II. *WPA ART IN OTHER BUILDINGS*: None

### III. *WPA BUILDINGS*

State Register 5-20-69 National Register 10-15-66

In addition to the remarkable prehistoric pueblo ruins at Bandelier National Monument, there is a historic district comprising thirty-one buildings constructed by the CCC. Built in the Pueblo Revival style, these buildings formed a complete development for the National Monument -- everything from a visitor center and offices for staff to lodging for guests and housing for employees. The buildings were built of locally quarried stone and connected to each other by portals, stone walls, and flagstone walks. Exterior details include wooden doors, window frames, viga ends, and post and decorated corbel portals. The interiors feature viga and latilla ceilings, corner fireplaces, bancos, and hand-carved wood. The CCC also built Spanish Colonial style furnishings for the guest lodge.

The District Office was laid out to look like a Southwestern village surrounding three sides of a plaza, and details like masonry drinking fountains and curbs and retaining walls give the entire complex a pleasing unity.

**IV.** *MYSTERY ART*: None

# CARLSBAD

*"...the federal art project might be termed the guardian of many artists, and we believe it is bridging a span of time which might have been disastrous to art developments when discouragement occurred from lack of patronage."* —Russell Vernon Hunter, "WPA Project Bringing Art Education Appreciation", *The Santa Fé New Mexican*, February 22, 1926.

**I.** **WPA ART IN WPA BUILDINGS**

CARLSBAD CAVERNS NATIONAL PARK
Carlsbad Caverns National Park Historic District (#269)
State Register 2-20-73 National Register 8-18-88

The Historic District at Carlsbad Caverns National Park comprises a number of Pueblo Revival buildings constructed by Park personnel in the 1920s and 1930s and several stuccoed adobe buildings in the New Mexico Territorial Revival style by the CCC in the early 1940s. Some of the trails and landscaping were also built by the CCC, but most predate this program. The district is

eligible for the National Register both because of its architectural significance and landscaped setting and because of its association with the CCC. Furniture and tinwork were also created for these structures and they are in use today.

Will Shuster, Santa Fé artist, created five paintings of the caverns in 1934 during his New Deal painting days. These works are now in the Western Archaeological Conference Center in Tucson, which is part of the National Park Service. He created an earlier set of works during a trip with Walter Mruk in 1926, works that "were objective in form and highlighted in white, grays, and blues. The later paintings were done under electric lighting and were warmer and utilize more color than the earlier canvases."—*Joseph Dispenza and Louise Turner, WILL SHUSTER, A SANTA FÉ LEGEND,* Museum of N.M. Press. Santa Fé - 1989, 135pp.

## II. *WPA ART IN OTHER PUBLIC BUILDINGS*

CARLSBAD MUSEUM AND ART CENTER
418 W. Fox Street
(505) 387-0276

A large mural-size painting, 42" x 50" by La Verne Nelson Black (1887-1938) under the Treasury Relief Art Project (TRAP) titled, "The Jicarilla Apache Trading Post," is a dramatic work of Jicarilla Apache Indians at the trading post some of whom are on horseback. The time of day is dusk with dark winter clouds in the background and with brighter colors on the individuals.

## III. *WPA BUILDINGS WITH NO WPA ART*

1. Eddy County Courthouse was begun in 1891, with additions in 1914 and 1939. The 1939 addition was done by WPA for $185,000.

2. The Flume--a concrete waterway

## IV. *MYSTERY ART:* See Chapter 2.

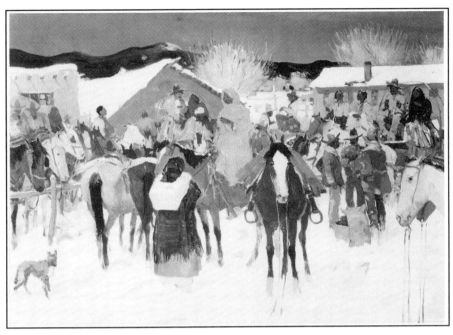

La Verne Nelson Black, "The Jicarilla Apache Trading Post" oil painting 42' x 50"

## CARRIZOZO

*"Working with WPA programs was a stimulating experience and the participants demonstrated enthusiasm, energy, and camaraderie. Undoubtedly the Federal programs were an enormous step forward for American art."* — Roland Dickey, Supervisor and later Director of the Roswell Museum and Art Center 1938-40.

**I. *WPA ART IN WPA BUILDINGS*:** None

**II. *WPA ART IN OTHER PUBLIC BUILDINGS*:** None

**III. *WPA BUILDINGS***

The Lincoln County Courthouse was built with New Deal funds in 1940. That portion of the building is now the annex to the main courthouse built in 1964.

**IV. *MYSTERY ART*:** None

# CLAUNCH
### (40 miles south of Mountainair on State Road 14)

*"The PWA brought new facilities, a high standard of construction, and safety to school buildings across the U.S. By 1936, over 79% of all school construction came through the PWA."* —Talbot, Faulkner Hamlin, "Architecture and Government", *Pencil Points*, 19 (May, 1938), p.25.

## I.  *WPA ART IN WPA BUILDINGS*: None

## II.  *WPA ART IN OTHER PUBLIC BUILDINGS*: None

## III. *WPA BUILDINGS*

Still standing is a rock structure which was once the community school house. The elementary school section was built in 1936 and the high school section was built in 1939. The inscription of "WPA" is highly visible over the front door. This building is identified in tribute to all of the school houses around New Mexico built by New Deal funds and the hard work of the CCC and NYA work forces. Many of New Mexico's citizens, including Governor Bruce King, received their education in these structures. Many of these structures were designed by Wilfred Stedman of the Krueger/Clark architectural firm. This firm did a great number of the buildings in the state.

## IV. *MYSTERY ART*: None

# CLAYTON

*"Even the bootleggers did their bit, in absentia. From all over the northern section of the county, students and ranchman brought in whiskey stills to Clayton-scores of them abandoned years before when their operators took hasty retreats. The fine copper they contained took form as massive wastebaskets for the school."* —"The Man Who Saved Union County," Elvon L. Howe, *Rocky Mountain Empire Magazine*, May 16, 1948.

## I.  *WPA ART IN WPA BUILDINGS*

CLAYTON PUBLIC SCHOOLS
Clayton High School/Administration
323 5th Street
(505) 374-2596

One could wonder if the whole town of Clayton survived during the Depression days as a result of the New Deal. The school buildings were built in 1939, and furnished with the products created in various vocational programs, funded by the New Deal programs. Some of those products included such things as mattresses and ironwork in addition to ceramic dishes, drapes and furniture. Many of these items are still in use in the school buildings of Clayton today. Other items have been saved and are on exhibit in their WPA Museum located in the junior high building. This museum was put together through the efforts of the home economics teacher and her classes in 1990.

The school also prides itself on its wonderful collection of easel works created during that era by a large variety of artists. They include:

| ARTIST | TITLE |
| --- | --- |
| Bakos | "Blue Shadow on the Hill" (Unknown whether Jozef or Teresa) |
| Bybee | "Timberline Trail Ridge" (This artist is unknown) "Windblown" |
| Chapman, Manville | "Indian Man" "Indian Woman" "Woodland Scene" |
| Cooke, Regina Tatum | "Blue Gate" "Still Life" "Well by the House" "Street in Taos" "Christmas Eve-Taos" "Arrival of Spring" |

| | |
|---|---|
| Jones, D. Paul | "Zinnias" |
| | "In Chamita" |
| | |
| Kloss, Gene | "Penitente Good Friday " |
| | "Christmas Eve, Taos Pueblo" |
| | "New Mexico Indian Village" |
| | "Acoma" |
| | "The Sanctuary - Chimayo" |
| | "Ranchito, N.M." |
| | "New Mexico Mountain Town" |
| | |
| Naumer, Helmuth | "Cottonwood Tree" |
| | "Sangre de Cristo" |
| | "Wagon Trail" |
| | "Mount Taylor" |
| | "Upper Pecos" |
| | "Canon Cito" |
| | |
| Nordfeldt, B. J. O. | "Street Scene" |
| | "Church & Cemetery" |
| | |
| Pillin, Polia | "Santa Fé Fiesta Booth" |
| | |
| Schleeter, Howard | "The Dead Tree" |
| | "Red Church" |
| | |
| West, Harold | "Get Down, Come In" |
| | "Oklahoma Storm" |
| | |
| Will, Blanca | "My Garden Gourds" |
| | |
| Willis, Brooks | "Still Life" |

II. *WPA ART IN OTHER PUBLIC BUILDINGS*: None

III. *WPA BUILDINGS*: School buildings noted above and town sidewalks

IV. *MYSTERY ART*: None

# CLOVIS

*"I learned a tremendous amount in the WPA project. Young, unknown artists and well-known artists were all having big problems. The WPA actually accomplished more than any other program that the government had previously backed. The money went directly to the people who needed it the most."* —James Ridgley Whiteman in interview with Sandra D'Emilio, Curator, New Mexico Museum of Fine Arts.

## I.  *WPA ART IN WPA BUILDINGS*

OLD POST OFFICE BUILDING (#1108)
State Register 10-17-84 National Register 12-27-84

The Carver-Clovis Public Library was constructed in 1931 as a post office. Between 1965-74 it provided classrooms and offices for the public schools Regional Service Center. Later in 1974 it was converted for their library use. The two-story sandstone and brick building with a tiled roof combined Spanish Colonial Revival and Neoclassical styles to create a dignified federal building that was still consistent with its Southwest location. This building was part of the Hoover administration's efforts to respond to the Depression within existing programs. Although it predated the WPA and other New Deal programs, the intention and effects were the same--employment for local workers and extra business for local suppliers.

A large, 48" x 111" untitled oil mural by Paul Lantz can be found in this building. It depicts the main street in Clovis at the turn of the century. Commissioned by the Treasury Section, the mural represents life when small towns were developing the West. Plans for this building and the mural's future are unknown at the time of this publication.

## II.  *WPA ART IN OTHER PUBLIC BUILDINGS*

CLOVIS COMMUNITY COLLEGE
417 Schepps Blvd.
(505) 769-2811

Two Howard Schleeter (1903-1976) paintings are on display at this institution. They were both created in 1937 and are titled "Aspen and Oak" and "Ochre Hills."

### III. *WPA BUILDINGS*

1. Curry County Courthouse
2. Memorial Hospital
3. Marshall Junior High School
4. Hillcrest Park

### IV. *MYSTERY ART*: See Kloss and Nordfeldt lists in Chapter 2.

# CONCHAS DAM

*"The men who worked on the WPA projects were not leanin' on a shovel. They earned the $18.75 a week they were paid by the government as opposed to being just placed on a welfare role. That payment amount was determined by the federal government."* —Mildred Constantine, New York New Deal staffperson. Telephone interview 1993 with Kathryn Flynn.

ARMY CORPS OF ENGINEERS-CONCHAS DAM
P. O. Box 1008
Conchas Dam, NM 88416

### I. *WPA ART IN WPA BUILDINGS*

Conchas Dam is the oldest and one of the largest water projects of the US Army Corps of Engineers in New Mexico. Begun under the New Deal's Emergency Relief Act of 1935, the construction of the dam and associated facilities provided employment for nearly 2400 people. The WPA supported school teachers for the children of the work crews and after the dam was completed, the work camp provided housing for CCC crews building onsite recreational facilities. Today the headquarters building is still in use, and five other units provide housing for staff. The buildings at the dam are, however, not registered on either state or national registers.

Odon Hullenkremer depicted the beginning of construction of the Conchas Dam in an oil approximately 6' x 4' in 1937. The painting shows the various workmen and equipment as the project began, and the painting is hung in the headquarters building today.

## II. *WPA ART IN OTHER PUBLIC BUILDINGS*

There is a "sister" painting to the above work located in the Army Corps of Engineers Central Office in Albuquerque at 517 Gold SW on the eighth floor.

## III. *WPA BUILDINGS*

See I. above

## IV. *MYSTERY ART:* None

# DEMING

*"Government programs did much to eliminate the idea that the artist was an odd guy...(he) was accepted by the community from that time on, just as was the doctor, the baker, the carpenter. He was no longer an odd-ball."* —Interview with Kenneth M. Adams conducted by Sylvia Loomis, April 23, for the Oral History Collections of the Archives of American Art in Albuquerque, April 23, 1969.

## I. *WPA ART IN WPA BUILDINGS*

DEMING POST OFFICE
Postmaster

This building was constructed in 1937 by the New Deal programs and was nominated to be included in the National Register for Historic Places on February 23, 1990.

The Deming Main Post Office is a red brick, single-story building with limestone belt courses, lintels, sills, and decorative panels. Built at a bid cost of $62,400, the post office building is eligible for the National Register not only for its architecture and association with the history of federal projects

in Deming, but also for the Kenneth Adams mural, "Mountains and Yucca" located in the lobby. This piece is specifically mentioned as contributing to the historic significance of the building.

Originally Andrew Dasburg, a Taos artist, was selected to do the mural for this post office. Unfortunately his poor health kept him from working in the hot climate found in Deming, so when he declined the opportunity he recommended they use Kenneth M. Adams instead. His recommendation was accepted and a pure landscape was done in 1937 by Kenneth M. Adams (1892-1966). Yucca and other local vegetation can be seen in the foreground, while the familiar landmark, Cook's Peak, dominates the background. The choice of palette used in this work comes from the soft greens, blues, violets, and yellows found in the nearby landscape.

II. *WPA ART IN OTHER PUBLIC BUILDINGS*: None

III. *WPA BUILDINGS*

1. Deming Country Club
2. Deming Junior High
3. Morgan Hall
4. Deming Public Library
5. Columbus School
6. Sunshine School
7. Hospital Addition
8. Park, street paving, sewer work, curbs and trees
9. National Guard OMS-1940

IV. *MYSTERY ART*: See Kloss and Nordfeldt lists in Chapter 2.

# DEXTER

*"Future historians writing of today perhaps will call this era the A.B.C. Period of the Alphabetical Decade, one of the most significant decades in the history of our country. More thought is being given by our national government to the betterment of mankind than ever before."* —Ina Sizer Cassidy, New Mexico Magazine, June 1935, p. 20.

I. *WPA ART IN WPA BUILDINGS*: None

II. *WPA ART IN OTHER BUILDINGS*

The Public Schools own an easel painting by Martin Hennings, called "Across the Valley."

III. *WPA BUILDINGS*: None

IV. *MYSTERY ART*: See Chapter 2.

E. Martin Hennings, "Across the Valley"   oil painting  36" x 40"

# EL RITO

*"One should remember that an entire generation of artists was kept active in art, not dissipated in idleness and other pursuits, and that a new generation was supported while training."*—Milton W. Brown, "New Deal Art Projects-Boondoggle or Bargain?" *Art News*, April, 1982, P.86.

I. *WPA ART IN WPA BUILDINGS*: None

II. *WPA ART IN OTHER BUILDINGS*

NORTHERN NEW MEXICO COMMUNITY COLLEGE
Administration
(505) 584-4501

An oil triptych by D. Paul Jones titled "The Founding of San Juan, The First Capitol of New Spain" can be found in the Bronson Cutting Hall.

III. *WPA BUILDINGS*

There was a CCC Camp located near El Rito. It is anticipated that this group may have worked on the rock walls and other landscaping done at the school early on. No buildings are identified as built by a federal New Deal program, however, Delgado Hall is on the State Register as a historic building.

IV. *MYSTERY ART*: See Chapter 2.

# ESTANCIA

I. *WPA ART IN WPA BUILDINGS:* None

II. *WPA ART IN OTHER BUILDINGS*: None

III. *WPA BUILDING*

1. COMMUNITY CENTER built in 1934 of adobe was renovated in 1992-93.

2.    The community's streets and the sewer and water system were put in with the help of the New Deal.

# FARMINGTON

**I.   *WPA ART IN WPA BUILDINGS*:** None

**II.  *WPA ART IN OTHER BUILDINGS*:** None

**III. *WPA BUILDINGS***

1.    FARMINGTON MUSEUM -- The Southwest room in the present building was the original WPA library built in 1937.

2.    SANITATION UNITS -- Refer to Kirkland, NM

**IV. *MYSTERY ART*:** None

# FORT STANTON

FORT STANTON HOSPITAL and TRAINING SCHOOL
Administration - (505) 354-2211
P.O. Box 8
Fort Stanton, NM 88323

"Both the depression and ill health-the latter of which brought many artists to New Mexico-made the employment problem of Southwestern artists a particularly urgent one. Many artists had been forced to give up painting entirely." —"New Mexico Art, " 1930 WPA New Mexico, *University of Arizona Press.*

**I.   *WPA ART IN WPA BUILDINGS*:** None known to exist.

**II.  *WPA ART IN OTHER PUBLIC BUILDINGS:*** None

**III. *WPA BUILDINGS***

The master plan for Fort Stanton notes that there was a CCC camp just across the Rio Bonito from the Fort. This was, in fact, the location developed into a POW camp. It also notes that research into the role of the CCC in construction of buildings at the fort should be a priority. The institutional records indicate that some buildings still in use were built in 1935 by the CCC. They include:

1. Boiler Rooms
2. Residences
3. Hidalgo Cottage

### IV. *MYSTERY ART*

Early records indicate there were approximately 80 watercolors here done primarily by New Deal artists from other states. Some may have gone to Ft. Bayard when the tuberculosis patients were transferred to that facility and the whereabouts of all are unknown at the time of this publication.

# FORT SUMNER

*"These murals will become in future years a possession which Fort Sumner will cherish as a community asset and thousands will visit there to see."* —Vernon Hunter "Historic Murals," *Curry County Times*, June 21, 1934, p.1.

### I. *WPA ART IN WPA BUILDINGS*: None

### II. *WPA ART IN OTHER PUBLIC BUILDINGS*

DE BACA COUNTY COURTHOUSE
The DeBaca County Courthouse (#1270)
State Register 5-9-86 National Register 12-7-87

Though architecturally interesting because of its unusual (for New Mexico) Georgian Revival style, the DeBaca County Courthouse is too early for the New Deal -- it was built in 1930. However, the murals on three walls of the second floor of this building were done by Russell Vernon Hunter (1900-1955). Mr. Hunter was the state-wide coordinator of the WPA program from 1933 to 1943 and grew up in this part of the state. The murals, titled "The Last

Frontier" and painted in 1934, depict many scenes with which he had personal knowledge. Depicted are periods in the history of Fort Sumner and Eastern New Mexico including subjects covering the adventures of Billy the Kid, Fort Sumner's beginnings, and early days in Texico, where Texas and New Mexico cowboys entertained themselves.

Hunter, whose parents were homesteaders in the Lakeview District, six miles north of Texico, researched his New Deal project thoroughly before taking up the brush. A Texas newspaper noted:

*One is struck with the amount of research required. Hunter's preparation has been life-long and his residence in Farwell and Texico have qualified him to interpret the Panhandle-Plains as few can. But a deeper understanding than mere research makes the mural a sort of unchangeable pageant of the men and women who fought their lives away in taming America's last badlands.* [1]

(1) "Vernon Hunter Completes His Frontier Mural at Fort Sumner," *Dallas Morning News*, Saturday, September 8, 1934.

III. *WPA BUILDINGS*: None

IV. *MYSTERY ART*: None

# GALLUP

*"..the mural portrays a powerful, all encompassing saga: the struggles of man against man and man's technological progress..."* —Patrice Locke, "Gallup Mural a Long Look Back," *Albuquerque Journal*, Section C, August 16, 1987. p.1.

Gallup was one of the four New Mexico towns with New Deal art centers. That center was located in a building that was once the old courthouse and may have been demolished.

I. *WPA ART IN WPA BUILDINGS*

MCKINLEY COUNTY COURTHOUSE (#1191) built in 1939
State Register 9-20-85 National Register 2-15-89
(505) 722-3869

The 1939 McKinley County Courthouse was partially funded by the Public Works Administration. The four-story Spanish-Pueblo Revival style building was designed by the regionally renowned firm of Trost and Trost. The interior is embellished with wood beams, posts and corbels, and the main entry has Indian motifs incised into the stucco. The building is eligible for the National Register both for its architectural qualities as well as for its association with the political history of New Mexico.

In this building is one of the state's most spectacular murals, which was painted by Lloyd Moylan in 1940. This untitled fresco covers 2,000 square feet of the entire courtroom wall above a six-foot high wood panel. The subject is the history of New Mexico, from prehistoric to modern times. Included are scenes of Indian life in pre-conquest days, the arrival of the Conquistadors, the Pueblo Revolt of 1680, the Gold Rush, and the Atchison, Topeka, and Santa Fé Railway.

Another mural can be found in the District Attorney's Office. This one was done in 1942 by Anna Keener Wilton. It is called, "Zuni Indian Pottery Woman."

A variety of WPA artwork can be found in the County Commission Room. The furniture in that room and other portions of the courthouse was created by WPA artisans. The artwork on view includes:

| | | |
|---|---|---|
| 1. | Jozef Bakos | "Cottonwoods" |
| 2. | Paul Jones | "Spring Landscape" |
| 3. | Gene Kloss | "Grazing Horses" |
| 4. | Paul Lantz | "Church in the Rio Grande Villa" |
| 5. | Lloyd Moylan | "Dinner" |
| 6. | Lloyd Moylan | "Breadwinner" |
| 7. | Lloyd Moylan | "Storage Barn" |
| 8. | V. Nye | "The Engineer" |
| 9. | Sheldon Parsons | "Nambé Valley Summer" |
| | | "Casa on the Hill" |
| 10. | Brooks Willis | "Desert" |
| 11. | Brooks Willis | "Trees" |

## II. *WPA ART IN OTHER PUBLIC BUILDINGS*

A.  OCTAVIA FELLIN PUBLIC LIBRARY
   115 West Hill
   Contact Person: Librarian
   (505) 863-1291

This art collection came about primarily as the result of the work created and/or acquired by the New Deal art center in Gallup. Octavia Fellin, retired librarian, took great personal care of this collection, and it was also included in a 1980s video presentation on New Deal programs developed by a German film company. The video featuring Gallup was later shown on the Public Broadcasting channel. The artwork that can be viewed at the library includes:

| | | |
|---|---|---|
| 1. Erik Barger | "Shiprock" |
| 2. Begay (possibly Timothy) | "Navajo Girl with Lamb" |
| 3. Harrison Begay | "Yeibachai" (Navajo Dance) |
| 4. Harrison Begay | "Navajo Rug and Weaver" |
| 5. E. A. Burbank | "A Lincoln Log Post Office" |
| 6. E. A. Burbank | "Hopi Indian House" |
| 7. E. A. Burbank | "Redwood Trees" |
| 8. Frederick Detwiller | "Dutch Harbor" |
| 9. Joseph Fleck | "Westwind" (Pueblo Maiden) |
| 10. A. L. Groll | "Enchanted Mesa" |
| 11. A. L. Groll | "Kit Carson House" |
| 12. A. L. Groll | "Inscription Rock" |
| 13. A. L. Groll | "Red Rocks" |
| 14. A. L. Groll | "Under Western Skies" |
| 15. Allan Houser | "Apache Devil Dance" |
| 16. Anna Huntington | "Mule" |
| 17. Wm. R. Leigh | "Horses and Whiskey Don't Mix" |
| 18. Lloyd Moylan | "Enroute to Ceremonial" |
| 19. Lloyd Moylan | "Approaching Storm" |
| 20. Lloyd Moylan | "Household Duties" |
| 21. Lloyd Moylan | "Journey through Long Horse Valley" |
| 22. Lloyd Moylan | "Pueblo Indians" |
| 23. Lloyd Moylan | "Rain on the Reservation" |

| | |
|---|---|
| 24. Lloyd Moylan | "Rolling One" |
| 25. Helmuth Naumer | "Dead Cottonwood" |
| 26. A. D. Smith | "Chief Deer, Sioux Indian" |
| 27. H. B. Tshudy | "Cedar Tree" |
| 28. WPA Craftsperson | Trastero |
| 29. WPA Craftsperson | Carved Trastero |

30. Another painting is on loan to the Red Mesa Art Gallery.

B.  GALLUP PUBLIC SCHOOLS

These paintings by Edgar Payne can be found at the public schools. They are believed to be WPA works and are titled:

1. "Grand Canyon"
2. "Canyon del Muerto"
3. "Mountain Redonia"

C.  RED ROCK MUSEUM
Museum Director
(505) 863-1337

This city museum is part of the Red Rock State Park. It was formerly called Gallup Museum of Arts and Crafts. They have five paintings by Lloyd Moylan.

III. *WPA BUILDINGS*

A.  UNITED ARTIST CABLE TV OFFICE (formerly Gallup Post Office)
201 South First
(505) 863-9334
#1189 State Register 9-20-85 National Register 5-16-88

This building was formerly the Gallup Post Office. It was constructed as part of the WPA project and still has the original carved beamed ceilings that are quite unique.

This whole building is unique in that it exhibits a mix of several architectural styles, including Mediterranean, Decorative Brick Commercial and Spanish Pueblo Revival. This eclectic approach works very well, however, as the

blond brick building is listed in the National Register as being significant architecturally as well as for its association with the civic history of Gallup.

Warren Rollins created three large paintings of Indian scenes which hung in this building. Those were removed and restored and two are now in the General Services Administration Regional Office in Ft. Worth, TX. The third one is in the regional office in Lakewood, Co.

    B.  NEW MEXICO NATIONAL GUARD ARMORY - This building was another WPA product and is still in use today.

**IV. *MYSTERY ART*:** See Kloss and Nordfeldt lists in Chapter 2.

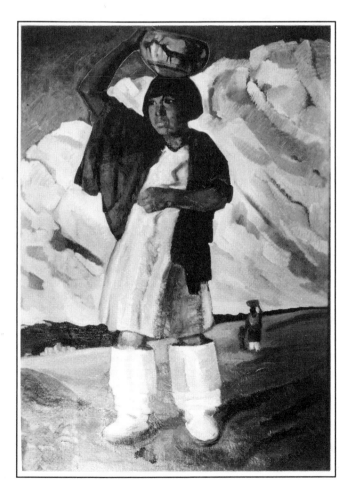

Joseph Fleck,
"Westwind"
Pueblo Maiden
46" x 32"

# KINGSTON

**I.** *WPA ART IN WPA BUILDINGS*: None

**II.** *WPA ART IN OTHER BUILDINGS*: None

**III.** *WPA BUILDINGS*

CAMP SHILOW

This CCC campground was built in the 1930's and includes 42 acres with 5 cabins, dining hall, dispensary and lodge. The camp is currently owned by the Bible Teaching Center in Albuquerque. In the 1950's the owners built an Olympic pool up on the side of the mountain and it is still available for swimming in the summer. The place is available for family and group reunions or camping. It is basically still in its original state. Contact number for more information is (505) 298-8656 in Albuquerque. There is usually a caretaker on the grounds year round. Contact person: Bonnie Geuss in Albuquerque or her sister, June Ander, in Hillsboro.

**IV.** *MYSTERY ART*: None

# KIRKLAND

**I.** *WPA ART IN WPA BUILDINGS*: None

**II.** *WPA ART IN OTHER BUILDINGS:* None

**III.** *WPA BUILDINGS*

SANITATION BUILDINGS

According to the San Juan County Historical Society there are at least two remaining WPA Sanitation Units as discussed in the following article from the "Farmington Times Hustler," April 17, 1936:

*COMPLETE 388 SANITATION UNITS*
*Floyd D. Painton in charge of the county's W.P.A. Sanitation program, reports that work is progressing steadily with 388 units complete to date out of a possible*

# MELROSE

*"Art in Melrose benefited greatly under the Federal Arts Porject of the WPA, as early as 1936. Art exhibits were regularly scheduled and several different projects got under way. Such things as the murals in the Library-Study Hall, curtains in the Administrative Office windows and in the stage of the gymnasium-auditorium, furniture in offices, commercial rooms, and stage, all were adjuncts to a scheduled training in the arts of painting, ceramics, carpentry, etc. The above had its highlight when a Dedicatory Service was held on June 22, 1938. A Federal Art Center was located on the lower floor of the Masonic Hall."* —Ray J. Lofton, former Melrose Superintendent of schools.

## I.  *WPA ART IN WPA BUILDINGS*

MELROSE PUBLIC SCHOOLS
100 E. Missouri
Contact Person: Superintendent
(505) 253-4267

Some of the remaining buildings in the public school complex were constructed during the WPA time; however, the artwork collection owned by the school district is currently located in the new buildings.

Five untitled mural panels by Howard Schleeter (1903-1976) were painted under the WPA/FAP to decorate the school library. Purchased by the school at a cost of $70.68, they depict early frontier activities, such as Santa Fé Railway surveyors at work, American Indians on horseback hunting buffalo, a pioneer family crossing the plains in a covered wagon, and cowboys working on a cattle ranch.

The rest of the collection which can be found in the Superintendent's Office, includes works created by some of New Mexico's finest artists. The entire collection was purchased for $57.50, with 60% of the sale of the paintings being paid to the artists and the government keeping the remainder to help with the costs.

Bakos, Jozef          "Autumn Flowers"
                      "Valley Scene"

### III. *WPA BUILDINGS*

The old Superintendent's House at the hospital and training school is the only remaining building that was created with New Deal funding.

### IV. *MYSTERY ART*: See Chapter 2.

# MADRID

**I.** *WPA ART IN WPA BUILDINGS:* None

**II.** *WPA ART IN OTHER BUILDINGS:* None

### III. *WPA BUILDINGS*

Madrid Stone Schoolhouse-1940.

### IV. *MYSTERY ART*: None

# MAGDALENA

**I.** *WPA ART IN WPA BUILDINGS:* None

**II.** *WPA ART IN OTHER BUILDINGS:* None

### III. *WPA BUILDINGS*

1. Magdalena High School

2. Sidewalks on Main Street

### IV. *MYSTERY ART*: None

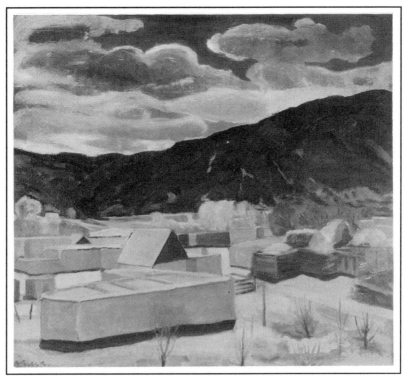

Joseph Amadeus Fleck "Landscape from Talpa" oil painting 32" x 35"

## LOS LUNAS

*"Of the many illusions about the political nature of art during the Federal Art Project years, the art community came face to face with the realities of union, the government, and the autonomy of the individual artist (both employed and unemployed) between those institutional realms."* —Contreras. *Tradition and Innovation in New Deal Art.* p. 151.

I. *WPA ART IN WPA BUILDINGS:* None

II. *WPA ART IN OTHER PUBLIC BUILDINGS*

LOS LUNAS HOSPITAL AND TRAINING SCHOOL

The Administration Office is quite proud of the oil painting "Road to Santa Fé," done by J. Charles Berninghaus.

3. SCHOOL

In 1938 WPA funds enabled the building of a Pueblo Revival style adobe school containing four large classrooms, an auditorium, indoor restrooms, and a kitchen. The school, closed in 1958, currently houses the foundry of Old West Bronze.

**IV. *MYSTERY ART* :** None

# LORDSBURG

*"There are throughout the nation murals in public buildings and works of art in museum and public collections which are now part of our cultural heritage that were created under government sponsorship."* —Milton W. Brown, "New Deal Art Projects - Boondoggle?" *Art News*, April, 1982, p.86.

**I.   *WPA ART IN WPA BUILDINGS***

LORDSBURG-HILDAGO PUBLIC LIBRARY
208 East Third
(505) 542-9646

This WPA building houses an oil painting by Joseph Fleck titled "Landscape from Talpa."

**II.  *WPA ART IN OTHER PUBLIC BUILDINGS:*** None

**III. *WPA BUILDINGS/STRUCTURES***

1. Lordsburg-Hidalgo Public Library 1937
2. Lordsburg City Hall 1935
3. Hidalgo County Fairgrounds
4. Animas High School 1934-35
5. Sunset Canal Dam 1936

**IV. *MYSTERY ART*:** See Chapter 2.

### III. *WPA BUILDINGS/STRUCTURES*

1. SAN MIGUEL COUNTY COURTHOUSE

This structure was built with WPA funding in 1940.

2. COMMUNITY CENTER —on westside of Las Vegas.

3. HIGHLANDS UNIVERSITY —The NYA program built the football field's rock bleachers.

### IV. *MYSTERY ART:* See Chapter 2.

# LINCOLN

### I. *WPA ART IN WPA BUILDINGS*: None

### II. *WPA ART IN OTHER PUBLIC BUILDINGS*: None

### III. *WPA BUILDINGS*

1. OLD LINCOLN COUNTY COURTHOUSE

WPA Official Project No. 465-85-2-150 was the restoration, begun on April 6, 1938 of the old courthouse in cooperation with the Museum of New Mexico. Foreman J. W. Hendron stated the project's objective was to restore the former county seat of Lincoln County, built in 1874 by George Peppin originally as the big store of L. G. Murphy & Co., "as nearly as possible to the time Billy the Kid made his escape." The restoration was completed in 1939 at the completed costs of $9,47.45 and the building was dedicated by Governor John E. Miles on July 30, 1939.

2. EL TORREON

This three-story tower was built by early Hispanic settlers for defense against Indian depredations. WPA funds and the Chaves County Historical Society of Roswell restored it in 1935.

# LAS VEGAS

*"...few dreamed there could ever be a national art movement. Regardless of the art quality or value of the work, the project has been successful in proving we do have and have had all along, an innate art consciousness...a definite awakening to the enrichment which art brings to life has taken place all over the country"* —Ina Sizer Cassidy, "Art and Artists of New Mexico," *New Mexico Magazine*, June, 1935, p.20.

## I.  *WPA ART IN WPA BUILDINGS*

NEW MEXICO HIGHLANDS UNIVERSITY
ROGERS HALL - Administration Building
#918 State Register 1-14-82 National Register 9-22-88

Designed by John Gaw Meem and constructed by the WPA, Rogers Hall was completed in 1937. The wall bases of the Spanish Colonial Revival building are of rusticated ashlar sandstone capped with a finished molding; the upper walls are of stuccoed brick and framed by sandstone quoins and a frieze below the eaves. Stone scroll brackets join the overhanging eaves and the walls; the sloped roof is covered with clay tiles. The walls of the main staircase and the second floor foyer are covered with murals by Lloyd Moylan. Originally built as a library, Rogers Hall now serves as the administration building of New Mexico Highland University.

"The Dissemination of Education in New Mexico" by Lloyd Moylan is a tremendous mural in fresco done under WPA/FAP in 1937. The fresco covers walls around a double stairway from first to second floor and continues in the second floor foyer. This beautifully rendered fresco focuses on an educational theme tracing its evolution from the Creation to New Mexicans engaged in ranching, weaving, pottery-making, dentistry, the sciences and modern technology.

## II.  *WPA ART IN OTHER PUBLIC BUILDINGS*

Brooks Willis painted seven oil paintings over the exit doors of the lobby in Ilfeld Auditorium on Highland's campus. Unfortunately they have been painted over.

E.  LAS CRUCES PUBLIC SCHOOLS

The administration has identified six paintings that were acquired by that school district as part of the New Deal work. They include:

1. Howard Barton  "Still Life on Table"
2. D. Paul Jones   Untitled landscape
3. Gisella Loeffler  "Girl by the Fireplace"
4. Sheldon Parsons  "Santa Fé Hills"
5. Brooks P. Willis  "Liberty Cafe"
6. Bakos      "Iris"

## III. *WPA BUILDINGS*

### 1.  NEW MEXICO STATE UNIVERSITY MUSEUM

This building, Kent Hall, was constructed during the WPA program days and now houses the university's museum. Contact museum director, (505) 646-3739

### 2.  DOÑA ANA COUNTY COURTHOUSE
SR # 1276 State Register 5-9-86

This 1937 Spanish-Pueblo Revival Style building is three stories high with a flat roof and two towers. The U-shaped building, with its exposed vigas and projecting wooden balconies carved with Spanish motifs, was partially funded by the Public Works Administration. The interior of the building features red tile floors with tile and wood base moldings, coved plaster walls,and exposed viga ceilings bearing Pueblo Indian motifs. This structure was built with funds from the Federal Emergency Administration of Public Works, an agency of the New Deal.

**IV. *MYSTERY ART*:** See Kloss and Nordfeldt lists in Chapter 2.

"It is well conceived and masterfully executed. This is one of the true frescos in New Mexico." — Ina Sizer Cassidy, "Art and Artists of New Mexico," *New Mexico Magazine*, May, 1947, p.52.

In 1934 Olive Rush, under WPA/FAP, decorated the dome-shaped entrance to the biology building with a fresco. Themes are the history of the development of plant and animal life from earliest beginnings on through to more complicated life forms, with special attention given to local flora and fauna. The cotton industry and farming, which flourished at the time, are also represented.

One can hope that public interest will see that professional conservation restores the fresco to its original state. Latest decisions about restoring this fresco can be obtained at the President's Office on campus.

### C.  NEW MEXICO STATE UNIVERSITY-FINE ARTS BUILDING

Tom Lea, currently a resident of El Paso, created two fifteen-foot panels which are housed in this gallery on campus. They depict scenes from New Mexico's colorful history from 1599 to 1870. "Conquistadors" presents the Spanish conquest and late historical developments in the area while "La Mesilla" deals with the two main industries at the time: agriculture and ranching. Also included are scenes from events in the Mexican War, Apache raids and the acquisition of La Mesilla as a part of the United States via the Gadsen Purchase. Lea researched his material in Santa Fé using documents from the Palace of the Governors as sources to ensure historical accuracy. These can be seen upon request.

### D.  BRANIGAN LIBRARY
   200 East Picacho Ave.
   Contact Person: Librarian
   (505) 526-1045

It is possible to view the "Navajo Blankets Portfolio" by Louie Ewing and a small watercolor by Ramos Sanchez, San Ildefonso Pueblo. On request one can also study the "Portfolio of Spanish Colonial Design" created by E. Boyd and others.

# LA LUZ

I. *WPA ART IN WPA BUILDINGS:* None

II. *WPA ART IN OTHER BUILDINGS*: None

III. *WPA BUILDINGS*

SENIOR CITIZEN CENTER-formerly the elementary school

IV. *MYSTERY ART*: None

# LAS CRUCES

*"Federally sponsored art programs were a great thing for me since they allowed me to do what I wanted to do."* —Telephone interview with Tom Lea in El Paso, conducted by Sandra D'Emilio, November 11, 1988.

I. *WPA ART IN WPA BUILDINGS*: None

II. *WPA ART IN OTHER PUBLIC BUILDINGS*

A. BRANIGAN CULTURAL CENTER
106 West Hadley
(505) 524-1422

On view at the Cultural Center is the existing mural, "First Book about New Mexico-1610" which was also done by Tom Lea (1907) in 1935. It was privately commissioned to be placed in this building which previously was the city library.

This building is on the State and National Historic Register.

B. NEW MEXICO STATE UNIVERSITY-BIOLOGY BUILDING

*800 in the county. Twenty men are engaged in this project, with sufficient orders piled up to keep them busy until June 1.*

*The sanitation project consists of replacing all outdoor toilets in the town and in the county wth modern flyproof buildings.*

*Mr. Painton states his department has received fine cooperation from the citizens and especially from town officials of Farmington who have rendered every possible assistance in encouraging the installation of these sanitary buildings within the city limits."*

NOTE: Although similar projects have not been identified by other communities during our research period, one can only project that similar projects were in place all over the state--and nation.

**IV. MYSTERY ART:** None

The public buildings built all over the state by the WPA and CCC projects included court-houses, schools, and even "flyproof interior sanitation units." This one still stands in the Kirkland area but it is unknown if there is any public art within or on its four walls.

| | |
|---|---|
| Bakos, Teresa | "Pears" |
| Cervantez, Pedro | "The Wind Mill" |
| | "Zinnias" |
| Claflin, Majel | "Hill Road" |
| Cooke, Regina Tatum | "Taos Chapel" |
| Jones, D. Paul | "Women Sweeping" |
| Kloss, Gene | "Mountains" |
| | "Snow Scene" |
| Naumer, Helmuth | "Autumn in Aspens" |
| | "Old Town-Pecos Plaza" |
| | "Oaktree in Winter" |
| Parsons, Sheldon | "Upper Canyon Road" |
| Schleeter, Howard | Four or Five Untitled |
| | "Rain" |
| | "Family in Wagon" |
| | "Cowboy on Horseback" |
| | "Farmer on Tractor" |
| | "Surveyors" |
| | "Indians on Horseback" |
| West, Harold | Untitled |
| Will, Blanca | "In the Greenhouse" |

During the 1930s, Melrose, along with Las Vegas, Gallup, and Roswell, was designated to have a New Deal art center where art classes and traveling exhibitions were held. These were well attended, and women in the communities enjoyed providing refreshments for the art exhibit openings.

II. *WPA ART IN OTHER PUBLIC BUILDINGS*: None

### III. *WPA BUILDINGS*

City Hall

### IV. *MYSTERY ART*: None

# MOUNTAINAIR

*"Our business is to put men to work, to do it quickly, and to do it intelligently."* To this end the PWA and the Procurement Division of the Treasury Department-responsible for Federal Building-had by 1937 allotted funds through grants and loans to over 34,500 projects and helped to bring into the economy nearly 7 billion dollars in new construction costs. —Short, C. W. and Stanley-Brown, R., *Public Buildings Architecture Under the Public Works Administration 1933-39* Vol.I, DeCapo Press, New York. 1986.

### I.   *WPA ART IN WPA BUILDINGS*: None

### II.  *WPA ART IN OTHER PUBLIC BUILDINGS*: None

### III. *WPA BUILDINGS*

MOUNTAINAIR MUNICIPAL AUDITORIUM
SR #1371 State Register 2-6-87 National Register 4-30-87

The Mountainair Municipal Auditorium or Community Center, as it is often called, was built with grants from the Federal Emergency Relief Administration and the WPA. Designed by local architect/builder Everett Crist, the building was constructed between 1934 and 1936. Like most federal relief program sponsored constructions, the Auditorium was built from local materials. Rock and mortar for the rough-faced sandstone ashlar walls were quarried east of town near the site of Abo Mission. The style of the building has been described as a provincial version of Modernistic style. The interior is notable for the tree trunk pillars which support the balconies and the roof.

### IV. *MYSTERY ART*: See Kloss List in Chapter 2.

Note: It is further suggested that one not miss viewing the artwork in the Shaffer Hotel. It is believed to have been done by Marvin Shaffer, the son of the original owner of the hotel but the work is unsigned. It is not a New Deal product, however, the young Shaffer did live and study in Taos with many of the known Taos artists during that time and was obviously greatly influenced by them.

## ORO GRANDE

I. *WPA ART IN WPA BUILDINGS*: None

II. *WPA ART IN OTHER PUBLIC BUILDINGS*: None

III. *WPA BUILDINGS*

Community Center built in early days as a school.

IV. *MYSTERY ART*: None

## PORTALES

*"One of the most beautiful murals in any public building in the United States."*
—Government official who inspected Lloyd Moylan's mural at Eastern New Mexico University, 1936.

I. *WPA ART IN WPA BUILDINGS*

    A. PORTALES POST OFFICE
       116 West First Street
       Contact Person: Postmistress
       National Register 2-23-90

Funded by the Public Works Administration, the Main Post Office in Portales was completed in 1937. This Classical Revival style building is a single story red brick structure on a raised basement. The relatively plain exterior is a common style for federal buildings in the West during this period. Two years

after the building was completed, the interior was embellished with a mural by Theodore Van Soelen. The Post Office is part of a complex of administrative buildings in downtown including the WPA constructed courthouse across the street.

Regional subject matter is the theme for Theodore Van Soelen's 1938 "Buffalo Range." Preliminary studies for the mural done by Van Soelen (1890-1964) were extensive. The *Portales News* reported:

The artist photographed sand hills and prairies and took back to his studio a cart load of bear grass and other flora to be sure that his painting would accurately portray the Roosevelt County landscape. He visited zoological gardens in Cincinnati and Chicago to study live buffaloes and sketched stuffed animals in the American Museum of Natural History.[1]

(1) "Large Mural Placed at Post Office," *Portales News*, July 18, 1938, pp. 3, 27.

B.  EASTERN NEW MEXICO UNIVERSITY

1.  ADMINISTRATION BUILDING
    (505) 562-2123

Located near the entrance of this building which was built in 1934 is a mural painted under WPA/FAP in 1936 by Lloyd Moylan (1893-1963) titled, "The 12th Chapter of Ecclesiastes" . It took Moylan and his assistant five months to complete what is considered his finest work. It covers the walls, floor to ceiling, around the stairway from the first to the second floor. The mural's theme, unlike others in New Mexico, is based on the scriptures. Semi-cubist in style, the subjects are rendered with a cross-hatching technique. Funds (approximately $200) for the mural were donated anonymously, with two conditions set: that the artist be on the WPA/FAP list and not work on Sunday and that the donor approve of the theme. The latter may have been the reason for the religious theme.

The *Clovis News Journal* described the mural in 1936:

*Colors of the mural range from deep brown to lavender, pale green and reds combining to make one of the most beautiful and inspirational centers of interest in the whole college.*

*The mural on the wall, extended from the floor of the first floor to the ceiling of the second floor, had been practically completed. Many persons watch the artist work daily as the details of his sketches become clearer.*

*The passage especially easy to identify in the mural now completed is "All when they shall be afraid of that which is high and fears shall be in the way and the Almond tree shall flourish and the grasshopper shall be a burden and desire shall fail: because man goethe to his long home and the mourners go about the streets; "Vanities of Vanities," saith the preacher, "all is vanity."*[1]

Also in this building and the Golden Library are one of two large abstract mural panels titled "Art" and "Science" by Raymond Jonson. They were planned as a pair, with the aim of serving as spiritual stimuli for the students. Regarding these panels, Jonson wrote in 1937:

*My desire is to have a fine quality in these works based on, as a starting point, "Art" and "Science." One panel will place the emphasis on Art - the other on Science ... note aim is to develop a series of rhythms and forms that can function as Abstract... These works will not be the usual or typical kind of decoration. Rather they will be powerful unusual ideas presented sincerely... As a result of my visit to the College, I have the conviction that there is a spirit of 'today' fully aware of what is occurring in the Art world. My hope is that these works will be a real stimulus to the student there and to all who may chance to see them.*

(1) "Bible Passages Theme for Gigantic Mural Being Executed at College," *Clovis News Journal*, Jan. 12, 1939.

## 2. ROOSEVELT COUNTY MUSEUM

Visitors to this museum will find a variety of items including one of the Gene Kloss etchings, "Christmas Eve, Taos Pueblo" and the Kenneth Adams etching, "The Spring." The building was created in 1940 during the New Deal projects for a total cost of $17,286.32. One half was WPA funding.

## II. *WPA ART IN OTHER PUBLIC BUILDINGS*

### A. EASTERN NEW MEXICO UNIVERSITY

1. GOLDEN LIBRARY

The paintings found in the library include one of the Jonson abstracts as well as the following:

| | |
|---|---|
| Wells, Cady | "Mesas" |
| Lumpkins, William | "Indian Village" |
| Walker, Stuart | "Black and White Sawmill" "Abstract" |
| Willis, Brooks | "Sawmill" |
| Kloss, Gene | "Penitente Friday" "Acoma" |

2. MUSIC BUILDING

Three oil paintings done around 1934 by Nils Hogner grace the walls of the staff lounge. They are colorful Navajo Indian scenes. It is believed that one other painting by this artist may have been part of the same group of paintings. It was titled "Sanitation, Isleta Pueblo" but it is yet to be found.

## III. *WPA BUILDINGS*

1. ROOSEVELT COUNTY COURTHOUSE
   SR #1278 State Register 5-9-86

The 1938 Art Deco Style Roosevelt County Courthouse is a four-story structure of cast stone and blond brick with cast concrete and metal bas relief embellishments. It was designed by R. E. Merrell and partially funded through the Public Works Administration. The decorative motifs include thunderbirds and a bas relief medallion depicting three early settlers with an Indian guide. The interior continues the Art Deco styling with terrazzo flooring and Deco style grills over the radiators. This building was constructed in 1939 for a cost of $187,756.

2. LEA HALL - ENMU dormitory

3. QUAY HALL - ENMU dormitory

4. PORTALES WOMEN'S CLUB - Some recall WPA paintings in this building.

5. BLACKWATER DRAW PARK- One house remains of the original WPA structures.

6. PUBLIC SCHOOL PLAYGROUND- $2,000

**IV.** *MYSTERY ART*: See Chapter 2.

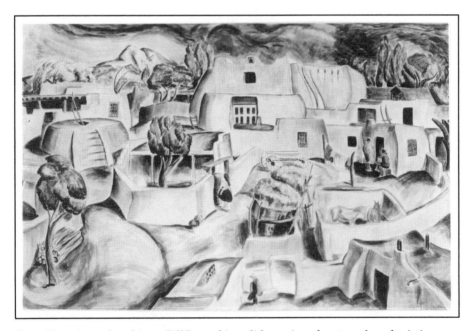

Santa Fe artist and architect, Bill Lumpkins, did a series of watercolors depicting our state's three predominant cultures' typical villages. Eastern New Mexico University is the owner of the "Indian Village" and has it in the school's art collection.

# RATON

*"New Mexico post offices will have probably the best murals of any of the post offices throughout the nation because New Mexico has the best artists, and it is difficult to find paintings of their equal."* — *Raton Range*, August 18, 1936.

## I. *WPA ART IN WPA BUILDINGS*

### ARTHUR JOHNSON MEMORIAL LIBRARY

This building was originally the Raton Post Office and was built during the WPA era. Paintings by various well known New Mexico artists can be viewed in the library and some are on loan to the City Hall. The Old Library (Carnegie) also had 27 ceiling decorations done by John Jellico and Juanita Lantz, but were demolished with the building during highway changes.

## II. *WPA ART IN OTHER PUBLIC BUILDINGS*

### A. RATON POST OFFICE

In 1936, under the PWAP, Joseph A. Fleck (1893-1977) was commissioned to paint two murals titled "Butterfield Mail" and "Unloading Mail at Raton." The first mural depicts Taos Indians and Raton miners in 1849 reading mail delivered by a scout on a white horse. The other mural focuses on the local mail system during the 1930s. The works were adhered to the wall of the post office and according to one official, "once placed are durable and will last as long as the building." We note that the murals were moved to the new post office at a later date and are still quite beautiful and durable. Fleck chose Raton as the site for these murals because he felt he could do his best work if he were familiar with the place. Raton was a site he visited often and liked. [1]

(1) Lynette Hunnicutt, "New Deal PWAP mural is rendered for local post office, *Raton Range*," Thursday, August 25, 1983.

### B. SHULER THEATER FOYER

Eight panel murals by Manville Chapman (1903-1978), created under PWAP, depict scenes from the history of Raton and surrounding communities.

"Cheyenne Village, 1845" depicts the annual spring buffalo hunt; "Maxwell's Mansion, 1865" is a view of a local house given by the Spanish governor to two of his friends; "Wooton Tool-Gate, 1868," built by Richard Wooton, depicts the first passageway in the mountains for traders and trappers. "Willow Spring Ranch, 1870," is of an early ranch house which welcomed travelers; "Clifton Station, 1875," was where the early Barlow and Sanderson stage coaches stopped; "Elizabeth Town, 1885," was a former mining town on the Red River. Also included are "Raton's First Street, 1893," and "Blossburg Mine, 1895," an early coal mine in the area. The viewer will note that Chapman had one figure in each mural pointing on to the next mural with the left arm.

### C. EL PORTAL HOTEL

This private hotel, originally known as the Seaburg Hotel, once housed the local WPA office. Manville Chapman, the local coordinator, also taught art classes here to WPA supported individuals. He created WPA murals here in 1939, and later in 1950 one of his students, William Warder, painted six other murals for the building.

D. PUBLIC SCHOOL - John Jellico created a mural for the junior high school.

E. MINERS HOSPITAL - Howard Schleeter's oil and tempura of "Red Foothills," 3 1/2" x 4 1/2", continues to hang in this facility and is signed as being created in March 1940.

### III. *WPA BUILDINGS*

1. COLFAX COUNTY COURTHOUSE
   County Clerk
   (505) 445-5551
   SR #1273 State Register 5-9-86 National Register 6-18-87

The 1936 Art Deco style Colfax Country Courthouse is a five-story blond brick building with a hipped tile roof on the top story and flat roofs on the lower portions. The building is embellished with glazed tile cornices and bas relief metal panels. The larger bas reliefs depict farming, mining, and cattle

raising, the main industries of Colfax County; motifs on the smaller embellishments include cattle brands from the region. The interior continues the Art Deco styling with terrazzo floors, tile wainscoat, and deco light fixtures.

> 2. NATIONAL GUARD ARMORY
> Built in 1940.

**IV. *MYSTERY ART*: See Chapter 2.**

## ROSWELL

*"Community Art Center projects of the Federal Art Project were an attempt to expand participation in the arts, bringing art "to the people." Easel painting, sculpture, and graphic arts were taught by Project teachers, giving the citizen the opportunity to apprehend as well aesthetic arts both as an artist as well as spectator."* —O'Connor, *Art for the Millions* (from Holger Cahill's essay *American Resources in the Arts*) p.36.

The Roswell Museum and Art Center was one of the four New Deal art centers created in New Mexico. It is the only one remaining. This woodcut by Manville Chapman was created at its opening in 1937 and used again for the 50th anniversary celebration in 1987.

## I. *WPA ART IN WPA BUILDINGS*

ROSWELL MUSEUM AND ART CENTER
100 West 11th Street
Registrar: Contact Person
(505) 624-6744

The Roswell Art Center came about as the result of the WPA project. Today it is the only remaining art center started during that era that has had its doors open continuously and has continued to fulfill its original mission to this day. It is an outstanding museum and art center. The Center and its furnishings were built between 1937 and 1939 at the cost of $10,338. Recently a room has been set aside to exhibit the remaining pieces of furniture and other creations from that era. On view in the museum are selections of WPA art from the permanent collection including Olive Rush's "Weird Land," a watercolor which was the first art work accessioned in the museum's permanent collection; Manville Chapman woodblocks of the museum with contemporary restrike prints; pastels by Helmuth Naumer; a mural study by Emil Bisttram (actual mural now in Albuquerque); bulto by Juan Sanchez; paintings by Regina Tatum Cooke and Sheldon Parsons; selected prints from the Louie Ewing "Navajo Blankets Portfolio" and from the Index of American Design project's "Portfolio of Spanish Colonial Design in New Mexico."

## II. *WPA ART IN OTHER PUBLIC BUILDINGS*

HISTORICAL CENTER FOR SOUTHEAST NEW MEXICO
200 N. Lea
(505) 622-8333

Four bronze busts done by John Raymond Terken in 1937 are included in their collection. The busts are of prominent citizens John S. Chisum, Joseph C. Lea, John J. Hagerman and Amelia Bolton Church.

## III. *WPA BUILDINGS*

1. NEW MEXICO MILITARY INSTITUTE
   SR #1008 State Register 6-8-84 National Register 5-7-87

Several contributing structures, all reflecting the Gothic Revival style, in the New Mexico Military Institute Historic District, were built with support from the Public Works Administration. The J. Ross Thomas Memorial Recreation Center was completed in 1933 and alumni and New Deal artist, Peter Hurd began painting a series of murals in the lounge. The panels were painted in egg tempera on a base of gesso and his major goal in the painting was to depict the three great strains of human life that have reacted and blended to form the history of New Mexico and the Southwest. Unfortunately the valuable paintings were destroyed in a fire of unknown origin in May 1938.

In 1934-1937 various other projects were financed with New Deal monies-- oiling of the streets, a new artesian well, Lea Hall, three officers homes, and new stables. The officer's quarters (commandant, dean of junior college, and high school principal) were built with PWA Project N.M. 1059R ($45,425) and fine horse stables were built with PWA Project N.M. 1059RS ($56,000). The Institute may have added matching funds for these structures. It is noteworthy that the stables were the finest in the country and could house 140 fine calvary horses which were also used to play polo. In 1938 a building fund was set up and more PWA funds were sought for a $250,000 project that was quite encompassing.

2.   CAHOON PARK

This local park was built in 1936 and includes within it a sunken garden all constructed as part of the federal programs.

3.   OLD ROSWELL MUNICIPAL AIRPORT--This facility was built in 1943.

4.   BOTTOMLESS LAKES STATE PARK--The CCC created this recreational facility which is just a few miles east of Roswell.

IV. *MYSTERY ART*: See Chapter 2.

# SANTA FE

*"It (Olive Rush's mural) will endure to carry its message to future generations. No one else could have caught the hunger for knowledge, or so sympathetically depicted the self-sacrificing spirit that prompts women's public works, as has Olive Rush in her splendid murals in our Santa Fé Library. Her work belongs not alone to this ancient city but the entire state."* — Ina Sizer Cassidy, "Art and Artists of New Mexico," *New Mexico Magazine*, April 1935, p.20.

## I. *WPA ART IN WPA BUILDINGS*

### A. SANTA FÉ PUBLIC LIBRARY
145 Washington Ave.
Bambi Adams
(505) 984-6788

The library's WPA building was built in 1937 at a cost of $121,131. Two charming sculptures by Hannah (Mecklem) Small can be seen in the entry area.

### B. LABORATORY OF ANTHROPOLOGY
708 Camino Lejo
SR #890 State Register 12-1-82 National Register 7-12-83

The Laboratory of Anthropology was founded to conduct anthropological research, to further the welfare of Native Americans in the Southwest, and to participate in public education and publication programs. The building, which was designed by John Gaw Meem, is considered a masterpiece of the Pueblo Revival style. The interior features detailed work by local craftsmen in tinwork, furniture, vigas, corbels, and even such details as carved wooden radiator screens and hand-wrought door plates and pulls. Even the switch plates were custom designed. The building was completed in 1931. The landscape and parking lot areas were created with New Deal funds. Please reference "The Indian New Deal in New Mexico" for details on artwork in this building. One can find some New Deal papers from the offices of some of the supervisors in the laboratory's archives.

C.  NATIONAL PARK SERVICE (NPS)
    1100 Old Santa Fé Trail
    (505) 988-6014
    State Register 1-20-70 National Register 10-6-70   NHL 5-28-87

Eddie Delgado, an accomplished tinsmith, carried on the family tradition of creating beautiful tinwork. This is part of the collection in the National Park Service building in Santa Fe and he also did elaborate pieces for the Albuquerque Little Theatre.

The NPS Southwest Regional headquarters building is a National Historic Landmark. Located at a bend in the old Santa Fé Trail, this Spanish Colonial style adobe building comprises some 24,000 square feet. Built around a patio surrounded by flagstone floored portals, the building abounds with beautiful architectural details--vigas, hand-hewn beams, wooden lintels, decorated corbels, and decorative buttresses. The interior features hammered tin light fixtures, hand-carved Spanish Colonial style furniture, flagstone floors, and

wooden grillework as well as Southwestern pottery, rugs, and art works. Many of the paintings, drawings, and etching were funded by the PWA and other Federal relief programs.

The Park Service Regional headquarters building is the largest known adobe office building and one of the largest secular adobe buildings in the United States. The timbers were cut and shaped and the thousands of adobe bricks were molded by local young men of the CCC. The actual construction was carried out under the auspices of the WPA. The building was completed in 1937.

An art collection including paintings, pottery, etc. can be viewed during normal working hours. The artworks include:

| | |
|---|---|
| Boyd, E. | "Hail Storm" |
| Fleck, Joseph | "Leisure Hour" |
| Gutierrez, Lela | Pottery (6 pieces) |
| Higgins, Victor | Untitled<br>"Landscape" |
| Kloss, Gene | "New Mexico Mountain Town"<br>"Winter Mass"<br>"Christmas Eve, Taos Pueblo" |
| Martinez, Maria | Pottery |
| Matta, Santiago | Pottery and painting |
| Naranjo, E. | Pottery |
| Quintana, Agapina | Pottery |

D. NEW MEXICO SCHOOL FOR THE DEAF
1060 Cerrillos Road
(505) 827-6711
State Register 7-8-88 National Register 9-228

In the 1930s, six buildings were built at the New Mexico School for the Deaf utilizing WPA resources. Of these buildings, two have been placed on the State and National Registers. School Building Number 2 is an excellent example of Spanish-Pueblo Revival style, with its stepped profile and projecting vigas; it was built as a multiple use classroom, administration, and teacher quarters building and is still used as a classroom building. The hospital, a single-story Spanish-Pueblo Revival building completed in 1937, is still in use for that purpose.

Currently the school's New Deal art collection is located in the Superintendent's Home. It includes:

| | |
|---|---|
| Ellis, Fremont | Untitled |
| Hullenkremer, Odon | Untitled |
| Parsons, Sheldon | "Chupadero" |
| Schleeter, Howard | Untitled |

E.   NEW MEXICO SUPREME COURT BUILDING
     237 Don Gaspar
     (505) 827-4860

This hall of justice was erected by the New Deal in 1937 at a cost of $282,433. This agency's art collection is distributed throughout the building in the offices of the different justices. Included in the collection are works by:

| | |
|---|---|
| Hennings, E. Martin | "Indian Hunters" |
| Jones, D. Paul | "Hernandez Church" |
| Parsons, Sheldon | Untitled |

## II.   *WPA ART IN OTHER PUBLIC BUILDINGS*

### A.   MUSEUM OF FINE ARTS PATIO

Four fresco panels by Will Shuster depicting scenes from Pueblo Indian ceremonial and domestic life adorn the Museum's patio walls. Painted under PWAP, the frescos are titled "Voices of the Earth," "Voices of the Sky," "Voices of the Sipophe," and "Voices of the Water." Text, which is inscribed on a bronze plaque on the patio wall by ethnologist Alice Cunningham

Fletcher, inspired the subject for the frescoes. It reads as the following:

*"Living with my Indian friends, I found I was a stranger in my native land. As time went on the outward aspect of nature remained the same, but a change was wrought in me. I learned to hear the echoes of a time when every living thing, even the sky had a voice. That voice devoutly heard by the ancient people of America I desired to make audible to others."*

Shuster's son, Don, recalls his father's preparation for the Museum project:

*"My Dad read everything he could about the fresco technique after he was asked to do the murals. In order to mix the pigments for the fresco, "Shus" decided to invent a machine to grind the pigments. He got a goldfish bowl and filled it with glass marbles driven by a motor. He then added pigment with water and ran the machine for days at a time until the pigment was ground very fine. He then stored the pigment and ground another color. He was always inventing things."*

## B. NEW MEXICO MUSEUM OF FINE ARTS - COLLECTION

| | |
|---|---|
| Adams, Kenneth | Untitled (Indian Woman) |
| | "Indian Woman" |
| Barela, Patrocinō | "Ascension" |
| | Untitled "Holy Family" |
| | "Resurrection" |
| | Untitled |
| Bisttram, Emil | "Two Indian Women" |
| Chapman, Manville | "Cemetery" |
| | "Chimayo Church" |
| | "Church at Night" |
| | "Church in Northern New Mexico" |
| | "Cottonwoods in Autumn" |
| | "Dry Trees" |
| | "Falling Leaves" |
| | "Farm House" |
| | "Fishing" |

"Indian Woman Sitting"
"Morning Sunlight"
"Adobe Pond"
"Drying 'Dobes"
"Laying 'Dobes"
"Cutting Vigas"
"Laying Vigas"
"Tamping the Roof"
"Plastering"
"Night"
"Peonies and Indian Pots"
"Reflections on Adobe"
"Rock Wall"
"San Antonio de Padua"
"Study in Brown and Gold"
"Taos Indian"
"Taos Pueblo"
"The Virgin"
"Winter"
"Eagle Dance"
"Our Lady of Guadalupe"

Ellis, Fremont     "Street Scene, Galisteo"

Goodbear, Paul     "Cheyenne Animal Dance"
"Flying Eagle"
"Cheyenne War Dance"
"Matachinas"
"Cheyenne Arrow Ceremony"

Henderson, William P.     Oil Landscape

Herrera, Velino (Shije)     Untitled
Untitled

Kavin, Zena     "Back Stage"
"Gringo at Fiesta"
"Santa Fé Plaza During Fiesta"

"Mother and Child" Sculpture
"Mother and Child" Sculpture

Kloss, Gene

"The Sanctuary-Chimayo"
"Acoma"
"Christmas Eve, Taos Pueblo"
"Church at Trampas, New Mexico"
"Rio Grande Pueblo"
"Winter Mass"
"Indian Pueblo"
"Penitente Good Friday"

Lea, Tom

"Government Aid to the Needy"
"Employment in Public Works"
Untitled (Mule Driver)

Loeffler, Gisella

"Church, San Antonio"

Lumpkins, William

Untitled
Untitled

Matta, Santiago

"Trinity"
"Crucifix"
"Guadalupe"

Morris, James S.

"Taxco"
"Lighting"
"Santa Fé Rococo"
"Valorio" Easel
"Cross of the Martyrs"
"Corn Huskers"

Nordfeldt, B. J. O.

"Canyon Road"
"Cerrillos"
"Morada, Santa Cruz"
"Tres Ritos"
"Water Street"
"Rio de Medio"

| | |
|---|---|
| Parsons, Sheldon | "Summertime - Alcalde" |
| Saville, Bruce W. | Six bronzes of Indian Dancers |
| Schleeter, Howard | "Cottonwoods by the Church House" |
| Willis, Brooks | "Architectural Subjects in Santa Fé" |

C.  MUSEUM OF INDIAN ART AND CULTURE and
MUSEUM OF INTERNATIONAL FOLK ART

These two museums on the Old Santa Fé Trail house various WPA art projects in their collections. Examples of Patrocinō Barela's carvings and other Hispanic artists are at the Folk Art Museum, and large murals by Velino Shije Herrera and Pablita Velarde at the Museum of Indian Arts and Culture can be seen by appointment. Ask about other items.

D.  OLD PUBLIC LIBRARY
Curator-Contact Person
History Museum-Washington Ave.

The former public library is located on Washington Avenue directly behind the Palace of the Governors. It is scheduled to become the History Division of the Museum of New Mexico soon.

Olive Rush (1873-1966) painted an enchanting mural in fresco around the walls of the entrance foyer under PWAP. The mural's inscriptions express a love of books and an understanding of the state's bilingual heritage. Theme inscriptions are "The Library Reaches the People," and "Con Libros no Estas Solo." The frescoes depict children getting books; a burro carrying books to remote places; and Indian children watching a Sister of the Dominican Order open a traveling library.

The frescoes created by Olive Rush in 1934 for the former Santa Fe Library building are still as beautiful as ever. The frescoes can be viewed by appointment until the building is once again open as the state's History Museum. The frescoes were appropriately called "The Library Reaches the People."

E.  FEDERAL BUILDING
    S. Federal Place
    GSA Regional Administrator: Contact Person
    (505) 766-8834
    SR #260 State Register 3-20-72 National Register 5-25-73

Federal funds for a "capitol" building in Santa Fé were appropriated by Congress in 1851, 1854, 1860, and 1886, but the building was not actually completed until 1889. It was never used as a capitol; instead it has housed various federal courts and offices of the United States Land Office. The three-story Greek Revival style courthouse was built of rough stone quarried in the Hyde Park area near Santa Fé; the door lintels, window frames and ornamental trim are of dressed stone quarried at Cerrillos. Six large murals by William P. Henderson were funded by the Federal Arts Project and installed in the building in 1938.

"In these large canvases he had masterfully combined reality with imagination...critics pronounced these murals outstanding works of art."
—Ina Sizer Cassidy, "Art and Artists of New Mexico," *New Mexico Magazine*, December 1943. pp. 18,37.

There are six large brilliantly painted murals by William Penhallow Henderson that are not to be missed. They can be viewed in the lobby during normal working hours. Begun in 1933, under the PWAP,they were finished in 1938 under TRAP. The themes for the murals are different landscape areas located in New Mexico. They are titled "The Old Santa Fé Trail," "The Old Cuba Road," "Monument Rock-Canon de Chelly," "Taos Mountains," "Cabezon Puerco Valley," and "Sand Trail up Acoma Rock."

A 1938 article in *The Santa Fé, New Mexican* explained why Henderson chose landscape as his subject:

Instead of using the courthouse theme, as other artists have done most generally, Mr. Henderson conceived the idea of bringing the gorgeous New Mexico landscape to the building's interior...to quote the artist, "After all it is best out here," he says, "so why not use it? [3]

(1) "Murals for New Patio," "*El Palacio*, vol. xxxvii, nos. 9-10, August-September, 1934, 1934, p. 74.

(2) Interview with Don Shuster in Santa Fé conducted by Sandra D'Emilio, September 29, 1988, Museum of Fine Arts, Museum of New Mexico.

(3) "Henderson Murals Installed at Federal Building by Art Project Chief-All Landscapes," *Santa Fé New Mexican*, May 11, 1938, WPA Files, Folder 155, N.M. State Records Center and Archives.

E.   TAXATION AND REVENUE DEPARTMENT

Helmuth Naumer did seven New Deal pastels that have been in the Taxation and Revenue Department since that time. They include:

1.   "Pines"
2.   "San Ildefonso Kiva"

3. "Evening at Lamy"
4. "Taos Pueblo"
5. "Copper Mine at Silver City"
6. "Mount Taylor"
7. "White Sands"

F. NEW MEXICO HUMAN SERVICES DEPARTMENT
   2009 S. Pacheco

Sheldon Parson's "View Near Espanola" was assigned to this agency as was "View Near Otowi" (also known as "View near San Ildefonso") but to date the latter's whereabouts are unknown.

G. NEW MEXICO STATE LIBRARY
   SOUTHWEST COLLECTION
   325 Don Gaspar
   Contact Person: Librarian
   (505) 827-3800

The "Portfolio of Spanish Colonial Design of New Mexico" is included with other WPA reference materials. The original artwork for this collection was done by E. Boyd then six engravers created woodcuts..." All six engravers worked on the woodcuts. It is believed that Fritz Broeske was the first engraver, and then Manville Chapman joined the group later. Two hundred sets of the 50 renderings were then painted with watercolors by various individuals. This project was planned to become part of the Index of American Design, a national goal to have a collection of typical design creations from every state.

H. NEW MEXICO HIGHWAY DEPARTMENT

Odon Hullenkremer did a beautiful painting which hangs in this building. Another one by Fremont Ellis, was stolen from this department and the highway officials are desirous of having it returned.

I. MILITARY AFFAIRS DEPARTMENT
   1050 Old Pecos Trail

At this writing, the Randell Davey painting of polo ponies can be found in the New Mexico National Guard Museum, which has recently relocated to the former New Mexico National Guard Armory. This was the original location of this painting.

    J.  SANTA FE WOMENS' CLUB
        1616 Old Pecos Trail

For a number of years a selection from the collection of drawings developed for the "Portfolio of Spanish Colonial Design" has hung in this building. This portfolio was developed and worked on by a number of New Mexicans and was submitted for inclusion in the national Index of American Design and provided a visual record of the traditional Spanish art found in the homes and churches around the state. Unfortunately, the collection was not included in the final Index.

## III. *WPA BUILDINGS*

    1.  SANTA FÉ COUNTY COURTHOUSE
        State Register 5-9-86, National Register 7-23-73
        (Santa Fé Historic District)

The 1939 Spanish-Pueblo Revival style Santa Fé County Courthouse is a two-story masonry structure with wooden details, including lintels, door frames, and a post and corbel portal with a beam and split cedar ceiling. The interior features brick floors, carved beams with Indian motifs, and tinwork light fixtures. The building was designed by John Gaw Meem and funding by the PWA.

    2.  LABORATORY OF ANTHROPOLOGY - See earlier references.

    3.  VILLAGRA BUILDING (formerly the WPA and CCC office building) now houses NEW MEXICO PARKS and RECREATION programs.

    4.  DISTRICT COURTHOUSE BUILDING (formerly HARVEY JR. HIGH),constructed for a total cost of $132,874 in 1938.

    5.  EVERGREEN RESTAURANT - Earlier CCC and Girl Scout building was created approximately 75 years ago.

6.   SANTA FÉ RIVER PARK  and  FT. MARCY PARK

7.   SANTA FÉ INDIAN SCHOOL-The murals in some of these buildings may have been created with New Deal monies.

8.   SANTA FE POST OFFICE--For informational purposes, there are two large murals in this building created by Gerald Cassidy in 1929 . Many people are under the impression that these are New Deal products but indeed they are not.  They were originally created for the Onate Theatre on the Santa Fé Plaza. After that building was closed they were purchased by John J. Hardin of Oklahoma City and transferred to one of his hotels in Hobbs.  Later they were transferred to another one of Mr. Hardin's hotels in Acapulco.   In 1948 he donated them to the State of New Mexico with the hope they would be placed in the State Capitol.  This did not happen and they remained in the Museum of New Mexico collection until 1962 when they were given to the federal government with the proviso that they were never to leave the state.  A conservator, John Pogzeba, restored them prior to their placement in the Santa Fé Post Office.

**IV.   *MYSTERY ART*:** See Chapter 2.

# SANTA ROSA

*"In Region 5 (which included New Mexico) climate has been the controlling factor is the development of plans...small windows and thick or well-insulated walls must provide protection against the heat of the sun in summer and extreme cold of winter."* —Short, C.W. and Stanley-Brown, R., *Public Buildings Architecture Under the Public Works Administration 1933-39* Vol.I, DeCapo Press, New York 1986.

**I.   *WPA ART IN WPA BUILDINGS*:** None

**II.   *WPA ARTS IN OTHER PUBLIC BUILDINGS*:** None

**III. *WPA BUILDINGS***

1. Guadalupe County Courthouse - 1940s-Cost: $13,394.
2. Mid-School

**IV. *MYSTERY ART*:** See Nordfeldt list in Chpater 2.

# SILVER CITY

*"Grant County has the best courthouse in the state, and I decided this buildings was the one that should have the murals."* —Theodore Van Soelen, "Van Soelen Murals at the Courthouse Formally Accepted," *Silver City Enterprise*, July 20, 1934, 1934. p.1.

## I.  *WPA ART IN WPA BUILDINGS*

GRANT COUNTY COURTHOUSE
County Clerk: Contact Person
(505) 538-2979
SR #197 State Register 5-9-86 National Register 5-23-78
(Siver City Historic District)

The Art Deco Style Grant County Courthouse was built in 1930 and was the first county courthouse in New Mexico use WPA funds for decorative murals. The three-story flat-roofed building is an excellent example of monumental use of the Deco style, which is carried over into the interior design.

Theodore Van Soelen, N.A. (1890-1964) painted two murals titled "Chino Mines" and "The Round Up" under PWAP in 1933 and 1934 for the Grant County Courthouse built in 1929-30. Mining and ranching are Grant County's main industries. Van Soelen researched his subject thoroughly and spent six months on the two murals. For "Chino Mines" Van Soelen spent time in the pits making sketches. For "The Round Up" he drew on his own experiences as a cowboy in Nevada and New Mexico. In 1934, the Silver City Enterprise newspaper reported the artist`s satisfaction with the project:

"I have given you the best I had and you in turn have given me whatever I asked for and I hope everyone is as well satisfied as I am with the results of our team work."

"The Round Up" was exhibited, along with Velino Shije Herrera`s mural, at the Corcoran in Washington, D.C. in the National Exhibition of Art by the Public Works of Art Project from April until May 1934.

## II.  *WPA ART IN OTHER PUBLIC BUILDINGS*

WESTERN NEW MEXICO UNIVERSITY

The school has a Carl Redin painting titled "Progress".

### III. *WPA BUILDINGS/STRUCTURES*

1. GRAHAM GYMNASIUM, Western New Mexico University
   State Register 10-23-81 National Register 9-22-88

During the 1930s, the New Mexico State Teacher's College, now New Mexico Western University now, took advantage of the availability of PWA funds to improve and enlarge the campus. They engaged the services of architect John Gaw Meem, and under his direction, many buildings were remodeled using these funds. In addition, Graham Gymnasium, a Pueblo Revival structure incorporating Indian motifs in its design, was built at this time.

2. **DOWNTOWN**
   Sidewalks and streets
   Riverwalk park area

3. NATIONAL GUARD VEHICLE MAINTENANCE BUILDING-1940

**IV. *MYSTERY ART*: See Kloss and Nordfeldt lists in Chapter 2.**

## SOCORRO

*"The WPA art projects have succeeded in developing many fine talents and have brought an understanding of art to a wide variety of people that otherwise would not have had the opportunity to see significant creative painting."* —Alfred Morang, "WPA Art Project Disclose Many Persons With Talent," The Santa Fé *New Mexican*, Friday, May 24, 1940.

### I. *WPA ART IN WPA BUILDINGS*: None

### II. *WPA ART IN OTHER PUBLIC BUILDINGS*

NEW MEXICO TECH
Administration
(505) 835-5766

Most of the school's art collection is housed in the new library. There you will find:

| | |
|---|---|
| 1. Jozef Bakos | "Hill Near Chama" |
| 2. Manville Chapman | 4 Watercolor Prints, "Indian Heads" |
| 3. Fremont Ellis | "Landscape in Autumn" Oil |
| 4. Blanche Grant | "Mine" |
| 5. Gene Kloss | 2 Lithographs |
| 6. D. Paul Jones | "Cottonwood Trees" Oil |
| 7. Sheldon Parsons | "Untitled" Oil Landscape |
| 8. Furniture | Small table, cabinet, and a set of carved chairs. |

## III. *WPA BUILDINGS*

### A. NEW MEXICO TECH

A number of buildings were built on campus thanks to the New Deal program funds and the labor of many. They include:

1. Fitch Hall
SR # 1461 State Register 7-8-88 National Register 5-16-89

Like many institutions of higher learning in New Mexico, the New Mexico School of Mines, as NMIMT was known then, took advantage of the New Deal federal assistance programs (PWA and WPA) to add new buildings and remodel existing buildings on campus. One of the new buildings from that period, Fitch Hall, is on the State and National Registers and is a two and one-half story, masonry and stucco, California Mission Revival Style building which was completed in 1937. Others include:

2. Assay Building
3. Gymnasium
4. President Hall
5. Weir Hall
6. Wells Hall

B.  SOCORRO COUNTY COURTHOUSE
    SR #920 State Register 3-4-83

The Spanish-Pueblo Revival style Socorro County Courthouse was built in 1940 in part with funding from the PWA. The Art Deco style of the interior reflects the PWA origins of the building, but the exterior details are purely Southwestern, including exposed vigas and wooden corbels and lintels. This county building was built in 1940 by WPA in a Spanish-Pueblo style.

C.  OFFICES OF ERNIE MOORE

This building was originally a CCC building in Escondido but was moved to this site at a later date and a new facade added. Sidewalks in the older part of town were all created by the WPA.

**IV. *MYSTERY ART*:** See Nordfeldt list in Chapter 2.

Also a sculpture piece titled "Maiden of the Desert" may have been done during this time but the artist and its whereabouts are unknown.

## SOFIA (NEAR GRENVILLE)

I.   *WPA ART IN WPA BUILDINGS:* None

II.  *WPA ART IN OTHER PUBLIC BUILDINGS*: None

III. *WPA BUILDINGS*

A number of years ago the town of Sofia was developed by a group of immigrants from Sophia, Bulgaria however there is little remaining of that community now. The old school building was built in 1939 for $5,994.00 and served the area unitl 1960 when it was closed as a public school. In 1990 it was purchased by a for-profit business called Sofia Outfitters and has been remodeled and now in use as a hunting lodge. The WPA sign is still in the front of the building. For more information, contact Sofia Outfitters, HCR 77 Box 224, Grenville, NM 88424 or call (505) 278-2900.

IV.  *MYSTERY ART:* None

# SPRINGER

*"Italy had its Renaissance, and thanks to President Roosevelt- we had ours in the 1930's: Painting, music, theater and literature. That period will never be equalled."*
—John Jellico, July 27,1992. Letter to the Secretary of State Stephanie Gonzales.

**I.  *WPA ART IN WPA BUILDINGS:*** None

**II.  *WPA ART IN OTHER PUBLIC BUILDINGS***

SPRINGER PUBLIC LIBRARY

A Carl Redin oil painting titled "Placita Wash Day" still hangs here.

**III. *WPA BUILDINGS:*** None

**IV. *MYSTERY ART:*** See Chapter 2.

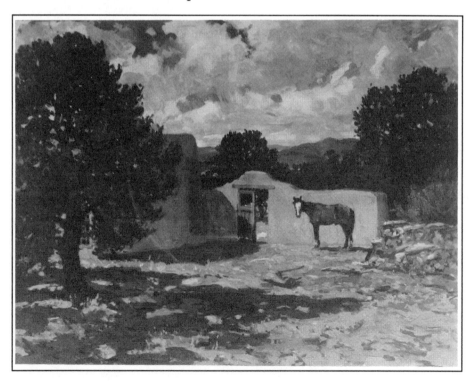

Fremont Ellis,  "El Puerton"   22" x 30" oil painting

# TAOS

*"They (Americans) have seen, across these last few years, rooms full of paintings by Americans... all of it native, eager and alive - all of it painted about things they know and look at often and have touched and loved."* — President Franklin D. Roosevelt in Marlene Park and Gerald E. Markowitz, *Democratic Vistas-Post Offices and Public Art in the New Deal*, Philadelphia: Temple University Press, 1984, p.6.

## I. WPA ART IN WPA BUILDINGS

A. FORMER COURTHOUSE/COURT ROOM
On the Plaza
(505) 758-9016
SR #860 State Register 5-9-86, National Register 7-8-82
(Taos Downtown Historic District)

"The Taos Fresco Quartet" included Bert Phillips, Victor Higgins, Ward Lockwood and Emil Bisttram and three are discussing the project above. They tried their hands at creating ten frescoes in the courtroom of the then Taos County Courthouse. More can be read about them in the information about Taos. Work is underway to restore the frescoes to their original condition.

The 1932 Spanish-Pueblo Revival style Taos County Courthouse was built with partial funding from the PWAP and is located on the north side of the plaza. It is on the State and National Registers of Historic Places. The two-story, flat-roofed building has a curvilinear parapet, exposed vigas, and an added portal with carved beams and corbels and wooden posts.

The second floor courtroom was decorated with ten frescoes of subjects related to the law and are some of New Mexico's finest art treasures. The frescoes were painted by the Fresco Quartet: Emil Bisttram (1895-1976), Ward Lockwood (1894-1963), Victor Higgins (1884-1949), and Bert Phillips (1868-1956). Work started in the fall of 1933 and was completed in the summer of 1934. The general subject is the use and misuse of law. Inscribed under each painting are mottos in English and Spanish. "Avarice Breeds Crime/Avaricia Engendra Crimen," "Justice Begets Content/Justica Causa Felicidad," "The Shadow of Crime/La Sombra del Crimen," are examples of some of the subjects. The largest fresco (4' x 8') is "Moses the Law Giver," executed by Victor Higgins and originally placed above the judge's bench.

Work on these frescoes did not always go smoothly. A local paper noted:

What with additional carloads of sand having to be brought all the way from Rinconada and washed in the river at Placita, Bisttram painting six-fingered ladies and Victor Higgins having suddenly to go back to bed with milk and toast, the artists are wondering what jinx is working against them- and what will happen next week. [1]

The project took three months to complete and the artists were paid $56.00 a month. All other expenses came out of the pockets of the artists, who had already established careers for themselves.

(1) "What's Wrong with This Picture? Artist Produces Freak in Courthouse," *Taos Valley News*, 1934.

B.  HARWOOD FOUNDATION
    238 Ledoux
    (505) 758-3063

This museum's collection includes about 40 wood carvings by Patrocinõ Barela, most of them were done during his WPA activities. The building itself, which houses the Harwood Library and Museum, is also a product of the WPA program and includes light fixtures and furniture from that period.

## II. *WPA ART IN OTHER PUBLIC BUILDINGS*

Rod Goebel Gallery also owns some Barela carvings however, this is a private building.

## III. *WPA BUILDINGS*

1.  FORMER TAOS HIGH SCHOOL
    (Currently part of the Middle School)

This building was finished in November 1935 and was built for a total of $71,377 via WPA funds. It included a gymnasium and auditorium all of which were designed by Wilfred Stedman.

2.  TAOS VALLEY SCHOOL
    Randall St.-Now a private school.

**IV. *MYSTERY ART:*** See Kloss and Nordfeldt list in Chapter 2.

# TEXICO

*"The Federal Art Project might be termed the guardian of many artists, and we believe it is bridging a span of time which might have been disastrous to art development when discouragement occurred from lack of patronage."* —Vernon Hunter, *The Santa Féan New Mexican*, 1936.

I. *WPA ART IN WPA BUILDINGS:* None

II. *WPA ART IN OTHER PUBLIC SCHOOLS*

TEXICO PUBLIC SCHOOLS
520 N. Griffin
Superintendent: Contact Person
(505) 482-3801

This community has a Howard Schleeter landscape painting in the Superintendent's Office.

III. *WPA BUILDINGS:* Unknown at this time.

IV. *MYSTERY ART:* See Kloss and Nordfeldt lists in Chapter 2.

Reference was made in one document of a number of paintings by Pedro Cervantez, a local artist, that may have originally been in the schools.

# TRUTH OR CONSEQUENCES

*"The New Deal sought to make the national governments' presence felt in even the smallest, most remote communities...The means for realizing this vision were eleven hundred new post offices...The post office was "the one concrete link between every community of individuals and the Federal government" that functioned importantly in the human structure of the community."* —Marlene Park and Gerald E. Markowitz, *Democratic Vistas-Post Offices and Public Art in the New Deal*, Philadelphia: Temple University Press, 1984, p. 8.

I. *WPA ART IN WPA BUILDINGS*

    A. TRUTH OR CONSEQUENCES POST OFFICE
        400 Main
        Contact Person: Postmaster
        National Register 2-23-90

Completed in 1940, the Hot Springs (as T or C was called before the town changed its name in response to a television show challenge) Post Office was built in 1940 according to the same standardized plan used for the Deming and Portales post offices, but with even less ornamentation. This very simplified Classical style building is of poured-in-place concrete with a flat roof and very plain window and door treatments. In 1990 the building was designated as part of the National Register of Historic Places.

The lobby of the building contains a mural by Boris Deutsch (1892-1978) which was the winner of a 48 state competition in the Fine Arts Section of the Federal Works Agency. This very expressive and stylized mural was also created in 1940 not for the purpose of record the authenticity of any dance in detail, but to represent the spirit and color of an Indian Bear Dance. One art critic describes the mural by noting "the artist gave his dancers a bizarre touch of surrealist angst muddled by leaden humor...the inspiration behind the design was the indigenous art of the Southwestern Indian ... large and small figures without regard to spatial positions, as though the Indians were decorative patterns on pottery." [1] Another source notes the muralist's sense of humor.

Deutsch's sketch for the national competition for post office mural designs cleverly showed an Indian chief dancing out of the path of an Atchinson, Topeka & Santa Fé Super Chief. Deutsch's mural, apparently redesigned, does not show the train but instead features background mountains.

(1) Karal Ann Marling, *Wall-to-Wall America: A Cultural History of Post Office Murals in the Great Depression*, Minneapolis: University of Minnesota Press, 1982, p. 223.

B. NEW MEXICO VETERANS CENTER
   (Formerly Carrie Tingley Hospital)
   992 South Broadway
   (505) 894-9081

All of the main buildings of this institution were created during the WPA project in the 1930's at a cost of $553,788 from the state funds and an additional $273,953 from federal New Deal funds. Included in the inner courtyard is a turtle fountain created by Eugenie Shonnard, WPA sculptor. The fountain, made of stone, has carved frogs which face in the four directions. It is an imaginatively designed fountain and one which reflects the artist's love for animal life. Records indicate that it was created at the cost of $700. Originally, painted tiles surrounded the base of the fountain but are o longer visible. They were done by Louie Ewing and Eliseo Rodriguez.

II. *WPA ART IN OTHER PUBLIC BUILDINGS:* None

III. *WPA BUILDINGS*

1. ELEPHANT BUTTE DAM SITE RESORT

The main building, now a restaurant, and a number of individual cabins are still providing recreational spaces for tourists vacationing at Elephant Butte Lake. The buildings were primarily built by the CCC work force in 1940. The site of the CCC camp is now the site of the Elephant Butte Lake State Park maintenance yard.

2. SIERRA COUNTY COURTHOUSE

A modest building was designed by Wilfred Stedman in 1937 when the voters chose to move the county seat from Hillsboro to Hot Springs.

3.  COMMUNITY CENTER

The original community center building was a New Deal project and is still in use. However, it is integrated within the current newer structure and not specifically identifiable .

IV. *MYSTERY ART*

A. See Kloss list in Chapter 2.

B. Decorative tiles around courtyard fountain at Veteran's Center and possibly a sculptured relief of birds in flight.

C. Mosaic tiles in a bathhouse, possibly the State Bath House.

# TUCUMCARI

*"Those that lived through it still wear scars like a well-earned badge of experience. Some lament the excess of governments it spawned; others remember this fondly as a creative response to a desperate situation."* — Peter Bermingham, *The New Deal in the Southwest-Arizona and New Mexico*, Tucson: The University of Arizona, p.3.

I.  *WPA ART IN WPA BUILDINGS*

QUAY COUNTY COURTHOUSE
County Clerk
(505) 461-0510
SR #1280 State Register 5-9-86

The 1939 Art Deco style Quay County Courthouse is a four-story concrete, granite, and cast stone building with concrete bas relief embellishments and a cast stone parapet. The interior exhibits terrazzo floors, plaster ceilings, marble walls in the lobby, and Art Deco details, such as hand rails, grilles, and light

fixtures. The second floor courtroom has aluminum bas relief embellishments and a mural of Coronado by Ben Carlton Mead. The building was paid for, in part, by the PWA. It, like others built during that time for the eastern portion of the state, resembled other public buildings in nearby Texas.

Located on the second floor of the courthouse is a 15' x 9' mural titled "Coronado" painted in 1939 by Ben Carlton Mead. It begins with two thin strips of landscape outlining the doors and extends from the top of the doors to the top of the third story. The mural depicts Coronado with brown hair, moustache and beard. He is attired in armor with a sword, tall boots with spurs. He is seated on a rock in front of a tall tree with yucca plants nearby. Indian and soldiers, both standing on horseback, surround Coronado as a large wooden cross is placed in the ground. One holds a blue and gold banner which depicts Our Lady of Guadalupe. Inscribed on the mural is "I, Francisco Vasquez de Coronado, have passed this way and left my mark." The palette is of the Southwest. There are also bas reliefs in white stone done in 1939 on the outside of the courthouse depicting farming, cowboys and the railroad.

**II.  *WPA ART IN OTHER PUBLIC BUILDINGS:*** None

**III. *WPA BUILDINGS***

NATIONAL GUARD ARMORY-This building was built in 1938.

**IV. *MYSTERY ART:*** See Kloss list in Chapter 2.

# TULAROSA

## I. *WPA ART IN PUBLIC BUILDINGS*

## II. *WPA ART IN OTHER BUILDINGS*

## III. *WPA BUILDINGS*

1. TULAROSA SCHOOL ADMINISTRATION BUILDING- Originally this was the High School. It was built for $4,653. The Junior High School was also created by New Deal funds at the same time and may have been done at the cost of $2,653.

2. POLICE STATION and JAIL--Still serving the community.

## IV. *MYSTERY ART:* None

# WAGON MOUND

*"Escape into the refuge of history marked nearly all the work of project artists doing murals...Thus was paved the most direct route to contact with the general public. Occasionally widened in succeeding decades, that road has remained open ever since."* —Peter Bermingham. *The New Deal in the Southwest-Arizona and New Mexico.* University of Arizona, 1980.

## I. *WPA ART IN WPA BUILDINGS:* None

## II. *WPA ART IN OTHER PUBLIC BUILDINGS*

The *public schools* of this community have identified that they still own two B. J. O. Nordfeldt etchings titled, "Morada" and "Canyon Road".

## III. *WPA BUILDINGS:* None

## IV. *MYSTERY PAINTINGS:* None

Kenneth Adams' "Native Woman" was possibly an 18" x 23" lithograph. Copies of it went to at least six schools around the state. Some were framed, others may have been unframed. Because of the latter situation they may have been lost more easily. Photo from N. M. State Records and Archives photo collection.

Chapter 2

# SOLVE THE UNSOLVED MYSTERIES OF ART

We have made numerous attempts to find the following artworks but to no avail. We plan to continue our search and we hope you will join us. Please let us know if you have information regarding the disposition and/or whereabouts of the following art or other pieces that were created originally as a result of the New Deal federally funded programs for the visual arts. These programs took place between 1933 and 1943. The art was supposed to be hung or be placed in public buildings or ones that were tax supported. Most started out there but moved elsewhere. These "moves" may have been planned or otherwise. Some art works may have also been destroyed for one reason or another. Poor record keeping of these situations have left us with these "Unsolved Mysteries of Art."

Identifying their whereabouts doesn't require giving them back to the original public facility unless the owner so chooses. Identification at this time is the prime goal. You may write to Sunstone Press, P.O. Box 2321 / Santa Fe, New Mexico 87504. Please help us solve these "UNSOLVED MYSTERIES." Unfortunately, there is no monetary reward but a great satisfaction is guaranteed whenever a piece of a puzzle is found.

| TOWN | ARTIST | NAME OF WORK | MEDIA/SIZE | LOCATION |
|---|---|---|---|---|
| ALAMOGORDO | 1.GENE KLOSS | GROUP B.<br>1. SANCTUARY CHIMAYO<br>2. N.M. MOUNTAIN TOWN<br>3. WINTER MASS | ETCHINGS 20" X 26" | PUBLIC SCHOOLS |
| | 2.B.J.O. NORDFELDT | GROUP A.<br>1. TRES RITOS<br>2. MORADA SANTA CRUZ<br>3. CANYON ROAD | LITHOGRAPHS 10" X 13" | PUBLIC SCHOOLS |
| ALBUQUERQUE | 1.NORDFELDT | GROUP A.<br>1. TRES RITOS<br>2. MORADO SANTA CRUZ<br>3. CANYON ROAD | LITHOGRAPHS 10" X 13" | 1.PUBLIC SCHOOLS (MILNE)<br>&<br>2.UNM |
| | | GROUP B.<br>1. RIO IN MEDIO<br>2. CERRILLOS<br>3. WATER STREET | LITHOGRAPHS 10" X 13" | 1.PUBLIC SCHOOLS (MILNE)<br>&<br>2.UNM |
| | 2.KLOSS | GROUP A.<br>1. INDIAN CEREMONY<br>2. INDIAN PUEBLO<br>3. INDIAN HARVEST | ETCHINGS 20" X 26" | 1.PUBLIC SCHOOLS (MILNE)<br>&<br>2.VETERANS HOSPITAL<br>&<br>3.ALBQ. POST OFFICE |
| | | GROUP B.<br>1. SANCTUARY CHIMAYO<br>2. N. M. MOUNTAIN TOWN<br>3. WINTER MASS | | 1.PUBLIC SCHOOLS (MILNE)<br>&<br>2.UNM |
| | | GROUP C.<br>1. CHRISTMAS EVE, TAOS PUEBLO<br>2. PENITENTE GOOD FRIDAY<br>3. ACOMA | | 1.PUBLIC SCHOOLS (MILNE)<br>&<br>2.UNM |
| | 3.CARL REDIN | RIO GRANDE VALLEY | OIL | N.M. GIRLS WELFARE HOME |
| | 4.LLOYD MOYLAN | FURNITURE, TINWORK, PAINTINGS | FURNITURE, TINWORK, PAINTINGS | OLD OFFICERS CLUB-KIRTLAND |
| | | FURNITURE, TINWORK | FURNITURE, TINWORK | ALBUQUERQUE LITTLE THEATRE |

| TOWN | ARTIST | NAME OF WORK | MEDIA/SIZE | LOCATION |
|---|---|---|---|---|
| ARTESIA | 1.KLOSS | GROUP A.<br>1. INDIAN CEREMONY<br>2. INDIAN PUEBLO<br>3. INDIAN HARVEST | ETCHINGS 20" X 26" | PUBLIC SCHOOLS |
|  | 2.NORDFELDT | GROUP B.<br>1. RIO IN MEDIO<br>2. CERRILLOS<br>3. WATER STREET | LITHOGRAPHS 10" X 13" | PUBLIC SCHOOLS |
| ANTHONY | KLOSS | GROUP B.<br>1. SANCTUARY CHIMAYO<br>2. N.M. MOUNTAIN TOWN<br>3. WINTER MASS | ETCHINGS 20" X 26" | PUBLIC SCHOOLS |
| AZTEC | KLOSS | GROUP B.<br>1. SANCTUARY CHIMAYO<br>2. N.M. MOUNTAIN TOWN<br>3. WINTER MASS | ETCHINGS 20" X 26" | PUBLIC SCHOOLS |
| BELEN | 1.KLOSS | GROUP C.<br>1. CHRISTMAS EVE, TAOS PUEBLO<br>2. PENITENTE GOOD FRIDAY<br>3. ACOMA | ETCHINGS 20" X 26" | PUBLIC SCHOOLS |
|  | 2.NORDFELDT | GROUP B.<br>1. RIO IN MEDIO<br>2. CERRILLOS<br>3. WATER STREET | LITOGRAPHS 10" X 13" | PUBLIC SCHOOLS |
| BERNALILLO | KLOSS | GROUP B.<br>1. SANCTUARY CHIMAYO<br>2. N.M.MOUNTAIN TOWN<br>3. WINTER MASS | ETCHINGS 20" X 26" | PUBLIC SCHOOLS |
| CAPITAN | NORDFELDT | GROUP A.<br>1. TRES RITOS<br>2. MORADA SANTA CRUZ<br>3. CANYON ROAD | LITOGRAPHS 10" X 13" | PUBLIC SCHOOLS |
| CARSLBAD | 1.KENNETH ADAMS | UNTITLED (NATIVE WOMAN) | UNFRAMED SKETCH | PUBLIC SCHOOLS |
|  | 2.CARL WOOLSEY | LANDSCAPE | OIL 22" X 25" | PUBLIC SCHOOLS |

| TOWN | ARTIST | NAME OF WORK | MEDIA/SIZE | LOCATION |
|---|---|---|---|---|
| | 3.KLOSS | GROUP A.<br>1. INDIAN CEREMONY<br>2. INDIAN PUEBLO<br>3. INDIAN HARVEST<br><br>GROUP C.<br>1. CHRISTMAS EVE, TAOS PUEBLO<br>2. PENITENTE GOOD FRIDAY<br>3. ACOMA | ETCHINGS 20" X 26" | PUBLIC SCHOOLS |
| | 4.NORDFELDT | GROUP B.<br>1. RIO IN MEDIO<br>2. CERRILLOS<br>3. WATER STREET | LITHOGRAPHS 10" X 13" | PUBLIC SCHOOLS |
| CARRIZOZO | 1.KLOSS | GROUP A.<br>1. INDIAN CEREMONY<br>2. INDIAN PUEBLO<br>3. INDIAN HARVEST | ETCHINGS 20" X 26" | PUBLIC SCHOOLS |
| | 2.NORDFELDT | GROUP B.<br>1. RIO IN MEDIO<br>2. CERRILLOS<br>3. WATER STREET | LITHOGRAPHS 10" X 13" | PUBLIC SCHOOLS |
| CERRILLOS | NORDFELDT | GROUP B.<br>1. RIO IN MEDIO<br>2. CERRILLOS<br>3. WATER STREET | LITHOGRAPHS 10" X 13" | PUBLIC SCHOOLS |
| CLAYTON | 1.KLOSS | GROUP B.<br>3. WINTER MASS | ETCHINGS 20" X 26" | PUBLIC SCHOOLS |
| | | GROUP C.<br>1. CHRISTMAS EVE, TAOS PUEBLO | ETCHINGS 20" X 26" | PUBLIC SCHOOLS |
| | 2.NORDFELDT | GROUP B.<br>1. RIO IN MEDIO<br>2. CERRILLOS<br>3. WATER STREET | LITHOGRAPHS 10" X 13" | PUBLIC SCHOOLS |

| TOWN | ARTIST | NAME OF WORK | MEDIA/SIZE | LOCATION |
|---|---|---|---|---|
| CLOVIS | 1. KLOSS | GROUP B. 1. SANCTUARY CHIMAYO 2. N. M. MOUNTAIN TOWN 3. WINTER MASS | ETCHINGS 20" X 26" | PUBLIC SCHOOLS |
| | | GROUP C. 1. CHRISTMAS EVE, TAOS PUEBLO 2. PENITENTE GOOD FRIDAY 3. ACOMA | ETCHINGS 20" X 26" | PUBLIC SCHOOLS |
| | 2. RUSSELL LUNBACH | CONNECTICUT IN WINTER | COLORED LITHOGRAPH 30" X 24" FRAMED | ? |
| | 3. NORDFELDT | GROUP A. 1. TRES RITOS 2. MORADA SANTA CRUZ 3. CANYON ROAD | LITHOGRAPHS 10" X 13" | PUBLIC SCHOOLS |
| CUBA | KLOSS | GROUP B. 1. SANCTUARY CHIMAYO 2. N.M. MOUNTAIN TOWN 3. WINTER MASS | ETCHINGS 20" X 26" | PUBLIC SCHOOLS |
| DAWSON | 1. KLOSS | GROUP C. 1. CHRISTMAS EVE, TAOS PUEBLO 2. PENITENTE GOOD FRIDAY 3. ACOMA | ETCHINGS 20" X 26" | PUBLIC SCHOOLS |
| | 2. NORDFELDT | GROUP A. 1. TRES RITOS 2. MORADA SANTA CRUZ 3. CANYON ROAD | LITHOGRAPHS 10" X 13" | PUBLIC SCHOOLS |
| DEMING | 1. KLOSS | GROUP A. 1. INDIAN CEREMONY 2. INDIAN PUEBLO 3. INDIAN HARVEST | | |
| | | GROUP C. 1. CHRISTMAS EVE, TAOS PUEBLO 2. PENITENTE GOOD FRIDAY 3. ACOMA | ETCHINGS 20" X 26" | PUBLIC SCHOOLS |
| | 2. NORDFELDT | GROUP B. 1. RIO IN MEDIO 2. CERRILLOS 3. WATER STREET | LITHOGRAPHS 10" X 13" | PUBLIC SCHOOLS |

| TOWN | ARTIST | NAME OF WORK | MEDIA/SIZE | LOCATION |
|---|---|---|---|---|
| ELIDA | KLOSS | GROUP C.<br>1. CHRISTMAS EVE, TAOS PUEBLO<br>2. PENITENTE GOOD FRIDAY<br>3. ACOMA | ETCHINGS 20" X 26" | PUBLIC SCHOOLS |
| EL RITO | 1.KLOSS | GROUP C.<br>1. CHRISTMAS EVE, TAOS PUEBLO<br>2. PENITENTE GOOD FRIDAY<br>3. ACOMA | ETCHINGS 20" X 26" | NORTHERN N.M. COMMUNITY COLLEGE |
| | 2.NORDFELDT | GROUP A.<br>1. TRES RITOS<br>2. MORADA SANTA CRUZ<br>3. CANYON ROAD | LITHOGRAPHS 10" X 13" | NORTHERN N.M. COMMUNITY COLLEGE |
| | 3.JAMES MORRIS & CHARLES BARROWS | VOCATIONAL STUDY | MURAL | NORTHERN N.M. COMMUNITY COLLEGE |
| ESPANOLA | KENNETH ADAMS | NATIVE WOMAN | UNFRAMED SKETCH | PUBLIC SCHOOLS |
| FARMINGTON | KLOSS | GROUP C.<br>1. CHRISTMAS EVE, TAOS PUEBLO<br>2. PENITENTE GOOD FRIDAY<br>3. ACOMA | ETCHINGS 20" X 26" | PUBLIC SCHOOLS |
| FT. STANTON | NUMEROUS ARTISTS | 80 WATERCOLORS--DIFFERENT SUBJECTS | WATERCOLORS | FT. STANTON--STATE INSTITUTION/HOSPITAL |
| GALLUP | 1.KLOSS | GROUP A.<br>1. INDIAN CEREMONY<br>2. INDIAN PUEBLO<br>3. INDIAN HARVEST | ETCHINGS 20" X 26" | PUBLIC SCHOOLS |
| | | GROUP C.<br>1. CHRISTMAS EVE, TAOS PUEBLO<br>2. PENITENTE GOOD FRIDAY<br>3. ACOMA | | |
| | 2.NORDFELDT | GROUP A.<br>1. TRES RITOS<br>2. MORADA SANTA CRUZ<br>3. CANYON ROAD | LITHOGRAPHS 10" X 13" | PUBLIC SCHOOLS |

| TOWN | ARTIST | NAME OF WORK | MEDIA/SIZE | LOCATION |
|---|---|---|---|---|
| GRANTS | NORDFELDT | GROUP A.<br>1. TRES RITOS<br>2. MORADA SANTA CRUZ<br>3. CANYON ROAD | LITHOGRAPHS 10" X 13" | PUBLIC SCHOOLS |
| HAGERMAN | FREMONT ELLIS | "WINTER"<br>(BELIEVED TO HAVE BEEN DESTROYED) | OIL | PUBLIC SCHOOLS |
| HATCH | CARL REDIN | "SUPERSTITION MOUNTAIN" | OIL | PUBLIC SCHOOLS |
| HURLEY | 1.KLOSS | GROUP C.<br>1. CHRISTMAS EVE, TAOS PUEBLO<br>2. PENITENTE GOOD FRIDAY<br>3. ACOMA | ETCHINGS 20" X 26" | PUBLIC SCHOOLS |
| | 2.NORDFELDT | GROUP B.<br>1. RIO IN MEDIO<br>2. CERRILLOS<br>3. WATER STREET | LITHOGRAPHS 10" X 13" | PUBLIC SCHOOLS |
| LAS CRUCES | 1.KLOSS | GROUP A.<br>1. INDIAN CEREMONY<br>2. INDIAN PUEBLO<br>3. INDIAN HARVEST | ETCHINGS 20" X 26" | PUBLIC SCHOOLS |
| | | GROUP B.<br>1. SANCTUARY CHIMAYO<br>2. N.M. MOUNTAIN TOWN<br>3. WINTER MASS | ETCHINGS 20" X 26" | PUBLIC SCHOOLS |
| | | GROUP C.<br>1. CHRISTMAS EVE, TAOS PUEBLO<br>2. PENITENTE GOOD FRIDAY<br>3. ACOMA | ETCHINGS 20" X 26" | LAS CRUCES UNION HIGH |
| | 2.NORDFELDT | GROUP A.<br>1. TRES RITOS<br>2. MORADA SANTA CRUZ<br>3. CANYON ROAD | LITHOGRAPHS 10" X 13" | PUBLIC SCHOOLS |
| | | GROUP B.<br>1. RIO IN MEDIO<br>2. CERRILLOS<br>3. WATER STREET | LITHOGRAPHS 10" X 13" | 1.LAS CRUCES UNION HIGH<br>&<br>2. PUBLIC SCHOOLS |
| | 3.SCHLEETER | "ELEPHANT BUTTE DAM, 1936" | OIL 4 X 12 | NM STATE UNIVERSITY |

| TOWN | ARTIST | NAME OF WORK | MEDIA/SIZE | LOCATION |
|---|---|---|---|---|
| LAS VEGAS | 1. NORDFELDT | GROUP A.<br>1. TRES RITOS<br>2. MORADA SANTA CRUZ<br>3. CANYON ROAD | LITHOGRAPHS 10" X 13" | N.M. HIGHLANDS UNIVERSITY |
| | | GROUP B.<br>1. RIO IN MEDIO<br>2. CERRILLOS<br>3. WATER STREET | " | PUBLIC SCHOOLS (EAST) |
| | 2. OMAR HEARN | 1. GEN. KEARNEY (PORTRAIT)<br>2. HISTORICAL SCENE | OIL | VEEDER MUSEUM |
| | 3. KENNETH ADAMS | NATIVE WOMAN | UNFRAMED SKETCH | PUBLIC SCHOOLS (OLD TOWN) |
| | 4. KLOSS | GROUP A.<br>1. INDIAN CEREMONY<br>2. INDIAN PUEBLO<br>3. INDIAN HARVEST | ETCHINGS 20" X 26" | PUBLIC SCHOOLS (OLD TOWN) |
| | | GROUP B.<br>1. SANCTUARY CHIMAYO<br>2. N.M. MOUNTAIN TOWN<br>3. WINTER MASS | " | PUBLIC SCHOOLS (NEW TOWN) |
| | | GROUP C.<br>1. CHRISTMAS EVE, TAOS PUEBLO<br>2. PENITENTE GOOD FRIDAY<br>3. ACOMA | " | N.M HIGHLANDS UNIVERSITY |
| | 5. ILA MC AFEE | "HORSE POWER" | OIL | PUBLIC SCHOOLS (NEW TOWN) |
| | 6. CARL REDIN | "NEW MEXICO CHAPEL" | OIL | PUBLIC SCHOOLS (OLD TOWN) |
| | 7. BROOKS WILLIS | SEVEN SMALL MURALS (PAINTED OVER) | OIL | N.M. HIGHLANDS-ILFELD AUDITORIUM ENTRY-OVER DOORS |
| LORDSBURG | 1. KLOSS | GROUP A.<br>1. INDIAN CEREMONY<br>2. INDIAN PUEBLO<br>3. INDIAN HARVEST | ETCHINGS 2-" X 26" | PUBLIC SCHOOLS |

| TOWN | ARTIST | NAME OF WORK | MEDIA/SIZE | LOCATION |
|---|---|---|---|---|
|  | 2.NORDFELDT | GROUP A.<br>1. TRES RITOS<br>2. MORADA SANTA CRUZ<br>3. CANYON ROAD | LITHOGRAPHS 10" X 13" | PUBLIC SCHOOLS |
| LOVINGTON | KLOSS | GROUP B.<br>1. SANTUARY CHIMAYO<br>2. N.M. MOUNTAIN TOWN<br>3. WINTER MASS | ETCHINGS 20" X 26" | PUBLIC SCHOOLS |
| MAGDALENA | KLOSS | GROUP B.<br>1. SANTUARY CHIMAYO<br>2. N.M. MOUNTAIN TOWN<br>3. WINTER MASS | " | PUBLIC SCHOOLS |
| MORA | KLOSS | GROUP B.<br>1. SANTUARY CHIMAYO<br>2. N.M. MOUNTAIN TOWN<br>3. WINTER MASS | " | PUBLIC SCHOOLS |
| MOSQUERO | NORDFELDT | GROUP A.<br>1. TRES RITOS<br>2. MORADA SANTA CRUZ<br>3. CANYON ROAD | LITHOGRAPHS 10" X 13" | PUBLIC SCHOOLS |
| MOUNTAINAIR | KLOSS | GROUP B.<br>1. SANCTUARY CHIMAYO<br>2. N.M. MOUNTAIN TOWN<br>3. WINTER MASS | LITHOGRAPHS 10" X 13" | PUBLIC SCHOOLS |
| PORTALES | 1.KLOSS | GROUP B.<br>1. SANCTUARY CHIMAYO<br>2. N.M. MOUNTAIN TOWN<br>3. WINTER MASS | ETCHINGS 20" X 26" | PUBLIC SCHOOLS |
|  |  | GROUP C.<br>1. CHRISTMAS EVE, TAOS PUEBLO<br>2. PENITENTE GOOD FRIDAY<br>3. ACOMA | " | EASTERN N. M.<br>UNIVERSITY |
|  | 2.NORDFELDT | GROUP B.<br>1. RIO IN MEDIO<br>2. CERRILLOS<br>3. WATER STREET | LITHOGRAPHS<br>10" X 13" | PUBLIC SCHOOLS |
|  | 3.NILS HOGNER | "SANITATION ISLETA PUEBLO" | OIL | EASTERN N. M. UNIVERSITY |
|  | 4.UNKNOWN | 3 PAINTINGS | UNKNOWN | PORTALES WOMENS' CLUB |

| TOWN | ARTIST | NAME OF WORK | MEDIA/SIZE | LOCATION |
|---|---|---|---|---|
| RATON | 1.KLOSS | GROUP A. <br> 1. INDIAN CEREMONY <br> 2. INDIAN PUEBLO <br> 3. INDIAN HARVEST | ETCHINGS 20" X 26" | PUBLIC SCHOOLS |
| | | GROUP B. <br> 1. SANCTUARY CHIMAYO <br> 2. N.M. MOUNTAIN TOWN <br> 3. WINTER MASS | " | " |
| | 2.NORDFELDT | GROUP B. <br> 1. RIO IN MEDIO <br> 2. CERRILLOS <br> 3. WATER STREET | LITHOGRAPHS 10" X 13" | PUBLIC SCHOOLS |
| | 3.REGINA TATUM COOOKE | "SEPTEMBER NIGHT" | OIL | ? |
| | 4.KENNETH ADAMS | "NATIVE WOMAN" | UNFRAMED SKETCH | PUBLIC SCHOOLS |
| ROSWELL | 1.KENNETH ADAMS | "NATIVE WOMAN" | UNFRAMED SKETCH | PUBLIC SCHOOLS |
| | 2.KLOSS | GROUP A. <br> 1. INDIAN CEREMONY <br> 2. INDIAN PUEBLO <br> 3. INDIAN HARVEST | ETCHINGS 20" X 26" | PUBLIC SCHOOLS |
| | | GROUP B. <br> 1. SANCTUARY CHIMAYO <br> 2. N. M. MOUNTAIN TOWN <br> 3. WINTER MASS | | |
| | | GROUP C. <br> 1. CHRISTMAS EVE, TAOS PUEBLO <br> 2. PENITENTE GOOD FRIDAY <br> 3. ACOMA | | |
| | 3.NORDFELDT | GROUP A. <br> 1. TRES RITOS <br> 2. MORADA SANTA CRUZ <br> 3. CANYON ROAD | LITHOGRAPHS 10' X 13" | PUBLIC SCHOOLS |
| SANTA FE | 1.LA VERNE N. BLACK | "MEXICAN CATTLE" | OIL | STATE CAPITOL |
| | 2.FREMONT ELLIS | "LANDSCAPE SANTA FE" | OIL | STATE CAPITOL |
| | | "HIGHWAY 66" | OIL | STATE HIGHWAY DEPT. (STOLEN) |

| TOWN | ARTIST | NAME OF WORK | MEDIA/SIZE | LOCATION |
|---|---|---|---|---|
| | 3.KLOSS | GROUP A.<br>1. INDIAN CEREMONY<br>2. INDIAN PUEBLO<br>3. INDIAN HARVEST | ETCHINGS 20" X 26" | 1.PUBLIC SCHOOLS<br>2.LAB. OF ANTHROPOLOGY |
| | | GROUP B.<br>1. SANCTUARY CHIMAYO<br>2. N.M. MOUNTAIN TOWN<br>3. WINTER MASS | ETCHINGS 20" X 26" | 1.PUBLIC SCHOOLS<br>2. LAB. OF ANTHROPOLO-GY<br>3.N.M. STATE WELFARE OFFICE |
| | | GROUP C.<br>1. CHRISTMAS EVE, TAOS PUEBLO<br>2. PENITENTE GOOD FRIDAY<br>3. ACOMA | ETCHINGS 20" X 26" | 1.PUBLIC SCHOOLS<br>2. LAB. OF ANTHROPOLOGY |
| | 4.NORDFELDT | GROUP A.<br>1. TRES RITOS<br>2. MORADA SANTA CRUZ<br>3. CANYON ROAD | LITHOGRAPHS 10" X 13" | LAB. OF ANTHROPOLOGY DEPT. |
| | 5.SHELDON PARSONS | "VIEW NEAR ESPANOLA" OR "VIEW NEAR SAN ILDEFONSO" | OIL | N.M. HUMAN SERVICES DEPT. |
| | | "WINTER IN TESUQUE" | OIL | N.M. STATE CAPITOL |
| | 6.BRUCE SAVILLE | HISTORICAL SCULPTURE OF SOLDIERS | SCULPTURE | NATIONAL CEMETERY |
| | 7.HOWARD SCHLEETER | "FALL PATTERN" | OIL | N.M. STATE CAPITOL |
| | 8.CARL WOOLSEY | "ARROYO ROAD" | OIL 34" X 40" | PUBLIC SCHOOLS |
| SANTA ROSA | NORDFELDT | GROUP A.<br>1. TRES RITOS<br>2. MORADA SANTA CRUZ<br>3. CANYON ROAD | LITHOGRAPHS 10" X 13" | PUBLIC SCHOOLS |
| SILVER CITY | 1.KLOSS | GROUP A<br>1. INDIAN CEREMONY<br>2. INDIAN PUEBLO<br>3. INDIAN HARVEST | ETCHINGS 20" X 26" | N.M. WESTERN UNIVERSITY |
| | 2.NORDFELDT | GROUP A.<br>1. TRES RITOS<br>2. MORADA SANTA CRUZ<br>3. CANYON ROAD | LITHOGRAPHS 10" X 13" | |
| | 3.SHELDON PARSONS | "EARLY OCTOBER" | OIL 38" X 56" | N.M. WESTERN UNIVERSITY |

| TOWN | ARTIST | NAME OF WORK | MEDIA/SIZE | LOCATION |
|---|---|---|---|---|
| SOCORRO | 1.KLOSS | GROUP B. 1. SANCTUARY CHIMAYO 2. N.M. MOUNTAIN TOWN 3. WINTER MASS | ETCHINGS 20" X 26" | N.M. TECH |
| | 2.NORDFELDT | GROUP B. 1. RIO IN MEDIO 2. CERRILLOS 3. WATER STREET | LITHOGRAPHS 10" X 13" | 1.N.M. TECH & 2.PUBLIC SCHOOLS |
| SPRINGER | 1.FREMONT ELLIS | "EL PUERTON" | OIL | N.M. BOYS' SCHOOL |
| | 2.NORDFELDT | GROUP A. 1. TRES RITOS 2. MORADA SANTA CRUZ 3. CANYON ROAD | LITHOGRAPHS 10" X 13" | PUBLIC SCHOOLS |
| TAOS | 1.KENNETH ADAMS | "NATIVE WOMAN" | SKETCH | PUBLIC SCHOOLS |
| | 2.KLOSS | GROUP C. 1. CHRISTMAS EVE, TAOS PUEBLO 2. PENITENTE GOOD FRIDAY 3. ACOMA | ETCHINGS 20" X 26" | PUBLIC SCHOOLS |
| | 3.NORDFELDT | GROUP A. 1. TRES RITOS 2. MORADA SANTA CRUZ 3. CANYON ROAD | LITHOGRAPHS 10" X 13" | PUBLIC SCHOOLS |
| TIERRA AMARILLA | KLOSS | GROUP C. 1. CHRISTMAS EVE, TAOS PUEBLO 2. PENITENTE GOOD FRIDAY 3. ACOMA | ETCHINGS 20" X 26" | PUBLIC SCHOOLS |
| TRES RITOS | NORDFELDT | GROUP A. 1. TRES RITOS 2. MORADA SANTA CRUZ 3. CANYON ROAD | LITHOGRAPHS 10" X 13" | PUBLIC SCHOOLS |
| TRUTH OR CONSEQUENCES | 1.KLOSS | GROUP C. 1. CHRISTMAS EVE, TAOS PUEBLO 2. PENITENTE GOOD FRIDAY 3. ACOMA | ETCHINGS 20" X 26" | PUBLIC SCHOOLS |
| | 2.EWING/RODRIQUEZ | MOSAIC TILES AROUND BASE OF COURTYARD FOUNTAIN | MOSAIC TILES | N.M. VETERANS CENTER OUTSIDE/INTERIOR COURTYARD |

| TOWN | ARTIST | NAME OF WORK | MEDIA/SIZE | LOCATION |
|---|---|---|---|---|
| | 3.IRENE EMERY | BIRDS IN FLIGHT | BAS RELIEF ON INTERIOR WALL | N.M. VETERANS CENTER |
| | 4.BLANCA WILL | MOSAIC TILES ON THE FLOOR | MOSAIC TILES ON FLOOR | STATE BATHOUSE (MAYBE-BUT NOW GONE) |
| TUCUMCARI | 1.KLOSS | GROUP A. 1. INDIAN CEREMONY 2. INDIAN PUEBLO 3. INDIAN HARVEST | ETCHINGS 20" X 26" | PUBLIC SCHOOLS |
| | | GROUP B. 1. SANCTUARY CHIMAYO 2. N.M. MOUNTAIN TOWN 3. WINTER MASS | ETCHINGS 20" X 26" | PUBLIC SCHOOLS |
| | 2.NORDFELDT | GROUP B. 1. RIO IN MEDIO 2. CERRILLOS 3. WATER STREET | LITHOGRAPHS 10" X 13" | PUBLIC SCHOOLS |
| TULAROSA | KLOSS | GROUP B. 1. SANCTUARY CHIMAYO 2. N.M. MOUNTAIN TOWN 3. WINTER MASS | ETCHINGS 20" X 26" | PUBLIC SCHOOLS |
| EAST VAUGHN | NORDFELDT | GROUP A. 1. TRES RITOS 2. MORADA SANTA CRUZ 3. CANYON ROAD | LITHOGRAPHS 10" X 13" | PUBLIC SCHOOLS (EAST) |
| WAGON MOUND | NORDFELDT | GROUP B. 1. RIO IN MEDIO 2. CERRILLOS 3. WATER STREET | LITHOGRAPHS 10" X 13" | PUBLIC SCHOOLS |

Gene Kloss, "Winter Mass" 20" x 26" framed etching.

Gene Kloss created nine black and white etchings that were reproduced and sent to public schools all over the state. They were all 20" x 26" framed and featured primarily northern New Mexico scenes. Since there were so many distributed, it has been difficult to locate them all. Refer to the "Unsolved Mysteries of Art" chapter for the list of possible school locations. Photo from UNM Art Museum.

## GENE KLOSS' MISSING ARTWORK
## IN FOLLOWING SCHOOLS

These etchings were done in groups but may have been separated when distributed around the state. They are all black and white etchings, 20"x26" in size.

### GROUP A.

1. "Indian Ceremony"
2. "Indian Pueblo"
3. "Indian Harvest"

### LOCATIONS where Group A was distributed:

1. Albuquerque
2. Artesia
3. Carlsbad
4. Deming
5. Gallup
6. Las Vegas - "City" or Old Town schools
7. Highlands University
8. Lordsburg
9. Mountainair
10. Raton
11. Roswell
12. Santa Fé
13. Silver City
14. Tucumcari

### GROUP B.

1. "Sanctuary Chimayo"
2. "New Mexico Mountain Town"
3. "Winter Mass"

**LOCATIONS where Group B was distributed:**

1. Alamogordo
2. Anthony
3. Aztec
4. Carlsbad
5. Clovis
6. Cuba
7. Las Vegas - New Town or "East" School
8. Lovington
9. Magdalena
10. Mora
11. Portales
12. Raton
13. Santa Fé
14. Tularosa
15. Tucumcari

## GROUP C.

1. "Christmas Eve, Taos Pueblo"
2. "Penitente Good Friday"
3. "Acoma"

**LOCATIONS where Group C was distributed:**

1. Belen
2. Elida
3. El Rito - Northern New Mexico Community College
4. Farmington
5. Hurley
6. Las Cruces
7. Santa Fé
8. Taos
9. Tierra Amarilla
10. Truth or Consequences

# B. J. O. NORDFELDT MISSING ARTWORK

These black and white lithographs were 10"x13" in size and were also distributed primarily to the public schools.

## GROUP A.

a. "Tres Ritos"
b. "Morada Santa Cruz"
c. "Canyon Road"

## LOCATIONS where Group A was distributed:

1. Alamogordo
2. Albuquerque
3. Gallup
4. Grants
5. Las Cruces
6. Mosquero
7. Roswell
8. Santa Rosa
9. Silver City - Western New Mexico University
10. Springer
11. Taos
12. Tres Ritos
13. Vaughn

## GROUP B.

a. "Rio in Medio"
b. "Cerrillos"
c. "Water Street"

## LOCATIONS where Group B was distributed.

1. Albuquerque
2. Artesia
3. Belen

4. Capitan
5. Carlsbad
6. Clovis
7. Deming
8. Hurley
9. Las Cruces
10. Las Vegas - "New Town"
11. Portales
12. Raton
13. Socorro
14. Tucumcari
15. Wagon Mound

James Morris (shown above) and Charles Barrows may have done a series of scenes for a mural called "Vocational Studies" for the Spanish American Normal School, now Northern New Mexico Community College, in El Rito. The whereabouts of this work is an unsolved mystery. They do have at the school in El Rito a D. Paul Jones tryptch in the Bronson Cutting Building . It is entitled "The Founding of San Juan, the New Spain." Photo from the N.M. State Records and Archives photo collection.

Chapter 3

# THE GREAT DEPRESSION AND ART IN NEW MEXICO: CREATE TO SURVIVE / SURVIVE TO CREATE

*Louise Turner/Sandra D'Emilio*

Letter from Will Shuster in Santa Fé to John Sloan in New York:

*November 11, 1933*

*Dear Sloan,*

*"...I have been able to make all told since I returned from the homestead only $75...*

*"The merchants here...are now beginning to feel the pinch and are consequently beginning to pinch the other fellow...I am trying my damndest to meet all my current bills and letting the old ones ride until such time as I get the cash to pay them. Yesterday I had to tell the light company to turn the godam (sic) electricity off if they wouldn't play on those terms and that I would use kerosene lamps. However, they didn't turn it off I notice.*

*"All of them are getting tough as hell. Except I might say, Kaune's [local grocery store(s), in existence since late 1800s].*

*"The etching business is non-existent...*

*"I started to paint but had lousy luck and then I realized I had to do something to make a little money..."* [1]

Thus it was late in the year 1933 that Santa Fé artist Will Shuster expressed his financial woes to his good friend, New York artist John Sloan, renowned as one of 'The Eight' or 'The Ashcan School', who annually spent time in Santa Fé.

The hardships of painter Shuster were replicated thousands of times over among artists country-wide, and his plight bespoke those of construction workers, clerical personnel, engineers, teachers, merchants—America's working class—as well. Shuster's words admitted the reality of a bleak and frightening future for the U.S. community at large.

Across the country, fifteen million people were unemployed.

Franklin Delano Roosevelt, who had been President of the United States for only a few months, faced potential economic, social and political disasters for his country, generated by the stock market crash of 1929.

For the artist, the collapse of the stock market equated the collapse of the art market: art collectors and patrons, now without stock dividend income that provided the means for the acquisition of 'luxury' items, could not purchase art. The romance of the timeless sobriquet 'starving artist' took on urgent and less than romantic connotation—and warning.

But on December 7, 1933, 'Shus' wrote once more to Sloan. This letter is one of ebullience and optimism, a far cry from his missive of the previous month.

*"The most important thing which has happened to the Shuster family is this Federal Art Project. [Shuster's wording: not to be confused with Federal Arts Project, implemented in August 1936.] Forty two fifty a week from the Government for painting. My God it doesn't seem real. The day after I landed the job I had to go to bed. That's a big help. I suggested three projects for myself: 1. To paint a series of portraits of the distinguished Indian artists of this region.... 2. To redesign the currency and stamps of the United States using Indian design elements.... 3. To do a series of large paintings of the Carlsbad Caverns for distribution in public buildings...*

*"Number three was handed to me as a job of work. Gosh, John, I think this is a tremendous opportunity for us to put something over in a big way...I think it would be a good thing for all organizations of artists all over the country to write every one connected with the inauguration of this movement an appreciatory note to help us keep the ball a-rolling."* [2]

(Ultimately, Shuster painted pictures of the Carlsbad Caverns, which were acquired by the National Park Service, and presently hang in the Western Archaeological Conference Center in Tuscon, Arizona. He was awarded a second Public Works of Art Project (PWAP) project: to paint murals on the walls enclosing the patio of the Museum of Fine Arts in Santa Fé.)

It is interesting to note that a weekly wage of $42.50 in 1933 was the equivalent of $472.00 per week in 1992.

What exactly was the cause for Shuster's elation scarcely a month after his expressions of despair and near hopelessness? What was the 'Federal Art Project' of which he spoke with such fervor, indeed, that necessitated his taking to his bed, nearly sick, one might assume, with relief and joy over the assurance of income for doing what he did best - creating art?

Specifically, it was the PWAP, the *first* federally funded art program under the Civil Works Administration (CWA)—a New Deal work-relief program created by President Roosevelt to alleviate the economic job crisis in this country.

In time, all the federal art projects have come to be generically referred to as "WPA Art", WPA the acronym for Works Progress Administration.

The CWA was administered by socially conscious Harry Hopkins whose heartfelt belief was that "artists have to eat like other people." The PWAP started in December 1933 and continued until June 1934, and was the brainchild of artist George Biddle, a former schoolmate of Roosevelt at Groton and Harvard.

An advocate of mural art in America, Biddle had studied with the Mexican muralist, Diego Rivera, and it was his belief that Rivera, with Mexican muralists Jose Clemente Orozco and David Alfaro Siquieros, gave voice to the social ideals of the Mexican Revolution of 1910 through their vivid, colorful murals. It would follow, he believed, that murals painted by American artists in the United States would be appropriate vehicles for the expression of the ideals of President Roosevelt's New Deal. He perceived the achievements of the Mexican muralists as 'grand', and believed that young American artists would be eager to express the ideals of a Roosevelt-guided

social revolution on the public walls of America where they would help achieve Roosevelt's social ideals, and remain as lasting monuments to them. The artistic community would welcome and embrace the government's cooperation.

As well, in this country, the work of American muralist Thomas Hart Benton had virtually exploded across the milieu of the private sector, and his popular motifs seemed to open a door to the feasibility of creating popular mural art under a federal umbrella.

The time was right, and Biddle expressed the thought that 'a little impetus' was all that was needed to generate national expression and national excitement—in the possibility of mural art that depicted social consciousness.

A little impetus! New Mexico artists benefited significantly from Biddle's little impetus. In the early days of January, 1934, an article in the Albuquerque Journal noted that 100 New Mexico artists had been assigned CWA art projects which would beautify selected New Mexico public buildings, and that the projects would be funded with federal money.

For nearly a decade these New Mexico artists worked under various federally funded art programs which included Public Works of Art Project (PWAP), 1933-1934; the Works Projects Administration/Federal Arts Projects (WPA/FAP), 1935-1943; the Treasury Relief Art Project (TRAP), 1935-1939; and The Section, 1934-1943. New Mexico was, with Arizona, number 13 of sixteen regional districts across the nation.

The administrative team for Region 13 was a distinguished one. New Mexico anthropologist Jesse Nusbaum was the director, another anthropologist, Kenneth Chapman, served as secretary and Gustave Baumann, a woodblock printer and one of Santa Fé's favorite artists, was regional coordinator.

They were assisted in selecting public sites, obtaining public funds for materials, and in deciding on themes for works to be commissioned by an equally distinguished and capable volunteer committee: United States Senator Bronson Cutting, esteemed Santa Fé architect John Gaw Meem, and social activist writer Mary Austin of Santa Fé.

The untitled Peter Hurd frescos include four panels on the front of the adobe U. S. Federal Building now housing the U. S. Forest Service in Alamogordo. These two main panels are bordered with the text: "Come sunlight after rain to bring green life out of the earth" and "Ven lluvia bendita, ven a acarciar la Tierra Sedienta." Photo by Mark Nohl-New Mexico Magazine.

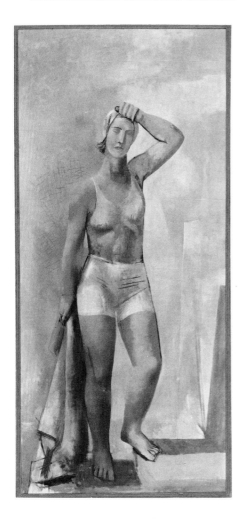 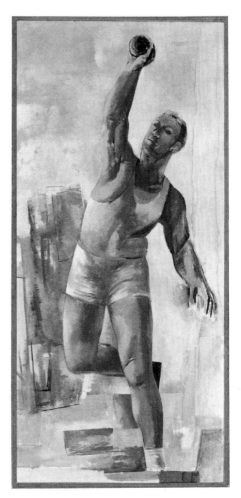

William Nash (1898-1934) found New Mexico a more stimulating artistic environment in 1920 than his previous lives in Pennsylvania and Michigan. Another member of the Los Cinco Pintores, he developed his abstract style and was marked as one of the more daring New Mexico modernists. These works are just some of those in the University of New Mexico Fine Art collection. They were both done in 1934 and are untitled but present, as do the entire group, various athletic opportunities at the school at that time. Photos loaned by UNM Art Museum.

Taos artist Gisella Loeffler, was born in Austria. Painting in bright vivid colors was her style and two large murals with rounded children of New Mexico's three main cultures interacting with well known children's literary figures were the subjects she chose to please the "crippled children" at the Carrie Tingley Hospital. These oil on fiberboard, 72" x 120," murals with gold leaf and bright reds continue to cheer the hospital's children. Photo by Greg Johnston, Carrie Tingley Hospital.

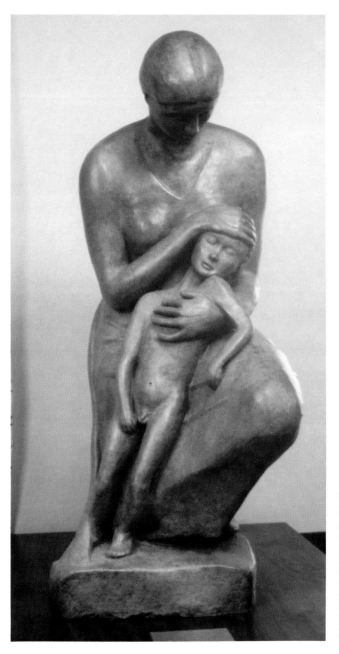

A young black student, Oliver LaGrone, in UNM's art department sculpted "Mercy" in 1935 in memory of his mother's tender care of him during a serious childhood illness. The initial piece, nearly lifesize, was placed in the lobby of Carrie Tingley Hospital and fifty-seven years later (1992) it was finally bronzed. The now retired professor LaGrone came home to Albuquerque from North Carolina for that official unveiling.

This pastel "Cottonwood Tree," 11" x 17," is quite typical of Helmuth Naumer's work and is part of the Clayton school's collection of New Deal art. That whole school complex is a New Deal treasure inside and out and should not be missed. Photo provided by the school.

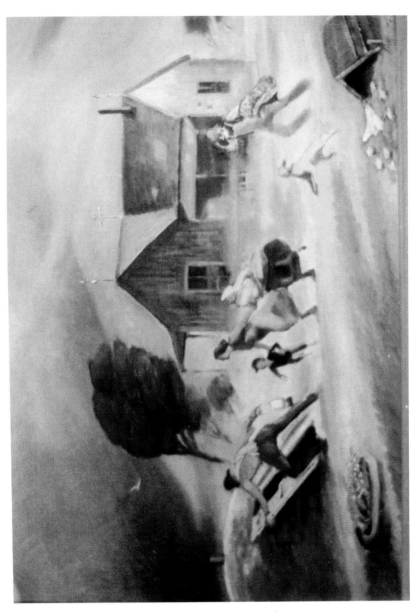

The "Oklahoma Storm," 20" by 24," was created by Santa Fe's self-taught artist, Hal West. It is part of the Clayton school art collection and is particularly appreciated since Clayton has received some of the same winds and dirt that have blown over from Oklahoma in similar looking storms. Photo provided by the school.

Kenneth Adams captured the state's desert in his large mural "Mountains and Valleys" for the Dexter post office. This PWAP mural painted in 1938 actually has more soft yellow and gold tones in it than presented in this reproduction. It is 60" x 144" and is in the entry area of the building as are the other post office murals around the state.

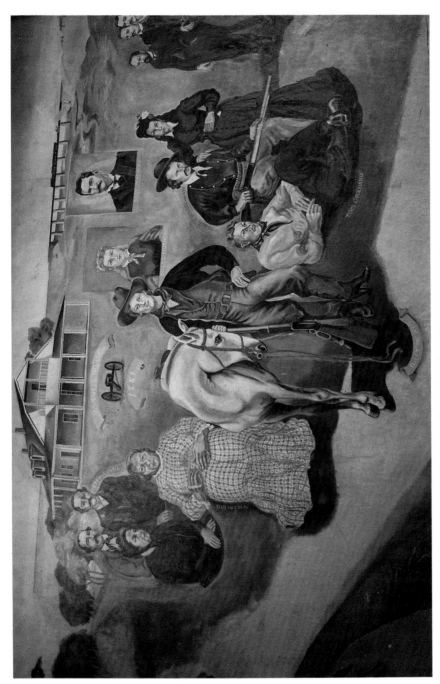

Billy the Kid, Charles Maxwell and his home, and many of the other prominent historical figures of the state's "eastside" were included in Russell Vernon Hunter's large fresco called "The Last Frontier." Created in 1934 under the PWAP, the history of the area is recorded pictorially in the De Baca Courthouse in Fort Sumner. Photo by P. J. Sharpe.

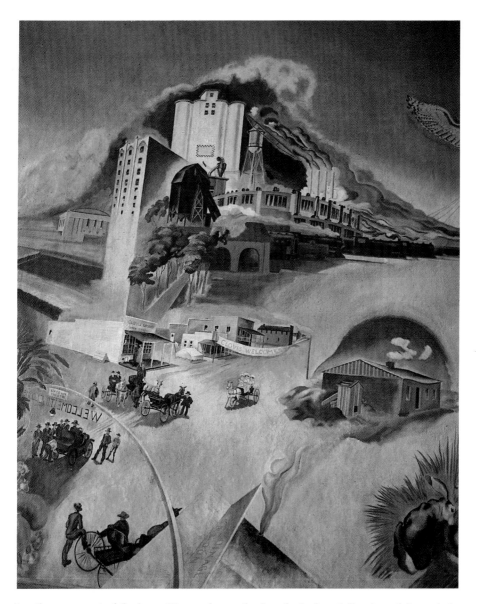

Another segment of the large Hunter fresco depicts the industrialization of the artist's home area near Clovis. The 1934 fresco is all encompassing in its storytelling. Pedro Cervantez, another eastside boy, assisted Hunter with this massive creation. Photo by P. J. Sharpe.

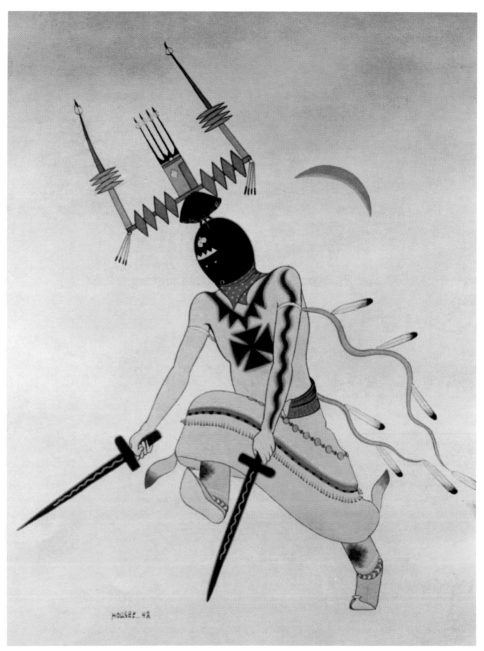

Internationally renown Indian artist, Allan Houser, was just a young man when in 1942 he created this typical two dimensional rendering in casein called "Apache Dancer." It is part of the Octavia Fellin Library Collection in Gallup. He later moved on to the three dimensional pieces for which he became famous. Photo provided by Octavia Fellin.

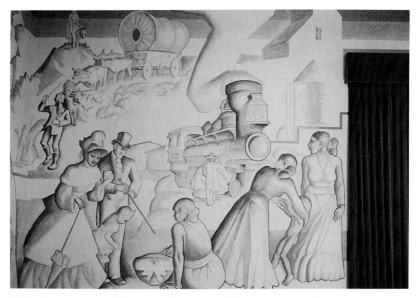

This depicts one small historical segment of the Lloyd Moylan 2000 square feet mural that encompasses the courtroom in the McKinley County Courthouse in Gallup.

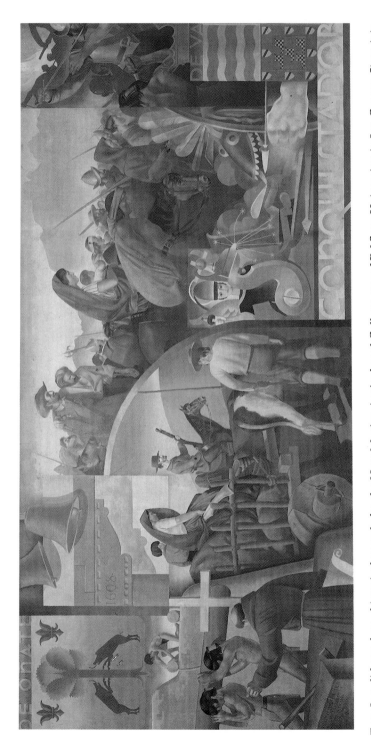

Tom Lea did two large historical murals for the New Mexico Agricultural College, now NM State University, in Las Cruces. Since it is a PWAP mural it must have been done in 1933-34 and is oil on canvas, 54" x 120" in size. It is now in the school's fine art museum collection and can be viewed upon request if not on display. Also murals by Olive Rush can be more easily viewed on the exterior front of the school's Biology Building. Photo provided by NMSU Art Museum.

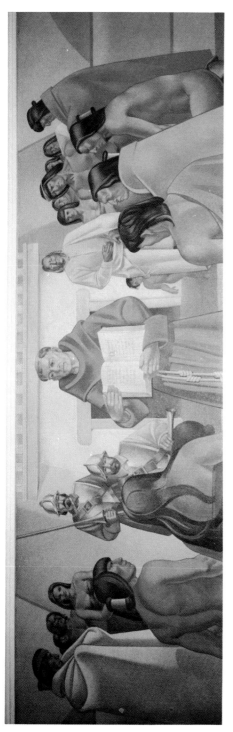

This Tom Lea privately-commissioned 1935 mural has viewed the townspeople for many years from its high perch in the Branigan Cultural Center. Formerly the city's library, the building's mural overlooks the then checkout area and was appropriately titled "The Dissemination of the First Book About New Mexico–1610." Photo by Pat Greathouse, Las Cruces.

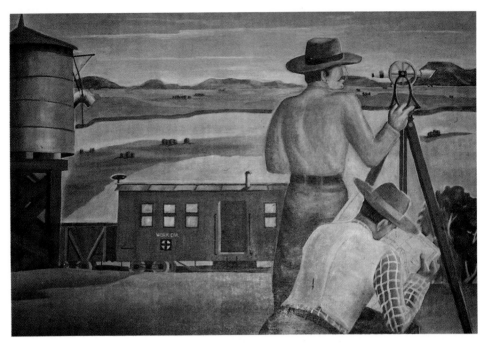

The Melrose schools have five choice murals hanging in their school library. They were done by Howard Schleeter for WPA in 1937-38 and are oil on board, sizes 47" x 71." Other New Deal art still exists in the building. However, their beautifully colcha embroidered stage curtain designed by James Ridgely Whiteman and stitched by local women burned in a fire. Photo by Kathryn A. Flynn.

The murals by Lloyd Moylan in the Administration Building of Eastern New Mexico University are not only beautiful but powerful. These 1934 PWAP murals depict the message of the twelfth chapter of Ecclesiastes as chosen by the private sponsor who assisted in the financing of these masterpieces. Moylan also did two other large murals—one at Highlands University and the other in Gallup at the McKinley County Courthouse.

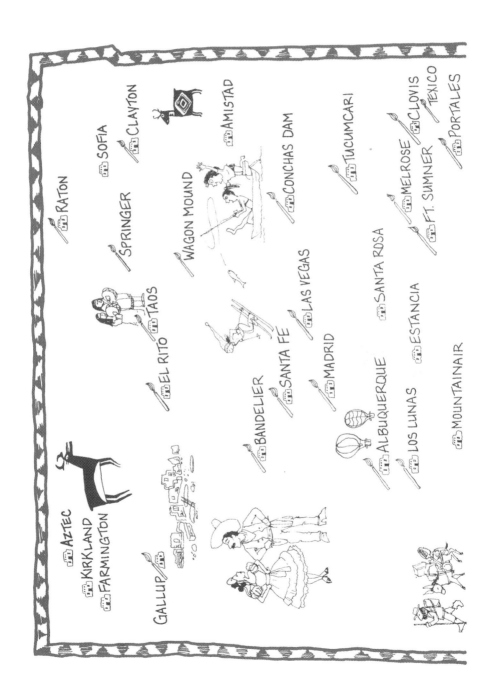

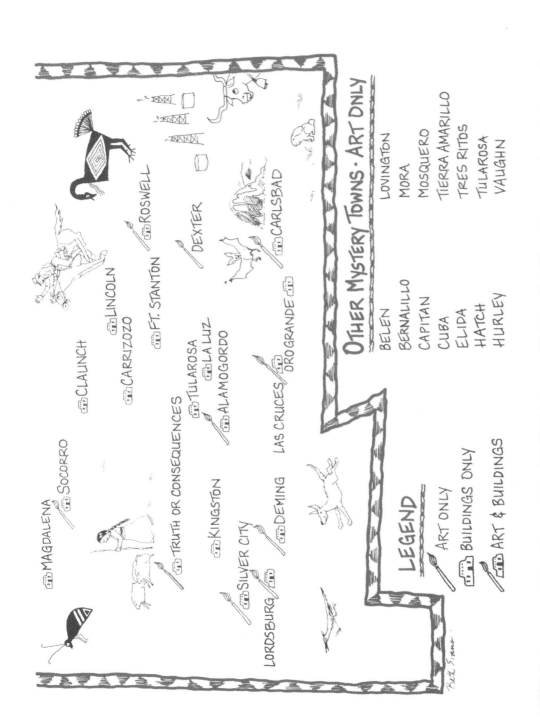

MAGDALENA

SOCORRO

CLAUNCH

LINCOLN

CARRIZOZO

FT. STANTON

ROSWELL

DEXTER

TULAROSA

LA LUZ

ALAMOGORDO

TRUTH OR CONSEQUENCES

KINGSTON

SILVER CITY

DEMING

LAS CRUCES

ORO GRANDE

CARLSBAD

LORDSBURG

OTHER MYSTERY TOWNS · ART ONLY

BELEN
BERNALILLO
CAPITAN
CUBA
ELIDA
HATCH
HURLEY

LOVINGTON
MORA
MOSQUERO
TIERRA AMARILLO
TRES RITOS
TULAROSA
VAUGHN

LEGEND

ART ONLY

BUILDINGS ONLY

ART & BUILDINGS

Nils Hogner did four colorful panels of Indian scenes in 1934. They are all 34" x 44" and went to Eastern New Mexico University but only three have been located. See "Unsolved Mysteries Chapter" for information about fourth painting. Photo by Kathryn A. Flynn.

The Schuler Theatre's entry ceiling in Raton holds eight stunning panels created by local artist, Manville Chapman. These were done for the PWAP in 1934 and are all 24" x 84" in size. Each oil panel depicts a historical scene from the beginnings of Raton and surrounding communities. Photo by Mark Nohl-New Mexico Magazine.

"Lucero's House" created in 1938 by William Penhallow Henderson is 32" x 39" and is part of the Arthur Johnson Memorial Library collection in Raton.

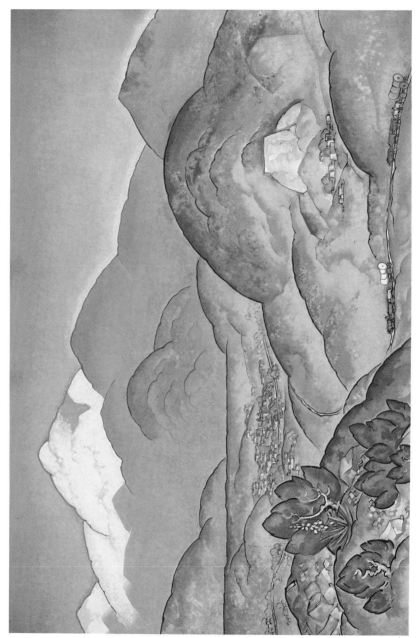

"The Old Santa Fe Trail-Sangre de Cristo Mountains" is one of six murals done by William Penhallow Henderson between 1935-37 for the U. S. Federal Building in Santa Fe. Photo by Mark Nohl-New Mexico Magazine.

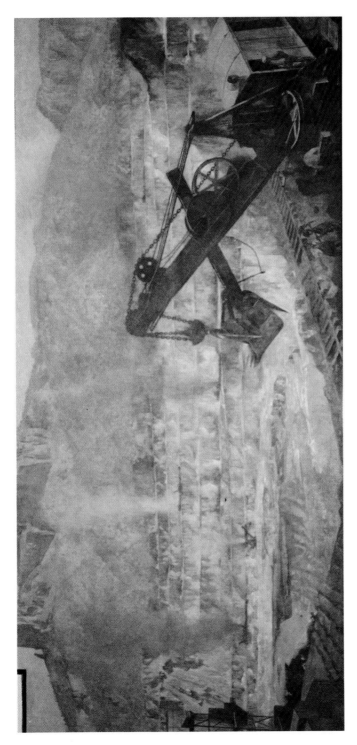

If you go to the Grant County Courthouse in Silver City, you can't miss Theodore Van Solen's two large murals in the entry area. "The Chino Mines" done in 1933-34 is oil on canvas and is 67" x 151," also the size of the companion mural, "The Roundup." Photo taken by P. J. Sharpe.

Albuquerque artist, Carl Redin, painted an 18" x 24" oil painting and called it "Placita Wash Day." This photo was damaged but the actual painting is in good condition. This painting went to the Springer Library but he has a number of paintings around the state as a result of the New Deal.

Patrocinō Barela's unique folk carving was a hit in 1935 and is more so today. The Harwood Museum in Taos may have the largest collection of his work today and this 1941 piece, "El Fidel," is part of it. The curator, David Witt, will soon have a new book out about Barela. Photo provided by David Witt.

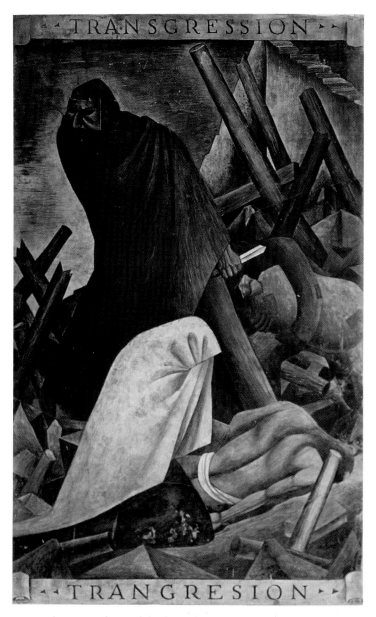

A singular view of one of the frescoes created by Emil Bisttram in the Taos County Courtroom is quite somber. He did two others titled "Reconciliation" and "Aspiration" in 1933 for the PWAP and they are 83" x 51 $^1/_2$" in size. Photo by Mark Nohl-New Mexico Magazine.

Gene Kloss, "Penitente Good Friday," 20" x 26" framed etching.

As part of the New Deal art program, Gene Kloss created nine 20" x 26" framed etchings featuring New Mexico scenes that were printed and placed in nearly every public school in the state. Some can still be seen at those sites while others appear to have "moved on to parts unknown." Wherever they are, they are surely enjoyed, but it would be nice to have them "come home again." Mrs. Kloss has continued to live and paint in Taos.

Gene Kloss, "Christmas Eve, Taos Pueblo," "20" x 26" framed etching.

Approximately 200 etchings of similiar New Mexico scenes were distributed to public schools around the state.

Jozef Bakos came to Santa Fe in 1921 and was an art teacher at Santa Fe High School. He was also one of the Los Cinco Pintores. This watercolor titled "Iris Lilies" can be found in the Las Cruces Public Schools.

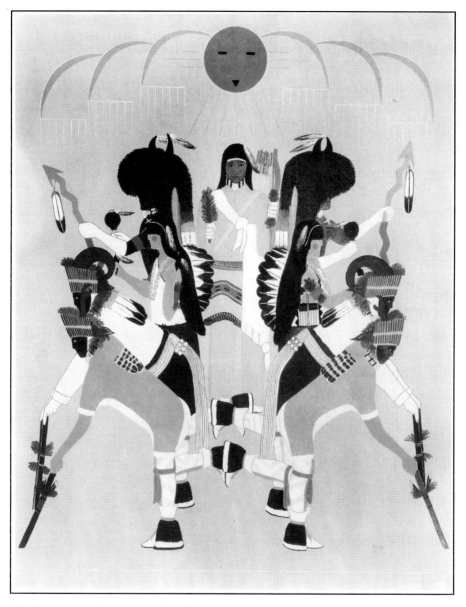

Po Qui created this version of Buffalo Dancers and others for the New Deal Indian Art Exhibit. Photo from New Mexico State Records and Archives.

Harrison Begay graduated from the Santa Fe Indian School in 1939 and most likely did this work during that period. It was included in the New Deal Exhibit of Indian Arts of the North American Indian. Photo from New Mexico State Records and Archives.

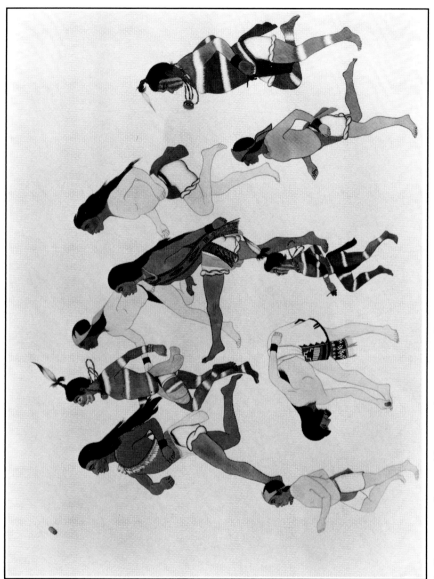

Indian games depicted by an unknown artist for The New Deal Indian Exhibition. Photo taken by Ernest Knee. Photo from New Mexico State Records and Archives.

Pedro Cervantez' painting on glass was representative of a piece from his culture. He also did a number of easel paintings and was included in many exhibits by Hunter. Photo from the New Mexico State Records and Archives photo collection.

Collectively and individually, they recognized the existence of potential difficulties. For example, mural painting would be a first for most New Mexico artists and fitting a painting into a predetermined architectural space would present a unique problem. Narrow hallways, stairwells and areas surrounding elevators presented challenges in terms of the utilization of color, composition, scale, and most of all, the artists would be working with new and unfamiliar materials and techniques particular to mural painting. While such problems were given appropriate attention and concern, they were not perceived as insurmountable.

Fired with verve generated by—at long last—optimism for a productive and economically more stable future for a significant number of gifted New Mexico artists, the administrative and volunteer teams, with the help of project-designated artists, launched the monumental task of selecting towns and sites for consideration for artwork.

For instance, Gus Baumann and artist Theodore Van Soelen trekked from northern to southern New Mexico in a less-than-reliable vintage Ford in the cold winter months of 1934 to inspect federal courthouses, post offices, universities and libraries as potential sites for murals as well as for easel paintings. Their journeys were often impeded by snow and vehicular breakdowns, necessitating that the artists momentarily turn their attention to mechanical matters! Other team members went to theaters, hospitals, office buildings, trading posts, auditoriums, high schools, national parks, federal offices and museums. In this book we have identified approximately 110 buildings.

Initially, sites were inspected in Albuquerque, Las Vegas, Raton, Taos, Santa Fé, Roswell, Carlsbad and Artesia, and indeed "WPA Art", appears today at various sites in most of these cities. Ultimately, however, and incredibly, more than 40 cities and towns in New Mexico in 1992 boast approximately 1000 pieces of WPA art, including murals, easel paintings, pottery, sculpture, and furniture and craft items.

The projects, under their various federal titles, were not in place simultaneously. As artists, administrators, mural sites and plans for specific works of art in towns and cities were determined for each given project over periods of time, the quintessential component was finally addressed—creating a picture.

Yes, a vast, historical *picture*. Mural painters, sculptors, easel painters, potters, furniture makers, embroiderers, tinsmiths, woodcarvers faced the exhilarating job of creating a visual history of New Mexico, an arts and crafts 'picture book' of the Land of Enchantment.

If the murals might be considered the front piece for New Mexico's picto-biography, then the other arts and crafts forms could be viewed as the intimate portraits and sketches of the New Mexico memoir.

But nearly a half century after their completion, the magnitude and brilliance of the enormous body of work produced cannot ultimately be confined by the simplicity of an analogy to a picture book.

Rather, the deep ebony of the black-on-black pottery coiled by Tewa artists, the long, elegant lines of the *trasteros* crafted by Hispanic craftsmen, the drama, color, poignancy, anguish or triumph conceived by the mural and easel painters, and the vivid detail defined by the sculptors are more than a story in pictures.

They are a rich, patterned, textured mosaic, each art form a vibrant tile in the finished work.

Energized by creative challenge and the welcome assurance of financial remuneration for work done (recall that Shuster's letter to Sloan revealed elation and raw incredulity), the artists began preparations for their work. Decisions as to themes and subject matter were the first order of business to be dealt with for this exhilarating creative endeavor.

The 'American Scene', as advocated by American muralists Thomas Hart Benton, Grant Wood and John Steuart Curry depicted local and regional American themes, or "Democrat art"—art for the people. American Scene painting, the earlier Mexican mural movement, and the Depression phenomena all combined to inspire New Deal art.

In the case of the New Mexico artists and craftsmen, an additional source of inspiration and subject matter was at hand: the rich multi-cultural heritage of a state scarcely out of territorialism. New Mexico was the 47th state to be admitted to the Union, and in 1933, at 21 years of age, had barely achieved

"adulthood." Many of the artists selected by the WPA were older by many years than the fledgling state, and could draw upon personal or family memories and knowledge of a land and a diverse people struggling for rights, recognition and a measure of reward.

The ancient Anasazi, the coming of the Spanish "conquistadores" and their impact on the lives of the Pueblo Indians, the frontier towns and their colorful, violent histories, the Pueblo rebellions, Mountain Men, Indian dances and ceremonials, the wildlife—buffalo, bighorn sheep, and grizzlies—the opening of the frontier, the dramatic, ever-changing topography of the huge state, the coming of the railroad, ranchers, farmers, trappers, cowboys, the Pentitentes, Apache and Comanche raids, and outlaws were but a sampling of the myriad of possible subjects for artwork. As well, philosophical and political themes came under consideration, as did those dealing with law and order, science, medicine, and obedience.

It is not difficult to imagine the frenzied excitement, the fervor of creativity, the challenges, the attention to detail, and dedication of the artists and administrators associated with the WPA project. Each surely must have had a special experience, a unique or difficult or absorbing one, in creating their work. Of the many anecdotes that bespeak the enthusiasm and creativity of the artists and the tireless work of the administrators involved in the WPA project in New Mexico, the following profiles reveal certain individual characteristics of the WPA participants which are at once personal, professional, devoted, inventive, often amusing, and always human.

Virginia Hunter Ewing, widow of Russell Vernon Hunter, recalls that her husband, himself a muralist and one of the significant creators of WPA art, was appointed State Director for the project in 1935. Although the Director's job was not conducive to "relaxed nights of peaceful sleep," [3] and that the Director was constantly on demand to "juggle requirements, needs, objections," [4] Vernon Hunter, and one other State Director were the only two in the United States who neither resigned nor were replaced. [5]

Hunter, unlike many of his muralist contemporaries who were transplants to New Mexico from the East (some for reasons of health), grew up six miles northwest of Texico, where his parents had homesteaded. He therefore had a lifelong, comprehensive perspective of "his" New Mexico. He researched

his subject matter thoroughly. The combination resulted in three American realism murals titled *The Last Frontier* located at the De Baca County Courthouse in Fort Sumner. To prepare for the work, Hunter interviewed hundreds of pioneers of the area, studied legends and photos for the work, and collected historical facts. Various reporters, in reviewing the work for their periodicals, noted that one figure in one of the murals, Billy the Kid, had his *left* hand on his gun (Hunter's research had turned up the fact that the gunslinger was left-handed), and that an image of Billy's mother in the mural had a ribbon on top of her head to hide a wound in her skull caused at an earlier time by an Indian tomahawk (Hunter had found an old tintype of the mother's image, which he studied at length, and found documentation that supported the tomahawk story). And, it was noted, the mother's right eyebrow drew upward, as did that of her notorious son!

Another descendant of a pioneering family, Manville Chapman had graduated from Raton High School, attended the Art Institute of Chicago, and returned to New Mexico where he painted in Raton and Taos. When awarded a commission to paint WPA murals, he boldly advertised in his hometown newspaper, the *Raton Range,* for *old* photographs to study, particularly those of *old* buildings, *old* trails, *old* railroad engines, *old* costumes, *old* famous characters, and emphasized that *scenic photos would be of no help to him at all!* Evidently the community responded, and with these images, in combination with his own lively imagination and spirit of creativity, he produced at least 8 murals depicting a wealth of early New Mexico history. He painted Indian villages and mansions of the era, a stage coach line station and early coal mines. Today, these murals are located in the foyer of the Shuler Theatre in Raton.

The "Fresco Quartette" of Taos executed, not without mishap, 10 of the most stunning frescoes of the WPA era. At the Old Federal Taos County Courthouse in Taos are the combined works of Emil Bisttram, Ward Lockwood, Victor Higgins and Bert Phillips. They are 'American Scene' in subject matter and moralistic in tone and emphasis, as revealed in some of the mottoes: "Avarice Breeds Crime", "Justice Begets Content", "The Shadow of Crime." It is believed that Bisttram taught the others fresco technique, and the murals depict, according to Alexandre Hogue, who wrote about the work upon its completion, "the use and misuse of law."[6] While the artistic progress was of interest to Taosenos, of equal interest was an assortment of

"jinxes" which befell the artists personally, and often hindered the execution of the project: Victor Higgins frequently took to his bed, sustaining himself on a diet of milk toast; Bert Phillips fell off a scaffold, and Emil Bisttram painted six-fingered ladies. Despite these difficulties, the murals were completed and the works are regarded as outstanding examples of WPA frescoes anywhere in the United States.

William Penhallow "Whippy" Henderson had a long association with the Southwestern culture, which he loved. A native of Massachusetts, Henderson spent his very early youth with his family in Texas. When he was 8 years old, he returned to Massachusetts, and in 1904, at 27, he came once again to the Southwest, specifically Arizona. In 1916, as a family man, he moved to Santa Fé with his wife, poet Alice Corbin Henderson, and "Little Alice," their young daughter. Alice, ill with tuberculosis, as was true of many of the members of the artistic community, regained her health and the Henderson family settled in as popular and respected members of the fledgling art colony. "Whippy" and "Little Alice" took long horseback rides to the various pueblos of the area or to Taos, and that on every trip, his daughter recalled years later, he observed minute details of the landscape, sometimes stopping to sketch during their horseback journeys.

"Whippy" was a Renaissance man. Painter, furniture maker, architectural designer, illustrator, scenic and costume designer, and ultimately muralist, his work—furniture, homes, renovated buildings, paintings, a museum, and murals—endure in Santa Fé today as testimony to his vast talent. When commissioned to paint murals for the WPA art project in the Federal Court House in Santa Fé, "Whippy" elected to use valleys, mountains, trails and rock monuments as his subject matter, a clear indication of his long love affair with the Southwestern landscape. (He summarily dismissed the idea of painting "courthouse" scenes.) The Federal Court House remains today a favorite place for visitors and locals alike to pause in a day's activity for a look at the magnificent work of William Penhallow "Whippy" Henderson.

One of the young modernists who came to the forefront of the art scene in Santa Fé in the 1920s, Willard Nash painted canvases characterized by forceful line and the use of bold color—the latter a trait he shared with his fellow Santa Fé modernists, "Los Cinco Pintores." In some of the canvases depicting sports scenes that hang in the Zimmerman Library in Albuquerque,

there is a hint, too, of John Sloan's influence—groups of men and women participating in ordinary, everyday activities, such as, in this case, athletic events.

By July 22, 1992, Chiricahua Apache artist Allan Houser, recently deceased, was a long-time resident of Santa Fé. On that date he was presented with the National Medal of Arts, the nation's highest art award. This medal, awarded under the auspices of the National Endowment for the Arts, was presented to Houser by President George Bush. (Back in the late 1930s, Houser painted murals for the WPA in Washington D.C. with Picuris Pueblo artist Gerald Nailor and Zia Pueblo artist Velino Herrera. Incredibly, the self-effacing Houser believed later that the murals weren't very good!) Although the bulk of Houser's work—spanning more than 50 years—is in the sculpture medium, he began as a student of painting under the tutelage of Dorothy Dunn at the Santa Fé Indian School. In 1991, the world-renowned sculptor was honored with a retrospective of his work on the occasion of his 77th birthday. A small Houser (oil) executed by the artist for the New Mexico WPA Art Project features a Native American youth seated on a horse. The work hangs in the Raton Public Library. Another casein creation is also in the Gallup Public Library.

Although his name was not a 'household' word among Southwestern art aficionados as were those of many other popular New Mexico artists, Lloyd Moylan's artistic output for the WPA was not only impressive creatively speaking, but prodigious in scope. Murals covering the walls of the Administration Building at New Mexico Highlands University in Las Vegas are of near titanic proportion, and address the theme of education; watercolors and oils, many of which depict Native American themes are on display in the Octavia Fellin Public Library in Gallup, at the Red Rock State Park (also in Gallup), and in the County Commissioner's chambers in the McKinley County Courthouse. Another colossal Moylan mural covers 2,000 square feet of the McKinley County Courthouse, and depicts centuries of New Mexico history. In the Administration Building at Eastern New Mexico University is yet another Moylan work, a religious mural, the theme for which is taken from the Scriptures. This mural might be regarded as Moylan's most ambitious work, and ultimately, may be recognized as his finest. In any case, no WPA artist utilized a greater range of subject matter,

media and style (some, but not all, distinctly late cubist) than Lloyd Moylan.

Influenced by her teacher Auguste Rodin, Eugenie Shonnard brought her talent as a sculptor to New Mexico when she moved to Santa Fé in 1927. She became a close friend of Maria Martinez, the renowned potter of San Ildefonso. Shonnard's lifelong love of animals, in combination with the knowledge of animal symbolism she acquired from her Native American friends was undoubtedly another influence in her work. She sculpted a stone fountain which features a turtle and frogs (respectively, Mother Earth and cleansing symbols in the Native American culture) for the WPA art project. The fountain exists today at the New Mexico Veterans Center in Truth or Consequences.

There is irony in the fact that the various WPA art projects are often referred to as "Depression Art." If ever anything lifted spirits out of a state of depression for creator and viewer alike, it was the WPA art project! The real significance is that these works of art came into being at all - that a bold and far-seeing federal administration created something called the New Deal, a program for survival. Grateful artists and craftsmen worked and survived *at the time,* producing magnificent treasures that might well survive *for all time.*

The New Deal? A good deal! "A job of work" one artist said...and a job well done.

## NOTES

(1) From unpublished correspondence of Will Shuster and John Sloan, Courtesy Museum of New Mexico

(2) Ibid.

(3) From unpublished manuscript, Virginia Hunter Ewing, "Some Memories Concerning New Mexico's WPA-Federal Arts Projects," Santa Fé, 1988, p. 3.

(4) Ibid.

(5) Ibid.

(6) Ibid.

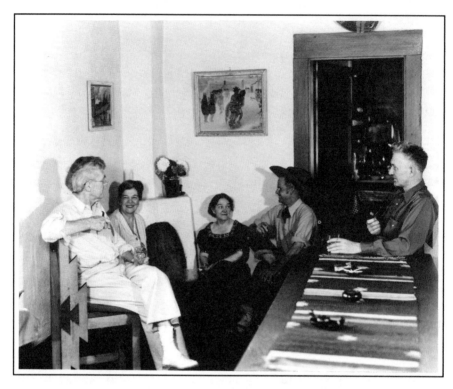

Will Shuster (in hat) visits with hostess, Dolly Sloan, and fellow artists John Sloan (left foregound) and Josef Bakos (at table). Teresa Bakos (visiting with Sloan) was also a New Deal artist as was her son, John Dorman. This setting was the Sloan home on Garcia Street and was the site of various gatherings as were all of the artists' homes since they loved to party with one another. It was an inexpensive and usually an exciting way to forget the depression of the times. Photo from N. M. State Records and Archives photo collection.

Chapter 4

# FEDERAL SUPPORT FOR HISPANIC ART

*Andrew Connors*

(Note: Andrew Connors wrote this paper in 1990 and gave us permission to use it for this publication. He continues to do research in this area and can be reached at the National Museum of American Art for further information on this subject.)

———

Several divisions of the Works Progress Administration succeeded in creating in New Mexico an intensely personal and responsive relationship with the Hispanic community. This success can be traced to a conscious attempt on the part of administrators and some dedicated staff to maintain a tangible sense of ethnic identity, community cohesiveness, and responsive training throughout their projects. Perhaps the most successful division was the Federal Art Project (FAP) which was directed by the artist R. Vernon Hunter. Hunter believed in a broad definition of "Art" which included both the fine arts and craft arts. He was dedicated to his task and encouraged his associates to imbue their wage labor creativity with an individuality and spirit in all media, from oil paintings to carved wooden religious statues and tinwork chandeliers. His personal interest in his artist colleagues was especially noteworthy with Hispanic artists and craftsmen. His diligence on their behalf, with the support of the Washington office, brought to a national audience, through exhibitions and published illustrations, the best work of the remote towns of his state.

This paper will focus on the administrative correspondence found in the Federal Art Project records in the National Archives These papers pertain primarily to the administrative management of the art program in New Mexico. Because of the presumably biased nature of this material, this paper will present the program as it saw itself. Because little critical analysis has been done on the art program in New Mexico, to commence such a study here would far exceed the scope of this paper. While a critical view from an exterior perspective would

be helpful to place the New Mexico local program in a national context, this paper will serve as an introduction to that assessment.

As it was nationally, this period was crucial in the history of Hispanic villages in New Mexico where environmental degradation, land grant dissolution, and a lack of wage labor opportunities created social problems of monumental proportion. Long term neglect by government agencies in the form of social and economic injustices and state and federal governmental insensitivities threatened the existence of traditional, primarily pre-industrial, Hispanic communities through external cultural pressures. Various New Deal programs mandated by President Roosevelt literally saved these villages from starvation. [1] Programs for economic and social modernization led to improved standards of living, health, and nutrition.

While some local, state, and federal authorities were trying to eliminate symptoms of poverty and social inequality by destroying historical characteristics of the non-industrial Hispanic way of life, others were working with great enthusiasm and little budget to record and preserve these same traditions and life ways. Much of this preservation activity was sponsored by a series of work relief projects designed to employee artists, writers, and musicians. The idea was first tested in the Federal Works of Art Project and in New Mexico, achieved greatest success in preserving traditional arts under administration of Federal Project One of the Works Progress Administration (later renamed the Works Projects Administration.)Federal Project One included the Federal Art Project, the Federal Writers' Project, the Federal Music Project, and the Federal Theater Project, though the latter was never instigated in New Mexico.

Holger Cahill, a writer, critic, authority on American folk art, and past director of exhibitions at the New York's Museum of Modern Art, was the FAP's first and only national director. The project was centrally controlled from Washington with regional advisors and state directors handling direct administration. New Mexico, with Arizona, Colorado, Utah, and Wyoming, comprised Region Five, which was administered by Donald Bear, the director for Colorado. Bear coordinated artistic activities in each of the five states and served as the liaison with Washington. R. Vernon Hunter, a respected New Mexican artist, served as first and only state director. Hunter's job consisted of the administrative direction and technical supervision of all projects under the FAP and coordination of personnel classification, placement, and assignments.

The FAP proposed, primarily, to employ artists certified for relief by their state or local relief agencies. At least ninety percent of employed staff had to have been listed on the relief register, and never was the total of non-relief workers to exceed ten percent of the total artists employed. In contrast to earlier New Deal programs which sought out the best art available for federal buildings, the FAP goal was to employ financially needy artists regardless of artistic consequences. Cahill wished to obtain for the public examples of outstanding contemporary American art, to integrate the concept of art into the daily life of the community, and to expand not only the skills of the artist but also the art consciousness of the nation. In an attempt to integrate art into the daily life of the community, educational programs, community art centers and galleries (called federal art centers), and traveling exhibitions of art produced with project support were presented to communities of all sizes which would otherwise not have been exposed to first-hand artistic activity.

The FAP in New Mexico promoted, initiated, and supervised all relief art activities in the state. In addition to commissioning easel work, prints, sculpture, and murals in fresco and oil for public buildings, the FAP supported programs for reviving craftwork of Spanish-Colonial origin (woodworking, embroidery, weaving, and metalwork), teaching of arts and crafts in community art centers, researching native arts for the Index of American Design (IAD), and compiling a project unique to New Mexico, the *Portfolio of Spanish-Colonial Design*. This portfolio reproduced illustrations of arts with significant regional historical and artistic value. These and other projects were officially sponsored by the New Mexico Department of Education and the Office of the Governor. Frequently, local sponsors funded projects, either cultural or social organizations or commercial ventures interested in promoting and furthering cultural work in the state. (See Editor's Notes at the end of this section for more specifics about the *Portfolio*.)

The *easel painting division* was the largest single unit of the Federal Art Project. The project furnished all art supplies to the artists. The number of workers depended upon the number of artists qualifed for relief and in need of work. The artists freely selected subject-matter and worked in their own studios. Depending upon the size of the project, the artist had from four to eight weeks to submit a work, and every work completed by a project artist was accepted for allocation to a tax-supported organization requesting the work.

In the eyes of some critics, the art accepted by the FAP fell short of the quality of art deemed appropriate by the previous non-relief projects. This may be attributed in part, to little restriction on acceptability of products and, primarily, to the requisite that ninety percent of the employed artists be certified for relief. To a large degree, this criticism is applicable to the easel painters and those who had moved to the state from the East [2], but is entirely incorrect in consideration of the contribution Hispanic artists and craftsmen made to the FAP. [3]

Of all the art programs in New Mexico, the FAP most benefited Hispanics by supporting and promoting arts through direct employment of artists, such as easel painter Pedro Cervantez, saint carvers Juan Sanchez (traditional) and Patrocinõ Barela (more untraditional), Jake Truillo, weaver, and Carmen Espinosa, colcha and tinwork, and others.

### STATE SUPPORTED PROJECTS

In addition to directing the FAP programs controlled from Washington, states established vocational training centers with federal funds. The New Mexico centers included arts and crafts instruction within the general vocational training programs which were directed by Brice H. Sewell, Supervisor of Trade and Industrial Education for the state.

Sewell had previously worked in New Mexico's state bureaucracy and was able to manipulate local, state, and federal funds to the advantage of Hispanic people. By combining resources, he was able to pay Hispanic men to build vocational schools that provided training for adults in a variety of traditional Hispanic crafts, including carpentry and furniture making, weaving, and black-and white-smithing. After the training programs had been completed, these schools functioned as community workshops for the use of all local craftspeople. At their heyday in 1936, there were twenty-eight vocational centers in New Mexico alone. These schools encouraged trained artists to pass their skills on to novitiates, thus contributing significantly to the revival and marketing of Hispanic crafts.

### THE DISPOSITION OF THE FEDERAL ART PROJECT
### TOWARD MINORITIES

Holger Cahill encouraged R. Vernon Hunter, along with all the other state and regional administrators, in his sensitivity towards artists and the promotion of those with no public voice. In a letter to Taos artist, Ernest L. Blumenschein, in the early months of the FAP, Cahill wrote:

*. . . I believe that we are helping many of the highly developed artists in these difficult times, and that we are getting some really vital work from them, especially from the young and almost unknown artists who are getting their first opportunities under our program.* [4]

Programs within the WPA made several conscious attempts to address the needs of minority groups, most notably African-Americans. In 1938 a national survey was conducted to assess "the creative contribution of the Negro. . . (and) the nature and value of their work." [5] Although the Hispanic population, or "Spanish-Americans" as they were identified in correspondence, were not specifically targeted by the WPA, in New Mexico they were the largest ethnic group. The size of the population alone made them an important issue for consideration. The Native American population was assisted in economic and health issues by the less innovative United States Bureau of Indian Affairs and was not officially assisted through the WPA. Hunter, however, was able to hire a few Native Americans under his program and was sensitive to Native-American issues demonstrated in his selection of exhibitions for the local art centers. [6]

## CRAFTS PROGRAMS IN FAP

During the early planning stages of the FAP, both Donald Bear and R. Vernon Hunter recognized the importance of traditional craft work to New Mexico's Hispanic population. In January 1936, Bear wrote to Cahill that the state program had the capability of employing more than one hundred people in wood carving and native crafts. He explained that "(t)he native wood carvers are capable of making some very excellent furniture" which could be used to supply government buildings, and that there were "one or two wood carvers in New Mexico who do very interesting and amusing wood sculpture." Such a development in crafts was dependent upon what Bear described as Hunter's ability to "work very closely" with these artisans. [7]

Cahill expressed concern over the "art quality" of such wood carving and advised serious consideration of the artistic nature of proposed projects. [8] Bear countered Cahill's position by explaining his perception of these "native craft projects" as important to the local communities, providing crucial support for public works of any sort, and relatively inexpensive in this region. Cahill had suggested that Hunter consider hiring artists who in East Coast art circles would have been called "folk artists." Hunter doubted that Cahill's proposal to feature such "peasant sculpture" at the expense of decorative arts would employ more than three artists in the entire state. [9] He used the argument of low cost to propose that New Mexico be allowed to embark on an ambitious crafts program

propose that New Mexico be allowed to embark on an ambitious crafts program "because their need is rather great." [10]

Bear followed this letter with another one two days later detailing seven crafts projects for the state for which he had already provided his authorization. These projects were all defended as legitimate under Federal Project Number One and as a most expeditious method of employing a large group of artisans certified for relief. [11] Thus he allowed Cahill no simple forum for rebuttal, and all seven projects were completed as originally intended and with enthusiastic local public support. Hunter then sent his own letter of support for the programs and included photographs of the type of high-quality workmanship he hoped to encourage through his programs. He explained the recent history of this type of work and its encouragement by the Anglo artists of Taos and Santa Fe.

... *This phase of craft work was started some years ago by the artists in New Mexico who did the work themselves. Gradually, through encouragement, the Spanish-Americans began their own revival of this kind of work, typical of the region. It is they who should rightfully do (the craft work). This is another expression which the 'art colonies' of the State has spawned; at least the artists were first to enthuse over this kind of handcraft.*

... *If I felt that the furniture item was in class with Grand Rapids stuff, or even considerably better, I would not think of entertaining such in connection with art projects. There seems to be a general attitude in the state that this work would come under art projects. The Relief Certifying Officers have considered it so, and almost daily I receive applications and inquiries. I certainly would not be one to encourage the production of unattractive gadgets of the souvenir type.* [12]

A marginal annotation in Cahill's hand expresses agreement with the statement that the Hispanic population themselves should carry on this sort of work. Cahill conceded authority to Bear and Hunter to make judgments on the appropriateness of crafts to New Mexico, where he saw them as perhaps more important than in other states, but expressed concern that crafts production remain proportion with the fine arts programs. Cahill believed crafts to be essential to the creative nature of New Mexicans because a vital craft tradition had existed in the state for several centuries, while the fine arts of painting and sculpture had been historically limited to small numbers of religious images. Cahill also expressed an interest in promoting weaving and embroidery as alternatives to an overly large furniture section. [13]

In May 1936, Hunter sent to Cahill a sample of *Colcha embroidery*, a type of wool embroidery unique to the region, which had been produced as requested by the exhibitions division of the FAP (in Washington) for inclusion in an exhibition of FAP work at the Phillips Memorial Gallery in Washington, D. C. This embroidery pattern had been designed and produced by women employed by Hunter only three months earlier, a testament to the speed which he was able to enact his projects. (14) The sixteen yards of embroidered fabric was completed for the stage curtain for the Albuquerque Community Playhouse, a building which was completely furnished with objects made by Hispanic artists.

(Editor's Note: Another location where this craft was used was in the office of Governor Clyde Tingley in the state capitol. "He furnished his office with the WPA furniture and the chairs had colcha embroidered seat cushions in them. Unfortunately, these cushions didn't last long since the metal brads on the levis of the cowboys that came to visit frequently got caught in the beautiful stitchery," according to Joy Fincke McWilliam's, Hunter's secretary.)

Hunter also wished to maintain traditional art forms which were in danger of extinction from pressures for wage labor jobs in a non-Hispanic dominated culture. He intended to revive the craft of *straw inlay work* on wood for use in the Albuquerque Playhouse. In a letter to the director of research for the IAD, Hunter wrote:

*This craft is one of the old mediums particularly appealing to me. I know of but one person in the state who has done it recently, a boy of twelve or fourteen years. Examples of this work are extremely rare. I have been of the opinion that it was done in imitation of marquetry.* (15)

There is no indication from the written record that straw inlay work was significantly revived by the FAP although at least a few examples were produced and included in a traveling exhibition.

(Editor's Note: That young boy may well have been Eliseo Rodriquez of Santa Fe who was active in the program and has become known nationally for his outstanding straw inlay creations. A large cross is on display in the State Capitol.)

*Classes in traditional crafts* were offered through the Federal Art Centers in Melrose, Las Vegas, Roswell, and Gallup. Woodworking was the most regularly taught craft and the instructors, such as Domingo Tejada and Abad Lucero, frequently furnished the art center with their handmade furniture. Many

developed talents which became important sources of income to otherwise unskilled laborers. In a few instances, the students attending such classes were later hired by the Project as craftsmen or artists' assistants. By Hunter's estimation, more than half of the instructors for the state vocational training centers received at least some of their experience through the WPA adult education program.[17]

The *exhibition programs* of the FAP actively included New Mexican Hispanic craft work in both regularly scheduled touring exhibitions and in large-scale retrospective shows highlighting the production of the FAP. Large exhibitions which included New Mexican Hispanic crafts were held at the Museum of Modern Art, New York, the New York World's Fair, the Art Institute of Chicago, and the National Museum (Smithsonian Institution) in Washington, D.C. An exhibition of FAP work organized for the Museum of Modern Art in Washington, D.C. (no longer in existence) included three tin light sconces by Eddie Delgado, a carved mirror frame by Felix Guara, historic religious paintings reproduced by Pedro Cervantez, and a Colcha embroidery panel by Ida Parsons. [18]

Exhibitions organized by the state administrators in conjunction with the national touring exhibition program included shows featuring paintings of landscapes and domestic settings by Pedro Cervantez, figurative carvings by Patrocinõ Barela, genre scene paintings by Johnnie Candelario ( a non-project artist), and a survey exhibition of the FAP's Spanish-Colonial crafts. This exhibition of crafts included photographs of installed works such as a large reredos (carved and painted altar screen), embroidered stage curtains, and other decorations for the Spanish-American Normal School auditorium in El Rito. Also included were many examples of historic reproductions made by craftsmen such as a trastero (standing cabinet), chairs with embroidered seats, tin and glass candlesticks, and several carvings of saints by Juan Sanchez, some in metal work niches. The exhibition was augmented with New Mexican illustrations from the Index of American Design which provided an historical context for the new objects. The exhibited objects, therefore, served two functions: first, to demonstrate the high quality of work produced in modern times, and second, to illustrate the continuity of cultural expression encouraged by the FAP.

The somewhat conservative selection of art types for these exhibitions mirrors the tendency throughout the WPA programs away from abstraction and the avant garde in both style and subject-matter. While there was no official censorship within the program, the avoidance of the new and unusual was expected, given Cahill's goals for the project. Certainly the Hispanic community

was not used to viewing art of a modernist aesthetic, and the artists and craftsmen had no experience creating it. Had the program or its artists tried to introduce such art into these communities, it would have been acting against the wishes of its audience. [19] Such action also would have countered Cahill's wish to provide art for the masses rather than art for individual artists or an elite art establishment.

The traditional art forms chosen by most of the New Mexico artists, and certainly by the craftspeople, reflected a general feeling during this fiscally conservative period in American history that only utilitarian objects could be considered truly pleasing. Abstraction in both style and purpose was interpreted as self-indulgent and wasteful. The only exposure most New Mexicans had to non-practical art was through commercially produced religious prints and locally created religious paintings and sculptures, where the art served a profoundly important spiritual purpose for the society.[20] Thus, without any external censorship, the artists and craftsmen (with the notable exception of Barela) imposed upon themselves limitations consistent with historic, communal precedents. The exhibitions of crafts and arts reflected these self-imposed guidelines, and the objects were received favorably nationwide.

*Children's art and craft classes* were probably the most oversubscribed service of the Federal Art Centers, and Hunter and the art center directors took great care to insure that instructors were competent, sensitive to the community, and, most important, able to communicate with their students. In a national artist loan program, several artist/teachers from the New York City FAP program worked in New Mexico for a period of months. One of these, Helena Herald, spoke fluent Spanish and was assigned to teach children's craft classes in Las Vegas. While there, Miss Herald helped to institute an innovative arrangement of public and private sponsorship to help buy class supplies for which students and the community were unable to pay. Roland Dickey, Director of the Roswell Museum and Federal Art Center, wrote to the Washington office, "The Children's Workshops in the Spanish district of Roswell has presented material of great charm and color interest. [21] Children's issues were also taken into consideration in the Art Centers' exhibition schedules to ensure that shows such as "Paintings by Mexican children" were exhibited at times convenient for classes from the art centers and the local school system. [22]

These Federal Art Program craft classes and sponsorship could have, in theory, meshed well with the programs of the state-sponsored vocational training schools. The staff of the FAP felt the state vocational program, under the direction of Brice H. Sewell, was uncooperative to mutually beneficial

programming. While Sewell's program was extremely effective within the state, both through direct training and publication of detailed technical bulletins on such topics as "New Mexico Colonial Embroidery" and "Spanish Colonial Furniture," he was unwilling to distribute these publications and share these skills nationally. Hunter interpreted Sewell's reluctance as fear that the strong native designs would be copied by furniture manufacturers in the East, pulling business away from the currently productive local communities which had originated the style. [23] Perhaps with similar justifications, Sewell was unwilling to cooperate in lending to the illustrators and researchers working on the Index of American Design antique objects which his staff had collected for reproduction by vocational craftsmen. Objects included in the Index of American Design were to be published and circulated throughout the country as examples of the best of American design and perhaps Sewell was concerned about this publicity. Hunter also commented that more than half of the teachers for the State Vocational Department were employed by the WPA Adult Education Program, and they were perhaps wary or even jealous of the attention earned by the similar craft programs of the FAP. [24]

Clearly Hunter viewed his programs as providing more than just crucial financial reward to the artists. For him, the national exposure which he consistently sought for the artists was a method of raising ethnic respect both within the state's Hispanic communities and throughout the nation. He was sensitive to the importance of maintaining communal traditions as a way to establish a context for individuality, and he understood self-worth as a direct factor in pride of ethnic identity. By exhibiting these works to a national audience, and returning the favorable response to the community, Hunter was able both to strengthen local support for his programs and to encourage high quality in production. Cahill's personal interest in these exhibitions only added to their effectiveness as propaganda and contributed to national support for the state's ethnic diversity.

Throughout Hunter's administration he considered the needs and interests of his Spanish-speaking constituents. Rarely was he contacted directly by members of the community, and he was required to rely on his own experiences with the population and those of acquaintances and members of his advisory panel. Hunter chose not to publicize the opening of the San Miguel Federal Art Center in Las Vegas, a racially and intellectually divided town. By avoiding all manner of official town attention, he provided no forum for partisan politics. The exhibition at the gallery's opening featured work from the state's crafts programs including reproductions of bultos (three-dimensional images of

religious figures) by Juan Sanchez. The exhibition was a great success with the Hispanic population and gossip provided a steady flow of visitors. The Las Vegas community had been particularly reluctant to share their family treasures with illustrators for the Index of American Design because they had suffered such great losses of their material cultural heritage at the hands of unscrupulous collectors. Hunter requested permission from Washington to lend some of Sanchez' religious carvings to interested individuals as an indication of the project's good intentions. This request ran counter to FAP regulations regarding loans of government art. Although Cahill supported the idea, his administrative assistant, Thomas Parker, advised against such loans and the request was denied in favor of a uniform national policy. [25]

Both the Spanish Colonial Art *Portfolio* and the Index of American Design initiated significant research projects in order to establish the history or heritage of illustrated objects. The original intention of the projects, especially the IAD, was to record not only the visual appearance of each object but a brief history and context of the piece or type. More than thirty years after the completion of her illustration and research work for the IAD. E. Boyd, who was to become the foremost authority on Hispanic New Mexican "popular arts," was highly critical of the research done on Index objects. It is not clear whether she was critical of the research methodology of the period or if she simply felt that subsequent research had disproved earlier findings. It is clear, however, that research was not a strong point of the Index nationwide. [26]

Because of their own personal interests in the region and its Hispanic culture, both Bear and Hunter encouraged and personally conducted research on the local arts. Bear, relying on his impressive knowledge of the subject, wrote an informed and impassioned essay to introduce the Spanish Colonial Art *Portfolio*. Hunter, in addition to administering the program and continuing to produce his own paintings, wrote several articles on his program and the artists within it. His essay on Patrocinõ Barela, originally written in 1939 for the FAP's planned publication Art for the Millions, was based on his working relationship and close friendship with the artist and expresses a thorough understanding of the artist's environment and creative motivation.

Hunter's fascination with the subject led him into thorough investigations of topics pertaining to the arts projects under his control. He never entered into a new project without first discovering the history of the type, style, or medium. In several instances such intensive research led to proposals for additional projects. One such project which was never realized was similar in organization

and purpose to the Portfolio of Spanish-Colonial Art but focused on the Colcha embroidery traditions of the region. [27]

Most projects proposed by the New Mexico office were received enthusiastically by the Washington office. The Washington officials were continuously asking for more information, more background stories, more human interest items, all of which were frequently absorbed into the extensive exhibition ephemera, promotional material, published reports, and funding justifications published by the office of both the FAP and the WPA in general. [28]

Folklore in the form of beliefs, stories, and legends was perhaps the most enthusiastically received type of information sent to Washington. Hunter explained the battered appearance of some of the saint carvings illustrated for the Index of American Design by relating the 'theory' that rain could be brought by breaking a small sliver of wood from the saint figure and burning it in the fireplace. He also reported that lightning could be diverted from a house by throwing the saint carvings out into the rain for the duration of the storm. [29] He received this information from fieldworkers on the Federal Writers' Project who were gathering such material from older members of communities throughout the state. Cultural context clearly enhanced Hunter's understanding of the works, their makers, and the community he served.

This sense that Hunter had in dealing with artistic personalities and also, even more importantly, with Hispanic cultural traits enabled him to instill throughout the Federal Art Project a respect for variation of cultural expression within a communal tradition. The FAP succeeded where other Works Progress Administration programs could not in both hiring Spanish-speaking peoples for other than blue-collar jobs and in directing their productivity toward the Hispanic population as audience. The artists on the FAP were not expected to abandon their culture's visual or communal heritage in order to enter into a labor system established by a foreign set of bureaucrats rather the system molded itself to suit the needs most appropriate to this cultural region.

The sensitivity of capable administrators forced a huge organization to accept the non-conformist within the American system. Artists, by nature, tend to be non-conforming, fringe members of society, but in New Mexico the case of Hispanic artists was slightly different. The population which did not conform to expected roles within the WPA was exactly the same population which had existed for more than two hundred years in the state simply by following set traditions. The Federal Art Project in New Mexico provided a great service to

the community by instilling a sense of self-respect and expressing national approval for community-based aesthetics and local, communally-conservative modes of life. Here the artists were individuals, but individuals with a culture and a long past, and the FAP, through R. Vernon Hunter and his staff encouraged them to show it.

———

(Editor's Note: More about the *Portfolio*. As presented in Connor's paper, the original intention of the Index of American Design and the *Portfolio* projects related to researching and visually recording native arts around the country and recording a brief history of the identified pieces and/or types of work. The goal was to have this happen in every state and reportedly twenty-four states got underway with the project. Unfortunately inadequate funds was the main deterrent to this goal being accomplished. New Mexico was among the few states who did create their own portfolio unique to this area. Other known states to have participated included California, Pennsylvania, Arizona and possibly Ohio.

The New Mexico *Portfolio* included 50 renderings of objects of art typical of our Spanish Colonial heritage. Two hundred portfolio sets were completed thanks to the talents and energies of various people. It is our understanding that despite all the efforts put forth, the New Mexico *Portfolio* was not accepted by the people in Washington to be included in the Index of American Design. This rejection was a great disappointment to Vernon Hunter and others who had worked so hard on it. Various reasons have been presented regarding this rejection which include:

● Exclusive of the original sets done by E. Boyd, there was inconsistent quality in the original work produced. Holger Cahill was not happy with the final results and the varied quality but there were no funds available to redo them. He had wanted them to be serigraphed originally to avoid this problem. It is important to note that the restrictions on the expending of money as established by the federal government did not allow for printing costs. Federal money could only be expended for labor costs. It is therefore projected that the costs for printing was covered by donations from supporters of the project and they may be the entities listed in the credit portion of the book.

•New Mexico's selection of typical Spanish Colonial art featured subject material that was predominantly religious and there were some who were possibly overly sensitive to the requirement of separation of church and state. However, what they were not sensitive to was the fact that this material was indeed highly representative of the most common art known to the predominant culture of New Mexico for many years and at that time.

Despite that rejection, today the *Portfolios* are valued highly and a complete and numbered set will bring a substantial price. Individual renderings are occasionally found on the market and also have value, though lesser. Seventeen complete and numbered sets have been identified in predominantly public ownership such as libraries and museums. (The N. M. State Library has two complete sets in their vault.) Sam Larcombe of Santa Fe has done extensive research regarding the New Mexico *Portfolio* and is extremely knowledgeable as to its history, whereabouts of copies, etc. Shirley Jacobson, a rare book dealer in Santa Fe, has also done some primary study on this document.

Fourteen Hispanics were among the forty-six artists and copyists who painted the watercolor duplicated illustrations. E. Boyd prepared the original text and watercolor studies for the plates. She gathered the material from various New Mexico churches and homes. She also is known to have hand-colored in watercolor one set of prints, which is still in existence today. Roland Dickey, then at the University of New Mexico, assisted in the research and edited the text. The woodblock engravings were made by six engravers listed below. The text and woodblocks were composed and created for use in the printing with equipment of Rydal Press (Santa Fe), Whiteman Printing (Clovis) and Gus Baumann's press at the Spanish American Normal School (El Rito). The school also provided production assistance. The frontpiece indicates that it was published in Santa Fe in 1938 by the Federal Art Project of New Mexico of the Division of Women's and Professional Projects, Works Progress Administration. The supporters and participants who made the project a reality are listed on the following page.

## LIST OF PARTICIPANTS WHO CREATED
## *THE PORTFOLIO OF SPANISH COLONIAL DESIGN IN NEW MEXICO*

The following credits are in the front of the text of the Portfolio:

Thanks to:
Archibishop R. A. Gerken
Historical Society of New Mexico
Laboratory of Anthropology
School of American Research-Museum of New Mexico
Paul Horgan
Ruth Laughlin
John Gaw Meem
Sheldon Parsons
James Seligman
B. Sweringen
Carlos Vierra
Cady Wells
Rydal Press---printing equipment
Whiteman Printing Co.--printing equipment
El Rito School--use of Gustave Baumann printing press

Contributors:
Holger Cahill, Director, FAP-Washington
Donald Bear, Regional Advisor
R. Vernon Hunter, New Mexico Coordinator
E. Boyd Hall-Text and Renderings
Roland Dickey-Research

Engravers:
Fritz Broeske
Louie Ewing
Donald Cole
Frank Stevens
Manville Chapman
Stuart Walker

Composition:
Bruce Gentry
Ridgley Whiteman

Artists:

| | |
|---|---|
| Mary Baca | William Hughes |
| Nash Bachicha | D. Paul Jones |
| Jean Barka | J. Henry Marley |
| Maye Barris | Charles Mattox |
| Charles Barrows | Alfonso Mirabel |
| Mae Brown | Sam Moreno |
| Stanley Carson | James Morris |
| Dale Case | Helmuth Naumer |
| Carlos Cervantez | Virginia Nye |
| Majel Claflin | Isauro Padilla |
| Regina T. Cooke | Edma Pierce |
| Lucius Cummings | Loda Ralston |
| R. L. Day | Lois Roberson |
| J. V. Delgado | Eliseo Rodriguez |
| John Dorman | Lumina Rodriguez |
| Evelyn Dryer | Ernesto Roybal |
| Chester Faris | Juan Sanchez |
| Florencio Flores | Howard Schleeter |
| Juan Garcia | Franz Trevor |
| Felix Gutierrez | Charles Wesley |
| Odon Hullenkremer | Ardyce Wynn |
| Lucino Huerta | Margery Wilson |

Some observers considered the New Deal in New Mexico to have been only a qualifed success. What they fail to take into account is that some complex human endeavors, like socioeconomic development, require a longer gestation period than others. Today one is able to see the powerful impact upon this state that has been sustained over time through these projects.

## NOTES

Unless otherwise noted, all papers are contained in Record Group 69, Papers of the Works Progress Administration, Federal Art Project, housed in the National Archives, Washington, D.C.

(1) John R. Van Ness introduction to Suzanne Forrest, *The Preservation of the Village: New Mexico's Hispanics and the New Deal*.(Albuquerque: Univ. of New Mexico Press, 1989), vii.

(2) These recent settlers to the region who primarily came from towns and cities in the Eastern United States are usually called "Anglo." This term is employed in the region to indicate persons of non-Native American, non-Hispanic heritage not-withstanding the person's true ethnic or national ancestry.

(3) This sentiment is evident in modern criticism of the era such as Peter Bermingham in his *The New Deal in the Southwest: Arizona and New Mexico*. (Tucson: The Univ. of Arizona Museum of Art, nd). It is perhaps more solidly stated through the administrative papers of the Federal Art Project. These papers indicated a strong bias from the Washington office towards the artwork produced by the Hispanic artists. While this may be viewed as an attempt toward cultural diversity, clearly Cahill, Mildred Holzhauer, Assistant Director for Exhibitions, and Edith Gregor Halpert, a New York art dealer who served for a time as Exhibition Coordinator, all preferred the work produced by the Hispanic artists to that of the Anglo artists.

(4) Letter dated March 12, 1936 Central Files: State, New Mexico 1935-1944, (Box 1929 651.3112 to 651.315), File: N.M. 651.315.

(5) Letter from Donald Bear to Vernon Hunter, August 25, 1938, Central Files: State, New Mexico 1935-44, (Box 1930 651.315), File: 651.315 N.M. July 1938.

(6) Letter from Eckles by Hunter to Kiplinger attn. Holzhauer, Dec. 10, 1941. Central Files: State, N.M. 1935-44, (Box 1931) 651.315 to 651.3159), file: N.M. 651.3152 April-Oct. 1940. *"I have seen the Indian Ceremonial Dance pictures (Exhibit #602) now showing at Roswell, and I believe we would do well not to show them in Gallup. That town is very critical of such subject matter, with which this particular artist seems none too familiar."*

(7) Letter of Jan. 28, 1936. Regional and State Correspondence, 1935-1940, (Box 27) Minnesota-New Mexico, File: N.M. 1936.

(8) Letter from Cahill to Bear, Feb. 4, 1936. Regional and State Correspondence, 1935-40, (Box 27) Minnesota-New Mexico, File: N. M. 1936.

(9) By the end of the N. M.'s FAP, the number of "peasant sculptors." or as they would be identified today, traditional folk carvers, had increased significantly. This can be attributed, at least in part, to the national attention and encouragement this art form received from the activities of the FAP.

(10)   Letter from Bear to Cahill, Feb. 8, 1936. Central Files: State, New Mexico 1935-1944, (Box 1929 651.3112 to 651.315), File : N.M. 651.315.

(11)   Letter from Bear to Cahill, Feb. 10, 1936.  Regional and State Correspondence, 1935-1940 (Box 27) Minnesota-new Mexico, File: N. M. 1936.

(12)   Letter from Hunter to Cahill, Feb. 12, 1936. Central Files: State, N.M. 1935-1944, (Box 1929  651.3112 to 651. 315), File: N.M. 651.315.

(13)   Letter from Cahill to Bear, Feb. 13, 1936. Central Files: State, N.M. 1935-1944, (Box 1929 651.3112 to 651.315), File: N.M. 651.315. and Letter from Cahill to Bear, Feb. 15, 1936. Regional and State Correspondence, 1935-1940, (Box 27) Minnesota-New Mexico, File: N.M. 1936. and Letter from Cahill to Hunter, Feb. 21, 1936.  Central Files: State, N.M. 1935-1944, (Box 1929  651.3112 to 651.315), File: N.M. 651.315.

(14)   Letter from Hunter to Exhibition Department, FAP, Washington, D.C., May 15, 1936. Regional and State Correspondence, 1935-1940, (Box 27) Minnnesota-New Mexico, File: N.M. 1936.

(15)   Letter from Lea Rowland by Hunter to Kathleen Calkins, Director of Research, Index of American Design, June 3, 1936. Central Files: State, New Mexico 1935-1944, (Box 1929  651.3112 to 651.315), File: N.M.651.315.

(16)   The loan of these works was discussed in a letter from Hunter to Mrs. Ruth Lawrence, Curator, The University Gallery, Univ. of Minnesota, Minneapolis, Minnesota, Feb. 1, 1940. Central Files: State, N.M. 1935-1944, (Box 1931) 651.315 to 651.3159), File: N.M. 651.3152  Nov. 1939-June 1940.
The artist of the straw inlay work was not identified.

(17)   Letter from Lea Rowland by Hunter to Kathleen Calkins, Director of Research, Index of American Design, June 3, 1936.  Central Files: State N.M. 1935-1944, (Box 1929 651.3112 to 651.315), file: N.M. 651.315.

(18)   A detailed objects list for the exhibition at the Museum of Modern Art in Washington was included in a letter from Hunter to Holzhauer, March 28, 1939.  Central Files: State, New Mexico 1935-1944, (Box 1931) 651.315 to 651.3159), File: N.M. 651.3152 Jan.-Sept. 1939.

(19)   The FAP administration probably assumed more about its audience's expectations than it actually understood.  They never instituted any methodical study of the intended audience for completed works of art.  As a whole, the Program, probably understood the public it served better in a local context than it did on the national level. members of the general public were quick to point out fault on the part of the federal government, and local administrators were occasionally called upon to defend actions taken by their programs.

(20)   For more information on the importance of religious art to the Catholic population of New Mexico see Thomas J. Steele, S. J.'s book referenced in the Bibliography.

(21) Letter from Roland Dickey, Director, Roswell Museum to Parker, Jan. 27, 1939. Central Files: State, N.M. 1935-1944, (Box 1930 651.315), File: N.M. 651.315 Jan.-Aug. 1939.

(22) These sentiments were expressed in letters such as one from Hunter to Holzhauer, May 12, 1939. Central Files: State, New Mexico 1935-1944, (Box 1931) 651.315 to 651.3159), File: N.M. 651.3152 Jan.-Sept. 1939.
"The early fall would be a very good time to send the exhibition of paintings by Mexican children to Roswell.......They should not be scheduled for Roswell before September as they should be seen by the Spanish children at the San Juan workshop, which is closed during the summer".

(23) Letter from Lea Roland by Hunter to Kathleen Calkins, Director of Research, Index of American Design, June 3, 1936. Central Files: State, N.M. 1935-44, (Box 1929 651.3112 to 651.315), File: N.M. 651.315.

(24) Letter from Lea Rowland by Hunter to Kathleen Calkins, Director of Research, Index of American Design, June 3, 1936. Central Files: State, N.M. 1935-1944, (Box 1929 651.3112 to 651.315), File:N.M. 651.315.

(25) Letter from R. Vernon Hunter to D.S. Defenbacher, Assistant Regional Adviser, FAP, Aug. 13, 1937. Central Files: State, N.M. 1935-1944, (Box 1930 651.315), File: 651.315 N.M. Jan. 1937 1 of 2. and Letter from R. Vernon Hunter to Mildred Holzhauer, Assistant Director for Exhibitions, FAP September 24, 1937. Central Files: State, N.M. 1935 to 1944, (Box 1930 651.315), File: 651.315 N.M. Jan. 1937 1 of 2. and Letter from R. Vernon Hunter to Mildred Holzhauer, Assistant Director for Exhibitions, FAP, March 4, 1938. Central Files: State, N.M. 1935-1944, (Box 1930 651.315), File: 651.315 N.M. Jan. 1938.

(26) This statement is based on communication with John Michael Vlach, Dept. of American Studies, George Washington University, Washington, D.C.

(27) Initial research on the subject of Colchas, and preliminary discussions of a portfolio of Colcha design can be found in: Letter from Walter M. Kiplinger, Director, Public Activities Programs, attn. Benjamin Knotts, Assistant to Director to Connelly, Attn. Eckles, Feb. 5, 1941; and letter from Eckles by Hunter to Kiplinger attn. Knotts, March 6, 1941. Central Files: State, N.M. 1935 -1944, (Box 1931) 651.315 to 651.3159, File: N.M. 651.3155 Jan. 1941.

(28) Requests from Washington office for additional information, stories, and explanations, are found throughout the correspondence files.

(29) Letter from R. Vernon Hunter to Glassgold, April 27, 1939. Central Files: State, N.M. 1935-1944, (Box 1931) 651.315 to 651.3159), File: N.M. 651.3155 Jan. 1941. and Letter from Florence Kerr by Glassgold to Connelly attn. R. Vernon Hunter, Oct. 14, 1939. Central Files: State, N.M. 1935-1944, (Box 1931) 651.315 to 651.3159), File: N.M. 651.3155 Jan. 1941.

# BIBLIOGRAPHY

**Primary Sources**

Administrative correspondence of Federal Art Project (FAP, August 1935-43), in Record Group 69, Civil Records Section, National Archives, Washington, D.C.

Papers of the Federal Writers' Project (FWP, 1935-1939), Manuscripts Division, Library of Congress, Washington, D.C.

**Secondary Sources**

Boyd, E. *Popular Arts of Spanish New Mexico*. Santa Fe: Museum of New Mexico Press, 1974.

Briggs, Charles L. *The Wood Carvers of Cordova, New Mexico: Social Dimensions of an Artistic "Revival"*. Knoxville: The Univ. of Tennessee Press, 1980.

Forrest, Suzanne. *The Preservation of the Village: New Mexico's Hispanics and the New Deal*. Albuquerque: Univ. of New Mexico Press, 1989.

Campa, Arthur L. *Hispanic Culture in the Southwest*. Norman: Univ. of Oklahoma Press, 1979.

Nestor, Sarah. *The Native Market of the Spanish New Mexican Craftsmen: Santa Fe, 1933-40*. Santa Fe: Colonial New Mexico Historical Foundation, 1971.

O'Connor, Francis V., ed. *Art for the Millions: Essays from the 1930's by Artists and Administrators of the WPA Federal Art Project*. Greenwich, Connecticut: New York Graphic Society, Ltd., 1973.

-----. *Federal Art Patronage: 1933 to 1943*. College Park: Univ. of Maryland, 1966.

Spurlock, William Henry, II. "Federal Support for the Visual Arts in the State of New Mexico: 1933-43." Master's Thesis, University of New Mexico. 1974.

Steele, Thomas J., S.J. *Santos and Saints: The Religious Folk Art of Hispanic New Mexico*. Santa Fe: Ancient City Press, 1974.

Stoller, Marianne L. with Suzanne Martin and Kathryn Nelson. "Hispanic Folk Artists, Their Works....Their Words." in *People and Policy: A Journal of Humanistic Perspectives on Colorado Issues*. (Summer 1980: 26-49).

Vedder, Alan C. *Furniture of Spanish New Mexico* Santa Fe: Sunstone Press 1976.

Weigle, Marta. *New Mexicans in Cameo and Camera: New Deal Documentation of Twentieth-Century Lives*. Albuquerque: Univ. of New Mexico Press, 1985.

-------------- *Hispanic Villages of Northern New Mexico: A Reprint of Volume II of the 1935 Tewa Basin Study, with Supplementary Materials*. Santa Fe: The Lightning Tree, 1975.

--------------, with Kyle Fiore. *Santa Fe and Taos: The Writer's Era, 1916-41*. Santa Fe: Ancient City Press. 1982.

--------------, with Claudia and Sam Larcombe. *Hispanic Arts and Ethonohistory in the Southwest*. Ancient City Press, 1983.

Wroth, William. "New Hope in Hard Times: Hispanic Crafts are Revived During the Troubled Years." in El Palacio. 89 (Summer 1983:22-31).

## Chapter 5

# THE INDIAN NEW DEAL IN NEW MEXICO

*Sally Hyer*

In his final report, Datus Myers, the field coordinator for the Indian Division of the Public Works of Art Project (PWAP), observed, "I think we artists in New Mexico were fortunate to work alongside of the Indian who was allowed to show his culture at the same time and make comparisons. There is no doubt in my mind that he has something which, to him, is just as important, though different, which might be worth our knowing." The significance of PWAP in the development of Indian arts in this century has been largely unrecognized. However, in spite of Myer's halfhearted opinion that native culture "might be worth knowing," the participants in the project are among the leading Indian painters, potters, and sculptors of this century. They created work of significant artistic and historical value under the federal sponsorship of this era. PWAP helped establish Santa Fe as a center of Indian art patronage and Santa Fe Indian School as an institution that fostered both traditional and innovative arts. [1]

At the same time that President Franklin Delano Roosevelt initiated "New Deal" emergency programs designed to boost the national economy and help bring the country out of the Great Depression, he appointed John Collier commissioner of Indian affairs (1933-1945). Collier took full advantage of New Deal funds to promote Indian arts and crafts, increase employment, improve infrastructure on reservations, and construct schools. He was an idealist who struggled to reform federal Indian policy during his twelve year term. Years earlier, during a 1920 visit to his close friend, Taos resident and cultural arbiter Mabel Dodge Luhan, he had embraced Pueblo Indian culture as offering nothing less than salvation from the ills of Western Civilization. [2]

Collier used New Deal funds to attempt to remedy the appalling federal neglect and underfunding of Indian health and education programs exposed in 1928 by private study of Indian affairs known as the Meriam Report. In 1933, the $19 million from Public Works Administration appropriations allotted to the Indian

Service almost equalled the entire Indian Bureau budget of $22 million.[3] Native Americans took part in the Civilian Conservation Corps (CCC), Public Works Administration (PWA), the Public Works of Art Project (PWAP), and the Treasury Section of Painting and Sculpture (TRAP), as well as in other federally supported programs for the visual arts and architecture.

### Visual Arts

The Public Works of Art Project (PWAP), supervised by the Treasury Department, was funded from January to June, 1934. With over $1 million in funding, its aim was to put artists to work in the decoration of public buildings and also to provide emergency employment for artists. The Thirteenth Regional Committee of the PWAP consisted of New Mexico and Arizona. Its Indian Division aimed to give Indians an opportunity to create and display murals, watercolors, pottery, and weavings in Indian service buildings under construction through the Public Works Administration.

Indians were not involved in the administration of the program or selection of participants. Jesse Nusbaum, director of the newly-constructed Laboratory of Anthropology, was director and chairman of the Thirteenth Regional Committee. Laboratory curator and Indian arts specialist Kenneth Chapman was appointed secretary and graphic artist Gustave Baumann area coordinator. Datus Myers, an artist who had studied art in Chicago, Los Angeles, and abroad and come to New Mexico with his wife Alice in 1923, was field coordinator for the Indian Division.

Commissioner Collier urged Southwestern traders on or near reservations to recommend Indian artists for the PWAP, but the final selection of artists was made on the basis of interviews with Datus Myers and his wife. Only a small percentage of the Indian artists in New Mexico participated in the project because many were unable to leave the reservation to come to Santa Fe. Others were ineligible because they had part-time employment and did not depend solely on their artwork for subsistence. [4]

The headquarters of the Indian Division was at Santa Fe Indian School, where the artists took room and board. Since his arrival at the school in 1930, Superintendent Chester E. Faris had endeavored to hire Indian artists and craftsmen and promote Indian arts as a profession that would permit students to continue living at home if they desired. Myers selected about thirty painters and craftspeople from the Pueblos and the Navajo Reservation to paint murals

and watercolors, weave rugs, and make pottery. They were to work under the direction of painting teacher Dorothy Dunn and crafts teacher Mabel Morrow. The artists included SFIS students Pablita Velarde (Santa Clara) and Andy Tsinajinnie (Navajo), both about 16 years old. They worked with established artists Velino Shije Herrera (Zia), Tonita Peña (San Ildefonso), Emiliano Abeyta (San Juan), Tony Archuleta (Taos), Jack Hokeah (Kiowa), and Calvin Tyndall (Omaha). During the 6-month project, 8 painters completed 13 panel murals and 46 watercolors. Two Pueblo copyists, Miriam Marmon (Laguna) and Alma Chosa (Jemez), along with several non-Indian artists, completed 200 Indian designs.

Velarde recalled that at SFIS, Tonita Peña became her mentor. "Tonita was really a help to me in my early years at the Indian school. . . . She was staying at the girls' dorm. That's how we got acquainted. She talked Tewa, and she used to tease and laugh and joke in Indian, and that was fun. Then she would be sitting in her room in the evening, just painting for herself, and I'd watch her and talk to her." These conversations convinced Velarde that she could overcome the difficulties of being both a Pueblo woman and an artist. [5]

Six Navajo weavers came to the school, bringing their own wool and yarn. The school furnished additional wool, yarn, and dyes and paid each weaver a salary of $14.85 per person per week plus room and board. After Morrow and the weavers selected textiles from the Laboratory of Anthropology's collections to duplicate, Datus Myers copied the designs. The weavers prepared the wool and wove blankets based on Myers' copies.

Six Navajo weavers completed 12 rugs ranging in size from 3 ft. by 4 ft. to 4 ft. by 5 ft. 5 in. The weavers were Nellie Cowboy, Mrs. John Jim, Mrs. Elizabeth Pablo, Mary Phillips, Sallie Kinlichini, and Bah [Smith?]. The records indicate that speed of production was important: Nellie Cowboy completed three rugs in 101 days, while Mary Phillips only finished one. Pueblo potters Marie Martinez and Julian Martinez (San Ildefonso), Eulogio Naranjo (Santa Clara), Lela and Evangelio Gutierrez (Santa Clara) and Agapina Quintana completed 62 pots.

A national exhibit of works done under the Public Works of Art Project was held at the Corcoran Gallery of Art in Washington, D.C. in April and May, 1934. Two-thirds of the objects sent from New Mexico were Indian-made, featuring Navajo rugs; mural paintings by Andy Tsinajinnie, Pablita Velarde, Velino Herrera, and Tonita Peña; and pottery by Eulogia Naranjo, Marie and Julian Martinez, and Lela and Evangelio Gutierrez. [6]

Some of the works completed at SFIS are now in the collections of the Laboratory of Anthropology in Santa Fe, and may be seen upon request. These include Navajo blankets by Sally Kinlichini,Mrs. John Jim, Nellie Cowboy, and Bah; two polychrome jars by Lela and Evangelio Gutierrez of Santa Clara Pueblo; and three matte on black jars by Marie and Julian Martinez. [7]

## Bandelier National Monument

In 1939, former PWAP participant Pablita Velarde, now 21, was hired to paint the ways of life, customs, and ceremonies of the Pueblo people for exhibition at Bandelier National Monument as part of a Works Progress Administration project. Velarde's work consists of 84 paintings in casein on masonite board and glass completed between 1939 and 1945. She interviewed Pueblo elders and did library research in order to describe the social, political, and economic life of her people in the early 1900s. The paintings document hunting and gathering, compare men's and women's activities, and describe daily events. Elements from different villages are often combined in single works. This exquisite series preserves a way of life that has changed irreversibly. Velarde believes that these paintings are among the most meaningful of all her work. [8]

The Velarde paintings are in the permanent collection of the National Park Service and are occasionally on exhibition.

## Department of the Interior Building, Washington, DC

The Interior Building in Washington, DC, constructed between 1935 and 1936, houses important murals by three of New Mexico's most notable Indian easel painters. The Treasury Section of Painting and Sculpture (1934-1938) and the Section of Fine Arts (1938-1943) commissioned Velino Shije Herrera (Zia), Allan Houser (Apache), and Gerald Nailor (Picuris), along with the Oklahoma artists Woodrow Crumbo (Creek/Potawatomi), James Auchiah (Kiowa), and Stephen Mopope (Kiowa), to decorate the building's arts and crafts shop, cafeteria, and employees' lounge. Each artist created vignettes of traditional tribal life in his own unique style. For example, Houser's "Apache Round Dance" and "Sacred Fire Dance" have a dynamic, linear vitality. "Nailor's Preparing Yarn for Weaving" and "Initiation Ceremony" are lovely examples of his graceful use of line and transparent color. Herrera's "Pueblo Woman and Child" and "Pueblo Symbol" show the artist's interest in pattern and geometric design.

These murals currently being restored, may be seen only if one has a special security pass to enter.

## Architecture

The Public Works Administration, Title II of the National Recovery Act of June, 1933, was set up to stimulate the economy through the construction of public buildings. PWA funds provided assistance for state, local, and federal projects ranging from schools and libraries to large-scale public works such as dams and highways. In the Southwest region alone, about $11 million in PWA funds was provided for Indian hospitals, day and high schools, employee quarters, dorms, shops, gyms, auditoriums, and other buildings. [9] Of this, $750,000 supported projects in Northern New Mexico such as a day school and hospital at Taos Pueblo; a school at Nambe Pueblo; roads at Taos, Nambe, and San Ildefonso; and comprehensive remodeling at the Santa Fe Indian School.

Nationwide, PWA architecture celebrated regional differences in culture and architecture. The goal of the building program was to provide work and to draw on indigenous building traditions and materials to create a new, distinctively American architecture. PWA architects did not simply copy old buildings, wrote a PWA advisor in 1939, they instilled new life into traditional styles. [10] The Spanish Pueblo Revival Style was by far the dominant architectural style used by PWA architects for Indian service buildings, both on the Navajo Reservation and among the Pueblos.

According to Collier, Indian Service architecture predating 1930 was "...a conglomeration of nondescript masses of wood, brick, stone, or other building materials, totally devoid of architectural feeling." (11) He recommended drawing on indigenous building traditions and using local materials and labor. For the first time, federal architects took into account the prevailing type of architecture in the area, the surrounding landscape, native building materials. (12) PWA funding made it possible to build carefully-designed schools drawing on regional architectural styles. Notwithstanding Collier's policy of sensitivity to cultural heritage, Indians were rarely involved in planning or designing buildings and were scarcely represented among laborers.

In Santa Fe, New Deal funding made it possible for regional architect John Gaw Meem to plan the remodeling in the Spanish Pueblo Revival style of 28 red brick school buildings constructed at Santa Fe Indian School between 1890 and 1928. Drawing on forms from Pueblo domestic architecture and mission churches, Meem made pitched roofs flat, stuccoed brick walls, altered window design and location, and added porches and buttresses. The campus became a showpiece of the Collier administration, but also showed the limitations of Collier's policy

in that it emphasized exterior remodeling at the expense of students' needs for improved dorm and classroom space.

Visits to many of the surviving PWA buildings must be arranged through the Bureau of Indian Affairs, Pueblo Governors' offices, the Navajo Nation Historic Preservation Department, or individual schools.

## Conclusion

The Interior Building's integration of Native American murals and the very creation of an Indian Division of New Deal programs show that, in spite of their shortcomings, Roosevelt's New Deal arts programs marked a transformation in Indian-White relations compared to the preceding decades. Indians did not take part in directing the programs or selecting artists who were hired. Fewer than one hundred benefited from jobs because of strict eligibility requirements and logistical problems. Nevertheless, they included individuals such as Maria and Julian Martinez, Tonita Peña, and Velino Shije Herrera, recognized today as pioneers in the field of twentieth-century Indian art. Several, for example, Pablita Velarde and Allan Houser, have gone on to build international careers. PWAP was among the art programs at Santa Fe Indian School that contributed to that institution's tremendous impact on Indian easel painting, which continues today. The remodeling of Indian service buildings under the direction of John Gaw Meem influenced the striking revival of regional architectural styles in the Southwest. Much remains to be done to document Indian participation in New Deal programs in New Mexico, and this is just a beginning, but it shows that Datus Myers' hunch that Indian culture had value clearly understated what is apparent today.

# NOTES

(1) For an excellent overview of New Deal programs in New Mexico as well as an inventory of projects, see David Kammer, "The Historic and Architectural Resources of the New Deal in New Mexico," unpublished report prepared for the New Mexico Historic Preservation Division, Santa Fe, N.M., June, 1994.

(2) Kenneth R. Philp, *John Collier's Crusade for Indian Reform: 1920-1954*. (Tucson: the University of Arizona Press, 1977) 1-25, 120-34.

(3) Margaret Connell Szasz, *Education and the American Indian: The Road to Self-Determination Since 1928*, 2nd ed. (Albuquerque: University of New Mexico Press, 1977), 42.

(4) Mrs. Charles Collier, "The Indian Art Exhibit under the Public Works of Art Project," *Indians at Work 1* (May 1934): 28-9; Robert Fay Schrader, *The Indian Arts and Crafts Board: An Aspect of New Deal Indian Policy* (Albuquerque: University of New Mexico Press, 1983), 79-81.

(5) Sally Hyer, *One House, One Voice, One Heart: Native American Education at the Santa Fe Indian School* (Santa Fe: Museum of New Mexico Press, 1990), 42.

(6) William Henry Spurlock II, "Federal Support for the Visual Arts in the State of New Mexico: 1933-1943," (M.A. thesis, University of New Mexico, 1974),13.

(7) Louise I. Stiver, "The Role of the Laboratory of Anthropology in Federally-Supported New Deal Programs: 1933-1943," unpublished manuscript, 8.

(8) Sally Hyer, "Woman's Work": *The Art of Pablita Velarde*. (Santa Fe: The Wheelwright Museum of the American Indian, 1933), 8-9.

(9) John Collier, "Indian Reservation Buildings in the Southwest," *American Architect and Architecture 150* (June 1937): 36.

(10) C.W. Short and R. Stanley-Brown, *Public Buildings:Architecture under the Public Works Administration*,1933-39 Vol. 1 (New York: Da Capo Press, 1986),II.

(11) Ibid., 35.

(12) Ibid., 38: Ellen Threinen, ("The Navajos and the BIA: A Study of Government Buildings on the Navajo Reservation," ) unpublished document funded by the Bureau of Indian Affairs, Navajo Area Office, 1981), 1-2.

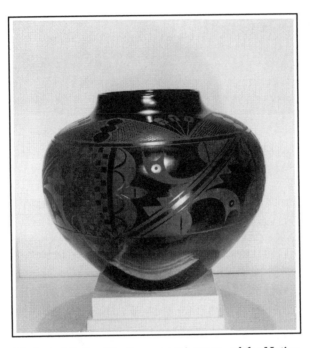

Maria and Julian Martinez were just two of the Native Americans who participated in the New Deal. This beautiful Black on Black Storage Jar (c. 1941) is part of the New Mexico Museum of Fine Arts collection.

Chapter 6

# BIOGRAPHIES OF THE BEST KNOWN NEW DEAL ARTISTS OF NEW MEXICO

This biographical information came from a variety of sources including personal interviews with living artists and family members of deceased artists.

## ABEYTA, EMILIANO
San Juan Pueblo. Native American name-Sa Pa

## ADAMS, KENNETH MILLER
(1897-1966)

Born in Topeka, Kansas, Adams was initially trained by George M. Stone, a Topeka artist. Later he attended the Art Institute of Chicago and the Art Students League in New York. In 1921, he went to Europe and studied in France and Italy for two years. Upon his return to America, he followed Dasburg, whom he had studied under in New York; to Taos. While there he was a member of the Taos Heptagon group that included Mozley, Dasburg and Lockwood. Adams, a resident of New Mexico since 1924, became the last member elected to the Taos Society of Artists before it dissolved in 1927. In 1938, a Carnegie grant brought him to the University of New Mexico in the early 1930's as an artist-in-residence, an association that ended some thirty years later as Professor Emeritus of Art.

Adams worked not only as a painter in both oil and watercolor, but also as a printmaker in lithography. His style was considered realism that was simplified and unadorned, somewhat related to the Mexican art of Diego Rivera. In his University of New Mexico murals, he used a flat, linear technique to create a formal design suitable to the architectural enframement and the Indian theme of the work. Adam's representations are free of false sentiment and have a sturdy feeling for construction, linked with the premise that art's mission is to clarify inherent qualities of nature.

In 1935 Adams was invited to compete for mural decorations in the new post office in Washington, D.C. and as a result was awarded a commission to paint a mural "Rural Free Delivery" for the Goodland, Kansas Post Office. He also painted a mural for the Post Office in Deming in 1937. Some of his other works can be found in various locations around the state. For his work with the Treasury Dept. art program he was paid $42.50 a month which was greater than one could earn as a professor at the University. He also did a later mural privately for the Colorado Springs Fine Arts Center with Andrew Dasburg and Ward Lockwood.

Adams was married to Hilda Adams and Helen Osborne Hugrefe Adams. He died in Albuquerque three years after being honored with the Professor Emeritus status.

LOCATIONS OF NEW DEAL ARTWORK: Albuquerque, Carlsbad, Deming, Espanola, Las Vegas, Raton, Roswell, Taos, Santa Fé, Washington, DC, and Goodland, KS.

### ARCHULETA, ANTONIO
(Dates unknown)
Taos. His work is in the collection of the Museum of New Mexico.

### AWA TSIREH (ROYBAL, ALFONSO)
(CA.1895-CA. 1955)

### BAHE, STANLEY K.
(Dates unknown)

Navaho. Attended school in Phoenix.

### BAKOS, JOZEF
(1891-1977)

He was born in Buffalo, New York on September 23, 1891 to a simple, humble family of Polish ancestry which he never forgot nor neglected to acknowledge with pride. He also loved to share stories about his days as a streetfighter in Buffalo. Bakos studied in the finest European schools and played as a child in the castles of kings. He studied at Albright Art School, Buffalo, Toronto, and in Denver with John E. Thompson.

Bakos arrived in Santa Fé in 1921 and was the organizer of the original Los Cinco Pintores and the youngest member of another group called the New

Mexico Painters. These groups were developed primarily to promote their work, having exhibitions throughout California and other places. In addition to painting, Bakos did carpentry work in order to pay his bills during the depresssion and over the years also taught at the University of Colorado, where he was their first art instructor, the University of Denver, and Santa Fé High School. He showed with other Santa Fé artists at the Los Angeles County Museum, 1923. In 1923 he married another artist, Teresa Bakos, and they spent a good portion of their lives together, both loving the out of doors and painting their own interpretations. Jozef created easel paintings for the federal project. Bakos reported that he felt the project was valuable for a variety of reasons one being that it "was almost the last of the period of regional painting." In the late fifties he painted over thirty registered bulls over eight or nine years as a special commission. He once noted that he felt it was one of the best things he did in painting. He became "a Remington of bulls." After the owner of these creations died, the collection was given to the Hereford Association in Kansas City. He died in Santa Fé in 1977.

LOCATIONS OF POSSIBLE NEW DEAL ARTWORK: Clayton, Melrose, Raton, Socorro.

## BAKOS, TERESA
### (1884-1974)

Teresa Dorman Bakos is reported to have grown up in Trinidad, Colorado but was born in Nervi, Italy as the Countess Di Locci Di Lante. Another reference notes that her family was related to the Roman Catholic Pope at that time. She studied music in her early years but being also interested in art, she did in depth studies of the Italian Primitives for three years in churches, museums, galleries and private collections. This research culminated in a book about her findings. She never had any formal art training.

As a young woman she lived primarily in El Paso, Boston, and San Francisco. An exhibition in San Francisco of the work of a group of Santa Fé artists, including "My Garden" by Jozef Bakos, shown in Chicago attracted her to Santa Fé. She brought her two young sons, Ralph and John Dorman to Santa Fé to see these artists and their work and two months later she was married to Bakos. They resided on the Camino de Monte Sol in a home he built and furnished with his own creations.

She noted that she belonged to no school of art since she felt there was only good painting and bad painting and she tried to follow the lead of only the *good* painters. That's why she chose to study the old masters. She did not intend to

give up her music for painting but enjoyed it so much she painted nearly all the time, finding no time for bridge and tea parties. She became best known for her imaginative still life creations of flowers with delicate colors and designs. Despite the fact that she was one of the federal project artists, she felt that the overall project "cheapened art and that the country never quite recovered from that." This related to the number of people who were paid to paint who knew nothing about painting. Her son, John, later became an abstract painter and assisted with the *Portfolio* completion.

LOCATION OF NEW DEAL ARTWORK: Melrose

## BARELA, PATROCINŌ
### (1908-1964)

Barela was born in Bisbee, Arizona in 1908 and his mother died at his birth. When he was a small boy, he and his father moved to New Mexico. At age eleven he ran away from home to face the world. He had no schooling and spoke no English but lived in Colorado for a time with a black foster family who taught him English and "American Ways." In 1930 he returned to New Mexico, married and settled in a small village in Taos Canyon. He began carving bultos and worked under the Emergency Relief Administration as a teamster. His carving skills were brought to the attention of R. V. Hunter with the WPA/Federal Arts Project in 1935 and finally he was able to be employed to carry out his chosen vocation through that program. Barela and Vernon Hunter became close friends with Hunter serving also has his patron, promoter, and advisor. He helped him relocate his family to a pleasant town in the mountains and "turned on" Holger Cahill and others in Washington to the simple beauty of Barela's folk art. They included him in every national exhibition for which his work was appropriate. For example, some of his works were displayed at the New York World's Fair in 1939. Today one can find his work in various museums including the Museum of Fine Art in Santa Fe and the Harwood Foundation collection in Taos. Unfortunately these unique creations are scarce since Barela died in a fire in his Canón workshop October 24, 1964.

According to Charles L. Briggs in his book, *The Wood Carvers of Cordova, New Mexico: Social Dimensions of an Artistic "Revival"*, "Barela's work is acknowledged work as some of the most important visionary art in the New Mexico folk tradition and the existence of much of his work can be directly credited to Hunter. His dedication to the man first and the employee/artist second encouraged Barela to carve many of his greatest works while in the employment of the FAP. Hunter had an ability to make suggestions in such a way that the

artist immediately accepted them as his own and proceeded to impress his admirers with inspired work.

POSSIBLE LOCATIONS OF NEW DEAL ARTWORK: Bandelier, Santa Fé, Taos, Washington, DC.

### BARGER, ERIK
(Dates Unknown)

Barger resided in Albuquerque. He worked primarily in watercolors. He created replicas of the different military insignias to be displayed at Kirtland and in traveling tours of New Deal art.

LOCATION OF NEW DEAL ARTWORK: Gallup

### BARROWS, CHARLES
(1903-1988)

Charles Barrows was born in Washington, Pennsylvania on October 17, 1903 and started drawing at age five. After high school he spent three years working in a chemical laboratory, but abandoned that career in favor of attending Carnegie Technical Institute's College of Fine Arts night school for one year in order to learn more about painting. During the summer he took classes at the Pennsylvania Academy of Fine Arts. Then he took classes in New York City at the Art Student League where he attempted to study while trying to make a living. Finding this difficult, he chose to quit the art school and work by himself.

Barrows heard about Santa Fé from the Santa Fé cowboy and artist, Hal West, in a sandwich shop in Long Island where they worked side by side. Finally Barrows and a friend, Jim Morris, took off hitchhiking and arrived in Santa Fe in June 1928. Fortune smiled on these men once they arrived and they became active in the art colony. Charles or "Chuck" was included in the WPA Art Project and earned $74 a month for his watercolors. He was one of the artists that worked on the *Portfolio*. He married and moved to Chimayo, where, as his family increased, he was able to fish and hunt for the family's food. This mouth-to-mouth lifestyle finally became too difficult so Barrows went back to New York to learn the silk screen process. While there he became a charter member of the National Serigraph Society and found the medium that he enjoyed the most. When he returned to New Mexico, he made the first reproductions of the paintings of Navajo artist Harrison Begay; and he and his second wife, Mary Habberley, developed a successful silk screen business, *The Tewa Enterprises*, which was later

merged with the Artists Exchange on Canyon Road in the historic building known as the Borrego House. They worked with numerous artists in Santa Fé and New Mexico.

Barrows felt that painting should always present more than just a picture of something. They should be looked at as one listens to music--"an emotional rather than a mental process."

Another love of this artist was collecting, identifying, painting and writing about the numerous species of mushrooms. He became a recognized authority in the field of mycology. He died on May 28 at the age of 85.

POSSIBLE LOCATIONS OF NEW DEAL ARTWORK: Albuquerque-UNM, Raton, Washington, DC.

## BARTON, HOWARD A.
### (1907-)

Born February 2, 1907 in Evansville, Indiana, Barton studied at the University of New Mexico 1937-39 with Raymond Jonson and in the summer of 1938 with Loren Mozley in Taos. He may still live in Albuquerque, New Mexico but has not been located there. Exhibited: "Art and The New Deal in the Southwest: Arizona and New Mexico;"University of Arizona Art Museum on November 27, 1979 to June 30, 1980, at the Phoenix Museum.

POSSIBLE LOCATIONS OF NEW DEAL ARTWORK: Albuquerque-UNM, Las Cruces.

## BAUMANN, GUSTAVE
### (1881-1971)

Born in Magdeburg, Germany in 1881, the family immigrated to Chicago when Baumann was 10 years of age. He grew up in there and studied at the Art Institute of Chicago as well as the Kunstgewerbe Schule, in Munich. In 1909 he went to Indiana and painted but began spending summers in Taos as of 1918. He ultimately moved to Santa Fé and in 1925 married Jane Devereux Henderson of Denver. They moved into their home at 409 Camino de las Animas where they lived for many years. The couple had one daughter. In 1939 he published a book of twenty six woodcuts which was selected as one of the "Fifty Books of the Year." A versatile artist, Baumann excelled as a painter, but also worked as a printmaker and a carver of marionettes. In fact, he became internationally famous as the creator of color woodcuts depicting a wide range of Southwestern

subjects. He was the New Mexico area coordinator of the initial PWAP program from December 1933-June 1934. In 1952 he was made a Fellow of the School of American Research.

Working closely with Will Shuster, they created the head of the first Santa Fé Fiesta Zozobra. Baumann reportedly made the head out of a "corrugated board box which was jammed on a pole draped with cheesecloth and stuffed to the shoulders with tumbleweeds." On a more serious vein, he created the beautiful altar screen in the Episcopal Church of the Holy Faith in Santa Fé. He died in 1971 in Santa Fé and a book about him and his creations was published in 1993 by the Museum of New Mexico Press.

LOCATION OF NEW DEAL ARTWORK: He served as a supervisor of the PWAP activity.

## BEGAY, HARRISON
### (1917-)

Begay's Indian name is Haskay Yah Ne Yah (Warrior Who Walked Up to His Enemy) and he was born at White Cone, Arizona on November 15, 1917. After attending several reservation schools and graduating from the Santa Fé Indian School in 1939, he attended Black Mountain in North Carolina and Phoenix Junior College before WWII where he served for three years in the Army.

Begay is now an internationally known artist and mural painter, noted for the fine, delicate lines and the softened colors of his paintings, often depicting scenes from the everyday life and work of his people. His work is distinguished by meticulous concern for detail and by his ability to catch a moment of action. His work is characterized as "quiet and peaceful." He has been able to work as a full-time artist and has had his paintings reproduced in quantity as silk screens. Since 1946, his work has been widely exhibited and has won numerous major awards. According to some sources, Begay's paintings have exerted greater influence on Navajo artists than those of any other painter.

In the recent past there was an exhibition of his paintings in Japan and a book published including many reproductions of his paintings with text in Japanese. Mr. Begay is believed to be residing on the Navajo reservation at Tsaile Lake, AZ.

LOCATION OF NEW DEAL ARTWORK: Gallup

## BERNINGHAUS, JULIUS CHARLES
### (1905 -1988)

Charles was born at St Louis, Missouri in 1905 to artist Oscar Berninghaus and first wife, Emelia Miller. Charles first came to Taos at the age of three with his parents and sister where they lived in the summers. He attended public schools in St. Louis and studied at the St. Louis School of Fine Arts, the Art Institute of Chicago and the Arts Student League. The family moved to Taos permanently in his late teens and he lived there for the remainder of his life until his death in 1988. He was a Western landscape and still life painter and almost always worked outdoors. He assisted his father with the murals for the Missouri State Capitol and other commercial projects. He loved to fish and play tennis and was married twice, once to Mary Jane Woolsey, whose brothers, Carl, Wood, and Jean, were also engaged in art. He had no children by either marriage. His sister resides with her family in Taos.

LOCATION OF NEW DEAL ARTWORK: Washington, DC.

## BERNINGHAUS, OSCAR EDMUND
### (1874-1952)

Oscar Berninghaus was born in St. Louis, Missouri in 1874. The son of a lithograph salesman, he was educated in St. Louis and taught himself art. He did attend the St. Louis School of Fine Arts at night and later taught at Washington University in St. Louis. He became an excellent lithographer himself and the company for whom he worked, as a gesture of appreciation, gave him a month vacation in 1899 and he chose to travel out west. He did pencil sketching as he traveled and entered northern New Mexico tied in a chair that was tied on the top of a railroad car. This arrangement was worked out by the conductor so he could view and sketch the whole panorama of beauty. When he returned to St. Louis, he married Emelia Miller in 1900 and brought her to his beloved Taos in the summers. During that time he became one of the six original founding members of the Taos Society of Artists which was organized in 1912. He also became well known as an illustrator and frequently designed the elaborate floats for the annual "Veiled Prophet" parades in St. Louis.

After his wife's early death he moved himself and his two children to Taos permanently in 1925 but retained a studio in St. Louis which was next door to his friend, Charles Russell. During his early years, Berninghaus's paintings were of the Pueblo Indians, the Spanish Americans, the adobes, the mountains, generally with at least one horse. With his practice as a lithographic artist and illustrator, his approach was direct and objective, showing the Indians as they

were rather than posed or nostalgic stereotypes. His technique was to work out of doors, painting on the scene. After he moved permanently to Taos, his style became more modern, his compositions more complex, and his colors richer. As a New Deal artist, he created murals in the main post offices of Phoenix, Az., Weatherford, Texas, and Ft. Scott, KS. The latter mural was restored by a family friend in 1988. A second marriage to Winnie Shuler, the daughter of a prominent doctor in Raton, took place in 1932. Oscar died in 1952 of a heart attack.

POSSIBLE LOCATIONS OF NEW DEAL ARTWORK: Los Lunas, Raton, Phoenix (P.O.), Weatherford, OK (P.O.), Fort Scott, KS (P.O.)

## BISTTRAM, EMIL JAMES
### (1895-1976)

Bisttram was born in Austria-Hungary on April 7, 1895. In 1906 he moved to New York where he began working early and developed a career as a commercial artist but also became an accomplished fine arts teacher. He studied successively at the National Academy of Design, Cooper Union, the Art Students League, and with Howard Giles at the New York School of Fine and Applied Art. He first traveled to New Mexico in 1930, for a three-month stay. Here he encountered the challenge as a painter in adjusting to the strong light and color typical of the region. He went on to Mexico to study true fresco techniques with Diego Rivera with the support of a Guggenheim grant which also afforded him the opportunity to return to Taos in 1931. At that time he opened the Heptagon Gallery which was the first commercial gallery in town. He also became known as the first teacher of modern art in Taos and opened the Taos School of Art with an avant-garde curriculum.

In 1938, Bisttram founded the New Mexico Transcendental Artists group. Bisttram's own style reflected the diverse range of his interests, from a 1930's classicism to cosmic abstractions. His work was influenced by Kandinsky, and by the theory of dynamic symmetry concerning the relationships of geometric forms.

Possibly because of this versatility and abilities as a teacher, his fellow artists selected him to be their supervisor during the first federal art project (PWAP) in New Mexico. In a 1963 interview, he recalled the artists got paid $56.00 a month and had to paint one painting a week which he collected and transferred on to Washington. Bisttram was one of the Taos "Fresco Quartet" who created the outstanding works in the Old Taos County Courthouse. He, along with Bert Phillips, Victor Higgins and Ward Lockwood, was commissioned in 1934 to execute a series of ten frescos in the courtroom. Here we see the true fresco technique and the interpretation of the subject matter in the full-bodied Marxist

inspired manner of the Mexican muralists as adopted by the New Mexican artists. Now some sixty years later, those works are in the process of being restored.

He created another mural, "Justice Tempered With Mercy" for the Federal Courthouse in Roswell which is now outside a courtroom in the Federal Courthouse in Albuquerque. The transfer occurred when the Roswell building was demolished. Another mural was done for the post office in Ranger, Texas. His most major work done during the project is in the Dept. of Justice Building in Washington, D. C. He called it "Justice" and was paid $2,500 for his nine months work on it. Bisttram resided in Taos until his death in 1976.

LOCATIONS OF NEW DEAL ARTWORK: Albuquerque, Raton, Taos, Washington, DC, Ranger, TX.

## BLACK, LA VERNE NELSON
### (1887-1938)

LaVerne Nelson Black was born at Viola, Wisconsin, in the Kickapoo Valley. This area was rich in Indian lore and as a boy, Black began drawing horses and Indians using vegetable juices and earth for his painting supplies. He once reported that he used "the red keel, a soft marking stone which the Indians used for painting their faces for their dances." In 1906 the family moved to Chicago and he enrolled in the Chicago Academy of Fine Arts. Because of his outstanding work he received a scholarship there the second year. Following his training he did artwork for newspapers in Chicago and New York City but continued painting. This included western pictures for the Santa Fé Railway. At some point he began sculpting in bronze and was the first to be shown at Tiffany's since Remington, an indication of his high quality work.

Ill health caused Black to take his wife and two children out west where they settled in Taos and once again in Indian country, he did some of his best work. Many in New Mexico remember well his snow scenes with Indians on horseback, the snow covered mountains and adobe buildings. One of his murals can be seen at the art museum in Carlsbad.

A warmer climate was required to improve his failing health so the family this time chose Phoenix. While in Arizona, he did four murals in post offices for the Public Works Administration including some in Phoenix. Friends believe he may have contracted a form of paint poisoning while doing the murals because not long after he required medical attention at Mayo Clinic and later died in a Chicago hospital at the age of fifty-one.

POSSIBLE LOCATIONS OF NEW DEAL ARTWORK: Carlsbad, Roswell, Santa Fé, Washington, DC, Phoenix, AZ.

## BLUMENSCHEIN, ERNEST L.
### (1874-1960)

Blumenschein was born in Pittsburgh, Pennsylvania in 1874 and studied at Cincinnati Art Academy, Academie Julien and Ecole des Beaux Arts, Paris. He taught at the Art Students League, New York and first visited Taos in 1898 later spending summers there in 1910-1918. In 1919 he moved to Taos permanently and remained until his death in Albuquerque in 1960. Some of his achievements include being elected to National Academy of Design in 1927, receiving an Honorary Master of Arts, University of New Mexico in 1947, and being named Honorary Fellow in Fine Arts by the School of American Research, Santa Fé in 1948. No New Deal work by him is known of in New Mexico but a large mural was done by him for the post office in Walsenberg, Co. His Taos home was donated to the Kit Carson Museums and is open to the public on a regular basis.

POSSIBLE LOCATION OF NEW DEAL ARTWORK: Walsenberg, CO.

## BOYD, ELIZABETH (E. Boyd)
### (1903-1974)

Elizabeth Boyd White was born in Philadelphia on September 23, 1903. She received training at the Academy of Fine Arts in Philadelphia and the Grande Chaumiere in Paris. Her studies were in both fine art and art history in her early years. She arrived in New Mexico in 1929 and began using a childhood nickname (E. Boyd) to sign her artwork. She returned to Philadelphia briefly but returned in 1930 to start a new life in New Mexico. Employment was hard to find so she worked along with other Santa Féans in the office of the Emergency Direct Relief Program. She joined several other artists in 1933 in forming the Rio Grande Painters with the common goal of displaying and selling their art since there were no galleries at that time. Unfortunately the goal was hard to achieve with a deepening depression and the group disbanded. Boyd was recruited by Donald Bear, the regional Federal Art Project Director, to help locate a New Mexico artist for the state director and she recommended Vernon Hunter who did get the job.

Hunter then assigned her to work on a mutual dream of theirs which involved documenting in color literal renderings of santos, altar screens, missal stands, etc. This became the forerunner of the *Portfolio of Spanish Colonial Design in New Mexico* which was later part of the federal project called the National Index of American Design. This nationwide project was established to record information on and the appearance of objects produced by Americans of

European descent. Two hundred copies of the *Portfolio* were created in 1938 and Boyd wrote the text relying heavily on historic sources for her descriptions. From this she went on to write other books and became the internationally recognized authority on Spanish Colonial Art of New Mexico. She continued to live and do her art work in Santa Fé and was actively involved in the creation of the International Folk Art Museum. She was married four times and died on September 30, 1974 in Santa Fé.

POSSIBLE LOCATIONS OF NEW DEAL ARTWORK: Portfolios-Santa Fé (various sites), Roswell.

### BURBANK, ELBRIDGE AYER
(1858-1949)

Burbank was born in Harvard, Illinois 1858 and lived in Muskogee, Oklahoma and San Francisco, California where he died in 1949. Burbank was an expert in the use of crayons as well as oils and watercolors. He also did an autobiography called "Burbank Among the Indians." His work is regarded as historically important because his portraits are, in some instances, the only visual records of some Indian subjects. Before Geronimo's death in 1909, he told Burbank that he liked him better than any white man he had ever known. Their friendship had begun in 1898 when Geronimo sat for his portrait, and thereafter Burbank often visited and painted the old warrior. Burbank made friends among the Indians not just because he paid them well for posing but because he liked them. Frequently they were his guests at meals, and on occasion they spent the night at his studio. They were painted whether they were famous or not, for Burbank chose them for their character. In all he painted representations of more than 125 western tribes.

LOCATION OF NEW DEAL ARTWORK: Gallup

### BURK, WM. EMMETT
(Little known)

### CASSIDY, GERALD aka (IRA DIAMOND CASSIDY)
(1869-1934)

This Covington, Kentucky boy was born Ira Diamond Cassidy on November 10, 1896 and was the son of a contractor and builder. He grew up in Cinncinnati and went to the Mechanics Art Institute and took first prize for drawing at the early

age of twelve. He was greatly influenced by Duveneck of Munich and became one of three best commercial lithographers in the country, living in New York and New Jersey. When he came to New Mexico in 1896 because of tuberculosis, he chose to change from commercial to fine art and also changed his name to Gerald at that time. He also included the Indian sign of the sun between the two names making it look like his name was Gerald O'Cassidy, the family's original name in Ireland. He worked in Albuquerque for ten years and also in Denver specializing in theatrical posters and portraits. In January 1912 he brought his new bride, Ina Sizer, to Santa Fé for their honeymoon. He was desirous of painting the Indians and she hoped to write about them.

They both accomplished their goals, in fact, he became known "as the last painter who painted Indians while they were still wild Indians," according to his wife. They both participated in the federally funded projects. She became the director of the WPA Federal Writers Project in New Mexico and he was the first local artist here to be chosen by the PWAP to do a large mural in Santa Fé. It was to be for the Federal Courthouse in Santa Fé. He planned to paint on very large canvas so he rented a warehouse to work in. Unfortunately, the warehouse was poorly ventilated and Cassidy, working high on scaffolding, became very ill from carbon monoxide poisoning and died in a matter of weeks in 1934. According to his fellow artist, Gus Baumann, he was a most prolific worker and this was the only project he failed to complete. Other fine work of this painter can be found in various locations in Santa Fé, including the Main Post Office, La Fonda Hotel, Bishop's Lodge and around the world. These were all done privately.

## CERVÁNTEZ, PEDRO "PETE" LOPEZ
### (1914-1987)

Cervántez was born in Wilcox, Arizona to parents of Mexican-Indian and Spanish heritage. The father worked for the Santa Fé Railroad and was transferred to Texico, New Mexico where the five children received their schooling. During the depression era he worked as an apprentice with Vernon Hunter on the historical murals located in the De Baca County Courthouse in Ft. Sumner. It would appear that he never received recognition for his contribution to these murals.

For two years beginning in 1938, he studied art at Eastern New Mexico University in Portales and then he joined the Army. After serving in the armed forces in Europe during World War II, he returned to his studies at the Hill and Canyon School of the Arts in Santa Fé from 1949 to 1952. Pedro married Merie Hernandez who had two sisters who married the other two Cervántez brothers. Pedro and his growing family lived in Texico and Clovis, New Mexico where he

worked as a sign painter for the Coca-Cola Bottling plant and later in the 1960's for the Clovis Municipal Schools. His wife is still working for the school system and may still have some of his floral paintings from the WPA period. She indicated that he quit painting in 1984 when his eyesight and arthritis worsened. He died in Clovis in July of 1987 at the age of 72 and was buried in the Bovina cemetery.

LOCATIONS OF NEW DEAL ARTWORK: Fort Sumner, Melrose, Washington, DC.

## CHALEE, POP aka Merina Lujan Hopkins
### (1916-1993)

One of five children, Pop Chalee was born in the Taos Pueblo to a Taos Indian father and an East Indian mother whom he met in Salt Lake City. Her grandmother gave her the Pop Chalee name which means "Blue Flower." She was also known as Merina Luhan and was also related to Mabel Dodge Luhan. All this gave this young girl quite a beginning. Her love of horses started early and she remembered riding around Taos and visiting many of the "big artists" in town; sitting and watching them paint but not realizing it was going to have such an effect upon her life. She went to school at the Santa Fé Indian School which she indicated was "military" but she was able to adjust. There she studied under Dorothy Dunn whom she noted "never really had to teach the Indians since it came natural for them. They worked primarily in watercolors since it was more like the earth colors and writing on skins. They worked in the two dimensional traditional style." While there she met and married a young man and soon was a young mother of a boy and girl. In 1937 when Dunn opened The Studio, an art school at the Indian School, Pop returned to study with her again for three years. As her own style emerged, she developed the horses and ponies with long hoofs and flying tails that she became famous for, along with other animals. She was the creator of "Bambi" for Walt Disney who came to Santa Fé and tried to get her and other Indians to go to California. She didn't go at that time but later was involved with Metro Goldwyn Mayer studios in the movie "Annie Get Your Gun" and traveled all over the country promoting it. Later while working with Warner Bros. , she also worked with the Santa Fé Railroad and was present at the ceremonies when the Santa Fé Railroad connected at San Francisco and Oakland. She decorated many of the trains and also did murals for Howard Hughes in the Albuquerque Municipal Airport. Those murals now hang in the new airport. In 1990 she was honored at the 17th annual Governor's Achievement and Excellence Award ceremony and a large creation of her ponies hangs outside the Office of the Secretary of State in the State Capitol in Santa Fé. It was her last large commissioned work.

She worked in the Indian Division of PWAP and created a number of works that were distributed around the country. During an interview she reported, "This period was a happy time despite the economic difficulties since all artists were having due to the depression. The happiness was directly related to the love we artists had for one another. We were all like one big happy family." Pop was a small framed woman who packed quite a lot of living into her life and would probably say "Jiminy Crickets, it was a good one!" She died in Santa Fé in 1993 and a memorial service at the Laboratory of Anthropology included representatives from the Taos Pueblo, the Santa Fé artists, the East Indian Sikh religious group, family, and many friends.

LOCATION OF POSSIBLE NEW DEAL ARTWORK: Unknown

## CHAPMAN, MANVILLE
### (1903-1978)

A Colfax County pioneer's son, Chapman grew up in Raton. Little was found about his youth. When designated to do the eight New Deal murals at the Shuler Theatre he spent weeks collecting photographs and stories of Raton's earliest day. This series shows trails blazed and towns created by the early settlers, stagecoach routes and railroad tracks. Chapman also lived in Taos and finally moved to California. He is well known for his woodcuts and paper batiks and during the New Deal activities an exhibit of his batiks traveled around the state and country. He created woodcuts for the *Portfolio of Spanish Colonial Design of New Mexico* as part of the Index of American Design and did the woodcuts for the program of the opening of the Roswell Museum. He taught other WPA artists and other aspiring students in Raton.

POSSIBLE LOCATIONS OF NEW DEAL ARTWORK: Albuquerque, Clayton, Raton, Roswell, Santa Fé, Socorro.

## CLAFLIN, MAJEL
### (Dates Unknown)

This Michigan preacher's daughter from Eaton Rapids went to Chicago to study at the Art Institute, living at "Temperament Chambers," which used to be at the corner of Rush and Superior Streets. Her stories of the life and characters, there are said to be as interesting as were her amusing drawings. Some of the residents there in Chicago were from Taos and no doubt that is how she learned of the enchanting state of New Mexico.

After completing her studies in Chicago, Claflin went abroad for further study in France, Holland, Spain, and Portugal - riding a bicycle on most of her travels. She became well known as a cartoonist and poster artist but once, while visiting New Mexico, she became fascinated with the indigenous tinwork. When she returned to Chicago she did all she could to master the handling of this material, but she became so fascinated with this craft that she returned to New Mexico and went into the country visiting homes of native Spanish-American families who could teach her more about the very early patterns of pierced tin and painted glass. She also did a great deal of study regarding the origin of this craft and compared it with what she had seen in her European travels. It was a very popular craft at that time and the New Mexico Art Project of WPA employed many artisans and craftspersons to make tin lighting fixtures for places like the Little Theater building in Albuquerque and the Laboratory of Anthropology. Claflin executed copies of native work, embroideries, tin work and santos and bultos for the New Mexico Art Project and many of her copies were included in the *Portfolio of Spanish Colonial Design* for the *Index of American Design*. She also did many of the original tin lighting fixtures for the La Fonda Hotel.

Most likely a very enjoyable individual, Miss Claflin often referred to herself laughingly as "Jill of all Trades." In addition to her art work, she was also active in the New Deal education programs. The Harwood Foundation of Taos is beholden to her for having been their cataloger of the Mabel Dodge Luhan collection.

LOCATION OF NEW DEAL ARTWORK: Melrose, Portfolios

## COOK, HOWARD
### (1901-1980)

Cook was born July 16, 1901 in Springfield, Mass. and began painting in high school. He later studied for three terms at the Art Student's League of New York and at different intervals studied in France, Turkey, China, Mexico, and North and Central America. Some of this was funded by Gugenheim Foundation Fellowships. He arrived on the Taos scene in 1926 and later was involved with the NewDeal projects but did none in New Mexico. His contributions in these projects included frescos in the Law Library at Springfield, MS, the Federal Building in Pittsburgh, PA and in post offices in Corpus Christi, TX and San Antonio, TX. The latter may be the largest mural done in a post office in this part of the country. In 1967 he was the Roswell New Mexico's art center's first "Artist-in-Residence" and they have an extremely large collection and information

about him in their archives. A number of his paintings, created when he was a war correspondent, can be viewed in the McBride Museum of NMMI in Roswell and an obscure creation can also be seen in the lobby of the Sagebrush Inn in Taos. In addition to his fresco work, Cook did a number of etchings, woodcuts, and watercolors. He died in Santa Fe on June 24, 1980 and the Roswell Museum and Art Center was the recipient of his estate's art collection. His wife, Barbara Latham, a writer and artist, lived in Santa Fé until her death in 1988.

LOCATIONS OF NEW DEAL ARTWORK: Corpus Christi & San Antonio, TX, Springfield, MA, Pittsburgh, PA.

### COOKE, REGINA TATUM
### (1902-1988)

Born in Corsicana, Texas on August 22, 1902, the daughter of a district judge, Mrs. Cooke was saluatorian of her high school graduating class, studied art at Ward-Belmont Junior College in Nashville, Tennessee, a gracious girl's school and received her bachelor's degree in art from Colorado College. Her paintings were exhibited in the Denver Art Museum early on. She married in 1925 and had one son. She moved to Taos in 1933 and along with many Taos artists, found a livelihood with the Works Projects Administration painting a series of dioramas, now the property of the Museum of Fine Arts in Santa Fé. Ms. Cooke also worked on the *Portfolio of Spanish Colonial Design*. Her body of artwork that is best remembered is her Southwestern mission church series. She is likewise and maybe better known for her writing career and impact upon the art movement in New Mexico. She was the arts editor of The Taos News for twenty three years and had a total of nearly fifty years in journalism with columns in Southwest Art, New Mexico Magazine, Mademoiselle, Golden Magazine's, Christmas Annual, El Crepusculo e la Libertad and numerous brochures. Cooke also helped found the Taos Arts Association, the Taos Little Theater and started the Taos municipal school's art collection. Before her death at 86 in Taos, she had numerous art exhibitions and her artwork is in numerous private and public collections.

LOCATIONS OF NEW DEAL ARTWORK: Clayton, Melrose, Raton, Roswell.

### CRUMBO, WOODROW WILSON
### (1912-1989)

Born in Lexington, Oklahoma, of a Pottawatamie Indian mother and French father, Crumbo attended Chilocco Indian School through two years of high

school and offered a scholarship at the American Indian Institute at Wichita, Kansas. He studied art at the University of Wichita and then transferred to Oklahoma University. In 1938 he became the Art Director at Bacone College at Muskogee, OK. That was the first college in the US with curricula for Indian artist and taught by Indian artists. The following year he was selected to participate in the painting of six murals in the US Dept. of Interior Building in Washington, DC. During the war years, he worked as an aircraft designer for Douglas Aircraft in Tulsa, OK and was commissioned by the New Deal Treasury Section project to do a mural in the US Post Office of Nowata, OK. In addition to the painting, he received New Deal funds in1933 to take fourteen Indian boys to all Indian reservations. He reported, "We wanted to show the old time Indians on the reservations that by sending their children off to school they did not have to forget their tribal backgrounds. The youth did Indian dances and ceremonials to show them what school Indians could do, that we could have a modern education but retain our Indian background." This group also entertained at Indian Civilian Conservation Corps (CCC) camps to stimulate interest in the CCC projects among Indians.

Crumbo spent some summers in New Mexico during the depression years and made friends with many of the artists. He and Nat Kaplan shared living quarters and occasionally others joined them. He was credited as being the first to mass market Indian paintings to the public with the help of the Taos Pueblo Indians. His own outstanding work brought him the Rosenwald Fellowship and while serving as the "Artist-in-Residence" for the new Gilcrease Museum, he brought Mr. Gilcrease to Taos to select paintings and artwork for the museum. He was once again impressed by this area and moved his family to Taos in 1948 and again in 1973. During those years he was at other locations in professional capacities including El Paso in 1960 where he was the curator of their art museum. Upon retirement in 1988, Crumbo and his wife, Lillian, moved to Cimarron and opened an art gallery. After his death one year later, she returned to Oklahoma to reside.

LOCATIONS OF NEW DEAL ARTWORK: Washington, DC, Nowata, OK.

## DAVEY, RANDALL
### (1887-1964)

Davey was born May 24, 1887 in East Orange, New Jersey. He entered Cornell University in 1905 to study architecture and drawing and in 1908 studied painting with Robert Henri in New York City and with others in Holland, France, and Spain. His teaching career included positions at the Chicago Art Institute,

Kansas City Art Institute, Broadmoor Art Academy (Colorado Springs) and the University of New Mexico. He came to Santa Fé with John Sloan in 1919 and became a resident in 1920 until his death in 1964. His Santa Fé home now houses the Audobon Society and is open to the public. He was elected to the National Academy of Design in 1938 and named an Honorary Fellow in Fine Arts by the School of American Research, Museum of New Mexico, Santa Fé in 1957. He is well remembered for his paintings of polo ponies and as part of the Works Project Administration, he created a polo mural that currently hangs in the Santa Fé National Guard Military Museum. This mural was originally planned to hang at the New Mexico Military Institute in Roswell but never left Santa Fé. He had numerous works in both public and private collections. Davey was married twice, his second wife was Bell Holt.

LOCATION OF NEW DEAL ARTWORK: Santa Fé, Claremore and Vinita, OK.

## DELGADO, ILDEHERT "EDDIE"
### (1883-1966)

Delgado was one of many generations of his family to do tinsmithing. He did outstanding decorative light fixtures and other craft items in the original Albuquerque Little Theatre, the National Park Service Building in Santa Fe, and the Cannon Airbase Officer's Club in Clovis, to name just three sites. His daughter, Adelina Delgado Martinez, continues the tradition in Santa Fe today.

## DETWILLER, FREDERICK KNECHT
### (1882-1953)

Born in Easton, PA. on December 31, 1882, he studied in Lafayette College and New York Law School where he was admitted to the New York State bar in 1906. He studied art, architecture and painting at Columbia University, Ecole des Beaux Arts in Paris, Art Student's League in New York City; Royal Inst. di Belle Art in Florence, Italy and Ecole Americaine des Beaux Arts in Fontainebleau, France. He was the originator of Frederick K. Detwiller System of Graphic Art Education and had a traveling exhibition, used by schools and colleges in 1929. Until his death on September 20, 1953, he made his home in Easton with a summer studio in New Harbor, ME.

LOCATION OF NEW DEAL ARTWORK: Gallup

## DEUTSCH, BORIS
### (1892-1978)

Deutsch was born in Krasnagorka, Lithuania, considered part of Russia. He received his art training in Russia and Germany and came to this country in 1919 where he settled in Los Angeles, California and became an American citizen. His work can be found in the Palace of the Legion of Honor; Portland Museum of Art; Denver Art Museum; San Diego Fine Arts Museum; Carnegie Institute; Mills College; and the Los Angeles Terminal Annex Post Office. While local landscapes, history and industry were muralists' most common subjects, Boris Deutsch's winning design for the Hot Springs Post Office also embodied a sense of humor. His sketch for the national competition for post office mural designs, which is now in the National Archives, cleverly showed an Indian chief dancing out of the path of an Atchinson, Topeka & Santa Fé Super Chief. Deutsch's mural, apparently redesigned, does not show the train, but instead features background mountains. He did another post office mural called "Grape Pickers" located in Reedley, CA and another one in the Los Angeles Terminal Annex Post Office.

LOCATIONS OF NEW DEAL ARTWORK: Truth or Consequences, Los Angeles & Reedley, CA, Washington, DC.

## DIXON, MAYNARD
### (1875-1946)

Dixon did not do any New Deal artwork in New Mexico having left in 1932 but did participate in one of the programs involving the post offices. Two of his creations can be found in the post offices of Canoga Park and Martinez, California. Information about his WPA work is included in a recent book about him, *Desert Dreams, The Art and Life of Maynard Dixon*. See Reference Section.

## DORMAN, JOHN
### (Unknown)

This young man was the son of Teresa Bakos and assisted with the *Portfolio of Spanish American Colonial Design* and one of his other works is in the UNM Fine Arts Museum collection. He lived in Santa Fé and photographic examples of his work can be found in the Kay Dorman (his wife) photo files at the N.M. Records and Archives collection.

## DUNTON, W. HERBERT "Buck"
### (1878-1936)

Born in Augusta, Maine, on August 28, 1878, Dunton became enamored of the outdoors at an early age by accompanying his grandfather on forays into the New England countryside. These early excursions were the foundation of Dunton's life as a big-game hunter and chronicler of North American wild-life. The young Dunton began early to carry a sketch pad along with his rod or rifle during his outings. He quit school at sixteen to work in a clothing store to earn money to take a trip to the West and finally in 1896 achieved his goal. He ended up in Montana where he worked with a bear hunter for nearly two years. He cowboyed or hunted all over the southwest and Mexico in the summers but returned east to study during the rest of the year. He developed a career in illustrations with emphasis on the western subjects which was most timely since the country was fixed on the cowboy craze in literature. His accomplishments in that area were later ignored or forgotten following his permanent move to Taos in 1914 where he became the third resident artist of Taos--after Phillips and Sharp. He was one of the six founders of the Taos Society of Artists. In this setting he was well known for his portraiture and lithographs. As he matured, animals took on prominence in his work with the bear assuming the most prominent roles in his canvases. One he did in 1934 in the Public Works of Art Project in New Mexico was selected by President Franklin Roosevelt to hang in the White House. That painting is now in the National Museum of American Art in Washington. Dunton died in Taos at the of 57 when one of his works focusing on bears, "Crest of the Rockies, Grizzly" was being printed in New York.

POSSIBLE LOCATIONS OF NEW DEAL ARTWORK: Mesa Verde,CO and Washington, DC.

## EASTON KITTS, CORA
### (Dates Unknown)

We have determined that Cora Easton Kitts was born in Greenfield, IA. She resided in Taos between 1938-1960. She used oil and watercolors primarily. In Mabel Dodge Luhan's 1947 book, *Taos and Its Artists* she was described thusly: "Cora Kitts, stripped of even the minor ease and comfort of her youth, alone, without encouragement from anyone, began to paint when all else failed her. In her small, meticulous pictures there is an appealing naivete that somewhat recalls the primitive Rousseau. No lions in the jungle, but the sunflowers and horses and blue skies of her environment. Her little paintings are becoming

collectors' items among the cultivated, blase sophisticates who are familiar with all the techniques of the art world, and who find, in the simple untutored observations of a child, a comfort and consolation too often lacking in more accomplished work."

LOCATION OF NEW DEAL ARTWORK: Unknown

## ELLIS, FREMONT F.
### (1897-1985)

Born in Virginia City, Montana in 1897, Ellis trained briefly at the Art Students' League in New York and was strongly influenced by the American Impressionists. On a family trip to New York City at the age of 12, Ellis' mother took him to the Metropolitan Museum and he was fascinated by the lighting and three-dimensionality of Albert Bierstadt's western scenes. He returned as often as possible and at home tried to recreate this style. He trained to be an optometrist and moved to El Paso, Texas where he painted southwestern scenes and taught art in his spare time. Once discovering Santa Fé he fell in love with northern New Mexico landscapes and a young woman from an old and aristocratic New Mexican family thereby moving north never to leave. He was the youngest of Los Cinco Pintores, a group that created an awareness of contemporary art which was essential to the foundation of an artist colony in Santa Fé in the early 1920s. Along with Jozef Bakos, Walter Mruk, Willard Nash and Will Shuster, the 24-year old Ellis held the principle to create art from the people and not surrender to commercialism. Each man's style varied greatly and each was a strong influence in the art movement over the years in New Mexico. Nearly all were a part of the Works Project Administration contributions to the public's exposure to original fine art. Ellis died in his beloved hometown in 1985 at the age of 87.

POSSIBLE LOCATIONS OF NEW DEAL ARTWORK: Albuquerque, Las Vegas, Santa Fé, Springer, Washington, DC.

## EMERY, IRENE
### (Dates Unknown)

One source indicated that this woman may have been from Roswell. She worked as an artist for Edward Hall in Santa Fé at the Aztec Studio with Paul Ruthling. Another source references a Berta Ione Emeree nee Mrs. William Henry Emery from Kansas and born in 1899. We are not absolutely sure this is the same artist. Reference to her in the Baumann retrospect article indicates that "she lived in

Santa Fé and created two coats of arms carved in wood for the State Museum." In the National Archives, we found a reference to a wall sculpture or relief design featuring birds in flight done at Carrie Tingley Hospital in Hot Springs, NM. Unfortunately we have not been able to locate such a creation in the buildings there which now houses the state's Veteran Center. The town's name has also changed and is now called Truth or Consequences.

LOCATION OF NEW DEAL ARTWORK: Unknown

## EVERINGHAM, MILLARD
### (1912-Date Unknown)

Born in Eagle Village, New York September 8, 1912, Everingham studied at Syracuse University, Tiffany Foundation and the University of Mexico. His work was exhibited at National College FA, Smithsonian, GGE, 1939; PAFA, 1940-41, Coronado Quatro Centennial 1940;, Museum of New Mexico, 1939-40. A mural of mining camp scenes in southern New Mexico is reported as being done in Deming but has yet to be found there. He was a resident of Ranchos de Taos between 1939-1950 and during that time he was the recipient of a foreign studies fellowship from the Augusta Hazzard School.

POSSIBLE LOCATION OF NEW DEAL ART: Albuquerque-UNM, Santa Fé-Museum of Fine Arts

## EWING, LOUIE
### (1908-1983)

Ewing was born in 1908 in Pocatello, Idaho and later moved to Richfield, Idaho where the family lived on a farm. Here he learned to love people and nature and painted, sketched and carved throughout his youth. He attended colleges that unfortunately had no art departments but took an art correspondence course. Finally in 1933 he moved to California to attend a junior college and live with the head of the art department. When this professor moved to Santa Fé in 1935, Ewing followed, and the WPA's Federal Art Project came to New Mexico a year after he arrived. Once involved in this program, he was exposed to serigraph possibilities and soon found his medium of choice. During the 1940s, he was most productive and may have been the first to illustrate books using the silkscreening process. He silkscreened the posters and programs for the Indian Ceremonial in Gallup as part of the federal program. He was reportedly proudest of his illustrations in *Kiva Mural Decorations at Awatovi and Kawaika-a*

by Watson Smith. The Laboratory of Anthropology in Santa Fé funded a WPA-FAP project for which Ewing made 200 silkscreen prints from his own paintings of fifteen Navajo blankets in the Laboratory's collection. He also did another series for them called the "Masterpiece Series." He continued to create but was not desirous of submitting his work for juried shows and therefore built no record of exhibitions and awards. Nevertheless his career and reputation flourished and his love, awe and respect for nature was always featured. He died December 19, 1983, with his wife Virginia Hunter Ewing at his side. Her first husband was Russell Vernon Hunter, who brought Ewing into the WPA program and she has been most instrumental in the development of this book.

POSSIBLE LOCATIONS OF NEW DEAL ARTWORK: Navajo Portfolio-Santa Fé, Roswell.

## FLECK, JOSEPH
### (1893-1977)

Born in Siegless, Austria in 1893, Joseph Amadeus Fleck studied at the Royal Academy of Fine Arts and also at the Royal Graphic Institute, both in Vienna, Austria. Fleck made his way from Vienna to America in 1922 and on to New Mexico in 1924, by way of Kansas City, where he saw his first Taos paintings. He came to Taos soon afterward, and once there became close friends with Ernest Blumenschein and others. In 1925 he married Mable Davidson Mantz and they moved to Taos to live. Fleck became an American citizen in 1927. He left Taos for two European painting tours and between 1942-1946 when he was Dean of Fine Arts and Artist in Residence at the University of Missouri in Kansas City. He died in Pleasanton, CA. and his son, Joseph Fleck, Jr. resides in CA.

Fleck worked in a variety of mediums; oil, tempera, watercolor as well as lithography. As with many representational painters, Fleck's paint application and use of color became freer as he parted from the discipline of this academic school years. Despite the expressive freedom of his later landscapes, Fleck's earlier portraits seem to be more individual and successful; they represent a firmer grasp on form-definition, where the paint was used to convincingly construct a volumetric mass. Whether the subject was an attractive Indian girl clothed in a geometrically-designed costume, or a pair of Spanish musicians in blue denim, all were painted in a simple, straight-forward manner without flourish of technique or decorative color. His work can be found in various collections in New Mexico and nationwide.

LOCATIONS OF NEW DEAL ARTWORK: Albuquerque-State Fair, Gallup, Lordsburg, Santa Fé, Raton, Hugo, OK.

# GILBERTSON, WARREN
## (1910-1954)

Born in Watertown, Wisconsin on August 7, 1910, Warren "Bud" Gilbertson became a ceramist of note. He spent most of his life in Illinois and studied at the Art Institute of Chicago. While there he taught sculpture and ceramics at Hull House and completed his formal American training with a master's degree at the New York State College of Ceramics. A sculpture of the "American Moose" and "American Bison" was created by Gilbertson in 1940 for the first floor of the Dept. of Interior building. This was done under the auspices of the Treasury Department's New Deal program to decorate federal buildings. He traveled in Mexico to study work of the Talavara potters and in 1941 he went to Japan to study with one of their top ceramists. One year he spent in Santa Clara Pueblo studying the techniques of this pottery making. It is assumed that during that year he worked with the New Deal programs here in this state.

Because of his knowledge of Oriental culture and languages, the Navy sent him back across the Pacific during World War II as an intelligence officer. He returned to the Santa Fé area after the war and established his pottery workshop on Alto Street. By this time he was a recognized authority in his field and his writings on oriental ceramic technique had been published by the American Ceramics society and reprinted in England and Italy. In early 1954 he was written up in Time magazine in connection with his discovery of a method of duplicating the oil-spot ceramics of the Sung dynasty - a feat no potter had accomplished in over 750 years. Unfortunately this art may have been lost since he was killed in a car wreck in February of 1954.

POSSIBLE LOCATION OF NEW DEAL ARTWORK: Department of Interior-Washington, DC.

# GOODBEAR, PAUL "Flying Eagle"
## (1913-1954)

Paul Goodbear was the grandson of Chief Turkey Legs, a Cheyenne Indian who was in the battle of the Big Horn. He was born in Fay, Oklahoma and lived with the other tribal members on disconnected farms. He was a young and gentle man who enjoyed sharing old stories of his tribe and his ancestors and became interested in expressing the movement and color of the living figures of the ceremonial participants. He married a Choctaw who was also interested in teaching about the antecedents of her people. He became an educator of Indians of all tribes and injected his personality into manuscripts written about them.

During World War II he had little time for his dancing, painting and writing and was wounded twice on the Normandy Landing and in the Battle of the Bulge. After returning to this country after his discharge, he decided to do more for his country outside of it and became a staff artist with three American daily newspapers in Japan. During this time a comic strip was born, "Chief Ugh" and deep rooted humor poured from his pen.

His Indian name "Flying Eagle" was officially bestowed upon him after he returned from World War II. He studied art at the University of New Mexico and in Chicago and did many illustrations thathave been reproduced in school books. Possibly his most outstanding contribution to New Mexico history came with the restoration of the prehistoric murals at Coronado Museum near Bernalillo. According to an article in the October 1961 issue of *N.M. Historical Review*, "the techniques he used were akin to those of the Greeks and Italian masters. He was forced to paint on fresh plaster and his patience and understanding of this task and his fidelity to his own style of painting is amazing." The Museum of Fine Arts has a large collection of his work. These works give insight into his concern that the Indian artist's right to retain his own expression and reflect his heritage. His untimely death in a hospital in Chicago cut short a potentially significant contributor to his people and to his country. He left two small children that were raised by their mother while she taught in Indian mission schools. She always tried to teach them respect and admiration for Paul Goodbear's work.

LOCATION OF NEW DEAL ARTWORK: Santa Fé-Museum of Fine Arts.

### GRANT, BLANCHE CHLOE
(1874-1948)

Born in Leavenworth, Kansas in 1874, Grant was a Taos landscape and Indian painter, illustrator and author. Blanche Grant, one of five children, was educated at Indianapolis High School and was a graduate of Vassar College's first graduating class in 1896. She was a leader of working girls' clubs, living at College Settlement in Philadelphia for two winters and also heading a Brooklyn club. In art, she studied at the Boston Museum School of Fine Arts, the Penn Academy of Fine Art and the Art Students League. By 1914 she was established as a magazine illustrator and landscape painter. In 1920 she came to Taos where she only planned to vacation but chose to settle permanently since it was better than any place she had ever dreamed of. In addition to her painting, which she did with many of the local figures, Grant was the author and editor of books on the history of Taos and on Western personalities such as Kit Carson. She was the

editor of the *Taos Valley News* as of 1922. Her books, *When Old Trails Were New* and *Taos Yesterday,* are an important reference on Taos history. At her death in 1948, she was buried from the Taos Presbyterian Church where she had created murals in 1921.

POSSIBLE LOCATIONS OF NEW DEAL ARTWORK: Santa Fé, Socorro

## GRANT, GORDON KENNETH
### (1908-Unknown)

Grant was born in Berkeley, CA on January 21, 1908. His father was Walter Grant who ran art galleries in New York for a number of years. Between 1920-25 he studied drawing at the California School of Fine Arts in San Francisco and the Arts and Crafts School in Berkeley. He turned to studying architecture during his time at the University of California in Berkeley (1925-29). Records also indicated that he employed in 1926 by the Anderson Galleries Inc. as a salesperson and later the Assistant Exhibition Manager. The following year he assumed charge of prints for the Century of Progress Exhibit at the Art Insitute of Chicago. After this Exhibition closed, he returned to New York and established his own gallery until the spring of 1935 when he moved to New Mexico. The next ten years he worked at promoting an interest in American Art via lectures and articles and during the New Deal designed some decorations for the New Mexico Fine Arts Museum but their execution had to be postponed. After three years in New Mexico, he returned to Santa Barbara, CA. where he worked has a designer, silversmith and blacksmith.

## GROLL, ALBERT LOREY
### (1866-1952)

Born in New York City, Groll was an etcher and also an Eastern landscape painter specializing in Western scenes. He was elected to National Academy of Design in 1910. Groll studied with the few Americans who attended the Royal Academy in Antwerp. He became a landscape painter on his return in 1895, it is said, because he was then too poor to pay for models. In 1899 he studied at the Royal Academy in Munich under N. Gysis and Loefftz as well as in London. He painted landscapes in the vicinity of New York until about 1904. He then went west with Professor Stuart Culin of the Brooklyn Museum, a famous ethnologist, who wrote a treatise on Indian games. Groll sketched desert and mountain scenes in Arizona and New Mexico. The resulting painting "Arizona" won a gold medal at the Penn Academy of Fine Art in 1906 and was reviewed by "a

critic familiar with the desert who said, "it glows like a gem with the indescribable color of the Colorado desert." Groll was the rare painter in northern New Mexico before WWI, choosing "bare mesas and towering cloud formations" rather than mountains. Laguna Pueblo was a favorite area, as it was for Thomas Moran. There are also many crayon paintings by Groll, particularly of the Taos area, as well as complete landscapes in crayon mixed with oil, the paper surface scuffed for texture. One of his paintings can be seen at the Octavia Fellin Public Library in Gallup. He died in New York City in 1952.

LOCATION OF NEW DEAL ARTWORK: Gallup

## HEARN, OMAR W.
### (Dates Unknown)

Little is known about this man or his work. A reference by Gus Baumann states, "General Kearney probably never expected to have his portrait painted by a preacher--not until recently were we aware of having a reverend at work on the project. His painting is not so hot but the Las Vegas Historical Society is appreciative--altogether he gives the project an air of much needed sanctity." There was reference in another document to his doing a mural at the Old Veeder Museum in Las Vegas. That museum is no longer at that location and we have not been able to establish the whereabouts of the mural or the portrait. We also wonder if the artworks may be one in the same.

POSSIBLE LOCATION OF NEW DEAL ARTWORK: Unknown

## HENDERSON, WILLIAM PENHALLOW
### (1877-1943)

Born and raised in Medford, Massachusetts, Henderson also lived for a time on a cattle ranch in Texas and in a small Kansas town. He studied at Massachusetts Normal Art School and the Boston Museum of Fine Arts with Edmund Tarbell. Following further art training and travel in Europe, Henderson returned to the states to teach at the Chicago Academy of Fine Arts. In 1916, after more than a decade teaching and painting in Chicago, Henderson moved to Santa Fé with his wife, the poet and editor, Alice Corbin, because of her poor health. He painted in a flat, decorative style somewhat related to the manner of Whistler when he first came to Santa Fé. Gradually, under the influence of Nordfeldt and others, he embraced much of Cezanne. Henderson's emotive, high-keyed color and decorative spacial treatment suggest Post-Impressionism applied to distinctly

southwestern imagery. His interest in the Indian and Hispanic residents of the Southwest inspired work in several media. Although best known for his pastels and oils, Henderson's artwork also included outstanding murals, handcrafted furniture, stage designs and innovative architectural projects. He created illustrations for an edition of the well-known book, *Alice in Wonderland,* and as a architect and developer designed and built various buildings in town. During the Federal Arts Project, he completed easel paintings and six murals for the Santa Fé Federal Court House. With the exception of 1918, Henderson resided in the Santa Fé area from 1916 until his death in 1943.

LOCATION OF NEW DEAL ARTWORK: Santa Fé-Federal Courthouse.

## HENNINGS, E. MARTIN
### (1886-1956)

Born in Pennsgrove, New Jersey 1886, Hennings studied at the Art Institute of Chicago; Munich Academy with Walter Thor; and Royal Academy, Munich with Angelo Junk. He was elected to membership in the Taos Society of Artists in 1921 and lived at the Harwood Foundation apartments with his wife, Helen, during their residence in the village. He won a large number of awards both in this country and received honorable mention in the 1927 Paris Salon. He created various murals, one of which is "The Chosen Site" in the U. S. Post Office of Van Buren, Arkansas and his wife and daughter served as his models for the pioneers. He died in Taos, 1956.

POSSIBLE LOCATIONS OF NEW DEAL ARTWORK: Albuquerque, Dexter, Santa Fé, Van Buren, AK, Washington, DC.

## HERRERA, VELINO SHIJE (Ma-Pe-Wi, Oriole or Red Bird)
### (1902-1973)

Born at Zia Pueblo, New Mexico, Herrera was a self-taught artist whose painting career began in 1917 at the School of American Research in Santa Fé. He credited Dr. Edgar L. Hewett for getting him started in the field of art. His subjects included native dances, genre scenes from the pueblos, portraits, and hunting scenes. As his work grew in breadth and confidence, his style changed from flat, pattern like compositions to more naturalistic representations often with a delicate rendering of texture and detail. He taught at the Albuquerque Indian School and some of the murals created for that school can now be found in the library of the Santa Fé Indian School. In 1938 he reproduced ancient kiva murals

found at Kuau (near Bernalillo, New Mexico). He also painted murals for the Department of the Interior building in Washington, D. C. and illustrated several books on Pueblo life and art. With his skillful blend of tradition and innovation he became one of the most highly regarded figures in the Indian watercolor movement. "However when the State of New Mexico adopted the sun symbol of the Pueblo Indians as its official insignia, he was accused by his own people of betraying them by giving the design to the whites," according to the references found in *AMERICAN INDIAN PAINTERS* by Jeanne O. Snodgrass.

He married Picuris native, Mary Simbola, and they had five children. He was also the cousin of Jose Rey Toledo, another New Deal artist. In the 1950's he was in a tragic auto accident killing Mary and injuring him for life. He died later in 1973.

LOCATIONS OF NEW DEAL ARTWORK: Santa Fé-Museum of Fine Arts, Santa Fé Indian School, Kuana Kiva (near Bernalillo), Washington, DC.

## HIGGINS, VICTOR
### (1884-1949)

Born in Shelbyville, Indiana, Victor Higgins left at the age of fifteen to study at the Art Institute of Chicago and the Academy of Fine Arts. Sponsored by ex-mayor and art collector, Carter Harrison, Higgins spent two and a half years in Europe studying with Rene Menard and Lucien Simon in Paris and Hans von Hyeck in Munich. The year after his return (1914), Harrison sent Higgins on a painting trip to New Mexico. He chose to reside in Taos from then on but divided his time between Chicago and Taos. He taught for several years at the Chicago Academy of Fine Arts all the while exhibiting in New York and an occasional showing in Europe.

Higgins found the strong light, brilliant color, and the lure of the New Mexico land a powerful antidote to the confines of academic training. He joined the Taos Society of Artists in 1917, and in 1923 was one of the co-founders of the Harwood Foundation with Bert Phillips and Louise Harwood. His Moses figure and landscape was part of the large fresco done in the Taos County Courtroom during the New Deal artwork projects. Those works are in the process of being restored as this book goes to press.

Another mural done thanks to the federal government is in a post office in Rocky Ford, Colorado and was completed between 1936-40.

His perceptions and renderings of the land in paint, according to some observers, may be unsurpassed by any other artist of the Taos colony. Higgins' own intuitively derived visual harmonies resulted in a rich and varied body of

work in still life, figure painting, and most significantly, landscape. Higgins' work is increasingly recognized as being among the most significant produced in New Mexico. He was married to Sara Parsons, daughter of Sheldon Parsons, and they had one daughter, Joan H. Reed, who is also now deceased.

LOCATIONS OF NEW DEAL ARTWORK: Albuquerque-UNM, Santa Fé-National Park Service, Taos, Rocky Ford, CO.

## HOGNER, NILS
### (1893-1970)

Nils Hogner was born in Whiteville, Mass. and studied at the Boston School of painting, the BMFA School, Rhodes Academy in Copenhagen (Denmark) and was a pupil of Leon Gaspard and Ivar Nyberg. This Swedish artist ended up running a trading post in the 1920's in western New Mexico. During that time he was married to a Navajo woman named Teckla. This marriage did not survive and he moved into Albuquerque. He became a professor in the University of New Mexico art department for four years in the early 1930's and while there met and married Dorothy Childs, an author. They collaborated on thirty-seven of her books; he provided the illustrations. Some of these books included *Navajo Winter Nights* (1935), *South to Padre* (1936), *Santa Fé Caravans* (1937), *Westward, High, Low, and Dry* (1938) and *The Bible Story* (1943).

According to *Who's Who in America* (1956), Hogner won various professional prizes and was a member of different professional organizations including the National Society of Mural Painters, and the American Artists Professional League and the Architectural League of New York City. His best known mural is the "Memorial to the Four Chaplains" commissioned by Daniel Poling commemorating the lives of the four chaplains who gave their life jackets to soldiers on the troopship Dorchester when it was sunk during World War II. This mural was dedicated by President Truman in 1951 at Temple University.

Three large and colorful paintings hang at Eastern New Mexico University and were done during his time with the New Deal programs. One more painting has disappeared. They were most likely painted during, or as a result of, his time spent on the Navajo reservation since they are of various Navajo scenes. While some of his works are housed in several mid-west public buildings and museums, most of his murals adorn government buildings on the East Coast. Prior to his death, he was known to have resided in New York City.

LOCATIONS OF NEW DEAL ARTWORK: Portales-ENMU, Washington, DC.

## HOKEAH, JACK
### (1902-1969)

A Kiowa Indian named White Horse, the warrior, was reared by his grandmother in western Oklahoma after being orphaned as a young boy. He attended the Santa Fé Indian School and was commissioned to do a mural at that school. During the 1930's he also lived with Maria Martinez and her family in San Ildefonso Pueblo as her adopted son. He was on the New York stage for a short period and was later employed by the Bureau of Indian Affairs.

LOCATION OF POSSIBLE NEW DEAL ARTWORK: Santa Fé-Museum of Fine Arts, Indian School

## HOUSER, ALLAN
### (1914-1994)

Born in Apache, Oklahoma, Allan Houser was proud of his Chiricahua Apace heritage and feels it has inspired him to the greatness he achieved! His real name was Allan C. Haozous but since many people had difficulty with this Apache name, which means "Pulling Roots", the young man became known - well known- as Allan Houser.

The need to help with the crops and other work on the family farm sometimes made education a luxury but he finally graduated from Chilocco Indian High School. In the early 1930's young Houser and his dad used their horses and wagon to haul rock for the WPA road building activities in that state. His aging father was sad when in 1936 the young man decided to go with others to the Santa Fé Indian School to pursue his budding talent in art. There he met Dorothy Dunn, the art instructor at that school. This woman, who became the devoted discoverer of many an Indian artist, tried to discourage this Oklahoma boy from trying to do three dimensional creations to which he felt drawn. Having been too busy working on the Oklahoma farm, Houser did not have the wealth of Indian stories that some of the New Mexico artists had so when he returned home for visits, he had his father share the family and tribal stories of his ancestor, Geronimo, and others. In 1937 he was the only Native American to be represented at the National Exhibition of American Art in New York and also had his first one-man show at the Museum of New Mexico. After graduating from the Santa Fé Indian School, he stayed on to study with Dunn in her extended art program called The Studio.

Paintings of the traditional two dimensional nature done by Houser during this time and as part of the New Deal programs can be seen today in the Gallup and Raton libraries while mural painting won him national recognition. In 1939 he joined other Native Americans to create two murals in the Department of the Interior Building in Washington, D. C. World War II brought another turning point in his career when he moved to California to work in a defense plant and while there continued his studies looking both at the old masters and investigating new art movements. As a result he broke out of the two dimensional creations and moved into the three dimensional medium of sculpture. He experimented with all kinds of materials but found he always stayed loyal to his favorite subject matter, the Indian.

In addition to his own painting and sculpting, Houser began to teach art and worked at the Inter-mountain Indian School in Brigham City, Utah from 1951 to 1962 then he returned to Santa Fé to become an instructor at the new Institute of American Indian Arts. He later was named the head of the sculpture division until his retirement in 1975. Today the IAIA Museum includes an area that is named for him and features large three dimensional creations of Houser and others inspired by him.

Up until his death on August 23, 1994, he resided in Santa Fé creating and receiving numerous accolades for his special creative talents. In July 1992 he received the nation's highest art award, the National Medal of Arts, and it is on display along with numerous other awards and prizes at his studio south of Santa Fe. Although he never finished college, Houser received three honorary doctorates from the University of Oklahoma, University of Maine and Colorado State University. He was without question the most outstanding and highly respected Native American artist in the world.

He and his Navajo wife, Anna Marie Gallegos, had five sons. Houser had his studio south of Santa Fé along with artist son, Bob Haozous, and the land is dotted with their sculpture and teepees. An amphitheatre was finished shortly before his death with the plan that he would be able to entertain his friends and family with his other talent, playing his Native American flute. This was the site of his memorial service with over five hundred attending and son, Bob Haozous, played the Native American flute in his memory. Three other sons were also involved in working with him prior to his death.

LOCATIONS OF KNOWN NEW DEAL ARTWORK: Gallup, Raton, Washington, DC.

## HULLENKREMER, ODON
### (1888-1978)

Odon Hullenkremer was born in Hungary in 1888 and painted extensively in Europe before he came to America in 1912. Settling first in the east, he later moved to Santa Fé in 1933. He is a recognized artist in both Europe and the United States and is listed in the *Who's Who In American Art*. In his early years he painted portraits, landscapes and murals extensively. He often depicted the people and times of the depression and the simplicity of life through a person's expressions. One of his most poignant works is the "Depression" which pictures a man and woman coping with their despair, the wife's arm around her husband offering comfort. Hullenkremer could also depict the simple joy of children as seen in the Carrie Tingley Hospital painting of "Children on a Teeter Totter." Working on the *Portfolio* was another new Deal project for him.

He set aside his painting later in life for an active role as a community leader in the American Red Cross and the Santa Fé Civil Defense Organization. He was awarded the American Red Cross Medal of Honor in 1946 and was honoree of a City of Santa Fé Resolution in 1960. He never married and died in 1978 leaving behind a long record of humanitarian efforts.

LOCATIONS OF NEW DEAL ARTWORK: Albuquerque, Conchas Dam, Raton, Santa Fé, Portfolios.

## HUNTER, RUSSELL VERNON
### (1900-1955)

Hunter was born in Hallsville, Illinois and raised in eastern New Mexico. He studied at the Art Institute of Chicago and was always interested in teaching and encouraging all types of art activity. A long-time resident of New Mexico, his career began as an art instructor in the Los Cerrillos schools near Santa Fé. During the twenties, he continued his teaching at the State Teacher's College (now N. M. Western University) in Silver City and the Otis Art Institute of Los Angeles (1923-27). Then he taught at the Master Institute of Roerich Museum in New York (1929-31). In the early thirties, he returned to his roots in eastern New Mexico. He painted the Fort Sumner Courthouse murals as a PWAP project. In November of 1934 he married and went to live in Puerto de Luna, N.M. where he organized a State Vocational Education school. In the late fall of 1935 he was asked to take the job of N.M. State Director for the WPA Art Project and the Hunters moved to Santa Fé to give him the opportunity to carry out these duties. This involved working with local, state and federal groups and discovering all the artists who might participate in the various projects.

Early in 1942 Washington closed the N.M. Art Project and one might note that Hunter was one of two state directors who survived in his position throughout the entire program. Others came and went in other states. Unfortunately for this writing and other related research, the New Mexico office was instructed to destroy all records, since copies had been sent to Washington. Some key material has yet to be found. Hunter went on to plan and supervise the interior decoration of the Officer's Club at the airbase in Clovis; then to Regional Buildings supervisor for USO in the east, then Administrative Director, Dallas Museum of Fine Arts, and back to New Mexico as the Director of the Roswell Art Museum which had been started as one of the state's four art centers under WPA. He died in Roswell in 1955. His wife, Virginia, resides in California near her son and his been most helpful with this book project.

LOCATION OF NEW DEAL ARTWORK: Fort Sumner.

## HUNTINGTON, ANNA VAUGHN HYATT
### (1876-1955)

Anna was born in Cambridge, Mass. on March 10, 1876, to Alpheus and Audella (Beebe) Hyatt. Her father was an eminent palaeontologist. The young girl nurtured his interest throughout her life by raising, riding and modeling horses at the family plantation in Hyattsville, Maryland. Hyatt studied in private schools-the Misses Smith, Cambridge, Art Students' League, New York; was a pupil of H. A. McNeil and Gutzon Borglum; AFD, Syracuse University. Huntington was a sculptor, particularly loving to create both domestic and wild animal models. Her small bronzes were exhibited in over 200 museums and art galleries and featured the animals and historic figures *Don Quixote*, New York City; *Lincoln* in Austria, Springfield, Portland; *Andrew Jackson* in GA. and an equestrian statue of *Joan of Arc* in Riverside Drive, New York (1915) and a wall statue of the same martyr in the Cathedral of St. John the Divine in the same city in 1922. She created Torchbearers statues for Madrid, Spain, Havana, Cuba, and Norfolk, Va. In 1923 she married Archer M. Huntington, a railroad heir, and they purchased Brookgreen Plantation in South Carolina. This homeplace became a public sanctuary after her death. She received many awards, prizes, and medals of honor from this country, France, and Spain . She was a member of the National Sculptor Society of Federation Arts and the first woman to ever be named a member of the Spanish Academia de Bellas Artes de San Fernando as well as a member of the American Academy of Arts and Letters. One of her pieces is in the Gallup library and a small bronze can also be seen at the Roswell Art Museum.

LOCATION OF NEW DEAL ARTWORK: Gallup, Roswell.

## HURD, PETER
### (1904-1984)

Peter Hurd was born in Roswell, New Mexico February 22, 1904, and lived there during his youth. As a painter and illustrator, he studied at the Pennsylvania Academy of Fine Arts where he was a pupil of N. C. Wyeth and married his daughter, Henriette Wyeth. He was a member of the Fellowship Pennsylvania Academy of Fine Arts and the Wilmington Society of Fine Arts. He exhibited widely throughout the United States and received several awards of national distinction. Hurd received quite a bit of notoriety over a portrait he did of President Lyndon Johnson in 1966 for the White House Historical Association. He was represented in a number of leading galleries and collections including the Art Institute of Chicago; Nelson Gallery of Art, Kansas City; Rochester Memorial Art Gallery; and the Metropolitan Museum of Art, New York City. Not only was he a fine painter of oils, tempera and watercolor paintings, but Hurd was also an excellent lithographer. He was an illustrator of numerous books such as *The Last of The Mohicans* by David McKay and *American History* by T. S. Lawler. Peter Hurd was also a Life Magazine correspondent in European, African and Oriental theaters during World Was II. His work is included in the Encyclopedia Britannica Collection of Contemporary American Painting. He created a mural for New Mexico Military Institute, one of his old alma maters, but it was lost in a fire in 1938 that was alledgedly started by a disgruntled individual. Other murals were done as part of the New Deal project and can be seen on the exterior of the Lincoln National Forest Service Building in Alamogordo and the post offices of Big Spring, Dallas and El Paso, Texas.

This cowboy artist was also well known for his great love of horses and polo. In the early 1970's he had a serious fall during a polo game and it seemed to have a lingering effect upon his general health. Later that year he virtually retired and was a patient in an Albuquerque nursing home at the time of his death in 1984.

LOCATIONS OF NEW DEAL ARTWORK: Alamogordo, Big Spring, Dallas and El Paso, TX, Washington, DC.

## IMHOF, JOSEPH ADAM ANDREW JOHN
### (1871-1955)

Born in Brooklyn, New York in 1871, Imhof lived in New York, Europe, Albuquerque and Taos, New Mexico. Imhof's paintings of Indians are so anthropological that some critics have deprecated their importance as art. From

his observations of Pueblo culture, he had become aware of the importance of corn in their lives and had used the medium of his art to explain its secular and ceremonial use. His lithographs received better treatment from the critics. Although largely self-taught, he was an excellent draftsman and printmaker. He had the first lithographic press in Taos which he set up sometime after his arrival in 1929. Imhof was not a newcomer to New Mexico, however, since he lived in Albuquerque from 1906 to 1912. The University of New Mexico Department of Anthropology has 60 of his oil paintings.

LOCATIONS OF NEW DEAL ARTWORK: Albuquerque-UNM Art Museum, Anthropology Department.

## JELLICO, JOHN
### (1914-)

Born in Koehler, New Mexico in 1914, Jellicoe is a graduate of the Art Institute of Pittsburgh and studied at Phoenix School of Design and Grand Central School of Art, both in New York, and at evening sessions at the University of Pittsburgh. From 1946 to 1950 Jellico was an instructor of commercial art and design, advancing to assistant director at the Art Institute of Pittsburgh, 1950-1956. In fall of 1956 he went to Denver to become director of the Colorado Institute of Art, becoming the president in 1962. As an artist Jellico has painted numerous murals for the Third Air Force chapels and seven larger murals for a church in Raton, New Mexico. He joined with Juanita Lantz to create twenty-seven ceiling decorations in the Old Library (Carnegie) in Raton but they were later demolished when the building was destroyed to reroute the highway. Today there are still two of his WPA works in the existing Raton Library and Public Schools. In 1993 he was one of the few remaining WPA artists of New Mexico and resides in Englewood, Colorado.

LOCATION OF NEW DEAL ARTWORK: Raton

## JONES, D. PAUL
### (Dates Unknown)

Born in Maryland, Jones grew to manhood and first studied art there. As a young man he found himself in France during World War I, and kept his sanity by subconsciously studying form and movement and the play of color over the tortured landscapes and dreaming of peace in a land of solitude. After the war he took himself to Phoenix and worked in a bank but needed more solitude,

nature and art so he bought some art supplies and food and went to the wilds of the Hopi and Navajo country. He learned all about these people, their country, and customs and was given the Navajo name of Kla-chi-yezzy or Little Dog, because of his gift of imitating animal sounds. After several years of the nomad life, he went to Colorado Springs for further study under Robert Reid and John Carlsen at the Broadmoor Art Academy and later became one of the teachers there himself.

In 1933 or thereabouts he moved to Alcalde, New Mexico and maintained a studio with his friend, Lloyd Moylan. During this time both men were involved in creating beautiful artworks thanks to the financial resources of the New Deal Programs. Being an artist on the *Portfolio* project was one of the activities. He did murals for the Northern New Mexico Community College (then called, Spanish-American Normal) at El Rito and they are hanging in the Bronson Cutting Hall. Two paintings of the mission church of Hernandez, north of Espanola, can be seen today in Albuquerque at Carrie Tingley Hospital and the Supreme Court in Santa Fé. Ina Sizer Cassidy noted about the mission church paintings that one can "trace in his brush strokes, the bleak setting, and meager life to which it is the spiritual sustenance, the earthy symbol of a living faith, the central pivot about which revolves the social structure of this primitive village."

LOCATIONS OF NEW DEAL ARTWORK: Albuquerque-CTH, Clayton, El Rito, Gallup, Las Cruces, Melrose, Santa Fé, Socorro, Portfolio.

## JONSON, RAYMOND
### (1891-1982)

Born near Chariton, Iowa in 1891, Raymond Jonson moved often during his childhood. At age twenty, Jonson had a spiritual experience in which he felt challenged to dedicate his life to art. His art training began at the Portland Art Museum School and continued when he moved to Chicago and attended the Chicago Academy of Fine Arts, later enrolling at the Art Institute. Encouraged by his teacher, B. J. O. Nordfeldt, Jonson became art director at the Chicago Little Theater (first American experimental theater). His experimental stage-design work and Bauhaus concepts influenced his painting, which took on distinctly abstract qualities. A summer visit to Santa Fé in 1922 prompted a permanent move for Jonson and his wife, Vera White, two years later. For the following twenty-five years. Jonson taught and painted in Santa Fé and then moved to Albuquerque to become a University of New Mexico professor. He resided there until his death in 1982. A strong and dedicated artist and a man of great industry and curiosity, Jonson was a one-man task force for modern art isolated in New

Mexico for more than forty years and as such was an active member of the Transcendental Movement. His home is now an art gallery on the UNM campus and houses his work including those creations done during the New Deal era for the university library.

Two interesting, personal anecdotes about Jonson include the fact that he insisted that his name be pronounced "Joanson" and towards the end of his life, he chose to eat only ice cream.

LOCATIONS OF NEW DEAL ARTWORK: Albuquerque-Jonson Gallery, UNM Art Museum, Portales-ENMU, Washington,DC.

## KABOTIE, FRED
### (1900-1986)

Kabotie was born on the Second Mesa of Hopi Land in Arizona on February 20, 1900. His Native American name was Nakayoma meaning Day After Day. When he was six years old the family joined others who left old Oraibi and established Hotevilla as an attempt to escape the efforts of the Government to force them to abandon their customs. They were forced to return and in 1913 the children were placed in schools for the first time. Kabotie was sent to Santa Fé Indian School at the age of ten as a further disciplinary action but there his artistic talents blossomed with the encouragement of Mr. and Mrs. DeHuff of the school's administration. After 1920 his work and his name usually appeared wherever Indian art is mentioned. His career included teaching, painting, writing, lecturing, and good will ambassador to India in 1960. He married a Hopi girl in 1931 and they had two children.

LOCATION OF POSSIBLE NEW DEAL ARTWORK: Unknown

## KAPLAN, NAT
### (1912-)

Kaplan was born in New York City and received his bachelor's degree in Zoology and Civil Engineering from the University of Connecticut. During the depressions days, he got a job at the university in Texas Station thanks to an old friend. From there he moved on to Red River and later Taos around 1936 where he did picture framing at a shop that assisted most of the known artists of the time. While in northern New Mexico he roomed with Woody Crumbo, lived next door to Herbert Dunton, and was friends with Gisella Loeffler and many of the others in the area. By the age of twenty eight, he was involved with the

WPA project in Gallup. Teaching art classes at the art center paid him $90 a month since he was the Assistant Director. The classes included both fine art and furniture making. He later became the Art Center Director. Kaplan has also always loved woodcarving. He also did mapping in 1939 of the Navajo reservation and noted "they were not easy days but they were GREAT days."

Kaplan went on to become a highly respected and successful engineer, architect and builder in the Albuquerque area where he still resides.

## KAVIN, ZENA
### (1912-Unknown)

Born in Berkeley, CA on October 25, 1912, this painter and engraver studied at the CSFA in San Francisco and privately with A. Kravchenko in Moscow. She has been a lifelong resident of Berkeley and Oakland except for four years in New Mexico during the 1930's. During that time she participated in the New Deal programs and five of her paintings are in the N.M. Fine Arts Museum collection. She also created two frescoes (3' x 4') as part of the kiva murals done in Bernalillo, N. M. She married artist Jon Cornin in 1940 and returned with him to a studio-home in Oakland. Using the pseudonym Corka, the Cornins produced cartoons for the Saturday Evening Post and the New Yorker. During her active life as an artist, she has specialized in figure studies in casein tempera however, she has also sculpted and contributed wood engravings for a number of books. As of 1988 she was reportedly concentrating on making tapestries. She has been a member of SFAA. Exhibited: SFMA Inaugural, 1935; Calif.-Pacific Intnl. Expo, San Diego, 1935; Golden Gate Intnl. Expo. 1939. At this writing she has not been located.

POSSIBLE LOCATION OF NEW DEAL ART: Bernalillo, Santa Fé

## KLOSS, GENE (ALICE GENEVA GLASIER KLOSS)
### (1903-)

Born Alice Geneva Glasier in Oakland, California in 1903, Gene chose to change her name since she felt it was too much name for a young girl. She graduated from the University of California, Berkeley, with honors in art, 1924. An academician of the National Academy of Design, she has been given numerous awards and critical acclaim and her work has been extensively exhibited. Since 1925 she has painted and etched both the country and the people of the Southwest. Using varied subject matter, media and treatment, she seeks to express an abstracted reality; a meaningful essence. She is best known for her etchings. Gene lives in Taos, New Mexico with her husband, the poet Phillip Kloss. As part of the New

Deal program she created a series of nine etchings of N.M. scenes which produced 200 works that can now be found all over the state. As noted in the "Unsolved Mysteries of Art" chapter, some of these etchings are not where they were originally placed.

POSSIBLE LOCATIONS OF NEW DEAL ARTWORK: (Not all have been located.) Albuquerque-UNM, Anthony, Artesia, Aztec, Bernalillo, Carlsbad, Clayton, Carrizozo, Clovis, Cuba, Deming, Elida, Farmington, Hot Springs, Hurley, Las Vegas, Lordsburg, Magdalena, Melrose, Milne, Mountainair, Mora, Portales, Raton, Roswell, Santa Fé, Silver City, Tierra Amarilla, Tucumcari, Tularosa, Washington, DC.

## KNEE BROOK SCHNAUFER, GINA
### (1898-1982)

Born in Marietta, Ohio in 1898, Gina Knee lived in Sag Harbor, New York and began painting early as a child but never really thought "ART" until she arrived in New Mexico. She came to Santa Fé in 1931, after seeing a 1930 New York City exhibition of Marin's Taos watercolors. She studied one summer with Ward Lockwood and taught at a girl's school. Her watercolors at first showed the influence of Marin, and later incorporated Klee symbolism to produce abstracted Indian and landscape motifs. She remained in Santa Fé for 15 years, with one-artist exhibitions beginning in 1942. "Up to 1945" she said, "I painted everything I could see: Indian dances, the Spanish Americans--the desert and mountains--but after a few years I started trying to paint more abstractly, expressing forms in their spirit, or sound, or smell--a more complete picture--a sensual statement--as important as the forms." Later she lived in Georgia, Spain, New York and the West Coast, but the shapes, feelings and memories of New Mexico were always with her. Gina Knee was married to the photographer Ernie Knee and the artist, Alexander Brook.

LOCATION OF POSSIBLE NEW DEAL ARTWORK: (Unknown)

## LA GRONE, OLIVER
### (1906-)

Born in 1906 in McAlester, Oklahoma, LaGrone is a creative man.. Besides being fond of expressing himself with poetry, he spent time making images out of the red clay of Oklahoma. He spent his formative years in Albuquerque and received his formal education at several universities including the University of

New Mexico where he earned a Bachelor and Master of Arts degrees and was the first African-American graduate from the school's art department. During his stay in New Mexico, LaGrone, through the WPA, created the "Mercy" sculpture in 1935. This precious reminder of the comfort given to him by his mother when he had malaria as a boy has stood first at Carrie Tingley Hospital in Truth or Consequences and now at the Albuquerque Carrie Tingley Hospital facility as a tribute to the care provided to the sick children. Oliver LaGrone has remained a friend to the hospital and it's children returning to be honored during the 50th anniversary in 1987. The sculpture was finally bronzed after nearly 60 years since its creation and this was financed by current funds for public art and funds from the University of New Mexico.

His love of poetry and sculpture led him through a life of teaching in Detroit, Marygrove, and Pennsylvania State University. His last appointment in 1974 was as special assistant artist-in-residence to the vice-president of undergraduate education. LaGrone and his wife, Lillian Graham LaGrone, now reside in Hamlet, North Carolina.

LOCATION OF NEW DEAL ARTWORK: Albuquerque-CTH.

## LANTZ LEIGHTON GOODWIN, JUANITA
### (1920-1969)

Juanita Donnell Lantz Leighton Goodwin grew up in Texas and eastern New Mexico. At one time she was married to Paul Lantz and assisted him with the paintings he created in the La Fonda Hotel in Santa Fé. She later married Fred Leighton, an importer, and Walter Goodwin of Santa Fé and continued to paint all her life. She worked on twenty-seven ceiling decorations with John Jellicoe for the Raton Carnegie Library during the New Deal era but they were later demolished when the building was destroyed to reroute the highway. Conducting art classes for the hispanic children of Roswell was another activity she engaged in as the result of New Deal funds. She died in Tucumcari, Arizona, below Tubac, in 1969. According to her son, Chris Lantz of Santa Fé, she had a one woman show in the National Gallery in Washington in the 1980's.

LOCATION OF NEW DEAL ARTWORK: Albuquerque-UNM Art Museum

## LANTZ, PAUL
### (1908-)

Born in Stromburg, Nebraska February 14, 1908, Lantz lived and painted in New Mexico from 1930 to 1939. His murals decorated La Fonda Hotel and other places in Santa Fé and could also be seen at the old mine headquarters in Madrid. During the mining days of that area he was hired by the mining company to make drawings of men killed in mine accidents for records and identification purposes since many folks could not read or write. He was married to Juanita Donnell by whom he had one son, Christopher. They were divorced when the son was six but he later remarried and had two other children. After leaving New Mexico, he lived, traveled and painted in New York, Kansas, San Francisco, Oregon and the east coast. He maintained a home in Santa Fé and New York City. Lantz led a productive life as an artist even illustrating some 30 books and some magazines. He was an individual who *"had* to paint or would become very fidgety" according to an old friend. He has five works displayed at the New Mexico State Museum in Santa Fé and the Metropolitan Museum of Art in New York City. The portraits of Clyde and Carrie Tingley at Carrie Tingley Hospital in Albuquerque are just two of many Lantz painted in his long career. His talents were extended to landscapes and murals which reflect the different areas of the country in which he lived and worked. There is one still in existence in New Mexico in a former post office in Clovis. He resided for sometime in the Springer, New Mexico area but his last known place of residence was Phoenix, Arizona.

LOCATIONS OF NEW DEAL ARTWORK: Albuquerque-UNM Art Museum, Clovis, Gallup, Raton, Washington, DC.

## LEA, TOM
### (1907-)

Born on July 11, 1907, Lea still lives in El Paso, Texas today. He studied at the Art Institute of Chicago from 1924 to 1926 and under John Norton in Chicago from 1926 through 1933. He worked on his first murals in Italy in 1930. He moved to Santa Fé in 1933 where he continued to paint while carrying on studies in Southwestern history and working as a part-time staff member of the Laboratory of Anthropology. In addition to his mural work in Las Cruces, which he did in the early 1930's while living in Santa Fé, he completed murals at South Park Community Building (Chicago), Court House (El Paso), State of Texas Building (Dallas), Post Office Department Buildings in Odessa and Seymour, TX and Washington, D. C., to name just a few. His work as an artist-correspondent for

Life magazine during World War II brought him considerable recognition and throughout his career he had illustrated over fifty books about the American West and the war, seven of which he also wrote. His works are in the collections of the University of Texas and the Dallas Museum of Fine Art. He has had numerous exhibits including one at the Whitney Museum of American Art, New York in 1938. At least three books have been done about his life and creations.

LOCATIONS OF NEW DEAL ARTWORK: Las Cruces-NMSU Art Museum & Branigan Cultural Center, Chicago, Dallas, El Paso, Odessa, Seymour, TX and Washington, DC.

## LEIGH, WILLIAM ROBINSON
### (1866-1955)

Born in Robinson, West Virginia in 1866, Leigh, son of impoverished Southern aristocrats, was educated privately. He studied art under Hugh Newell at Maryland Institute in Baltimore from 1880 to 1883. He then went to the Raupp-Royal Academy in Munich 1883-84, the pupil of Gysis 1885-86, of Lofftz 1887, and of Lindenschmid 1891-92. He became adept at drawing animals as a boy, winning a $100 award for a sketch of a dog from W. W. Corcoran of Washington, D. C. In 1897, Scribner's Magazine sent him on an assignment to North Dakota. In 1906 Leigh persuaded the Santa Fé Railroad to give him free transportation for his first trip to the West, in exchange for a painting. Five more paintings were commissioned, permitting Leigh to make an elaborate sketching trip through Arizona and New Mexico, living with the Indian tribes and cowboys. His realistic paintings are represented in major museums throughout the United States. His critics who had not seen the west said that the resulting paintings were of "purple horses with yellow bellies," a "ridiculously false color," and only illustrations. It was not until the 1940s that Leigh's Western work was completely accepted. An author of several short stories and books on the Southwest, his studio and many of his works are on exhibit at the Gilcrease Institute in Tulsa. He died in New York in 1955, the year he was elected to the National Academy of Design.

LOCATION OF NEW DEAL ARTWORK: Gallup.

## LOCKWOOD, JOHN WARD
### (1894-1963)

Born in Atchinson, Kansas in 1894, Ward Lockwood received his artistic training at the University of Kansas, Pennsylvania Academy of Fine Arts and at the

Academie Ransom in Paris. Further studies with Andrew Dasburg at Woodstock, New York, preceded his move to New Mexico in 1926. In addition to his contact with Dasburg, Lockwood also spent a good deal of the time fishing and sketching with John Marin, and painting with fellow Kansan, Kenneth Adams. He ended up in Taos because of these friends and because living was cheaper there. He was a member of the Taos Heptagon. In his landscapes, form rather then storytelling was the major concern; the painted landscapes had a raw vigor which was conveyed through a variety of simple shapes and sharp contours, with an influence from Dasburg's tamed and modified cubism. During the 1930s, when Lockwood participated in WPA mural projects, he responded to the taste for American Scene realism in various post offices ie. "Daniel Boone Leading His Men Into Kentucky," a post office rendering in Lexington, Kentucky and two in Washington called "Building the West" and Opening the West". He was also one of the Taos Fresco group that did the large frescos in the old Taos courthouse.

A versatile artist in many media, Lockwood was also a sought-after teacher; he taught at the University of New Mexico 1936-37 and University of Texas where he served as Chairman of the Department of Art (1938-39). Later he taught at the University of California at Berkeley (1939, 1949-61). Although he spent many years away from Taos, teaching art in California, he always retained contact with the Taos artist colony, visiting there from time to time throughout his life and finally died there in 1963.

LOCATIONS OF NEW DEAL ARTWORK: Taos, Edinburgh & Hamilton, TX, Lexington, KY, Washington, DC.

## LOEFFLER LACHER, GISELLA
### (1900-1969)

Born in Vienna, Austria (Wertherburg, Austria-Hungary) in 1900, Mrs. Gisella Loeffler Lacher lived in New Mexico as of 1932 residing in Taos and Albuquerque. This painter of egg tempera, enamel and lacquer maintained her own individual decorative and illustrative folk style and was said to have painted everything in her sight. She studied at the Washington University School of Fine Arts in St. Louis and while in that city painted the ceilings in the Children's Hospital. She also studied in Gloucester, Massachusetts and was the pupil of Mary McCall and Hugh Breckenridge. Her work have been exhibited at the Museum of New Mexico and in Los Angeles and two large murals can be seen at the Carrie Tingley Hospital for Crippled Children in Albuquerque. In addition to her painting and mural work, she illustrated a number of children's books and one, *Franzi and Gizzi*, which she both wrote and illustrated, was critically acclaimed. Another

was *Spanish Games of New Mexico*. She also did a poster for the New York Herald Tribune called "The Little Boy Dance of Taos." Her work was the basis of the decor of The Shed Restaurant in Santa Fé.

LOCATIONS OF NEW DEAL ARTWORK: Albuquerque-CTH, Las Cruces, Santa Fé-Museum of Fine Arts.

## LUCERO, ABAD
### (1909-)

In his 80's, this outstanding craftsperson is still at it! Lucero was born in Cerrillos, New Mexico in 1909 and has spent a lifetime carving everything from signs to santos. Through the New Deal programs he worked with the National Youth Administration (NYA) to teach young people woodworking. Many traditional pieces of Spanish furniture were created and distributed around the state's public buildings. He also worked for the Vocational Division of New Mexico Education Dept. and the U. S. Forest Service. Once retired he began teaching woodworking to other seniors in the Senior Art, Inc. program in Albuquerque where he resides and for the past years has guided them in their creations of retablos, traditional religious images painted or carved on wood and furniture.

## LUJAN, MERINA (See Pop Chalee)

## LUMPKINS, WILLIAM
### (1909-)

Born on a ranch near Clayton in the territory of New Mexico in 1909, Lumpkins has made quite a name for himself in the field of architecture and art. He grew up on his family's ranches in Lincoln County and in Arizona. Young Lumpkins and his friend, Peter Hurd, frequently went on camping trips where they did a great deal of sketching and studying art books provided to them by the librarian at New Mexico Military Institute, Paul Horgan.

Since the family's resources were not adequate for supporting a young aspiring artist, Lumpkins focused his educational activities on architecture at the University of New Mexico where he started in 1929 but while there he took courses in art, anthropology and journalism. Then he left to study architecture at the University of Southern California in Los Angeles but hitchhiked back to New Mexico where he finally graduated from the University of New Mexico in 1934. He began looking for work during the depression era when jobs were tough to come by. He was able to secure employment with the Public Works of Art

Project by presenting some samples of his art work to the supervisor Gustave Baumann who seemed to like his work and commented, "Yes, you are an artist, now go home and paint for us." He did just that for six months and three of those works are now in the Museum of Fine Arts in Santa Fé and one in Portales. Another watercolor has been located in Carville Maine Hospital in Los Angeles.

Six months later he was transferred to the WPA Architectural Division as a junior grade architect and assigned along with an old friend from Roswell, Frank Standhart, to design a state hospital for children who had been stricken with polio. Since neither of them knew exactly what was needed for such treatments they consulted with Mrs. Eleanor Roosevelt, wife of the President, himself a polio victim. She made arrangements for them to obtain the architectural plans of the Warm Springs facility where her husband had received his treatments. The WPA funded institution was built in Hot Springs, New Mexico and served its original purpose for over 50 years and then became the home of the New Mexico Veteran's Center. Lumpkins went on to become "the grand old man of solar adobe architecture" and is world renowned in this capacity.

Architecture did not keep him from continuing with his artwork. During the college days at UNM he was strongly supported by Raymond Jonson and others in the beginnings of his abstract style. This was not the most popular or acceptable form of art and they met with some opposition when they formed their Transcendental Painting Group in 1938 in Taos. The purpose of the group was to carry painting beyond the appearance of the physical world, through new concepts of space, color, light and design to imaginative realms that are idealistic and spiritual. Unfortunately World War II shortened the duration of this group and pilot Lumpkins found himself somewhat limited to creating portraits during his many hours of "waiting and ready" status.

Lumpkins feels that he was early influenced by a man who had traveled throughout the Orient and later came to the family ranch when he was pre-adolescent. Others along the way who made some impact on his style included Peter Hurd, Nils Hogner, John Marin, Loren Mozley and Cady Wells - many involved with the New Deal programs in New Mexico.

His talents in architecture and art seemed to come together in 1935 for Lumpkins and over the years he has noted that painting for him has freed up his architecture. His artwork is in both private and public collections.

LOCATIONS OF NEW DEAL ARTWORK: Portales-ENMU, Santa Fé-Museum of Fine Arts, Los Angeles-Carville Maine Hospital.

## LUNA, MAXIMO L.
### (1896-1964)

Furniture maker and carver "par excellent" from Taos according to many and particularly in the book *The Taos Artists, A Historical Narrative and Biographical Dictionary* by David Witt. He was involved in the vocational programs in northern New Mexico training the young men in building the traditional Hispanic furniture.

## MALDONADO, MANTHER
### (Dates Unknown)

This man was one of four junior high students who were chosen to do two murals for the public library in Raton. It is unknown whether he did other artwork. William Warder was one of those four to go on with his art.

LOCATION OF NEW DEAL ARTWORK: Raton

## MARTINEZ, JULIAN
### (1897-1943)

This San Ildefonso Indian was known in his pueblo as Po-Ea-No, which means "herd of animals." As a young man he began working with Dr. Edgar Hewett of the School of American Research. He was also chosen in 1903 to go to the 1904 World's Fair in St. Louis. He was most desirous of going and taking Maria Montoya, a young San Ildefonso girl, with him as his wife. After this was worked out between the families, the marriage was planned and held on the same day that they left for St. Louis. While there they both worked as singers and dancers and helped to educate the world about the Native American life in the southwest. Upon their return, Julian again worked with Hewett between 1907-1910 on the excavation of Puye Canyon dwellings. Initially his wife and son stayed at their pueblo home but later they went up to the excavation site also. In 1908 he began to be recognized for his drawings which he began doing as the result of seeing the petroglyph drawings and the designs on the ancient pottery. By 1909 he and Maria began working together to make and design pottery. During the winter months of 1909 Julian worked at the Palace of the Governors as a janitor and maintenance person and in 1910-1912 Maria and the children joined him. While living there, a market for their regular pottery and their new black pottery became a major activity in their lives. They were involved in the Indian New Deal project but we have not found any detailed records of what they did and where

it ended up. Making the black pottery, which came about as a firing error, changed their lives financially and they became most successful. Over the years the Martinez's attended World's Fair in Chicago, San Francisco, and Washington. They met with the President and Mrs. Roosevelt and were honored by them. Enroute home Julian collected clay from each state for the purpose of their trying to create pottery from clay from every state. With the financial success came some sadness. Julian had begun drinking which created problems for the family. Despite this he was elected governor of the pueblo in 1940 and saw some major changes in the pueblo at that time. His health problems became worse as the result of not taking care of his body and finally he died one evening when he wandered away from their home in the pueblo.

LOCATION OF POSSIBLE NEW DEAL ARTWORK: Santa Fe-Laboratory of Anthropology, Washington, DC.

## MARTINEZ, MARIA
### (1886-1980)

This Indian woman is probably the best known American potter in the world. Born in the San Ildefonso Pueblo to Reyes and Tomas Montoya she was named Povika, which means "flower leaf" and christened Maria. She had three sisters. Maria began making pots at the age of 14 and her quick intelligence was noticed by her school teacher and the tribal council. Both she and her sister, Desideria, were chosen by the council to go to St. Catherine's Indian School for two years in Santa Fé and then back to the pueblo for further study with one of the government teachers, Miss Grimes. At seventeen she married Julian Martinez (Po-Ea-No) whom her parents did not consider the most eligible bachelor in the pueblo but she talked them into letting her marry him. He was chosen to go to the World's Fair in St. Louis that year and they left for the fair directly from their wedding feast. This was the first of four world expositions in which they participated together as potters and dancers and just the beginning of the numerous experiences they had in the white man's world.

Their special pottery came together as a result of their early work with Dr. Edgar L. Hewett, Director of the School of American Research in 1907. First Julian worked with him on the excavations of prehistoric pueblo sites. Maria remained at the pueblo to care for their firstborn son and later a baby girl who did not survive her first winter. After this Maria joined Julian at the Puye Canyon site so the family could be together. Together they studied the prehistoric potsherds when asked by Hewett to reproduce the old pottery again if possible. They achieved making the "new old pots" and in the process also had a batch

that were fired poorly and turned out all black. Maria put these "bad" pots away but years later they were brought forth when they were trying to keep up with the orders they were getting once they moved into Santa Fé and worked at the Palace of the Governors. The "blackened pots" immediately became very popular. In addition to making fine pots, Maria was a good business woman and was always planning for having their own place to sell their pots and ways to improve their life style like having a new stove in her kitchen. They worked together for thirty-nine years recreating and creating designs on a matte band on a polished black body which made them both famous.

Maria's mastery of the old pueblo pottery making gave her family an economic way out of their economic struggles but then it also did the same for the whole pueblo village. Other women and then other husbands and wives began making the pottery in order to survive financially. However, no one's work became as revered as the Martinez's and in particular, Maria's. Finally the signing of the pots became important to keep track of who made what. It is interesting to note that Maria varied her own signature from time to time with different spellings, etc.

Maria raised four sons and her baby sister, Clara, who was deaf. One son, Popovi Da, helped her make her pottery after the death of her husband, Julian. Other family members also assisted. For over seventy years this working mother of five children created for her people and this country pottery works that are extremely valuable. It also brought her honorary doctorates, the last when she was 94 and just prior to her death. The other awards and decorations from various countries are too numerous to mention.

LOCATIONS OF NEW DEAL ARTWORK: Santa Fé-National Park Service, Museum of Fine Arts, Laboratory of Anthropology, Washington, DC.

## MC AFEE TURNER, ILA
### (1897-)

Ila McAfee Turner was born in 1897 and raised near Gunnison, Colorado. As a young girl she assisted her father, who had the use of only one hand, in his work with the farm animals. She became a lover of horses very early on. Later she went to California on $100.00 where she became a student of James E. McBurney in Los Angeles and later studied art in Chicago and New York City. She settled in Taos in 1928 with her husband, Elmer Page Turner. She is well known for her pictures of animals, particularly horses. Ila McAfee illustrated the children's book "All the Year 'Round with the Furry Fold" and furnished her home with many of her own hand carved pieces. The Turner's studio is named "White

Horse Studio" after a plaster sculpture of a white horse which served as a model for her life-size sculpture of Joan of Arc on her horse. McAfee has designed fabrics, wrapping paper, dishes, and calendars. wood carvings, and provided the illustrated cover for Walter Foster's book, "How to Draw Horses." She was delighted to get to do a mural in the post office of her hometown during the New Deal and has other murals in Gunnison, Co., Clifton, Tx. and Cordell and Edmond, Ok. In her later years she has also enjoyed hot air ballooning. She has moved to Pueblo, Colorado after residing in Taos for nearly 65 years.

LOCATIONS OF NEW DEAL ARTWORK: Albuquerque-CTH, Clifton, TX, Cordell, Edmond, & Gunnison, OK, Washington, DC.

## MC MURDO, J.T.
### (Dates unknown)

Supervisor Bauman indicated that McMurdo lived in Albuquerque and "continued to wear cowboy boots long after the advent of the automobile. He is self-taught or a 'natural born artist.' No review of his work is quite adequate---it must be seen to be appreciated. One of his paintings, "A Salty BobCat" is to hang in Mayor Clyde Tingley's office in Albuquerque." That work has not been located nor two other paintings that appeared to have been sent to Washington.

LOCATION OF NEW DEAL ARTWORK: Unknown

## MEAD, BEN CARLTON
### (1902-1986)

Born in Bay City, Texas. Mead lived in Texas and Oklahoma before settling at Amarillo. During high school he painted theater posters and stage sets, and worked as sports editor for the Amarillo Daily News. After graduating from Amarillo High School in 1923, Mead studied at the Art Institute of Chicago for three years, and later with painter, Hugo D. Pohl at San Antonio. While working as a commercial artist at San Antonio in 1929, Mead met the noted folklorist J. Frank Dobie and eventually illustrated several Dobie books including *Coronado's Children* (1930), *On The Open Range* (1931) *I'll Tell You a Tale* (1960), and *Cow People* (1964). From 1930 to 1932 Mead was staff artist at the Witte Museum at San Antonio, after which he returned to Amarillo. He taught art at Amarillo Junior College and in his downtown Amarillo studio, and maintained a studio near Palo Duro Canyon. Another Coronado mural is located in the Quay County courthouse in Tucumcari. In 1934 he began the first of three murals for the west

wall of the Panhandle Plains Historical Museum's Pioneer Hall. Painted under the auspices of the Public Works of Art Project, the first mural depicts Coronado and his party in Palo Duro Canyon. After moving to Chicago and back to Amarillo, Mead moved to Dallas in 1941 where he again worked as a commercial artist. One of his war bond posters was shown in over 17,000 theaters in the United States. He continued to live and work at Dallas and in 1973 appeared in an episode of the television series "Gunsmoke." After enduring virtual blindness for some three years in the late 1970s, a corneal transplant enabled Mead to begin painting again. He moved to California in the early 1980s, and died there in 1986.

A student of Western history, Mead took great pride in the historical accuracy and attention to detail found in his work. Careful sketches and drawings of historical artifacts supplied Mead with an immense pictorial vocabulary upon which he would depend for his compositions. He was a member of the Western History Association, the Texas State Historical Association, and the Panhandle-Plains Historical Society. Mead's inclusion in Jeff Dykes *Fifty Great Western Illustrators* indicates the high regard in which his work is held.

LOCATIONS OF NEW DEAL ARTWORK: Tucumcari, Canyon, TX.

## MIRABEL, VICENTE
### (1918-1946)

Chiu Tah (Dancing Boy) was born at the Taos Pueblo and graduated from the Santa Fé Indian School He was an assistant painting instructor there when he entered the Army during World War II and his budding art career was cut short when he was killed in the Battle of the Bulge. He was married to a Navajo woman and they had three sons.

LOCATION OF POSSIBLE NEW DEAL ARTWORK: Unknown

## MORANG, DOROTHY
### (1906-)

Born in Bridgton, ME in 1906, Dorothy's first artistic talent was focused in music. She was trained as a pianist and later taught in West Bridgton, ME in 1922-23. In 1928 she went to Boston to study at the New England conservatory of Music. After marrying artist, Alfred Morang, in 1930 she taught piano and performed as a soloist in Maine from 1928 to 1936. The couple moved to Santa Fé in 1939 where he became involved as an artist. She had begun developing her fine art

talents as a result of being with him and many other artists. As a result, she also became active in the New Deal projects both with easel painting and as a music teacher. They both carried on the visionary work of artist/philosopher Wassily Kandinsky of Paris and they joined others who were also active in his Transcendental Movement. The others included Bisttram, Morang, Lumpkins and Jonson and they referred to themselves as the Transcendental Painting Group. Today she has become one of the unsung heroes of that movement here in New Mexico.

She worked for the Museum of Fine Arts for over 20 years beginning in 1942 and served as the curator there during that time. During this period of her life, she was a most prominent and visible force in Santa Fé's art community. She received numerous awards at juried shows throughout the region. Her vision and style always challenges the viewer and Kim Wiggins commented that "Morang's world is an ethereal, spiritual one. Trying to understand it, one has to be willing to enter his or her own fantasia."

Mrs. Morang became interested also in working with enamels and that was as close to any form of commercialism in art that she touched. Capturing her mood, expressing it with the use of color was most rewarding to her. She has retired in Santa Fé.

LOCATION OF NEW DEAL ARTWORK: Albuquerque-UNM Art Museum

## MORRIS, JAMES S. "JAY"
### (1902-1973)

Born in Marshall, Missouri, Morris variously listed his birthdate as 1898 or 1902. He studied at the Cincinnati Art Academy from 1925 to 1926 and at the Pennsylvania Academy of the Fine Arts. In the late 1920s was encouraged to come to Santa Fé by Willard Nash and while visiting in the city he met John Sloan and became entranced by the southwestern landscape. Sloan subsequently arranged a scholarship for Morris at the Art Students League in New York. During the depression, Morris returned to New Mexico with Charles Barrows and they were found sleeping in the park their first night in town by poet, Witter Bynner. He befriended them and they both got settled in the community. Morris worked on the New Deal *Portfolio* at one point. As he continued to paint, Morris' boldly executed oils and more delicate watercolors grew increasingly abstract, then shifted to a more representational, social-commentary style. During World War II he was in the Seabees in Alaska and afterwards his work took on elements of fantasy, perhaps reflecting his concern about the diminishing coherence of

twentieth-century society. Morris worked with Barrows on a mural for the vocational school at El Rito but it has not been found.

LOCATIONS OF NEW DEAL ARTWORK: Albuquerque-UNM Art Museum, El Rito?, Portfolio.

## MOSES, TRINIDAD
### (Dates Unknown)

This man was one of four junior high students who were chosen to do two murals for the public library in Raton. It is unknown whether he did other artwork. William Warder was one of those four to go on with his art.

## MOYLAN, LLOYD
### (1893-1963)

Moylan was born in St Paul, Minneapolis and studied at the Minneapolis Art Institute. Further art training followed at the Art Students League of New York between 1917 and 1919. A teaching position at the Broadmoor Art Academy in Colorado Springs brought him west. Moylan was a resident of New Mexico as of 1939, living for a time in Gallup. One of his largest murals can be seen there in the McKinley County Courthouse. His work both as a painter, primarily in watercolor, and his printmaking in the form of lithographs has been exhibited throughout several principal cities of the United States and Mexico. Trips to Mexico exposed Moylan to the burgeoning mural movement there and inspired him to execute several murals in the Colorado Springs area. Eventually, investigating Indian themes for his work, he gravitated to New Mexico where his mural work continued under WPA sponsorship. In addition to the mural in Gallup, two other outstanding murals can be found at Highlands University in Las Vegas and Eastern New Mexico University in Portales. He also did at least seven paintings of Indian dances for the Kirtland Air Base and six are still in the Officers Club Bar area. A traveling show of fourteen paintings depicting Navajo life was also created by Moylan. His style could be described as being abstract and expressionistic in nature. Before his death, he was the museum curator of the Museum of Navajo Ceremonial Art (now Wheelwright Museum) in Santa Fé.

LOCATIONS OF NEW DEAL ARTWORK: Albuquerque-Kirtland Officer's Club & UNM Art Museum, Gallup, Las Vegas-NMHU, Portales-ENMU, Washington, DC.

## MOZLEY, LOREN NORMAN
(1905-1989)

Mozley's family moved to New Mexico shortly after he was born on October 2, 1905 in Brookport, Illinois. His father came here to be a "cow country doctor" so Mozley was educated in country schools, Indian schools and finally studied at the University of New Mexico. He primarily studied art independently but did study three years in Paris in the early 1930's at the Academie Colarossi and the Academie Grande Chaumiere. Over the years he held many jobs in order to support himself and his painting. This included being an Indian trader, lumbercamp merchant, museum curator, hotel clerk, bartender, lithographer, commercial photographer retoucher and airplane plant worker. In 1924 he became a resident of Taos and was a member of the Taos Art Association and the Taos Heptagon. Later, after moving to Austin, Texas, Loren Mozley executed murals in Alvin, Texas, the United States Post Office in Clinton, Oklahoma and the Federal Building and U. S. Courthouse in Albuquerque. He was the author of *Yankee Artist*, a monograph on John Marin and exhibited his work at the Museum of Modern Art, New York for the Marin Exhibition in 1936. References were also found to the fact he also wrote beautiful poetry.

LOCATION OF NEW DEAL ARTWORK: Albuquerque, Alvin and Clinton, OK.

## MYERS, DATUS ENSIGN
(1879-1960)

Myers was born in Jefferson, Oregon and studied at the Art Institute in Chicago between 1905-1910. While there he met Alice Clark who became his wife. She became one of the first women architects in the country. He painted as much as was possible while trying to make a living and raising a family. In 1926 the family moved to Santa Fé and Mrs. Myers designed a large home for them on the Camino de Monte Sol and many parties were held there including all of the Santa Fe artists and their families. While in the southwest, he was named the Field Coordinator for the Indian Division of the PWAP. In 1939 he was chosen to do a mural for the post office in Winnsboro, LA entitled "Logging in Louisiana Swamps." For this he was paid $530 by the Section portion of the New Deal projects. He also did a watercolor called "Clowning Koshares" that may have ended up in Washington. Another work can be seen in the museum at West Texas State University in Canyon, Texas. Over the years he combined his Egyptian and Oriental art research with his love of American Indian painting. According to his daughter, his work is not as well known as some of the others of his time primarily because he did not sell through the local established galleries.

He was active in the I AM activity, a religious group, while living in Santa Fé and continued this association in his work when he moved in 1953 to Shasta Springs, CA. where he died. A daughter, Eve Myers Foley, still resides in Santa Fé and has been known for her modern dance work.

LOCATION OF NEW DEAL ARTWORK: Canyon, TX, Winnsboro, LA, Washington, DC.

## NAILOR, GERALD
### (1917-1952)

Pindedale, N.M. was the birthplace of this Navajo whose name was Toh Yah meaning Walking By the River. He later married a Picuris Pueblo woman and moved to her pueblo. Their son, Jerry Nailor, later became the tribe's governor and also an artist.

Gerald Nailor graduated from the Albuquerque Indian School and later studied with Dorothy Dunn, Kenneth Chapman, and the Swedish muralist, Olaf Nordmark. He created murals for the U. S. Department of the Interior in 1939-40 with Allan Houser, Velino Herrera and other Native American artists. Houser and Nailor shared studio space in Santa Fé over the years and were very close friends. Nailor also did murals for the Mesa Verde Post Office in Colorado and the Navajo Tribal Council House in Window Rock, AZ.

LOCATION OF NEW DEAL ARTWORK: Washington-Dept. of Interior, Mesa Verde, CO. Window Rock, AZ.

## NARANJO, EULOGIO
### (Little known)

Pottery vessel created by Naranjo is on exhibit at the National Park Service in Santa Fé.

## NASH, WILLARD
### (1898-1943)

Born in Philadelphia, Pennsylvania, Nash studied in Detroit with John P. Wicker. He then moved to New Mexico in 1920 in search for a more stimulating artistic environment. Known as the Santa Fé "modernist", Willard Nash's early work was still academic in conception, as he used rather subdued tones and conventional compositions. However, after studying with Dasburg, he experimented with the techniques of the Fauves and Post-Impressionists, especially Cezanne. By the

end of his first year in Santa Fé a greater brilliance and feeling for luminous color began to characterize his canvases.

He became a founding member of Los Cinco Pintores and built a home alongside his colleagues on Camino del Monte Sol. All the artists in this group were struggling financially except Nash who had a wealthy patron. His growing devotion to the architectonic structure of Cezanne in the thirties and to abstraction in the forties marks him as one of the more daring New Mexico modernists. Nash was frequently able to reduce the forms of nature to visually exciting notations of color and shape which had ingenious harmonies and geometric rhythms. In 1936 Nash left Santa Fé for California, where he taught at the San Francisco Art School and the Art Center School in Los Angeles but returned to Albuquerque in 1942 where he died.

LOCATION OF NEW DEAL ARTWORK: Albuquerque-UNM Art Museum.

## NAUMER, HELMUTH
(1907-1989)

Reutilingen, Germany, near Stuttgart, was the birthplace for a German youngster who fell in love with the romantic west through the books of Karl May. At age 17 he left Germany for the life of a sailor and traveled around the world twice. By 1927 he was living with the Santo Domingo Indians learning about New Mexico. A year or so later he moved up to Santa Fé to further develop his talents as an artist among other artists. As part of that he was one of the artists involved with the *Portfolio*. One of his mentors, Carlos Vierra, provided regular opportunities for growth with other European trained artists at his home in the southern part of Santa Fé. Naumer built his initial slab cabin outside Santa Fé with the help of other artists such as Tom Lea and Harper Henry. Naumer was also a fine accordion player and musician and enjoyed playing at local dances where he met his future wife, Tomee Reuter, a resident of Pecos.

Naumer continued his close relationship with the Native Americans throughout his life, yet he himself loved and lived the cowboy image. He was an avid horseman and marksman who was a member of the Santa Fé County Sheriff's Posse for 30 years. However, his life's focus was to capture the spirit of New Mexico through his favorite medium, pastels, which he felt were ideal for catching the fleeting effects of sky and earth in New Mexico's changing landscape. He believed that when properly handled, pastels were a more permanent medium than oils and portrayed New Mexico's vast pallet of colors better than any other medium. In many of his paintings he would use the full

array of the 1,000 colors available in his especially produced European pastel boxes.

Naumer studied art in Germany and later at the Frank Wiggins School of Art in Los Angeles. New Mexico was always his favorite subject, but he painted throughout the U. S. and around the world.

His paintings are present in private and museum collections throughout the world. He is well known for a series of pastels of Pueblo communities created in the 1930's under the New Deal program and these works can be found at the Bandelier National Monument. Other creations can be enjoyed around the state and in the state's Museum of Fine Arts which is part of the state's museum system that his son, Helmuth J. Naumer administered prior to his death in 1994.

Just prior to his death, the artist Naumer stated he had only two disappointments in life--first that he had not swum 5000 miles (he made 4910) and that he had gone blind and could not still paint the land he loved so much. (This segment written by his son, Helmeth J. Naumer.)

LOCATIONS OF NEW DEAL ARTWORK: Albuquerque, Bandelier, Clayton, Gallup, Melrose, Roswell, Santa Fé.

## NORDFELDT, Bror Julius Olsson (B.J.O.)
### (1878-1955)

Nordfeldt emigrated to Chicago in 1891 from his native Sweden. After a year of training at the Art Institute of Chicago, he began a decade of further art studies, painting, and printmaking in this country and Europe. In 1919 he established residence in Santa Fé, where he lived for the next twenty years and was referred to primarily as "Nordy." His wife was a local psychoanalyst. In his paintings, etchings, and lithographs he analyzed the rugged southwestern landscape or expressed fascination with his Hispanic neighbors. Elements of Cézanne and the Fauves are present in his work, along with a personal strain of expressionism. From 1934 to 1937 Nordfeldt divided his time among Wichita, Minneapolis, and Santa Fé, where he taught, painted portraits, and made lithographs for the PWAP. In 1937 he moved to Lambertville, New Jersey, which became his home for the rest of his life. However, he died in Henderson, Texas in 1955.

POSSIBLE LOCATIONS OF NEW DEAL ARTWORK: (Not all have been located in the public schools.) Alamogordo, Albuquerque, Artesia, Belen, Capitan, Carlsbad, Carrizozo, Clayton, Clovis, East Vaughn, El Rito, Grants, Hurley, Las Cruces, Las Vegas, Lordsburg, Mosquero, Portales, Raton, Roswell, Santa Fé, Santa Rosa, Silver City, Socorro, Springer, Taos, Wagon Mound, Washington DC-a large collection of privately done works.

## NYE, VIRGINIA
(Unknown)

Very little known about this artist. She worked on the *Portfolio* and there is a small creation in the county commissioner's Board Room in Gallup. She was believed to have lived in that area with her husband who was in the military.

LOCATION OF NEW DEAL ARTWORK: Gallup, Portfolios

## PARSONS, SHELDON
(1866-1943)

Sheldon Parsons was born in Rochester, New York in 1866 and was known for his portraiture in the early 1900's. President McKinley and Susan B. Anthony were two of the famous Americans whose portraits Sheldon Parsons painted in the early 1900s. His talent for portraiture had emerged while he was still a student at the National Academy of Design, and a successful career in New York seemed assured. But his wife's death in 1913 abruptly changed his plans. The artist and his young daughter, Sara, sold all their possessions and took the train west to Denver. There Parsons suffered a relapse of tuberculosis and was advised by doctors to try New Mexico's climate. When well enough to travel, Parsons and his twelve-year old daughter boarded a southbound train. In Santa Fé they were welcomed into the community by helpful citizens willing to exchange the necessities of life for Parson's paintings. As the artist recovered his health, he began painting landscapes---a longstanding interest of his. Absorbed with the color and light of his new environment, he recorded the town, nearby Indian pueblos, and the imposing New Mexico desert and mountains. In time Parsons became a well-known artist, accommodating his early Barbizon and Impressionist training to the light-drenched scenes of the Southwest. He worked on the *Portfolio* and did numerous paintings for the New Deal art projects. He served as an early administrator at the Museum of New Mexico, assisting in that capacity many later arrivals to the artistic community.

The young daughter, Sara, who came west with Parsons grew up to be a distinguished painter herself. It is reported that Sara and her father would journey out in a horse drawn wagon to wander the countryside painting as they went. Looking over the next rise for another good view might mean returning to town in a few hours or six weeks. That ceased when he died in 1943 in Albuquerque.

LOCATIONS OF NEW DEAL ARTWORK: Albuquerque-CTH, Melrose, Roswell, Santa Fé, Washington, DC, Portfolios.

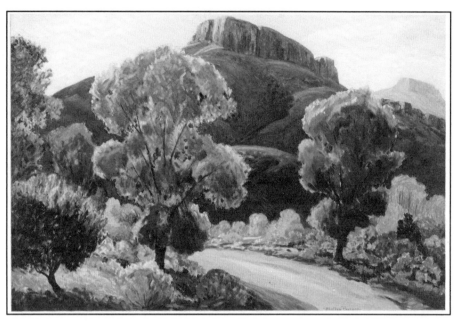

Sheldon Parsons, "View from San Ildefonso" (also referred to as "View from Otowi")

## PAYNE, EDGAR ALWIN
### (1882-1947)

Born in Washburn, Missouri in 1882, Payne left home at fourteen to paint in the Ozarks, followed by a trip to Mexico. He had begun as a house and sign painter and also as a decorator. He became known, however, as a western landscape painter and muralist and, while living in Chicago, became a member of the Chicago Society of Artists. In 1911 a sketching trip West took him to Laguna Beach, California where he settled in 1917, and where he did many coastal scenes in the Monterey and Laguna Beach areas. His paintings are in many collections and his murals are in commercial and public buildings in several western states as well as Indiana and Illinois. Payne, a largely self-taught artist, is well known throughout the Southwest for his mountain and desert landscapes, the latter frequently depicting Indian life as he saw it in northern Arizona. He also painted in New Mexico, the Grand Canyon, Canyon de Chelly, and the mesas. His work is displayed at the National Academy of Design, New York; Southwest Museum, Los Angeles; University of Nebraska, Lincoln; Hubbell Trading Post Museum, Ganado, Arizona. Edgar Payne was a member of the Alumni Association of the Art Institute of Chicago. He died in Los Angeles, California on April 8, 1947.

LOCATION OF NEW DEAL ARTWORK: Gallup

# PENA, TONITA
## ((1895-1949)

Tonita's San Ildefonso tribal name was Quah Ah meaning White Coral Beads. She was born at the pueblo on June 13, 1895 and was reared by an aunt, Martina Vigil. As a child of seven, she was already painting. She attended the Santa Fé Indian School and was one of the eight painters who completed 13 panel mural paintings at the school and numerous watercolor paintings. Her first husband, Juan Chaves, was from Cochiti Pueblo and after he died she married Felipe Herrera and their son, Joe Herrera, has also become an outstanding painter. Pena was one of the first Indian painters to reject the tradition that Indian women painted only on pottery. She came to use painting as a form of personal artistic expression and as such was the first pueblo woman to win independent recognition as a painter.

LOCATION OF NEW DEAL ARTWORK: Santa Fe Indian School.

# PHILLIPS, BERT GEER
## (1868-1956)

Born in Hudson, New York, Phillips grew up with a passion for art. He studied at the National Academy of Design and the Art Student League in New York. After five years in a New York studio, he went to Paris, where he enrolled at the Academie Julian and studied with Constant and Laurens. There he met Joseph Sharp, who convinced him and fellow student Ernest Blumenschein to visit Taos, New Mexico where Sharp had been two years earlier. In 1898, Phillips and Blumenschein acquired a wagon, team and outfit in Denver and started out on a painting expedition southward but due to major misfortune with their wagon ended up in Taos. It may have been fate for Phillips established his home there and was a resident of New Mexico from that time on. He became a founding member of the Taos Society of Artists and committed himself to New Mexico for the next sixty years. At one point he almost lost his eyesight and decided to stop painting for four years. During that time he worked for the Carson National Forest Service and he later expressed that this experience "opened his eyes and heart" allowing him to create his best works. His vivid, realistic, oil paintings fostered a romantic view of Native American life. Phillips wrote, "...I believe it is the romance of this great pure-aired land that makes the most lasting impression on my mind and heart." In his contact with the Indians, Phillips attempted to break through their native reserve by patience and understanding

which gave his paintings an aura of idealized ethnology, and instilled in his subjects a visionary and unreal conceptual quality. His work is exhibited widely throughout the United States and is represented in several State Capitols and a number of museums including the Museum of New Mexico. He died in San Diego, California in 1956.

LOCATIONS OF NEW DEAL ARTWORK: Raton, Taos.

### PIERCE, EDMA
(Dates Unknown)

We believe this woman came to Albuquerque from Melrose or Carrizozo (unable to verify) and studied art at UNM circa 1937. She worked on the *Portfolio* and her supervisor, Roland Dickey, recalled "she was in tears when he came to pick up her work that involved painting numerous drops of blood in the renderings of Jesus on the cross." She was a devout Protestant and may have done a mural at the First Baptist Church in Albuquerque at the corner of Broadway and East Central Ave. One person who remembered her described her as "very shy, talented and sweet" and Gus Baumann described her work as "rather melancholy in tone due to the subdued color and deep shadows, her work is marked by broad simplicity of treatment." Little else has been found about her.

LOCATION OF NEW DEAL ARTWORK: Albuquerque-UNM Art Museum.

### PILLIN, POLIA
(1905-Date Unknown)

This young Polish artist was born in Poland where her father was an instructor in the Czenstokowa Teck in crafts, specializing in metal and leather - beginning her life in a creative atmosphere. She came to the United States when she was fifteen and settled in Chicago. In 1932 she visited Santa Fé for the first time and vowed to return as soon as possible. She accomplished this in 1936 and worked consistently to grasp the essential quality of the countryside. She noted that an artist "must experience New Mexico before he/she can hope to paint it." Records indicate she was part of the New Mexico New Deal program in October 1938.

Prior to coming here she had studied art at the Art Students League in New York, the Art Institute in Chicago and worked with private teachers with emphasis on the School of Expressionism. Once in New Mexico she found these styles not suited to the aesthetic presentation of these landscapes and evolved

a style of her own. Her watercolors were her strongest works because it was through this medium she felt the ability to express the ever changing moods of light and shadow that passed so rapidly. She was always very sure of herself and knew what she wanted and went ahead and did it. This carried over in her painting. If something did not come out in her first attempt, she would destroy it and immediately start over again until she obtained exactly what she wanted. She did not paint for the acclaim of the world but for the satisfaction of her own creative ego and its expression.

LOCATION OF NEW DEAL ARTWORK: Albuquerque, Clayton.

## QUINTANA, AGAPINA
(Dates Unknown)
From Cochiti Pueblo. Pottery on exhibit at National Park Service in Santa Fé.

## REDIN, CARL
(1892-1944)

Carl Adolf Hjalmer Persson Redin was born in southern Sweden and while still a youngster began covering household objects with his creations. Likewise he was frequently caught not doing his chores but rather drawing and sketching his family and surrounding scenery. The young boy also had a great desire to come to America and dreamed of it during many of his periods of illness and poverty. When Redin was 14, the village doctor's wife made arrangements for him to study art in Stockholm at night while he worked during the day to help support his family. Finally in 1913 he was able to immigrate to the United States and lived in Chicago for three years until he went west to New Mexico in 1916 to improve his failing health as a result of tuberculosis. During his recovery he became close friends with an Albuquerque dentist and amateur painter who spoke fluent Swedish and they went on sketching trips once a week.

During and after his recovery Redin had various benefactors who provided him with opportunities to continue his painting. He taught in 1929-30 in the University of New Mexico art department but some have suggested that his heavy accent kept him from a lengthier teaching career. Other New Mexico painters chose to live and paint further north but Redin remained in Albuquerque and through his painting mythologized "his" town. His style was perfectly congruent with the popular tastes of the day and his images and vision became part of what most people think of today when they imagine New Mexico. Dying at an early age (52), not associating with any particular group or school of art, and choosing to work in a town with less artistic reputation may be the key

reasons why his outstanding work is not as well known as others during that time. However, his artwork hangs in many public and private collections.

In 1940 Redin and his wife moved to Los Gatos, CA as a result of his failing heart. He continued to paint the seascapes and environment around him but never responded to this environment like his beloved New Mexico. He died four years later.

POSSIBLE LOCATIONS OF NEW DEAL ARTWORK: Albuquerque, Hatch, Las Vegas, Los Lunas, Los Lunas, Silver City. Springer, Washington, DC.

## RODRIGUEZ, ELISEO
### (1915-)

Rodriguez was born in Rowe, New Mexico and currently lives in Santa Fé with his wife, Paula. He began his art studies at 14, when his talent was noted and he was given a scholarship to the Santa Fé Art School where he painted for three years. In 1936 he was one of a group of New Mexico artists assigned to paint murals for the Texas Centennial which featured Coronado's entry into New Mexico. As part of the New Deal projects he worked with Louie Ewing on a mosaic fountain base holding animal creations by Eugenie Shonnard at the Carrie Tingley Hospital for Crippled Children in Hot Springs, NM. That facility is now the Veteran's Center in that same town, now called Truth or Consequences. He also worked on the *Portfolio of Spanish Colonial Design* in New Mexico and the other portfolios in the possession of the Laboratory of Anthropology. After WWII he taught cabinet-making and design for the N.M. Department of Vocational Education and also worked for several years for a company specializing in church architecture in California, Colorado and New Mexico. One of those creations-a 15 panel "Stations of the Cross" took him eight years and was completed in 1964. It is located in Our Lady of Grace Catholic Church in Castro Valley, CA. A much smaller "stations mural" can be seen at the Penitente Morada at Cordova, NM.

Today he has become renown for his intricate straw mosaic work. This craft died out in the latter part of the 19th century but Eliseo is leading its revival and has become particularly well known for his straw mosaic crosses which have been exhibited all over the world. He and his wife are also busy passing on this beautiful tradition to their grandchildren.

LOCATION OF NEW DEAL ARTWORK: Portfolios, Truth or Consequences.

## ROGERS, R. HUBERT
(Unknown)

Little known about his life. During the New Deal era, he created a mural painting called "Federal Road Work" for the Federal Building (early Post Office) in Santa Fé. This work was later transferred to Denver by the U.S. General Services Administration. He also did two murals called "San Felipe Man" and "San Felipe Woman" that are believed to have been sent to Washington.

POSSIBLE LOCATIONS OF NEW DEAL ARTWORK: Denver and Washington, DC.

## ROLLINS, WARREN ELIPHALET
(1861-1962)

Born in Carson City, Nevada on August 8, 1861, Rollins was raised in California. He was the pupil of Virgil Williams at the San Francisco School of Design, becoming assistant director of the school. In 1887 after further study in the East he moved to San Diego. He began to specialize in Indian subjects, traveling through the Western states. He was one of the first artists allowed to live among the Indians and admitted to their ceremonies. In 1900 he was in Arizona painting Hopi Indians. He also worked at the Chaco Canyon ruins in northern New Mexico and had a studio near El Tovar at the Grand Canyon. Rollins was an early member of Santa Fé artists colony, painting and teaching along with Carlos Vierra, Gerald Cassidy, Kenneth Chapman, and Sheldon Parsons, arriving in 1915 through his friendship with E. I. Couse. He had previously spent years at Pueblo Bonita. Rollins had the first formal exhibition in Santa Fé, showing Indian paintings before 1910 so that he was properly regarded as the "dean of the Santa Fé art colony." Some of his work can still be seen at Bishop's Lodge in Santa Fé. Three paintings created for the former Gallup Post Office have been restored and hang in offices of the regional offices of the U. S. General Services Administration in Ft. Worth. Although Rollins worked primarily with oils, he began in 1925 some experiments with wax crayons which became a life-time interest. "Crayon gives stability," said Rollins. "It never fades or cracks, and may be viewed from almost any angle." Many of his Arizona desert and Santa Fé area scenes were done in that medium. Rollins and his wife, Birdella, had two daughters, Ramona and Ruth. Late in his life he was stricken with a palsy condition which impeded his ability to do his beloved painting. He died January 15, 1962 with his family in Winslow, Arizona.

An unpublished biography of his life was done by his grandson, Warren Griffin, and a copy is on file in the N. M. Records and Archives.

LOCATION OF NEW DEAL ARTWORK: Fort Worth, TX.

## ROMERO DE ROMERO, ESQUIPULA
### (1889-1975)

Born in Cabezon, New Mexico in 1889, Romero de Romero was an early New Mexico artist who settled in Albuquerque in 1904. He established a successful outdoor advertising company and turned to serious painting in 1926. By the 1930's he was well known locally for his portrait, landscape, and Penitente paintings. In 1936 Romero sold his combined home, studio, and art gallery, built in 1924, and left Albuquerque to live and paint in Latin American countries. He exhibited widely and was still preparing for solo exhibitions at age 73. That year, 1962, he returned to Albuquerque, assisted in the building of a new home, and on occasion was seen riding a motorcycle. Prior to that time he had also painted in Mexico, Canada, and in other Western states, especially along the West Coast. He specialized in landscapes. Records indicate he did a New Deal mural along with Brooks Willis and Stuart Walker for the old Bernalillo County Courthouse but that work is now privately owned. Also a mural was done by him in his old Villa de Romero Inn, later Sunset Inn, and now Manzano Day School, and it too has disappeared, possibly painted over.

LOCATION OF POSSIBLE NEW DEAL ARTWORK: Unknown

## ROYBAL, ALFONSO "AWA TSIREH"
### (1895-1955)
### San Ildefonso

This San Ildefonso native was commissioned in 1917 by Alice Corbin Henderson to execute paintings for her. Later without formal education beyond the primary grades, he painted with others at the School of American Research. In 1933 the St. Louis Post Dispatch quoted the artist, John Sloan, as saying that "when Awa Tsireh sits down to paint a leaping deer he remembers not only the way a deer looks when leaping over a log but he feels himself leaping in the dance, with antlers swaying on his forehead and two sticks braced in hands for forelegs." Fred Kabotie, Velino Hererra and Roybal were the first Pueblo Indians to win individual recognition as artists. By 1950 according to "El Palacio" he had abandoned his painting, silversmithing and other unrelated jobs due to poor eyesight, shaky hands and other personal reasons.

## ROYBAL, SEVERINO
### (1900-1986)
### San Ildefonso Pueblo

# RUSH, OLIVE
## (1873-1966)

Olive Rush was born in Fairmount, Indiana in 1873 and studied at the Art Students League of New York and with Howard Pyle in Paris. She was an independent spirit, experimenting with many styles during her lengthy career as an artist. Best known as a proficient painter in oils, watercolor and fresco, she was able to combine "old world" sophistication with a daring sense of adventure. There is a refreshing spontaneity in her work, and a subtle feeling for the design of basic shapes which Rush intensified by daring color application to suggest the piercing light of New Mexico.

She was a long time resident of New Mexico, making her home in Santa Fé and that home she gave to the Quakers for their Meeting House and it is in use as such today. Her work has been widely exhibited in the United States and she won numerous awards including an Honorary Doctor of Fine Arts from Earlbain College. Rush's work is represented in various museums and public buildings around the country. Here in New Mexico, as part of the New Deal, she created a delightful fresco in the old Santa Fé Public Library which is to become the state's History Museum and a large mural was also done in Las Cruces at the Biology Building at New Mexico State University. Unfortunately, that work was "repainted" with enamel by some individuals who did not necessarily know better and it is hoped that the work can someday be restored to its original presentation. She did other work at the Indian School in Santa Fé, but the funding source is unknown. Privately known works included the exterior entrance walls of La Fonda Hotel in Santa Fé and Maisel's Trading Post in downtown Albuquerque where she was commissioned and included young Indian students from the Santa Fé Indian School to assist her. Some went on to achieve some recognition. Two other New Deal murals were created for post offices in Pawhuska OK and Florence, CO.

LOCATIONS OF NEW DEAL ARTWORK: Las Cruces, Roswell, Santa Fé, Florence, CO, and Pawhuska, OK.

# SANCHEZ, JUAN AMADEUS
## (1911-1990)

Spanish carver who's religious creations adhered strictly to the traditional form. He was hired in 1936 by the FAP to create this traditional work. These creations can be found in New Mexico and Colorado Museums. He also worked on the *Portfolio*. Tom Riedel did a master's thesis in 1992 on Sanchez and his work.

LOCATIONS OF NEW DEAL ARTWORK: Roswell Art Center, Santa Fe-International Folk Art Museum & Museum of Fine Arts, Colorado Springs-Taylor Museum, Boulder-University of Colorado.

## SANCHEZ, RAMOS
### (Dates Unknown)

Oqwa Owin or Kachina Town or Rain God Town was born in San Ildefonso Pueblo March 17, 1926. He married Marie Gertrude Montoya in 1949 and they had three children.

## SAVILLE, BRUCE WILDER
### (1893-1938)

Little has been found about this sculptor but we believe he was born in Massachusetts. He designed and executed many symbolic figure groups including war memorials in Maine, Ohio, New York, Michigan, Mississippi, Missouri and New Mexico. An early letter between Vernon Hunter, the N. M. State Director, and Holger Cahill, the national director, references a horizontal panel of dance figures in clay that was to be cast soon and sent to the Laboratory of Anthropology in Santa Fé. Another photograph and reference presented a sculpture piece of soldiers of various wars and it was planned for the National Cemetery in Santa Fé. Records for these pieces have not been found. The Museum of Fine Arts may also have six bronze Indian Dancers. He also did portrait busts that are in Santa Fe. E. Dana Johns is part of the New Mexico Museum collection and the 1938 bust of Bronson Cutting, a former U. S. Senator and supporter of the New Mexico *Portfolio* project, can be seen on the corner of South Capitol and Don Gaspar within the capitol complex in Santa Fe. Saville died in Santa Fe.

LOCATION OF POSSIBLE NEW DEAL ARTWORK: Santa Fe.

## SCHLEETER, HOWARD
### (1903-1976)

Born in Buffalo, New York, Schleeter studied very early in his years at the Albright Art School in his hometown. He later made his living as an airplane mechanic and as such got to know Lindbergh, Earhart and Doolittle. He came to New Mexico in 1929 and became a permanent resident as of 1930, the year he also married his wife, Ruth. Howard Schleeter studied under Brooks Willis and became known as an experimenter both with media and image. The various

medias he worked in included oil, watercolor, gouache, scratchboard as well as wood engraving. His style can best be described as abstract fantasy but the five large New Deal murals in Melrose Public School library are highly realistic portrayals of the West. Both the local ranchers and Schleeters's mother-in-law provided critical guidance on these murals.

In the 1930's, he evolved a style of pigment application which gave his surfaces a raised mosaic appearance. This technique was coupled with conventionally organized and selected subject matter ranging from landscapes to still-life motifs. In 1936, while studying with Brooks Willis, he became involved with the New Deal art programs which was a great help to the family income since he had been digging ditches. He worked on the *Portfolio* and the five murals mentioned earlier. His wife alsobecame apart of the program working as a timekeeper and as part of a sewing project. At this writing she still resides in Albuquerque.

He was one of the first N. M. artists chosen by Jane Mabry and Peter Hurd as contributing significantly to New Mexico's art and was referred to in the 1945 Encyclopedia Britannica as "an artist's artist." Later in his career, Schleeter left this articulated surface treatment and concentrated upon a more abstract and visionary type of imagery. In addition to his murals in several New Mexico public buildings, his work is represented in the Institute of Religion, Cedar City, Utah and he is well known in Europe. He died in Placitas, New Mexico May 27, 1976.

LOCATIONS OF NEW DEAL ARTWORK: Clayton, Melrose, Santa Fé, Washington, DC.

## SHONNARD, EUGENIE F.
### (1886-1978)

Born in Yonkers, New York on April 29, 1886, Shonnard was a descendent of Francis Lewis, one of the signers of the Declaration of Independence. She was a fragile and lonely child who spent many hours with the animals she loved. As a young woman she studied first at the New York School of Applied Design, but when she first held a piece of clay in her hands she knew that she had found the reason for her life. Over the protests of her doctor and family, she decided to go to Paris to study sculpture. She has said that from the moment she set out for Europe she became strong and healthy -- a testament to her faith and need to create. In France she studied with the sculptor Emile Bourdelle and with Auguste Rodin. Back in New York she worked on many important sculpture commissions before discovering Santa Fé and making it her home. Eugenie Shonnard's life and presence in Santa Fé enriched and brought joy to the many friends who knew her.

In New Mexico Miss Shonnard formed close friendships with many Indian people, and an especially strong bond with Maria Martinez, famed potter of San Ildefonso who taught her much about working in clay. She also worked in stone, bronze, wood, and in a material she developed herself which she called "Keenstone." Through the years Eugenie Shonnard received many honors including a fellowship from the School of American Research, and inclusion in museum collections such as the Luxembourg Museum in Paris. She exhibited work at the Museum of Modern Art in New York, The Pennsylvania Academy, The Art Institute of Chicago, The Whitney Museum and the Brooklyn Museum.

In New Mexico she carved the reredos at Rosario Chapel in Santa Fé, did architectural sculpture for the Episcopal church in Las Cruces, and a PWAP funded outdoor sculpture and a fountain at the Carrie Tingley Hospital for Crippled Children in Hot Springs, New Mexico in 1936. That institution has relocated to Albuquerque, New Mexico but the fountain remained with the buildings that became the home of the New Mexico Veteran's Center. The town also changed its named and is now known as Truth or Consequences. Another New Deal work includes two wooden carvings in the post office at Waco, TX. Shonnard also did bronze busts and bas reliefs of many leading New Mexicans. In 1976 she was honored by an exhibition of her work at the Governor's Gallery in Santa Fé sponsored by Governor and Mrs. Jerry Apodaca. In the following statement by Eugenie Shonnard we feel she identifies the honest and shining purpose of her life. "God created form and color in this world. Also He gave some of us talents for the use of these; Therefore, we human beings must need them in our daily lives. There is perhaps no other answer; and so, we artists must fulfill life's commission as artists and craftsmen." She died in Santa Fé, New Mexico in 1978.

LOCATION OF NEW DEAL ARTWORK: Truth or Consequences-Veteran's Center, Waco, TX.

## SHUSTER, WILL
### (1893-1969)

Born in Philadelphia, Pennsylvania Shuster's early art training was with J. William Server and John Sloan. He was gassed in World War I and developed tuberculosis so he was another one of the artists who came to the west for health reasons. He moved to New Mexico in 1920 and lived in Santa Fé for the rest of his career. Like many of his fellow artists, he was a fine oil painter as well as a printmaker, working with etchings. The style of Shuster's work is generally

considered to be expressionistic. His artwork is represented in Neward Museum, New Jersey; Brooklyn Museum; and the Museum of New Mexico.

Shuster was one of the noted Los Cinco Pintores of Santa Fé and was the creator in 1925 of the Zozobra figure of the annual Santa Fé Fiesta. As a New Deal artist, he created four paintings of the Carlsbad Caverns which are now in the National Park Service Headquarters in Arizona and a series of murals with Indian subjects for the inner courtyard at the N. M. Fine Arts Museum in Santa Fé. More about him can be found in the paper done by Louise Turner in this publication and also the biography she did about Shuster, *WILL SHUSTER, A Santa Fé LEGEND*, along with Joe Dispenza.

LOCATIONS OF NEW DEAL ARTWORK: Santa Fé-Museum of Fine Arts, National Park Service in AZ.

Will Shuster, as noted earlier in the book, was selected by PWAP to paint the Carlsbad Caverns. Today this painting is in the Regional Office of the National Park Service in Arizona. Photo from N.M. State Records and Archives photo collection.

## SMALL LUDINS, HANNAH MECKLEM
### (1903-1992)

Born in New York City January 9, 1903, Hannah Small was the daughter of Eugene and Grace Workum Small. While in her teens she enrolled at the Art Students League and studied under Boardman Robinson and sculptor A. Sterling Calder, among others. Married in 1937, she and her husband, Eugene Ludins, were early residents of Woodstock, New York's now legendary maverick art and music colony.

In 1933, enroute to California, the Ludins discovered Santa Fé and decided to stay temporarily. She became involved in the PWAP and was commissioned to do two stone sculptures in conjunction with the Olive Rush fresco mural for the lobby of the old Public Library. The stones were quarried in Las Vegas and she worked on the pieces at their rented adobe. The placement of those statues today is in the newer Santa Fé Public Library, a building which was also created as the result of the New Deal projects. Mr. Ludins, her husband, was not involved with the New Deal projects of New Mexico but after they left here and returned to Woodstock, he became the WPA supervisor there in 1937-38 and the New York State supervisor in 1938-39.

Hannah Small won many prizes including the Logan Award at the Chicago Art Institute in 1940. She was honored by her home artists association by receiving the 1984 Sally Jacobs Award in Woodstock and had work shown at the Metropolitan and Whitney Museums and the National Academy in New York. Her work is represented in many private and public collections. She died April 25, 1992 at the Kingston (NY) Hospital at the age of 89.

LOCATION OF NEW DEAL ARTWORK: Santa Fé

## STEWART, DOROTHY NEWKIRK
### (1891-1955)

Born in Philadelphia, Pennsylvania, Dorothy Stewart began drawing amazing likenesses of people in early teens. As a young child she stopped talking as the result of an illness but got what she wanted by drawing pictures of objects. In her early teens she was drawing remarkable likenesses of people from memory. She was never an outstanding student in school, however, she later took courses in chemistry, Spanish, Greek and French and studied at the Academy of Fine Arts in Philadelphia. She came to be considered one of the most talented students of her period. and one of her greatest loves was Shakespeare. She also enjoyed

her period. and one of her greatest loves was Shakespeare. She also enjoyed horses and kept them at her Santa Fé place on Canyon Road. She was a resident of New Mexico as of 1925. Her work was mainly in oil and fresco painting and linoleum cut; her style varied from realistic to expressionistic to abstract. She exhibited in several galleries including Artists for Victory show, Metropolitan Museum, New York City. Stewart's work is represented in the Museum of New Mexico.

The WPA fresco she did in the Albuquerque Little Theater titled "Los Moros" was done in 1936 but was later destroyed during remodeling activities. Stewart chose her subject material as her depiction of the annual re-enactment of the Christians doing battle with the Moors held in Santa Cruz and is believed to be the first known theatre activity in New Mexico. The loss of such a treasure is extremely sad.

Stewart lived on Canyon Road and reportedly painted beautiful murals of Shakesperean creations on the walls of her home and her other love, horses, were kept in the field below the house. She died of cancer on Christmas Day in 1955.

LOCATION OF NEW DEAL ARTWORK: Destroyed

## TAFOYA, LEGORIA
### (Dates unknown)

Sister of Pablita Velarde. Pottery at Bandelier National Monument.

## TAMOTZU, CHUZO
### (1888-1975)

Mr. Tamotzu was born on a Japanese island below Kyushu on Feb. 19, 1888 and came to America in the 1920's to continue his painting. He did no New Deal art in New Mexico but an interesting story is included here to share about his experience with the New Deal project in New York in the 1930's. He applied and was accepted to do easel paintings and graphic art for the Public Works of Art Project. He was paid $40.00 a week and expected to paint one painting a month. When that program (PWAP) was over in 1934, many of the artists transferred to the WPA programs but you only got paid $28.00 a week and were required to file and go on relief. At that time he was denied participation in the program because he was not an American citizen. There were artists like him who were denied and they organized a march to Washington and appeared before Harry Hopkins, close associate of President Franklin Roosevelt, who stated, "He felt sorry for them but it's up to the Congress. I can't do it myself." Interestingly,

he volunteered and was accepted as a member of the United States Army's Office of Strategic Service during World War II where he served our country but bore no arms.

Tamotzu moved to Las Vegas, New Mexico in 1948 with his American bride, who had been a WAC during WWII. She had friends there who had invited them to come to New Mexico. After two months in Las Vegas they moved on and settled in Santa Fé where they lived on Canyon Road. Tamotzu was a most active painter in Santa Fe for many years until his death in 1975. His lithographs are in many museums all over the country and Japan. His widow, Louise, still resides in that home which had earlier been owned by the artist, John Sloan, and she has put plaques noting the studio location where both fine artists created their fine works.

### TERKEN, JOHN RAYMOND
(Dates unknown)

Four busts of historical figures in Chaves County were done by this sculptor and can be found in their historical museum in Roswell. This appears to be the only work done here prior to his moving to New York.

LOCATION OF NEW DEAL ARTWORK: Roswell

### TOLEDO, JOSÉ REY
(1915-1994)

Born in Jémez Pueblo, New Mexico in 1915 Toledo was a painter of the San Ildefonso movement, a muralist and teacher. He also signed as Morning Star (Shobah Woonhon). His father was chief of the Jémez Arrow Society, a warrior lodge, and the first Indian owner of a modern general store in the Pueblo. Toledo was influenced toward art by his cousin, Velino Shije Herrera. He attended Albuquerque Indian School, and earned his MA in art education from UNM in 1955. He has had more formal training than is usual for Indian artists but his style and subject matter remained pueblo-oriented. He painted with the WPA 1940-41 primarily in his home which he felt was a great opportunity and reward because it allowed him to do what he loved, recording his tribal activities in his painting, and at the same time he was able to be at home and assist in the raising his eight children.

During World War II he went to work in the shipyards in California but later returned to be an instructor in 1949-57 at the Santa Fé and Albuquerque Indian schools. Toledo was an active member of the pueblo watercolor movement until the early 1960s when he had less time to paint due to his full time employment

as a Health Education specialist for the U.S. Public Health Service and later with the N. M. Health Dept. In 1980 he suffered a heart attack and retired to return to his painting in his home. A year prior to his death in 1994, his children built him his first studio and his wife no longer had to share their dining room table with him as she created her pottery.

LOCATION OF NEW DEAL ARTWORK: Washington, DC.

## TREVORS, FRANZ
(Unknown)

One oil painting is on exhibit at Carrie Tingley Hospital in Albuquerque along with their other New Deal artwork. He was also one of the *Portfolio* artists.

LOCATION OF NEW DEAL ARTWORK: Albuquerque-Carrie Tingley Hospital, Portfolio.

## TSCHUDY, HERBERT BOLIVAR
(1874-1946)

Born Plattsburg, Ohio in 1874, Tschudy's work is displayed in Brooklyn Museum, Museum of New Mexico, Yellow Springs Public Library, National Museum, Warsaw, National Museum, Sofia, Bulgaria, and Gallup Public Library. About 1914 Tschudy was on a Western sketching expedition which included Arizona, California, and Glacier National Park and his sketches were to be used in making installations at the Brooklyn Museum. A regular visitor to the West thereafter, Tschudy in time achieved recognition as an artist, and by the 1930, was receiving favorable reviews in New York City. About half of his paintings for a 1934 exhibition at "Fifteen Gallery" were of New Mexico, painted during the previous summer. By 1935 Tschudy was identified in New York reviews as a painter of the Southwest. During the early years of Tschudy's career he sometimes simplified the spelling of his name. An oil called "Hubbell Hill," at Hubbell Trading Post Museum in Ganado, Arizona, is signed "Judy." The first volume of *Brooklyn Museum Quarterly* also used that spelling.

LOCATION OF NEW DEAL ARTWORK: Gallup

## TSIHNAHJINNIE, ANDY
### (1918-)

This Navajo Indian was born in Rough Rock, Arizona in 1918. His Indian name is Yazzie Bahe, Little Grey, and his long last name has been spelled five different ways. As early as five "Andy" was drawing on stone and later on wrapping paper and the back sides of can labels. He was at Santa Fé Indian School as of 1932 and graduated in 1936. We believe he created murals around the country during his stint in the army during World War II. His artwork created during the New Deal period was sent to the U.S. Indian Service for distribution. One work was done for the Indian school in Phoenix but was later demolished. He may have done some art at the Santa Fé Indian School. He lived in Scottsdale, AZ but is now believed to be in the Chinle, AZ area.

He married Minnie McGert ca. 1945 and they had five children. In addition to his art work, he is musically inclined and has performed in the Navajo Salt River Band out of Scottsdale and the Navajo Tribal Band in Window Rock, AZ.

LOCATION OF NEW DEAL ARTWORK: Unknown

## TYNDALL, CALVIN T.
### (Unknown)

Little was found about this Omaha native whose Indian name was Umpah meaning Elk. He attended the Santa Fé Indian School and participated in the creation of the 13 panel murals done as part of the PWAP.

## UFER, WALTER
### (1876-1936)

Born in Louisville, Kentucky 1876, (late July or early August) Ufer was the son of an immigrant German gunsmith. He received early art training from his father who engraved gunstocks. Around 1890 he left high school to work in the Lithography Department of the Louisville *Courier Journal* and in 1893 he went to Hamburg, Germany to study with German lithographer Johan Jergens and on to the Royal Applied Arts School and the Dresden Royal Academy under Thor, and the Art Institute of Chicago. By 1898 he had returned to work in Louisville, KY before going to Chicago to study at their Art Institute. Ufer continued to study alternating between Europe and America until 1914 when he was offered a trip along with Victor to the Southwest by Carter H. Harrison, former Mayor of Chicago and local art patron. In 1915 he and his wife, Mary Frederickson,

settled in Taos and was elected a member of the Taos Society of Artists. In this new environment his style lightened up and became more academic. He received many awards and did quite well financially until 1927 when he was near bankruptcy. Alcohol, gambling and bad investments took their toll on him and in David Witt's book, *The Taos Artists* it was noted that "his studio had a sign on it marked "Danger...Explosives" which seemed to say something about his personality at that time."

He survived by giving private art lessons and did some painting for the New Deal project. He died unexpectedly of appendicitis on August 2, 1936, just a few days after his 60th birthday. Today he is remembered as one of the most colorful of the Taos artists of his time, painting in a bold agressive style until his death.

LOCATION OF NEW DEAL ARTWORK: Albuquerque-UNM

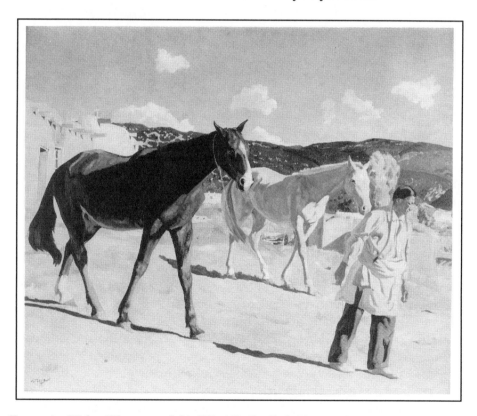

Taos artist, Walter Ufer, created this 25" x 30" oil called "Blaze and Buckskin." It is in the UNM Art Museum collection. Unfortunately Ufer's life was cut short early due to his unexpected death caused by ruptured appendix. Photo from New Mexico State Records and Archives photo collection.

## VAN SOELEN, THEODORE
### (1890-1964)

Born in St. Paul, Minnesota 1890, Van Soelen first studied at the Institute of Arts and Sciences in his hometown, and then at the Pennsylvania Academy of Fine Arts, where he earned a travel-study scholarship to Europe. By 1916, when he moved to New Mexico for his health he was a thoroughly trained painter. He spent his early years in Albuquerque as a painter-illustrator, but by 1920, Van Soelen, seeking a closer view of Indian subjects, moved to a Indian trading post in San Ysidro. In 1922, he moved to Santa Fé living there for four years before making his permanent home in nearby Tesuque. Prior to this move, he also spent some time on a Texas ranch to observe cowboy life. Van Soelen's illustrations of cowboy life have been very popular. He recorded the Southwest and its people with keen accuracy and harmonious composition. His work is represented in a number of recognized galleries and in public buildings including the Pennsylvania Academy of Fine Arts; National Academy of Design, New York; and the Museum of New Mexico. As a muralist, he spent much painstaking time on research of his subjects, along with extensive preparation in creating truly accurate depictionsof the land, the animals, the vegetation, the people and spirit of the Southwest. His New Deal artwork can be seen in the places noted below. Van Soelen died on May 15, 1964.

LOCATIONS OF NEW DEAL ARTWORK: Portales & Silver City, Wawrika, OK,("Wild Geese"), 2 in Livingston, TX, ("Buffalo Hunting" & "Landscape"), Washington, DC.

## VELARDE, PABLITA
### (1918-)

Born in Santa Clara in 1918, she is also known as Tse Tsan -- Golden Dawn. She is perhaps the best-known Indian woman artist today. A childhood eye disease caused temporary loss of sight. "Temporary darkness made me want to see everything," she said. "I have trained myself to remember, to the smallest detail, everything I see." Tse Twan was sent in to Santa Fé to attend the grades 1-6 at St. Catherine's Indian School and later studied with Dorothy Dunn during her educational days at the U.S. Indian School in Santa Fé. She worked with other Indian students on a mural on the exterior of Maisel's store in Albuquerque and that is still there today. As a member of the Santa Clara Pueblo, she sold her work under the portal of the Palace of the Governors in the early days. As a young woman she traveled all over the county with the Ernest Thompson Seton family

caring for their child but finally became homesick and asked to return to her pueblo. After that she spent some time living at the Bandelier National Monument creating a vast collection of paintings for that park. The work is still there as is some work by her sister, Legoria Tafoya. Once married in 1942, she moved to Albuquerque and raised her daughter and son. The daughter, Helen Hardin, now deceased, followed in her mother's creative footsteps and became renown prior to her early death. Now her granddaughter, Tindel, is carrying on the family's art tradition. Her son, Herbert Hardin, became a pipefitter by trade and moved into sculptoring for his creative outlet. Still in residence in Albuquerque, Velarde continues to paint but also creates outstanding Native American dolls in full costumes which are already true collector's items. She has been honored in a number of ways and has had numerous one woman shows including one in the Governor's Gallery. Even though she does not live in Santa Fé, she has been included her in their collection of "Living Treasures" based on the outstanding person she is.

LOCATIONS OF NEW DEAL ARTWORK: Bandelier, also the U.S. Indian Service.

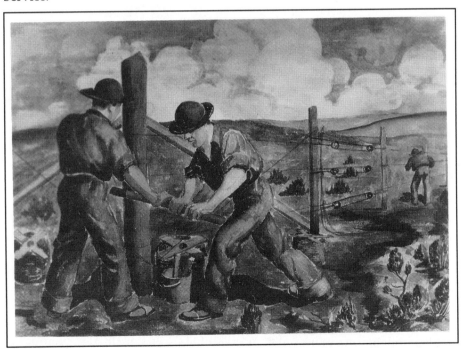

Stuart Walker created a series of ten watercolors for the U.S. Forest Service that captured the New Deal supported field workers at their jobs. The "Fencing" scene was one of the set, all 22" x 28", which is believed to have started at the District Office of that agency in Albuquerque.

## WALKER, W. STUART
(1888-1940)

Very little has been found on this artist. He appears to have been artistically active between 1898 and 1947. He lived in Albuquerque and painted at least six and maybe nine watercolor sketches of forest scenes as part of the Public Works Art Project for the District Office of the U. S. Forest Service which was located in the Post Office building. The six identified titles were "Fencing", "The Red Gate", "Sawmill", "Five O'Clock", "Bridge Gang", and "Logging." The whereabouts of these watercolors in now unknown. He also created a mural in the same building with Brooks Willis, one of his closest friends, and this is now in a private collection. In 1938 he became a member of Emil Bisttram's Transcendental Artist group and in 1939 he had artwork exhibited in the World's Fair in New York and a Golden Gate Exhibition in San Francisco.

LOCATIONS OF NEW DEAL ARTWORK: Albuquerque, Portales, Washington, DC.

## WARDER, WILLIAM "WILLIE"
(1920-)

Born in Mora, New Mexico with a variety of ethnic ancestors, Warder considers himself an American since he is Comanche, Pueblo Indian, Spanish and English. His grandfather was a wagonmaster in the very early territorial days. Warder attended school in Raton graduating in 1940. He went to the University of New Mexico and later joined the armed forces during World War II and ended up in the South Pacific. He painted all over those islands in USO buildings before returning to New York Art Institute, UCLA and other schools. He also studied with some of the New Mexico "masters"--Berninghaus, Bisttram, Dasburg and Chapman. He has six daughters, two sons and thirteen grandchildren and lives in Albuquerque today. Warder is a mural painter feeling that murals are "humanizing our environment." He recalls his first painting job was to improve upon the painting of a horse's tail done earlier by Manville Chapman. The first payment he received for a painting job was art supplies (oil paints, brushes, etc.) and he immediately went up on the east slope of Raton Peak and painted a mural on the largest flat rock face he could find. He has murals in numerous locations around the state including the El Portal Hotel and Yucca Hotels (formerly Swaztika Hotel) in Raton, the Legends Hotel in Angel Fire and other sites. At age nine he won the opportunity to paint, along with three other classmates, two paintings for the children's area in the Raton Library. This was part of a New Deal project. He recently restored those two paintings for the library. Warder was

responsible for starting New Mexico's Artist-in-Residence Program.

LOCATIONS OF NEW DEAL ARTWORK: Raton, Washington, DC.

## WELLS, CADY
### (1904-1954)

Born in Southbridge, Massachusetts in 1904 to a wealthy family, Wells initially studied music and theater design. He attended Harvard and trained as a concert pianist and early on tried to develop a business career for himself. However at the age of 28 he came to Taos to study painting with Andrew Dasburg and determined on art as a career along with Ward Lockwood and Kenneth Adams. To find his own way in expression, he went to Fogg, MA in 1933 to learn art history before returning to Taos and Dasburg. He also studied in France and was greatly influenced by the French cathedrals and their stained glass windows. Not happy with Taos, Wells chose to move to Santa Fé and by 1934 found a secluded spot in Jacona outside of Santa Fé. He worked with architect John Gaw Meem to create a cluster of beautiful small buildings where he lived happily with his six dogs who loved to sing whenever he would play the piano. He was passionate about music and frequently traveled to Chicago to go to "The Ring." He was a loyal friend to many and reportedly had quite a wicked but beautiful sense of humor. He was a member of the committee that supported the creation of the *Portfolio of Spanish Colonial Design* in New Mexico.

Prior to Pearl Harbor, he enlisted in the U.S. Army Engineers and served in the ETO from D-Day until the end of the war. Upon his return in 1945 he found atom bomb research going on in Los Alamos just in view of his lovely home and it was too reminiscent of the war and therefore disconcerting to his painting. Many were sad when in 1949 he made the decision to leave the area and move to St. Croix in the Virgin Islands. In 1950 he donated his large and rare santo collection to the Museum of New Mexico and established E. Boyd as the curator of the Spanish Colonial Arts Department. He also helped establish the Jonson Gallery at the University of New Mexico. By 1952 he returned to Jacona but did some traveling and studying in France. A bad heart condition began to limit his abilities to paint and early in 1954 he had two heart attacks, later dying in Santa Fé on November 15, 1954. A significant retrospective exhibition was organized by the Museum of New Mexico, School of American Research in 1956 and toured throughout the country.

LOCATION OF NEW DEAL ARTWORK: Portales-ENMU

## WEST, HAROLD "HAL"
### (1902-1968)

West was born in Honey Grove, Texas on October 16, 1902 but grew up in Tishamingoe, Oklahoma. During those early years he won first prizes at the county fairs with the best acre of cotton, the best pig and the best painting. At 17 he had a small studio of his own and worked as a commercial artist apprentice between his first and second tries at high school graduation. With the accomplishment of this educational hurdle, he set out to see the world and had numerous experiences traveling about this country during the severe depression era. He settled in New Mexico in 1920 and lived some 20 years on a ranch south of town.

He studied under Vernon Hunter but otherwise was self-taught. He painted realistic scenes of the Southwest depicting ranch life. He also was a print maker and serigrapher, making linoleum cuts and wood cuts of scenes he knew well - many having stories to go with them. In 1938 he got involved again with his painting as part of the New Deal projects in order to feed his growing family and worked with them for two years.

According to his artist son, Jerry West, "Hal loved his art, people and children so in 1950, about the time his five children were in high school, he opened a shop and studio on Canyon Road and became a full-time artist. Before that he had limited his painting to time when he was more free - generally in winter." For this reason, West noted "that he generally painted from memory and imagination rather than `on location', because as a part-time naturalistic artist, he did not have time or opportunity to paint what he saw when he saw it." That shop became a popular site for all the local painters to gather, socialize and compare notes on their work.

LOCATIONS OF NEW DEAL ARTWORK: Clayton, Melrose.

## WHITEMAN, JAMES RIDGLEY
### (1910-)

Mr. Whiteman was born in Portales, New Mexico January 15, 1910 when the state was still a territory and lives a few miles out of Clovis at this writing. He considers himself a full blooded American since he has many nationalities represented in his genes. His early ancestors were German. During the New Deal era he was involved with the WPA project for four years and during that time he helped hand paint many of the color plates and assisted in the printing of the *Portfolio of Spanish Colonial Design* and also did some of the watercolor

work in the *Portfolio*. Whiteman designed a theatre curtain for the Melrose school stage and a large number of Clovis women did the colcha embroidery as per his designs. Unfortunately the curtain was later destroyed in a fire. Whiteman taught metal craft in Gallup and Albuquerque and did a great deal of research and wrote a book about Hopi kachinas. Unfortunately it was never published due to the controversy over his attempting to publish something which at that time was information not to be shared with the outside world according to the Native American people.

LOCATION OF NEW DEAL ARTWORK: Portfolios

## WILL, BLANCA
### (1881-Dates Unknown)

Born in Rochester, New York July 1881, Will studied at Rochester Mechanics Institute; Grande Chaumiere, Paris; H. Adams; J. Fraser; G. G. Barnard; D. W. Tryon; J. Alexander; Tyrohn, in Karisruhe; Luhrig, in Dresden; Castellucho, in Paris; H. Hofmann. Her work was displayed at University of Arkansas; Memorial Art Gallery, Rochester. AAA 1917 Rochester; AAA 1919-1921 Palo Alto, California, and Rochester; AAA 1923-1924 Rochester; AAA 1929-1933 Rochester; Benezit; Fielding; Havlice; Mallett: WWAA 1936-1941 Rochester; (at some time she was the director of sculpture at the University of Rochester); WWAA 1947-1962 Winslow, Arkansas; School of American Research, 1940. She was in Who's Who in American Art in 1985.

Will worked in Santa Fé, New Mexico, long enough to be included in *Representative Art and Artists of New Mexico*, published by the School of American Research in 1940 and was in another show in 1947 as part of the Santa Fé Fiesta. She painted in oil and watercolor and did sculpture. One source indicated she did a mosiac tile creation in the porch floor of a Hot Springs, N. M. bathhouse as part of a New Deal project. This may have been in the State Bathhouse which no longer exists. We have not been able to confirm this but it was the only public owned bathhouse in Hot Springs at that time. Records indicate that she spent a great deal of her life in Rochester, New York but she spent her summers in Blue Hill, Maine from 1919 on.

LOCATIONS OF POSSIBLE NEW DEAL ARTWORKS: Albuquerque-UNM Art Museum, Clayton, Melrose, Truth or Consequences.

## WILLIS, BROOKS
(1903-1981)

Willis was born in Farmington, New Mexico but lived his early years in Durango and Colorado Springs, Colorado. As a young man he went to Paris to study art and paint but this was interrupted when World War II broke out. He joined some friends when they all decided to enlist in the American Volunteers Ambulance Corps which was attached to the French Army. Upon his return to the United States he enjoyed very much being the Executive Director of the Harwood Foundation particularly since there were so many fine artists in Taos at that time. This was around 1939 and then he moved to Albuquerque to be an instructor at the University of New Mexico Art Department. In the early 1940's the call to California won him over and he moved his family there where they resided for thirty years. When retirement time rolled around, the family came back home to New Mexico and he continued to paint until his death in 1981.

He created numerous paintings during the WPA activities which are located around the state. He joined his good friend, Stuart Walker, in creating a mural for the Bernalillo Courthouse but when that building was destroyed the mural went to a private collection. Another one of his creations was a series of panels over the exits of N.M. Highland University's Ilfeld Auditorium, however, they have been painted over. They depicted art, music, drama, health, literature, education, history, and science and were symbolic creations being primarily decorative. It is sad that they, like other New Deal creations, have been destroyed or covered up out of both ignorance and as a result of changes in buildings or policies.

Willis was a representational painter using oils, watercolors, acrylics and unique collages to portray the world in which he lived. His realism sometimes blended with impressionism as he responded to color and light. His definition of art was that age old "creation of that which appeals to the aesthetic senses" and from these, he did not stray into the foreign fields of moralizing, propaganda or those of the occult.

He also taught painting and two of his students and good friends were Carl Redin and Howard Schleeter, two other New Deal artists.

LOCATIONS OF NEW DEAL ARTWORK: Albuquerque-UNM Art Museum, Carlsbad, Clayton, Gallup, Las Cruces, Las Vegas-Highland's Ilfeld Auditorium (painted over), Portales, Santa Fé, Washington, DC.

## WILTON, ANNA K. aka (ANNA E. KEENER)
### (1895-1982)

Born in Colorado in 1895, Wilton studied, assisted and taught under the famed Birger Sandzen while receiving her BA and BFA Degrees at Bethany College in Lindsborg, Kansas. She also studied at Chicago Art Institute, Kansas City Art Institute, Detroit School of Design, Colorado State Teacher's College, California College of Arts and Crafts and in Mexico with well known masters in painting, block printing etching, mural painting, lithography, calligraphy and sculpture. She was a member of the U. S. Navy during World War I. In her early career days, she lived in the Gallup area and ran the New Deal Art Center. From the early twenties she did much to promote the understanding and appreciation of Indian and Spanish art. She became fascinated by the crafts of the Spanish-American people she came to know and while attending a vocational school, she learned how to make her own furniture and santos. Later she completed a survey of colcha embroidery, Her interest in, and respect for, the Navajo land and its people became the inspiration for many of her paintings that won various awards. The research for and creation of, her mural "Zuni Pottery Making" still located in the McKinley County Courthouse became the basis of her Master's degree from the University of New Mexico.

As an art teacher she worked in various states and in New Mexico the range of settings included a stint in one room school house in Red River all the way to the Head of the Art Department at Eastern New Mexico University in Portales. The latter responsiblity she held for many years prior to her retirement. As a New Mexico artist she was a member of the early Taos art colony, well known in Gallup and Portales and active in Santa Fé upon her move there in 1952. Santa Fé provided the opportunity to be surrounded by her grown twin daughters and young granddaughter, to be continually stimulated artistically and to continue her professional activities in the field. Wilton was instrumental in establishing the New Mexico Arts Commission and other art related organizations in the state and southwest region.

LOCATION OF NEW DEAL ARTWORK: Gallup

## WOOLSEY, CARL E.
### (1903-1965)

Born April 24, 1903 in Chicago Heights, Illinois, Carl Woolsey moved to Indianapolis with his family as a teenager and later accompanied them to Long Beach, CA where he was associated with some of the Pacific Coast artists. While there he and his two brothers, Wood and Jean, conducted a commercial art studio. For the most part the brothers were self-taught artists and captured many art awards. Carl was curious about the southwest after seeing the artwork of Walter Ufer in a gallery in Indianapolis in 1927 so by summer he was resident in Taos. By spring he had a southwestern scene painting accepted in the National Academy of Design show in New York. His southwestern landscapes and still life scenes became a trademark and his brother, Wood, soon joined him in Taos creating paintings which included human life scenes. Their varied styles and subjects made for interesting "family" exhibitions and both became quite popular. Brother Jean also came to Taos and made a name for himself in the framing of art world. Carl joined the Army in 1940 and after his discharge lived in New Hampshire. At the time of his death he was residing with Wood in East Strasburg, Penn.

POSSIBLE LOCATIONS OF NEW DEAL ARTWORK: Carlsbad, Santa Fé, Washington, DC.

## ZDNUICH, MIKE
### (Dates Unknown)

This man was one of four junior high students who were chosen to do two murals for the public library in Raton. It is unknown whether he did other artwork. William Warder was one of those four to go on with his art.

# ALL KNOWN NEW DEAL ARTISTS IN NEW MEXICO

Note: * Brief biographies in Chapter 6.

The names in **bold** print are artists who were alive at the time of this publication.

Abeyta, Emiliano
Adams, Kenneth*
Appleton, Carolyn TenEyck
Archuleta, Tony
Austin, E. J.
Bakos, Jozef*
Bakos, Teresa*
Barela, Patrocinõ*
Barger, Erik
Barrows, Charles*
Barton, Howard*
Baumann, Gustave*
Begay, Harrison*
Berninghaus, Charles*
Berninghaus, Oscar*
Bisttram, Emil*
Black, La Verne Nelson*
Blumenschein, Ernest L.*
Boyd, E. (Van Cleave)*
Burbank, E. A.*
Burk, William Emmett
Cassidy, Gerald*
Cervantez, Pedro*
Chalee, Pop*
Chapman, Manville*
Chosa, Alma
Claflin, Majel*
Connelly, Ruth
Cook, Howard*
Cooke, Regina Tatum*
Corson, Stanley B.
Cowboy, Nellie
Crumbo, Woodrow*

Davey, Randall*
Delgado, Ildebert "Eddie"
Delgado, Jr. S.
Detwiller, Frederick*
Deutsch, Boris*
Dixon, Maynard*
Dorman, John*
Dunton, Nellie G.
Dunton, W. Herbert*
Easton Kitts, Cora*
Ellis, Fremont*
Emery, Irene*
Everingham, Millard*
Ewing, Louie*
Fleck, Joseph*
Gilbertson, Warren*
Goodbear, Paul "Flying Eagle"*
Grant, Blanche*
Grant, Gordon*
Groll, A. L.*
Gutierrez, Evangelio
Gutierrez, Lela
Hearn, Omar*
Henderson, William Penhallow*
Hennings, E. Martin*
Herrera, Velino Shije*
Higgins, Victor*
Hogner, Nils*
Hokeah, Jack*
Houser, Allan*
Hullenkremer, Odon*
Hunter, Russell Vernon*
Huntington, Anna*

Hurd, Peter*
Imhof, Joseph*
**Jellico, John***
Jim, Mrs. John
Jones, D. Paul*
Jones, Wendell
Jonson, Raymond*
Kabotie, Fred
**Kaplan, Nat***
Kavin, Zena*
Kinlichini, Sally
**Kloss, Gene***
Knee, Gina*
**LaGrone, Oliver***
Lantz, Juanita*
**Lantz, Paul***
**Lea, Tom***
Leigh, William*
Lockwood, Ward*
Loeffler, Gisella*
Lopez, Jose Dolores
**Lucero, Abad***
Lujan, Merina*
**Lumpkins, William***
Luna, Max
Maldonado, Manther
Marmon, Miriam
Martinez, Maria*
Martinez, Julian*
Matta, Santiago
**McAfee, Ila Turner***
McMurdo, J. T.*
Mead, Ben Carlton*
Mirabel, Vincente*
**Morang, Dorothy***
Moreno, Samuel J.
Morris, James*
Moses, Trinidad
Moylan, Lloyd*
Mozley, Loren*

Myers, Datus*
Nailor, Gerald*
Naranjo, Eulogio
Nash, Willard*
Naumer, Helmuth*
Nordfeldt, B. J. O.*
Nye, Virginia
Pablo, Mrs. Elizabeth
Padilla, Emilio
Parsons, Sheldon*
Payne, Edgar*
Pena, Tonita*
Phillips, Bert*
Phillips, Mary
Pierce, Edma*
Pillin, Polia*
Quintana, Agapina
Redin, Carl*
**Rodriquez, Eliseo***
Rogers, R. Hubert*
Rollins, Warren*
Romero de Romero, Esquipula*
Roybal, Alfonso (Awa Tsireh)
Roybal, Severino
Rush, Olive*
Sanchez, Juan*
Sanchez, Ramos
Saville, Bruce*
Schleeter, Howard Behling*
Shonnard, Eugenie*
Shuster, Will*
Sizer, John Allen
Small, Hannah M.*
Stewart, Dorothy*
Tafoya, Legoria
Terkin, John R.
Tamotzu, Chuzo*
Toledo, Jose Rey*
Trevors, Franz*
Tschudy, H. B.*

Tsihnahjinnie, Andy Rey*
Trevors, Franz
Tyndall, Calvin
Ufer, Walter*
Van Soelen, Theodore*
**Velarde, Pablita***
Walker, Stuart*
**Warder, William***

Wells, Cady*
West, Harold*
**Whiteman, James Ridgely***
Will, Blanca*
Willis, Brooks*
Wilton, Anna Keener*
Woolsey, Carl*
Zdnuich, Mike

The following names have also been identified by the UNM Fine Arts Museum as New Deal artists whose works are included in their collection. For the most part they were artists that were involved in the New Deal projects in other states. This was confirmed by the U. S. General Services Administration staff in Washington who also has works by these artists in various locations around the country.

Abelman, Ida
Abramoritz, Albert
Anderson, Carlos
Arnold, A. Grant
Borne, Mortimer
Breslow, Louis
Botts, Hugh
Campbell, Blendon
Chaney, Ruth
Davis, Hubert
Dorman, John
Dwight, Mabel
Eldred, Thomas
Fruhauf, Aline
Good, Minetta
Grossman, Elias

Hicks, William
Kouner, Saul
Kruse, Alexander
Limbach, Russell
Lowell, Nat
Mongel, Max
Murphy, Minnie Lois
Nooney, Ann
Parish, Betty
Sanger, William
Skolfield, Raymond
Steffen, Bernard
Supfer, Blanche
Wahl, Theodore
Weissbuch, Oscar

# ARTISTS AND CRAFTPERSONS WHOSE WORK WENT TO THE U.S. INDIAN SERVICE

Note: Unfortunately, very little is known about most of these artists or where their artwork is today.

## ARTISTS

Abeyta, Emiliano
Archuleta, Tony
Connely, M. Ruth
Herrera, Velino
Hokeah, Jack
Pena, Tonita
Toledo, Jose Rey
(See Biography Section)
Tsihnahjinnie, Andy
(See Biography Section)
Tyndall, Calvin
Velarde, Pablita
(See Biography Section)

## COPYISTS
*(worked on Portfolios)*

Appleton, Carolyn TenEyck
Chosa, Alma
Corson, Stanley B.
Delgado, Jr., S.
Dunton, Nellie G.
Marmon, Miriam
Sizer, John Allen

## POTTERS

Gutierrez, Evangelio
Gutierrez, Lela
Naranjo, Eulogia
Quintana, Agapina

## TINSMITH

Delgado, Francisco & Eddie

## WEAVERS

Bah
Cowboy, Nellie
Jim, Mrs. John
Kinlichini, Sallie
Pablo, Mrs. Elizabeth
Phillips, Mary

## WOODCARVERS

Lopez, Jose Dolores and
Padilla, Emilio

# ARTWORKS AT THE NATIONAL MUSEUM OF AMERICAN ART, SMITHSONIAN INSTITUTION, CREATED BY NEW MEXICO NEW DEAL ARTISTS

*New Deal art

| | |
|---|---|
| Adams, Kenneth | "Harvest"<br>"Juan Duran"*<br>"Deer Track" |
| Barela, Patrocinõ | Nine carvings* |
| Barrows, Charles | "Crosses"* |
| Baumann, Gustave | 4 prints |
| Berninghaus, Oscar | Mural study for Phoenix Post Office*<br>"Red Peppers" |
| Bisttram, Emil James | "Justice Tempered with Mercy"*<br>(mural study for Roswell Federal Courthouse)<br>Untitled<br>"Upward"* |
| Black, La Verne Nelson | "Jicarilla Apache Fiesta"* |
| Cervantez, Pedro | "Los Privados"*<br>"View of Artist's Home"* |
| Deutsch, Boris | Color study for "Indian Bear Dance"*<br>(mural in T or C Post Office)<br>Detailed color study for "Indian Bear Dance"* (mural in T or C Post Office)<br>Color painting detail color study for "Indian Bear Dance"* (mural in T or C Post Office.)<br>"Mother and Child"<br>Portrait - Man<br>"Sleeping Woman" (private)<br>"The Tailor" |
| Dunton, W, Herbert | "Fall in the Foothills"*<br>"The Enemies' Horses" |
| Goodbear, Paul<br>"Flying Eagle" | "Buffalo Dance Oklahoma" |
| Henderson, William Penhallow | "Alice in Wonderland Series" |

| | |
|---|---|
| Hennings, Ernest Martin | "Homeward Bound"* |
| | "Riders at Sunset" |
| Herrera, Velino Shije | "Bronco Busting" |
| | "Calf Roping" |
| | "Comanche Dance" |
| | "Story Teller |
| Hurd, Peter | "Big Whit Whitaker" |
| | "Day's Work" |
| | "The Night Watchman" |
| | "Windmill Well at Night" |
| | "Untitled" |
| Jonson, Raymond | "Monument to Sound"* |
| | (4 paintings not WPA) |
| Kloss, Gene | (5 paintings not WPA) |
| | "Midwinter in the Sangre de Cristo"* |
| Lockwood, Ward | (4 paintings believed to be WPA)* |
| Martinez, Maria & Julian | (3 pottery pieces)* |
| McAfee, Ila | "Mountain Lions"* |
| Moylan, Lloyd | (3 works)* |
| Nordfeldt, B. J. O. | (60 - all private pieces) |
| Redin, Carl | "A Madrid Coal Mine, New Mexico" |
| Schleeter, Howard B. | "Mexican Landscape"* |
| Tsihnahjinnie, Andy | "Navajo Women" |
| Toledo, Jose Rey | "A Stick Race"* |
| Ufer, Walter | "Callers" |
| Van Soelen, Theodore | "Buffalo Range-Study" for Portales P.O.* |
| Warder, William | "Sandia Mountains, New Mexico"* |
| Willis, Brooks | "Country Store" |

*Other New Deal artists from New Mexico are also included in this collection.*

# FEDERAL / STATE SUPPORTED VISUAL ARTS PROGRAMS IN NEW MEXICO, 1933-43

## PUBLIC WORKS OF ART PROJECT (PWAP)
### December 1933-June 1934

Edward Bruce, National Director
REGION 13: Arizona and New Mexico
Regional Director: Jesse Nusbaum
Arizona Art Coordinator: Howe Williams
New Mexico Area Coordinator: Gustave Baumann

## TREASURY SECTION OF PAINTING AND SCULPTURE
### (THE SECTION)
### October 1934-October 1938

National Director: Edward Bruce
Region 13: Arizona and New Mexico

## TREASURY RELIEF ART PROJECT (TRAP)
### July 1935-June 1939

National Director: Olin Dows
Region 13: Arizona and New Mexico
Regional Director: Jesse Nusbaum
Southern New Mexico Supervisor: Jesse Nusbaum
Northern New Mexico Supervisor: Emil Bisttram

## WORKS PROGRESS ADMINISTRATION FEDERAL ART PROJECT (WPA/FAP)
### August 1935- September 1939

National Director: Holger Cahill
Region 5: Arizona, New Mexico, Colorado, Utah, Wyoming
Regional Advisor: Donald Bear
Arizona Supervisor: Mark Voris; Philip Curtis
Phoenix Federal Art Center Director: Philip Curtis
New Mexico Director: Russell Vernon Hunter
Roswell Federal Art Center Director: Roland Dickey
Melrose Federal Art Center Director: Martha Kennedy
Las Vegas Federal Art Center Director: Mary E. (Toni) Thoburn

Gallup Federal Art Center Director: Mary E. (Toni) Thoburn
Indian Project: John Collier

## WORKS PROJECT ADMINISTRATION - ART PROGRAM
### (WPA ART PROGRAM)
### September 1939-March 1942

National Director: Holger Cahill
Region 5: Arizona, New Mexico, Colorado, Utah, Wyoming
Regional Advisor: Donald Bear
Arizona Superintendent: Philip Curtis; Thomas Wardell
New Mexico Director: R. Vernon Hunter

## GRAPHIC SECTION OF THE WAR SERVICES DIVISION
### March 1942-April 1943

National Director: Holger Cahill

## OTHER FEDERALLY FUNDED NEW DEAL PROGRAMS

Civilian Conservation Corp., 1932

Public Works Administration, 1933

Federal Emergency Relief Administration

Civil Works Administration, 1933-34

Works Progress Administration, 1935-1939

Federal Writers Project, 1935

Federal Theater Project, 1935

Federal Music Project, 1935

National Youth Administration, 1933

# NEW MEXICO CIVILIAN CONSERVATION CORPS

Vincent T. Wathen
CCC Alumni-Albuquerque

The Civilian Conservation Corps (CCC) program was another federally funded activity that grew out of the need to provide employment for Americans. It was a nationwide program and today we are still benefiting from the labors of the many young men who were active in this program. In New Mexico there was a District Headquarters complex and at least three main districts. Various federal agencies employed and supervised the activities of those districts and camps and they were identified in the following manner:

"Co." --Company and the number following is an Army designation of the camp.
"F" --designates or refers to the U. S. Forest Service.
"SCS" --designates or refers to the U.S. Soil Conservation Service.
"DG" --designates or refers to the U. S. Dept. of Grazing.
"SP" --designates or refers to the National Park Service.
"NM" --designates or refers to the State of New Mexico.

The annual report of CCC activities in 1936 provides us the following information. The federally funded project began in 1932 and historians are attempting to find more information for subsequent years.

## Albuquerque District Camps in 1936

Besides the District Headquarters, the District contained the following offices and camps:

1. Army Personnel Office Rio Arriba Sub-District
2. Co. 1818 (F43N) La Madera
3. Co. 2843 (SCS3N) Espanola
4. Co. 2832 (SCS4N) Espanola
5. Co. 2834 (SCS5N) Espanola
6. Co. 2831 (F31N) Jemez
7. Co. 815 (NM-1-N) Espanola
8. Co. 837 (SCS7N) San Ysidro
9. Co. 2836 (SCS8N) San Ysidro
10. Co. 3834 (DG42N) Magdalena
11. Co. 3837 (SCS9N) Albuquerque
12. Co. 2837 (SCS-10N) Grants
13. Co. 833 (SP1N) Santa Fe

14. Co. 836 (SCS6N) Ft. Stanton
15. Co. 3808 (DG40N) Carrizozo
16. Co. 814 (F8N) Sandia Park
17. Co. 3835 (F41N) Corona

Some of the projects that were carried out at these camps are still viable sites around the state today. For example, the New Mexico Co. 815 (originally the F7N group) worked mostly in Bandelier using the existing cableway that lowered equipment and supplies into Frijoles Canyon. According to records over 2,500,000 lbs. of equipment went down the cableway to be reassembled and utilized to build all the required facilities. A very steep access road was also built in and out of the canyon and a quarry was established from which stones were taken to build the buildings now comprising Bandelier National Park.

The Soil Conservation and Department of Grazing camps worked on numerous projects to stop erosion, replant rangeland, control pests, and stabilize stream watersheds. A most significant major project was the one on the Rio Puerco watershed which accounted for holding back 80% of the silt being washing into Elephant Butte Lake.

Co. 833 in Santa Fe built the large adobe Southwest Regional Headquarters Building for the National Park Service and did grading and rock work along the Santa Fe River through the city.

These camps, during their stay at the indicated location, also operated several side camps of a temporary or seasonal nature at or near project sites. Such camps and their crews built roads, hiking trails, campgrounds, picnic areas and other recreational facilities in their areas. Notable among these are the facilities in the Sandia and Manzano Mountains built by Co. 1818 and side camps under the direction of the Forest Service. Other camps near other cities like Santa Fe and Espanola created similar recreational areas in the mountains as well as conservation work.

The Headquarters camp in Albuquerque did major repair on trucks and equipment for the District and operated a Cooks and Bakers School for the southwest area.

The *Fort Bliss District* operated camps in southern New Mexico and Texas. The *Carlsbad Sub-District* maintained an Army Personnel Office in Carlsbad and camps as follows:

1. Co. 1830 (BR3N) Carlsbad
2. Co. 2868 (F37N) Carlsbad

3.  Co. 2842 (DG41N) Lake Arthur
4.  Co. 2845 (DG39N) Tularosa
5.  Co. 1850 (F32N) Mayhill

These camps did work similar to that outlined above for the Albuquerque District. They are responsible for Bottomless Lakes State Park and Bitter Lakes National Wildlife Refuge as well as Sumner Lake State Park and President's Park in the city of Carlsbad. They built the access trails in Carlsbad Caverns National Park, did the wiring for electric lights in the caverns, and developed a water supply for them at Rattlesnake Springs. They engaged in flood control and watershed stabilization work along the length of the Pecos River and its tributaries, reforestation of the surrounding mountains, and reseeding much of the grazing land in the area.

The Fort Bliss District also operated the *Las Cruces Sub-District Army Personnel Office* in Las Cruces and the main camps listed below:

1.  Co. 3833 (SCS16N) Las Cruces
2.  Co. 3829 (BR39N) Las Cruces
3.  Co. 3832 (DG38N) Radium Springs
4.  Co.  855 (BR54N) Elephant Butte
5.  Co. 3831 (DG37N) Cuchillo
6.  Co. 2873 (A4T) Berlino

Company 2873 was located on the Army Target Range in Dona Ana County. They constructed access roads for the area, did flood control, and erosion work for the entire area.

The most notable works of the other camps and their side camps include the buildings of the Bosque del Apache National Wildlife Refuge, Elephant Butte Lake State Park facilities, landscaping and erosion control work and Pancho Villa State Park.

The *Colorado District* supervised camps in northern New Mexico and moved established companies from Colorado after completion of their assigned tasks there. Camps were located at or near Raton, Farmington, Bloomfield and Clayton. They reforested and replanted forest and grazing land throughout the area, stablized and built facilities near the ruins at Chaco Canyon. We do not have a complete list of these camps and the works they did, but it would appear that there were eight or nine major camps and a number of side camps.

All in all, there were about forty main camps in New Mexico with about twice that many side camps. These camps housed young men from surrounding states and from eastern states in addition to the large number of young New Mexicans.

Among these many heavy/manual laborers in these camps were also artists employed to visually record the efforts put forth at these sites and around the camps. It has been difficult to identify who some of these artists were. Such work of one of the better known artists, Oden Hullenkremer, is still visible at Conchas Dam.

Our information supports a figure of 54,500 young men having been employed by camps in New Mexico by 1936. This meant a payroll of approximately $1.65 million per month going into the economy of the state. Quite a significant boost to New Mexico during that depressed era!

# NEW DEAL PROGRAM REFERENCES

## BOOKS/CATALOGS

1.   Adams, Clinton. *Printmaking in New Mexico 1880-1990.*Albuquerque: Univ. of New Mexico Press. 1991.

2.   *Artists of the 20th Century.* New Mexico Museum of Fine Art Collection. Museum of Fine Arts. Santa Fe: Museum of New Mexico Press, 1992. 166pp.

3.   Bermingham, Peter. *The New Deal in the Southwest:Arizona and New Mexico.* Tucson: The University of Arizona Museum of Art, 1980.

4.   Bickerstaff, Laura M. *Pioneer Artists of Taos.* Denver: Sage Books, 1955. Also Reprint Ed. Denver: Old West Publishing Co., 1985.

5.   Biebel, Charles. *Making the Most of It, Public Works in Albuquerque During New Deal 1929-1942.* An Albuquerque Museum History Monograph. The Albuquerque Museum, 1986.

6.   Braeman, John, Robert H. Bremmer, and David Brody, eds. *The New Deal, vol. 2: The State and Local Levels.* 2 vols. Columbus: Ohio State University Press, 1975.

7.   Broder, Patricia J. *Taos: A Painter's Dream.* Boston: New York Graphic Society, 1980. 321pp.

8.   Brown, Lorin W., with Charles L. Briggs and Marta Weigle. *Hispaño Folklife of New Mexico: The Lorin W. Brown Federal Writers' Project Manuscripts.* Albuquerque: University of New Mexico Press, 1978.

9.   Cahill, Holger. *New Horizons in American Art.* New York: Museum of Modern Art, 1936.

10.  Coke, Van Deren. *Taos and Santa Fé: The Artist's Environment: 1882-1942.* Albuquerque: University of New Mexico Press for the Amon Carter Museum of Western Art, 1963.

11.  Córdova, Gilberto Benito,(Compiled by.) *Bibliography of Unpublished Materials Pertaining to Hispanic Culture in the New Mexico WPA Writers' Files.* Santa Fé: New Mexico State Department of Education, December, 1972.

12. Dickey, Roland. *New Mexico Village Arts.* Albuquerque: Univ. of New Mexico Press, 1949. 266pp.

13. Dunn, Dorothy. *American Indian Paintings of the Southwest and Plains Areas.* Albuquerque: UNM Press, 1968. 429pp.

14. Eldredge, Charles C., Schimmel, Julie, & Truettner, Wm. H. *Artists in New Mexico 1900-1945, Paths to Taos and Santa Fé.* New York: Abbeville Press, for the National Museum of American Art, Smithsonian Institution, Washington, D. C. 1986.

15. Fisher, Reginald. (Compiled and edited by.) *An Art Directory of New Mexico.* For the School of American Research and the Univ. of New Mexico. Albuquerque: Univ. of New Mexico Press.

16. Griffin, Warren. *A Circle of Light.* Unpublished biographical manuscript on Warren Rollins. Santa Fe: N. M. State Records and Archives. Miscellanous Records / Miscellanous Persons.

17. Hagerty, Donald. *Desert Dreams, The Art and Life of Maynard Dixon.* Layton, Utah: Gibbs Smith Publishers, Peregrine Smith Books. 1993. 272pp.

18. Hefner, Loretta L. comp.*The WPA Historical Records Survey: A Guide to the Unpublished Inventories, Indexes and Transcripts.* Chicago: Society of American Archivists, 1980.

19. Hewett, Edgar L. *Paths to Taos and Santa Fé.* Washington. Smithsonian Institution.

20. -----*Representative Art and Artists of New Mexico.* Santa Fe: School of American Research, Museum of New Mexico (Santa Fe Press), 1940.

21. Howard, Donald S. *The WPA and Federal Relief Policy.* New York: Russell Sage Foundation, 1943.

22. Hyer, Sally. *One House, One Voice, One Heart, Native American Education at the Santa Fé Indian School.* Albuquerque: Museum of New Mexico Press, 1990, 108pp.

23. *Light & Color, Images from New Mexico.* Masterpieces from the Collection of the Museum of Fine Arts, Museum of New Mexico. Introduction by Norman A. Geske, Director, Sheldon Memorial Art Gallery, University of Nebraska-Lincoln. Museum of New Mexico Press, 1981. 94 pp.

24. Luhan, Mabel Dodge. _Taos and its Artists_. New York: Duell, Sloan and Pearce, 1947.

25. Marling, Karal Ann. _Wall to Wall America: A Cultural History of Post Office Murals in the Great Depression_. Minneapolis: University of Minnesota Press, 1982.

26. Marriott, Alice., _Maria the Potter of San Ildefonso_. Norman: University of Oklahoma Press, Norman, 1948.

27. McDonald, William F. _Federal Relief Administration and the Arts: The Origins and Administrative History of the Arts Projects of the Works Progress Administration_. Columbus: Ohio State University Press, 1969.

28. McKinzie, Richard D. _The New Deal for Artists_. Princeton, N. J.: Princeton University Press, 1973.

29. Mecklenburg, Virginia. _Art in Federal Buildings. Vol. 1. Mural Designs. 1934-36_. Bruce & Watson Publishing Co.

30. ------------------- _The Public as Patron_. College Park: Univ. of Maryland Press.

31. Minton, Charles Ethridge (State Supervisor). _Guide to 1930's New Mexico: A Guide to the Colorful State_. Compiled by the Workers of the Writers Program of the WPA in the State of New Mexico. American Guide Series. Foreword by Clinton P. Anderson. First Edition. New York: Hastings House Publishers.1940. Sponsored by the Coronado Centennial Commission and Univ. of New Mexico. _Current edition_: Phoenix: Univ. of Arizona Press. 1989. Foreword by Marc Simmons.

32. Morris, Margaret. _Masterworks of the Taos Founders_. Gerald Peters Gallery Catalog. Sept. 10 through Nov. 25, 1984.

33. Nabokov, Peter. _Architecture of Acoma Pueblo: The 1934 Historic American Buildings Survey Project_. Santa Fé: Ancient City Press, 1985.

34. Nelson, Mary C. _The Legendary Artists of Taos_. New York: Watson-Guptill Publications. 1980.

35. O'Connor, Francis V. _Federal Support for the Visual Arts: The New Deal and Now_, Greenwich, Connecticut: New York Graphic Society, 1969.

36. ----------------- _Art for the Millions: Essays from the 1930's by Artists and Administration of The WPA Federal Art Project_. Boston: New York Graphic Society, 1973.

37. ----------------- *Federal Art Patronage 1933-43*. College Park: University of Maryland, 1966.

38. Ortega, Joaquin.(Introduction by.) *New Mexico Artists: N. M. Artists Series #3*.From the New Mexico Quarterly Spring 1949-Winter 1950-51. Albuquerque: Univ. of New Mexico Press. 1952.

39. Ostrander Dawdry, Doris. *Artists of the American West I-III:* Sage Books, Swallow Press, Inc. 1985.

40. *Anthology of Memoirs*. Washington, D. C.: Smithsonian Institution Press, 1972.

41. Park, Marlene & Markowitz, Gerald E. *New Deal for Art*. Gallery Association of New York State. 1977.

42. --------------------------------- *Democratic Vistas: Post Offices and Public Art in the New Deal*. Philadelphia: Temple University Press, 1984.

43. Porter, Dean A. *Victor Higgins: An American Master*. South Bend: Snite Museum. Museum of Art Notre Dame, Peregrine Smith Books. 1975.

44. Reid, J. T. *It Happened in Taos*. University of New Mexico Press, Albuquerque, 1946.

45. Robertson, Edna & Nestor, Sarah. *Artists of Canyons and Caminos: Santa Fé, the Early Years*. Salt Lake City: Peregrine Smith Inc. 1976. 166pp.

46. Samuels, Peggy & Harold. *The Illustrated Biographical Encyclopedia of Artists of the American West. New York: Doubleday & Co., Inc. 1976.*

47. Schimmel, Julie & White, Robert R. *The Taos Art Colony*. Albuquerque: Univ. of New Mexico Press. 1994

48. Sheppard, Carl D. *Creator of the Santa Fe Style: Isaac Hamilton Rapp, Architect*.Albuquerque: Univ. of New Mexico Press. 1988. 140 pp.

49. Short, C.W. & Stanley-Brown, Rudolph. *Public Buildings: Architecture Under the Public Works Administration 1933-39 Volume 1*.Introduction by Richard G. Wilson, Da Capo Press, Inc., New York, 1986.

50. Snodgrass, Jeanne O. *American Indian Painters: A Biographical Directory. Contributions from the Museum of the American Indian*. Heye Foundation, Vol. 21, Part 1. New York: Museum of American Indian, Heye Foundation, 1969.

51. Taggert, Sherry Clayton & Schwartz, Ted. *Paintbrushes and Pistols, How the Taos Artists Sold the West*. Santa Fe: John Muir Publications, 1990.

52. Tanner, Clare Lee. *Southwest Indian Painting, A Changing Art*. Tucson: Univ. of Arizona Press. 1957, 1973.

53. Udall, Sharyn Rohlfsen. *Modernist Painting in New Mexico 1913-1935*. Albuquerque: university of New Mexico Press, 1984.

54. ----------------------*Santa Fé Art Colony 1900-1942*. Gerald Peters Gallery Catalog. July 1-Aug. 8, 1987.

55. Weigle, Marta, Larcombe, Claudia & Sam. *Hispanic Arts and Ethno History in the Southwest*. Santa Fe: Ancient City Press. 1983.

56. Weigle, Marta, and Fiore, Kyle. *Santa Fé and Taos, The Writer's Era 1916-41*. Santa Fe: Ancient City Press, 1982.

57. Weigle, Marta. *New Mexico Artists and Writers: A Celebration"*. Santa Fe: Ancient City Press.

58. *Who's Who in American Art*. Peter Hastings Folk, Editor, Sound View Press, 1985.

59. Witt, David. *The Taos Artists, Historical Narrative and Bibliographical Dictionary*. Ewell Fine Art Publications, 1984. A book on Patrocinõ Barela is in production.

60. Wroth, William, ed. *Russell Lee's FSA Photographs of Chamisal and Peñasco, New Mexico*. Santa Fé: Ancient City Press; Colorado Springs: Taylor Museum of the Colorado Springs Fine Arts Center, 1985.

61. *The New Deal Art Projects. An Anthology of Memoirs*. Washington, D. C. Smithsonian Institution Press, 1972.

## ARTICLES/PAPERS
(Where author of article unknown, the paper is referenced by the town being discussed.)

Primary Sources:
    A. Numerous Papers in the WPA Files at the New Mexico State Records and Archives Center.

B.     Record Group 69, Civil Records Section, National Archives, Washington, D.C. Numerous papers and correspondence.

1.   Bates, Zelpha. "A Homemaking Department Built From Community's Own Resources." *Practical Home Economics.* Dec. 1939

2.   Baumann, Gustave. "A Retrospect of Work and the Artists Employed in the Thirteenth Region Under the Public Works of Art Project. " WPA reports/records. N. M. State Records and Archives.

3.   Bisttram, Emil. "Abstract Memories, Transcendental Groups." *Albuquerque Journal,* Aug. 29, 1982.

4.   Bisttram, Emil. "WPA Murals-Fine Art From Hard Times." *New Mexico Magazine,* Nov. 1982.

5.   Bruce, Edward. "Implications of the Public Works of Art Project, American Scene in All It's Phases." *American Magazine of ART*, March 1934.

6.   "Call for Historical Pictures." and "Library Paintings Selected." *Raton Range,* 1934.

7.   Campbell, Suzan & D'Emilio, Sandra. "Modern Women in Taos," *Antiques & Fine Art,* July/August. 1991.

8.   Campbell, Suzan. "Aesthetic Energies, Early Women Traditionalists in Taos," *Antiques and Fine Art,* Sept./Oct. 1991.

9.   Chapman, Manville. "Blazed Trails."  A series of Colfax County Historical Narratives based on the mural paintings in the Shuler Auditorium of Raton, N. M., done under PWA project and written by the artist Manville Chapman. Copyright, 1935.

10.  Cassidy, Ina Sizer. "Memorial Library, Las Cruces." Art and Artists of New Mexico. *New Mexico Magazine,* April 1938.

11.  -----------------"Blumenschein in Retrospect." Art and Artists of New Mexico. *New Mexico Magazine.* July 1948.

12.  ----------------- "Teresa Bakos." Art and Artists of New Mexico. *New Mexico Magazine.* March 1939.

13.  ----------------- "Adventures in Tin." Art and Artists of New Mexico. New Mexico Magazine. August, 1937.

14. ----------------(Numerous other articles featuring New Deal artists were written by Cassidy in her monthly column of the New Mexico Magazine.)

15. Coke, Van Deren. "Why Artists Came to New Mexico, Nature Presents a New Face Each Moment. " *Art News*, Jan. 1974. vol. 73, no. 1.

16. Crane, Cathy. "Courthouse Mural Holds Mysterious Tale." *Roswell Daily Record*. Oct. 29, 1991.

17. D'Emilio, Sandra. "The New Deal Was a Great Deal: Federal Patronage and Mural Painting in New Mexico-1933-43. Unpublished manuscript compiled as result of personal interviews done by author and Virigina Ewing with New Deal artists still alive and living in New Mexico. c.1991.

18. Dumont, Andre. "Ina Sizer Cassidy and the Writers Project." *Albuquerque Journal-IMPACT Magazine*. Jan. 19, 1982.

19. Ewing, Virginia. "Some Memories Concerning New Mexico's WPA Federal Art Project." Unpublished. Santa Fe, 1988.

20. --------------""Russell Vernon Hunter's Mural "The Last Frontier" in the DeBaca County Courthouse. Unpublished paper. March 23, 1984.

21. Ford, D'Lynn. "Depression Era Art Still Lifts Spirits" *New Mexico Magazine*, Nov. 1990.

22. Ft. Sumner-"Vernon Hunter Historic Murals." *Curry County News*. June 21, 1934.

23. Gallup Independent. "Art Project is Aid to Beauty of Courthouse. Oct. 7, 1939.

24. ----------------"New Courthouse Murals Are Complete History." Ruth Kirk. Date Unknown.

25. ----------------"Depression Art Not Wallpaper." Ernie Bulow. Jan. 18, 1990.

26. Gallup-The Paper. "WPA Art Returns to Public Library." Chris Murphy. May 27, 1992.

27. Gibson, Daniel. "Art Around Town: Public Places Host Array of Art." *Santa Féan Magazine*, Jan.-Feb. 1990.

28. Gugliotta, Guy. "VIPS Get the Pick of the Paintings Store for Museum." *Washington Post*. March 29, 1994.

29. "Henderson Murals Installed at Federal Building by Art Project Chief are Landscapes." *Santa Fe New Mexican*, 1938.

30. Hendrickson, P. & Streeter, Lynne. "White Sands National Monument"-Handout

31. Hodges, Carrie. "The Spanish American Craftsmen." WPA Archives reports/records. 1937.

32. Howe, Elvon L. "The Man Who Saved Union County." *Rocky Mountain Empire Magazine*, May 16, 1948.

33. Laine, Don. "Taos County to Restore Frescoes." *Albuquerque Journal-North*. June 8, 1993.

34. Las Vegas-"Brooks Willis Completes WPA Commission at Las Vegas." *Albuquerque Journal*, Jan. 17, 1937.

35. Lofton, Ray J. "Art Projects in Melrose Under the WPA." Unpublished article by School Superintendent 1941-58.

36. Loh, Jules. "WPA Injected Life Into Paralyzed Areas." *Albuquerque Journal*: Associated Press. July 28, 1991.

37. *Lordsburg Liberal*. "Present Library Built in 1937." Feb. 10, 1958

38. Nathanson, Rick. "Anti-Depression Transfusion:WPA." *Allbuquerque Journal*, July 28, 1991.

39. *Portales News*, "Large Mural Placed at Post Office." (Van Soelen Mural) July 28, 1938.

40. Sandlin Scott. "Roswell's Missing Mural Finds a Home." *Albuquerque Journal*. Oct. 30, 1991.

41. Smith, Janet, "The Arts in Albuquerque," WPA Archives reports/records. 1937.

42. Wroth, Will. "New Hope in Hard Times-Hispanic Crafts are Revived During Troubled Years." in *El Palacio*. 89 (Summer 1983).

## INTERVIEWS

A. 1963 Interviews by Sylvia Loomis for the Santa Fé Office of the Archives of American Art on microfilm at the Archives of American Art in Washington, D.C.

1. Kenneth Adams
2. Jozef and Teresa Bakos
3. Patricino Barela
4. Charles Barrows
5. Emil Bisttram
6. E. Boyd
7. Ina Sizer Cassidy
8. Roland Dickey
9. Olin Dows
10. Louie Ewing
11. Virginia Hunter Ewing
12. Joy Yeck Fincke
13. Gene Kloss
14. Jesse L. Nusbaum
15. Olive Rush
16. Eugenie Shonnard
17. Will Shuster
18. Harold E. West

B. 1992-1994 interviews by Kathryn A. Flynn for the Office of the Secretary of State for the purpose of the publication of this book. Family members so identified.

1. Josephine Baca
2. Emily Otis Barnes
3. Jane Cahill Blumenfeld(Holger Cahill's daughter)
4. Dorothy Berninghaus Brandenbury, (Oscar Berninghaus's daughter)
5. Suzan Campbell
6. Pop Chalee
7. Andrew Connors
8. Roland Dickey
9. Teresa Ebie
10. Bambi Ellis (Fremont Ellis's daughter)
11. Virginia Ewing (Widow of Vernon Hunter and Louis Ewing)
12. Octavia Fellin
13. Joseph Fleck, Jr. (son of Joseph Fleck)
14. Tish Frank (granddaughter of William P. Henderson)
15. Joy Y. Fincke McWilliams
16. Edward "Ned" Hall (former husband of E. Boyd)
17. Susan Herter
18. Capt. Glee Homan
19. Allan Houser
20. Lee Roy Jones
21. David Kammer
22. Nat Kaplan
23. Gene and Phillip Kloss
24. Ellen Landis

25. Oliver LaGrone
26. Chris Lantz (Paul and Juanita Lantz's son)
27. Sam Larcombe
28. Betty Lloyd
29. Ray Lofton
30. Abad Lucero
31. Edgar Ludins (Hannah S.M. Ludin's husband)
32. William Lumpkins
33. Ila Mc Afee
34. Elizabeth McGorty
35. John Meigs
36. Dorothy Morang
37. Helmuth Naumer, Jr.
38. Rod Peterson
39. Sarah Woolsey Pirkl (daughter of Jean Woolsey)
40. Dean Porter
41. Eliseo Rodriquez
42. Helen Schleeter (Howard Schleeter's widow)
43. William Spurlock
44. Myrtle Stedman (Wilfred Stedman's widow)
45. Louise Tamotzu (Chuzo Tamotzu's widow)
46. Jose Rey Toledo
47. Pat Smith (Stepgranddaughter of Mabel D. Luhan)
48. Don Van Soelen (T. Van Solen's son)
49. Bill Thomas
50. Pablita Velarde
51. William Warder
52. Alicia Weber
53. Marta Weigle
54. Jerry West (Hal West's son)
55. Mary Wheeler
56. James Ridgely Whiteman
57. Helen Willis (Bruce Willis' widow)
58. Woodrow Wilson
59. David Witt
60. Will Wroth
61. Vicente Ximenez

## DISSERTATIONS AND THESES

1. Contreras, Belisario R. "Treasury Art Programs: The New Deal and the American Artist, 1933 to 1943." Unpublished PhD. dissertation, American University 1967.

2. LeBovit, Linda. "Government Art Patronage of the 1930's." Master's Thesis, Santa Fe, 1993-35.

3. Randall, Mallory B. "Murals and Sculpture of the Public Works of Art Porject and the Treasury Section in the Southwest." Master's Thesis in American Civilization, University of Texas 1967.

4. Riedel, Thomas L. "Copied for the W.P.A.": Juan A. Sanchez, American tradition and the New Deal politics of saint-making. 1992 Master's Thesis.

5. Spurlock, William Henry, II. "Federal Support for the Visual Arts in the State of New Mexico 1933-1943," Master's Thesis, University of Texas, 1974.

## AUTHORS

*ANDREW CONNORS* is Assistant Curator at the National Museum of American Art, Smithsonian Institution, Washington, D. C. His fields of research include Hispanic art, Native American art, and folk art and craft.

His most recent exhibition project have included "Pueblo Indian Watercolors," and Paintings of the American Southwest". He coordinated the Washington, D.C. venue of the national touring exhibition "Chicano Art: Resistance and Affirmation, 1965-01985."

For Smithsonian Folkways Recordings, he compiled an album of folk songs and stories for children *A Fish That's A Song* which received a Notable Children's Recording award from the American library Association and a Parents' Choice Foundation 1991 Recording Award. He is now writing, with Chicano artist Carlos Fresquez, a children's book about the Fresquez family.

A Ph.D. candidate in Folklore at George Washington University, Connors received his B. A. in architecture and art history from Yale University in 1984. He grew up in Colorado.

*SANDRA D'EMILIO* is the curator at the New Mexico Museum of Fine Arts for this same era. She has written articles and books related to this time period. With Suzan Campbell, she did *Vision and Visionaries: The Art and Artists of the Santa Fe Railroad;* with Suzan Campbell and John L. Kessell, *Spirit and Vision: Images of Ranchos de Taos Church.*

*SALLY HYER*, Ph.D., has worked for tribal organizations and museums in the Southwest since 1975. She is the author of the oral history, *"One House, One Voice, One Heart: Native American Education at the Santa Fe Indian School,"* recently co-edited a volume on the Historic American Buildings Survey in New Mexico, and is currently writing a biography of Pablita Velarde. Her work on New Deal programs is part of an ongoing study of Native American mural painting. Hyer is research director at the Institute of American Indian Arts' Center for Research and Cultural Exchange in Santa Fe.

*LYNNE SEBASTIAN*, Ph.D. is an archaeologist specializing in the American Southwest. Her fieldwork, carried out in New Mexico, Colorado, Utah, and Arizona, has included nearly the full range of Anasazi development from Basketmaker III through Pueblo III. In addition to excavation and survey reports, her publications include an overview of the archaeology of southeastern New Mexico, a book on archaeoolgical uses of predictive modeling, and various articles on Chacoan archaeology. Her most recent work is a book published by Cambridge University Press about the political and economic structure of the Chaco system.

Dr. Sebastian received her Ph. D. from the University of New Mexico in 1988. Since 1987 she has been the Deputy State Historic Preservation Officer for the state of New Mexico and, since 1992, the State Archaeologist as well. She is also an adjuct assistant professor of anthropology at the University of New Mexico.

*LOUISE TURNER,* a native new Mexican, grew up in Santa Fe. She vividly remembers herself and friends following Shuster around town while he sketched. She received her undergraduate degrees from the University of New Mexico and has been an educator and administrator in the United States and abroad. She is the recipient of the Princeton Prize for Distinguished Teaching. Ms. Turner was the co-author of *Will Shuster, A Santa Fe Legend*. She has also been a feature editor and writer for such magazines as *Santa Fe Lifestyle* and *Southwest Profile*. She is currently teaching at the New Mexico State Penitentiary and working on a novel set in Santa Fe.

## COMPILER/EDITOR

As Deputy Secretary of State, *KATHRYN A. FLYNN,* has compiled and edited the 1991-21 and 1993-94 *New Mexico Blue Books* distributed by the Office of the Secretary of State. This encouraged her to proceed with a search for where our New Deal art and buildings were in New Mexico. Flynn grew up in Portales but has lived in Santa Fe for a number of years working in private and public settings. Earlier she obtained her undergraduate degree from the University of Utah and Master's degree from Southern Illinois University. Ms. Flynn has written a column in the Santa Fe *New Mexican* for a number of years and is a radio talk show hostess.

# ACKNOWLEDGEMENTS and CREDITS

The following people have all been participants in the origination of this book and it is with heartfelt gratitude that we extend our appreciation to all of them for their sincere and laborious efforts. Through their efforts we have been able to compile this information to recapture the impact of the New Deal programs on life in New Mexico.

## COMPILED BY

Kathryn A. Flynn

## WRITERS

Andrew Connors
Sandra D'Emilio
Kathryn A. Flynn
Sally Hyer, PhD.
Lynne Sebastian, PhD.
Louise Turner

## RESEARCHERS

Sue Black
Phyllis Cohen
Virginia Ewing*
Pauline Giglio
Rose and George Kaplan
Judy Schmutz

## CONTRIBUTORS

Mary Ann Anders, PhD.
Andrew Connors
Roland Dickey*
Barbara Dimond
Octavia Fellin
Michael R. Grauer
Kittu Longstreth-Brown
Thora Hagerty
Meg Harris
Shirley Jacobsen
Nat Kaplan*
Ellen Landis
Virginia Lierz
Helen Lucero, PhD.

William Lumpkins*
Ila McAfee*
Elizabeth McGordy
Joy Y.Fincke McWilliams*
John Meigs
Sally Noe
Rod Peterson
Sarah Pirkl
Lynne Robertson
Myrtle Stedman*
Vincent Wathen*
Alicia Weber
Mary Pollard Wheeler*
Helen Willis*

* Individuals directly involved with New Deal programs.

Numerous other interested individuals and family members of the artists from various communities were likewise most helpful in the gathering of information for the creation of this book.

Finally, the staff of three other state agencies must be thanked for their cooperation, hard work, and enthusiasm shared with us during the detective work involved in compiling this book. This includes the New Mexico Museum of Fine Arts, the State Library-Southwest Room, and the State Records and Archives. Their New Deal detective badges will be forthcoming.

## TECHNICAL ASSISTANCE

John Daniels                                         Lorraine Valencia
Diane H. McNeil                                   Walt Williams

## PHOTO CREDITS

**On the Cover:** "The Old Santa Fe Trail-Sangre de Cristo Mountains" is one of six murals done by William Penhallow Henderson between 1935-37 for the U. S. Federal Building in Santa Fe. Just as the earlier settlers found New Mexico a treasure, we can continue on this famous trail and many others around the state to find New Deal treasures. Photo by Mark Nohl-New Mexico Magazine.

### FRONT SECTION

**Page 6:** Victor Higgins did his modern version of the "Ranchos Church" of Ranchos de Taos c.1933. This 29" x 21 1/2" watercolor is part of the University of New Mexico Art Museum collection and photo was provided by them.

**Page 8:** State Director of WPA Art Program, Russell Vernon Hunter, and Eugenie Shonnard, Santa Fe sculpturess, at WPA sponsored art exhibition with some of her work. Photo from New Mexico State Records and Archives photo collection.

**Page 12:** Horses and other animals have been the focal pieces for most of Ila McAfee's paintings. This oil painting (28" x 30") called "Horsepower" was most likely sent to the New Town schools in Las Vegas. Its current location is an unsolved mystery. Photo from N.M. State Records and Archives photo collection.

**Page 18:** "Fall in the Foothills" caught the eye of President Franklin Roosevelt and Herbert Dunton's painting hung in the President's Office. It now is part of the National Museum of American Art in Washington, D. C. Photo from N.M. State Records and Archives photo collection.

### ALAMOGORDO

**Page 129:** The untitled Peter Hurd frescos include four panels on the front of the adobe U. S. Federal Building now housing the U. S. Forest Service in Alamogordo. These two main panels are bordered with the text: "Come sunlight after rain to bring green life out of the earth" and "Ven lluvia bendita, ven a acarciar la Tierra Sedienta." Photo by Mark Nohl-New Mexico Magazine.

## ALBUQUERQUE

**Page 26:** In 1934 Willard Nash did six 85" x 55 1/4" oil panels to be hung opposite Raymond Jonson's creations in the Zimmerman Library. They depicted the physical activities of modern youth. The paintings are now in the UNM Art Museum Collection and photo was provided by them.

**Page 31:** Raymond Jonson and his abstract creations were different from most of the New Deal artists in New Mexico. He was a strong proponent of the Transcendental Movement and a UNM art professor. His home now houses the Jonson Gallery on campus. This large mural is a part of that collection. Photo from the N.M. State Records and Archives photo collection.

**Page 130:** William Nash (1898-1934) found New Mexico a more stimulating artistic environment in 1920 than his previous lives in Pennsylvania and Michigan. Another member of the Los Cinco Pintores, he developed his abstract style and was marked as one of the more daring New Mexico modernists. These works are just some of those in the University of New Mexico Fine Art collection. They were both done in 1934 and are untitled but present, as do the entire group, various athletic opportunities at the school at that time. Photo loaned by UNM Art Museum.

**Page 131:** Taos artist Gisella Loeffler, was born in Austria. Painting in bright vivid colors was her style and two large murals with rounded children of New Mexico's three main cultures interacting with well known children's literary figures were the sujects she chose to please the "crippled children" at the Carrie Tingley Hospital. These oil on fiberboard 72" x 120" murals with gold leaf and bright reds continue to cheer the hospital's children. Photo by Greg Johnston, Carrie Tingley Hospital.

**Page 132:** A young black student, Oliver LaGrone, in UNM's art department sculpted "Mercy" in 1935 in memory of his mother's tender care of him during a serious childhood illness. The initial piece, nearly lifesize, was placed in the lobby of Carrie Tingley Hospital and fifty-seven years later (1992) was finally bronzed. The now retired professor LaGrone came home to Albuquerque from North Carolina for that official unveiling. Photo by Greg Johnston, Carrie Tingley Hospital.

## CARLSBAD

**Page 39:** The Carlsbad Museum may now have this oil painting (42' x 50") created by La Verne Nelson Black as part of the Treasury Relief Art Project. It is entitled "The Jicarilla Apache Trading Post" and is quite typical of his work. Photo from N. M. State Records and Archives photo collection.

## CLAYTON

**Page 133:** This pastel "Cottonwood Tree", (11" x 17") is quite typical of Helmuth Naumer's work and is part of the Clayton school's collection of New Deal art. That whole school complex is a New Deal treasure inside and out and should not be missed. Photo provided by the school.

**Page 134:** The "Oklahoma Storm" (20" by 24") was created by Santa Fe's self taught artist, Hal West. It is part of the Clayton school art collection and is particularly appreciated since Clayton have received some of the same winds and dirt that have blown on over from Oklahoma in similar looking storms. Photo provided by the school.

## DEMING

**Page 47:** Oil painting "Across the Valley" (36" x 40") by E. Martin Hennings hangs in the Deming schools but may be a scene of a valley close to the Taos artist's home. Photo from N.M. State Records and Archives photo collection.

## DEXTER

**Page 135:** Kenneth Adams captured the state's desert in his large mural "Mountains and Valleys" for the Dexter post office. This PWAP mural painted in 1938 actually has more soft yellow and gold tones in it than presented in this reproduction. It is 60" x 144" and is in the entry area of the building as are the other post office murals around the state.

## EL RITO

**Page 124:** James Morris (shown above) and Charles Barrows may have done a series of scenes for a mural called "Vocational Studies" for the Spanish American Normal School, now Northern New Mexico Community College, in El Rito. The whereabouts of this work is an unsolved mystery. They do have at the school in El Rito a D. Paul Jones tryptch in the Bronson Cutting Building . It is entitled "The Founding of San Juan, the New Spain." Photo from the N.M. State Records and Archives photo collection.

## FORT SUMNER

**Page 136:** Billy the Kid, Charles Maxwell and his home, and many of the other prominent historical figures of the state's "eastside" were included in Russell Vernon Hunter's large fresco called "The Last Frontier." Created in 1934 under the PWAP, the history of the area is recorded pictorially in the De Baca Courthouse in Ft. Sumner. Photo by P. J. Sharpe.

**Page 137:** Another segment of the large Hunter fresco depicts the industrialization of the artist's home area near Clovis. The 1934 fresco is all encompassing in its storytelling. Pedro Cervantez, another eastside boy, assisted Hunter with this massive creation. Photo by P. J. Sharpe.

## GALLUP

**Page 138:** Internationally renown Indian artist, Allan Houser, was just a young man when in 1942 he created this typical two dimensional rendering in casein called "Apache Dancer." It is part of the Octavia Fellin Library Collection in Gallup. He later moved on to the three dimensional pieces for which he became famous. Photo provided by Octavia Fellin.

**Page 55:** "Westwind"-Pueblo Maiden (46" x 32") created by Joseph Fleck is characteristic of his strong individual portraits. This young woman is in the Octavia Fellin Library Collection and may have been part of the town's original New Deal art center. Photo provided by Octavia Fellin.

**Page 139:** Lloyd Moylan has portrayed the McKinley County's history in a 2000 square foot mural from prehistoric time to tourist times.

## KIRKLAND

**Page 57:** The public buildings built all over the state by the WPA and CCC projects included courthouses, schools, and even "flyproof interior sanitation units." This one still stands in the Kirkland area but it is unknown if there is any public art within or on its four walls. Photo provided by the San Juan County Historical Society.

## LAS CRUCES

**Page 140:** Tom Lea did two large historical murals for the New Mexico Agricultural College, now NM State University, in Las Cruces. Since "Conquistadors" is a PWAP mural it must have been done in 1933-34 and is oil on canvas, 54" x 120" in size. It is now in the school's fine art museum collection and can be viewed upon request if not on display. Also murals by Olive Rush can be more easily viewed on the exterior front of the school's Biology Building. Photo provided by NMSU Art Museum.

**Page 141:** This Tom Lea privately commissioned 1935 mural has viewed the townspeople for many years from its high perch in the Branigan Cultural Center. Formerly the city's library, the building's mural overlooks the then checkout area and was appropriately titled "The Dissemination of the First Book About New Mexico-1610." Photo by Pat Greathouse, Las Cruces.

**Page 156:** Josef Bakos came to Santa Fe in 1921 and was an art teacher at Santa Fe High School. He was also one of the Los Cinco Pintores. This watercolor titled "Iris Lilies" can be found in the Las Cruces Public Schools. Photo donated by school.

## LORDSBURG

**Page 64:** Joseph Amadeus Fleck started out in Austria but New Mexico won his heart in 1924 and Talpa provided the setting for this oil painting. The 32" x 35" piece still hangs in the Lordsburg public schools and is entitled "Landscape from Talpa," an area near Taos. Photo from N. M. State Records and Archives.

## MELROSE

**Page 142:** The Melrose schools have five choice murals hanging in their school library. They were done by Howard Schleeter for WPA in 1937-38 and are oil on board, sizes 47" x 71". Other New Deal art still exists in the building however their beautifully colcha embroidered stage curtain designed by John Ridgely Whiteman and stitched by local ladies burned in a fire. Photo by Kathryn A. Flynn.

## PORTALES

**Page 143:** The murals by Lloyd Moylan in the Administration Building of Eastern New Mexico University are not only beautiful but powerful. These 1934 PWAP murals depict

the message of the twelfth chapter of Ecclesiastes as chosen by the private sponsor who assisted in the financing of these masterpieces. Moylan also did two other large murals--one at Highlands University and the other in Gallup at the McKinley County Courthouse. Photo loaned by ENMU.

**Page 146:** Nils Hogner did four colorful panels of "Indian scenes" in 1934. They are all 34" x 44" and went to Eastern New Mexico University but only three have been located. See "Unsolved Mysteries Chapter" for information about fourth painting. Photo by Kathryn A. Flynn.

**Page 73:** Now well known Santa Fe artist and architect, Bill Lumpkins, did a series of watercolors depicting our state's three predominant cultures' typical villages. Eastern New Mexico University is the owner of the "Indian Village" and has it in the school's art collection. Photo from the N.M. State Records and Archives photo collection.

## RATON

**Page 147:** The Schuler Theatre's entry ceiling in Raton holds eight stunning panels created by local artist, Manville Chapman. These were done for the PWAP in 1934 and are all 24" x 84" in size. Each oil panel depicts a historical scene from the beginnings of Raton and surrounding communities. Photo by Mark Nohl-New Mexico magazine.

**Page 148:** "Lucero's House" created in 1938 by William Penhallow Henderson is 32" x 39" and is part of the Arthur Johnson Memorial Library collection in Raton.

## ROSWELL

**Page 76:** The Roswell Museum and Art Center was one of the four New Deal art centers created in New Mexico. It is the only one remaining. This woodcut by Manville Chapman was created at its opening in 1937 and used again for the 50th anniversary celebration in 1987. A much larger structure today houses many fine paintings and furniture from the New Deal and other collections. Reproduction provided by the facility.

## SANTA FE

**Page 149:** "The Old Santa Fe Trail-Sangre de Cristo Mountains" is one of six murals done by William Penhallow Henderson between 1935-37 for the U. S. Federal Building in Santa Fe. Just as the earlier settlers found New Mexico a treasure, we can continue on this famous trail and many others around the state to find New Deal treasures. Photo by Mark Nohl-New Mexico Magazine.

**Page 87:** The frescoes created by Olive Rush in 1934 for the former Santa Fe Library building are still as beautiful as ever. The frescoes can be viewed by appointment until the building is once again open as the state's History Museum. The frescoes were appropriately called "The Library Reaches the People." The current library houses two small statutes of a boy and girl reading a book. They are also New Deal creations by Hannah M. Ludins. Photo from N.M. State Records and Archives photo collection.

## SILVER CITY

**Page 150:** If you go to the Grant County Courthouse in Silver City, you can't miss Theodore Van Solen's two large murals in the entry area. "The Chino Mines" done in 1933-34 is oil on canvas and is 67" x 151", also the size of the companion mural "The Roundup." Photo taken by P. J. Sharpe.

## SPRINGER

**Page 96:** "El Puerton" by Fremont Ellis went to the N. M. Boys School in Springer. This 22" x 30" oil painting has yet to be found. Another one of his paintings placed in Santa Fe's State Highway Department and titled "Highway 66" has also disappeared. Where are they? Photo from the N.M. State's Records and Archives photo collection.

**Page 151:** Albuquerque artist, Carl Redin, painted an 18" x 24" oil painting and called it "Placita Wash Day." This photo reproduction was damaged but the actual painting is in good condition. This painting went to the Springer Library but he has a number of paintings around the state as a result of the New Deal. The Albuquerque Museum has a large collection of his work. Photo by Kathryn A. Flynn.

## TAOS

**Page 152:** Patrocinõ Barela's unique folk carving was a hit in 1935 and is more so today. The Harwood Museum in Taos may have the largest collection of his work today and this 1941 piece, "El Fidel" is part of it. The curator, David Witt, will soon have a book out about Barela. Photo provided by David Witt.

**Page 97:** "The Taos Fresco Quartet" included Bert Phillips, Victor Higgins, Ward Lockwood and Emil Bisttram and three of them are shown at work above. They tried their hands at creating ten frescoes in the courtroom of the then Taos County Courthouse. More can be read about them in the information about Taos. Work is underway to restore the frescoes to their original condition. Photo from the N. M. State Records and Archives photo collection.

**Page 153:** A singular view of one of the frescoes "Transgression", created by Emil Bisttram in the Taos County Courtroom is quite somber. He did two others titled "Reconciliation" and "Aspiration" in 1933 for the PWAP and they are 83" x 51 1/2" in size. Photo by Mark Nohl-New Mexico magazine.

## BIOGRAPHY SECTION

**Page 256:** Sheldon Parsons enjoyed touring the beautiful countryside in a wagon with his artist daughter, Sara. They stopped and painted along the way and possibly this scene "View from San Ildefonso" (also referred to as "View from Otowi"). This painting with the Black Mesa looming up in the background is one of our unsolved mystery paintings. Its sister painting, "View from Espanola" is still in the state's Human Services Department main office where both were originally placed. Photo from N.M. State Records and Archives photo collection.

**Page 267:** Will Shuster, as noted earlier in the book, was selected by PWAP to paint the Carlsbad Caverns. Today this painting is in the Regional Office of the National Park Service in Arizona. Photo from N.M. State Records and Archives photo collection.

**Page 275:** Stuart Walker created a series of ten watercolors for the U.S. Forest Service that captured the New Deal supported field workers at their jobs. The "Fencing" scene was one of the set, all 22" x 28", which is believed to have started at the District Office of that agency in Albuquerque. Where did they go? Photo from N. M. State Records and Archives photo collection.

**Page 273:** Taos artist, Walter Ufer, created this 25" x 30" oil called "Blaze and Buckskin." It is in the UNM Art Museum collection. Unfortunately Ufer's life was cut short early due to his unexpected death caused by ruptured appendix. Photo from N. M. State Records and Archives photo collection.

## HISPANIC SECTION

**Page 160:** Pedro Cervantez's painting on glass was representative of a piece from his culture. He also did a number of easel paintings and was included in many exhibits by Hunter. Photo from the N. M. State Records and Archives photo collection.

**Page 21:** The carved chest and chairs were of the style discussed in this chapter. Similiar beautiful furniture was placed in various public buildings around the state. These were in the Girls Scout Office in Roswell. This kind of work was designed and constructed in the New Deal programs and the vocational school programs. They were so well constructed that they are still in use today in many sites around the state and treasured. The Roswell Art Center and the National Park Service in Santa Fe have some fine pieces. Photo from N. M. State Records and Archives.

**Page 80:** Eddie Delgado, an accomplished tinsmith, carried on the family tradition of creating beautiful tinwork. This is part of the collection in the National Park Service building in Santa Fe and he also did elaborate pieces for the Albuquerque Little Theatre. Photo from the N.M. State Records and Archives photo collection.

## MYSTERY PAINTINGS SECTION

**Page 106:** Kenneth Adams' "Native Woman" was possibly an 18" x 23" lithograph. Copies of it went to at least six schools around the state. some were framed, others may have been unframed. Because of the latter situation they may have been lost more easily. Photo from N. M. State Records and Archives photo collection.

**Page 120:** Gene Kloss created nine black and white etchings that were reproduced and sent to public schools all over the state. They were all 20" x 26" framed and featured primarily northern New Mexico scenes. Since there were so many distributed, it has been difficult to locate them all. Refer to the "Unsolved Mysteries of Art" chapter for the list of possible school locations. Photo from UNM Art Museum.

**Page 154 and 155:** These are two more of the nine etchings that were sent to thirty schools in NM including two schools of higher education. Where are they all now?

## GROUP OF ARTISTS PICTURE

**Page 168:** Will Shuster (in hat) visits with hostess, Dolly Sloan, and fellow artists John Sloan (left foregound) and Josef Bakos (at table). Teresa Bakos (visiting with Sloan) was also a New Deal artist as was her son, John Dorman. This setting was the Sloan home on Garcia St. and was the site of various gatherings as were all of the artist's homes since they loved to party with one another. It was an inexpensive and usually an exciting way to forget the depression of the times. Photo from N. M. State Records and Archives photo collection.

## INDIAN SECTION

**Page 157:** Po Qui created this version of Buffalo Dancers and others for the New Deal Indian Art Exhibit. Photo from New Mexico State Records and Archives.

**Page 158:** Harrison Begay graduated from the Santa Fe Indian School in 1939 and most likely did this work during that period. It was included in the New Deal Exhibit of Indian Arts of the North American Indian. Photo from New Mexico State Records and Archives.

**Page 159:** Indian games depicted by unknown artist for New Deal Indian Exhibition. Photograph taken by Ernest Knee. Photo from New Mexico State Records and Archives.

**Page 196:** Maria and Julian Martinez were just two of the Native Americans who participated in the New Deal. This beautiful pot (c. 1941) is part of the New Mexico Fine Arts Museum collection. Refer to the chapter on the Indian New Deal programs for more specifics on the activities and participants of this group of New Mexicans. Photo from Sunstone Press.

# INDEX

# IDENTIFICATION OF OTHER WPA/NEW DEAL ART AND ARCHITECTURE IN NEW MEXICO

Surely more of these treasures are out in the Land of Enchantment and maybe even somewhere else. Hopefully we will located some of the "Unsolved Mysteries of N. M. New Deal Art." Most likely we will even find other unknown creations. You can help us. If you are aware of or come upon some of the things created during the New Deal era in New Mexico that has not been included in this book, please fill out this tear sheet and mail it to Sunstone Press, P. O. Box 2321, Santa Fe, New Mexico 87504-2321.

## *ARTWORKS*

TOWN:_____

TYPE OF ARTWORK: (Circle One) Painting, Mural, Sculpture, Craft Item, Other.

ARTIST:_____

NAME OF ITEM:_____

LOCATION OF ITEM:
ADDRESS_____PHONE_____

CONTACT PERSON:_____

CONDITION OF
ITEM:_____

## *ARCHITECTURE*

TOWN:_____

BUILDING:_____

ADDRESS:_____

CONTACT PERSON:_____

PHONE NUMBER:_____

OTHER COMMENTS:_____

_____

_____

*We thank you.*